FRIDA

IN

AMERICA

FRIDA
IN
AMERICA

The CREATIVE AWAKENING
of a GREAT ARTIST

CELIA STAHR

St. Martin's Press
New York

First published in the United States by St. Martin's Press, an
imprint of St. Martin's Publishing Group

www.stmartins.com

Designed by Meryl Sussman Levavi

All letters from the Nelleke Nix and Marianne Huber Collection of
Frida Kahlo Papers translated by Cristina Visus

Library of Congress Cataloging-in-Publication Data

Names: Stahr, Celia, author.
Title: Frida in America : the creative awakening of a great artist /
Celia Stahr.
Description: First edition. | New York : St. Martin's Press, 2020. |
Includes bibliographical references and index.
Identifiers: LCCN 2019041724 | ISBN 9781250113382 |
ISBN 9781250113399 (eISBN)
Subjects: LCSH: Kahlo, Frida. | Kahlo, Frida—Psychology. |
Expatriate artists—United States—Biography. |
Artists—Mexico—Biography.
Classification: LCC N6559.K34 S73 2020 | DDC 759.972 [B]—dc23
LC record available at https://lccn.loc.gov/2019041724

First Edition: March 2020

10 9 8 7 6 5 4 3 2 1

To Gary and Mei Lin

Contents

IV. MEXICO

V. NEW YORK

VI. DETROIT

VII. NEW YORK

Introduction

To step within the blue walls of Frida Kahlo's home in Coyoacán is to enter into the artist's sanctuary. You feel Frida's spirit as soon as you walk through the rectangular vestibule and into the central courtyard, filled with green leafy plants and trees surrounded by those deep blue walls. It's ravishing.

In the house, yellow and blue tiles spread out over the kitchen, yellow shelves hold green Jalisco pottery in the dining room, and masks, colonial-style paintings, and papier-mâché figures adorn the walls. Everywhere you look, interesting objects abound, yet nothing looks cluttered. Instead, everything appears to have been lovingly placed in just the right spot.

Entering Frida's painting studio was the most intense experience of my visit. A later addition to her childhood home, originally built by her father, the room is on an upper floor with large windows overlooking the garden. The only bright colors in this room are found on an unfinished still life of fruit propped up on Frida's wooden easel. The easel was specially made to allow for different heights, so the painter could sit if needed. Her wheelchair, empty, faces it. I imagine Frida sitting there, her black hair braided with colorful ribbons, paintbrush in hand, lost in concentration, as she figures out her next stroke. Brushes of all sizes stand in containers, bottles of powdered pigment line a table, and a black model locomotive

stands nearby. My mind flashed to Frida's photographer father, who had a train set in his studio; was this his?

In contrast, the many ceramic figures from western Mexico set Frida apart from her German father. Yet these figures stand on top of bookshelves against the walls, and the impressive collection of books also recalls Frida's father. Both were voracious readers. There is a wide variety of subjects, and the books are written in many languages: Spanish, French, German, Hebrew, and English: José Guerra's *Historia de la Revolución de Nueva España,* John Steinbeck's *In Dubious Battle,* Harold Nicolson's biography of Dwight Morrow, Alfonso Toro's *Historia de México: La Dominación Española,* José Vasconcelos's *Lógica Orgánica,* Morris Bishop's *A Gallery of Eccentrics,* Georges Rodenbach's *Brujas, la Muerta.* As I perused these titles, novelist Isabel Allende's words rang in my ears: "The library is inhabited by spirits that come out of the pages at night."[1]

What spirits might emerge from the pages of Rodenbach's nineteenth-century Symbolist novel portraying a widower who retreats to a decaying city in Belgium to mourn the death of his wife? Rodenbach said the city of Bruges was a character in the book. He understood the importance of place for the psyche. Frida did too.

She made her home a place where she could feel safe, rejuvenated, creative, mentally and visually stimulated, and surrounded by love. This is what stood out to me as I walked through her house and sat in her garden. It was like no other museum I had ever visited. I could feel all the love Frida had put into this place, where she was born in 1907 and where she died in 1954. Her ashes, placed in a ceramic urn shaped like a headless squatting figure, still sit on a table in her bedroom.

Frida in America is a story about the impact of place. The word "America" in the title refers to Frida's time living in the United States of America. But because this is a story about a Mexican artist, it's an America seen through Frida's eyes. She brings a very different and complicated perspective to the American experience. For her, America is both the United States and Latin America; it is the problematic North American border relationship between Mexico and the United States; and it is the promise of Pan-Americanism that Venezuelan politician Simón Bolívar first promoted in 1826 and which was taken up by artists, intellectuals, and social activists in the 1930s.

In this biography, readers follow Frida's unfolding personal and creative awakening within the United States from 1930 to 1933, a period of great

turmoil. As the Depression grew worse, fractures in society deepened: the divide between rich and poor widened; tensions about Mexican workers taking jobs in the United States snowballed; lynchings of black men increased; and, ten years after winning the right to vote, women explored their emancipation alongside men who were experiencing a masculinity crisis because of job loss. The uncertainty of what lay ahead was exacerbated by the rise of fascism abroad.

There hasn't been a major biography of Frida since Hayden Herrera's 1983 book. And no author has explored in depth the body of work Frida created while living in the United States. Focusing on these pivotal years of her development allows for a deeper understanding of this gifted woman and artist. It opens a door on many of the issues, attitudes, and norms Frida came up against in this significant period of her life, which provided the foundation for her later identity, public persona, and mature art style.

Prologue

The Aztec sun god Huitzilopochtli threw a rebel's heart into Lake Texcoco and proclaimed: "When you see an eagle perched on a cactus holding a snake in its mouth, this is where you shall build your city."

—AZTEC MYTH

 Frida was lying in a blood-soaked bed. Small creases in the white cotton sheets had absorbed the red liquid like the fruit of a prickly pear cactus, sliced open. Glistening magenta, fruit of the earth, the blood miracle that consecrated the Aztec capital of Tenochtitlán, now surrounded Frida's naked body with the pain of death. The eagle and snake were missing in the dark early morning hours, but the sun still came up, casting light on Frida's dark, damp hair covered with salty tears.

She wailed in agony and despair. Diego, frantic, didn't know what to do. The blood, the screaming—it was all too much for him. He rushed into the living room muttering something about the doctor. A call was made, but Frida would have to suffer for another hour before an ambulance arrived.

At the Henry Ford Hospital, Frida, recumbent on a gurney, was whisked through a long, narrow cement hallway in the basement. Her eyes fixed on what she perceived to be multicolored pipes on the ceiling. "Look, Diego! *Qué precioso!* How beautiful!" she exclaimed.[1] This was the last bit of beauty Frida would encounter for a while.

"We descend from death," Carlos Fuentes sings out.[2] Death smiles, dances, and provides the sweet caresses of a lover. The skeletons of José

Guadalupe Posada fill the imagination, especially during Day of the Dead celebrations, embracing Mexicans with their origins, holding on to Aztec times. "The past is always present," Fuentes whispers.[3] The heart, center of the human body, is the axis mundi. Keep the universe in motion, the Aztecs proclaimed. Feed the gods. Blood was the cuisine the gods favored. Blood creates a line from the earthly to the divine, from death to life, from darkness to light. The duality of life for the Aztecs, as for Frida, was a bringing together of opposites. "Everything is all and one," Frida wrote.[4] Seating these opposites side by side to share the blood of death and life, she painstakingly stitched them together with paint, one small stroke at a time.

Blood and the concept of duality became central for Frida's art and life while living in the United States. She was "a child of the Mexican Revolution," as she liked to say, a passionate defender of the underdog.[5] But it took living in the United States, a place she'd longed to visit since her teenage years, to shake her foundations of home and homeland, forcing her to see a different reality. She struggled and stumbled in this foreign country, cursing it at times, embracing it at others, but always she visualized it with a keen eye for the humor that bubbled under the surface of pain.

Frida loved life. It came through in her infectious, throaty laugh and in her direct manner of speaking, even in English; sometimes she'd exaggerate her Mexican accent when necessary to spice up the conversation or punctuate a point. It came through in her way of dressing, whether she was wearing a man's suit or a colorful peasant-style pleated skirt and *huipil* (top), details mattered: the right Aztec-inspired earrings, the perfect length cane, the precise size of jadeite beads, the best shade of lipstick. Everything was done with love. "Love is the only reason for living," she proclaimed.[6] Fuentes said Frida was "a natural pantheist, a woman and an artist involved in the glory of universal celebration, an explorer of the interrelatedness of all things, a priestess declaring everything created as sacred."[7]

When she came to the United States at twenty-three with her husband, muralist Diego Rivera, she was still at the beginning of this exploration, with eyes wide open, seeing how all things were interrelated and integrating this universal celebration into her art. The young Frida was a novice painter. Her husband, on the other hand, was forty-four and at the height of his creative powers. When *Time* magazine ran a short article on Diego a year into his stay in the United States, it referred to Frida as "his pretty little Mexican wife, the former Frieda Kahlo."[8] Frida would always be physically

petite, but her identity as Frida Kahlo, the great painter, grew in stature as she grew creatively and personally in the United States.

Her first stop was San Francisco, a place she'd dreamt about for years. The day before Diego received the letter from the American architect Timothy Pflueger inviting him to paint a mural on the wall of his recently completed Pacific Stock Exchange building in San Francisco, Frida had her recurring dream. She saw herself waving goodbye to her family as she left her beloved Mexican homeland for San Francisco, the "City of the World," as she called it.[9] It amazed Diego that Frida's dream had been so prescient. Frida knew she had to start packing because she believed you had to "protect what Destiny has given you."[10]

I

ENTERING GRINGOLANDIA

Frida in the Wilderness

*My biggest dream for a very long time
has been to travel.*

—FRIDA KAHLO, 1927

Frida Kahlo was a spontaneous woman who adored adventure, as long as it didn't keep her away from home for too long. She was thrilled to realize her dream of traveling to San Francisco, but leaving her family and her homeland for the first time was monumental. There were many unknowns. What was San Francisco really like? Would she get along with Diego's artist friends and their wives? Would she be able to communicate, given her poor command of English? Would she like the food? Would she be inspired to paint? Would Diego, her husband of fifteen months, be faithful? Would she?

In the short time she'd been married, Frida had found adjusting to Diego's all-consuming painting schedule, late hours, chaotic lifestyle, and erratic moods challenging. Their life together was shaping up to be a syncopated rhythm with explosive accents. This was no surprise. From a young age Diego had possessed an intense energy that frightened his mother and charmed his father. He would harness this potent energy to fuel his prolific painting career, incite political brawls, and pit admiring women against one another. Frida was only beginning to feel the complexity of this man's emotional needs—if she wasn't a chain smoker at this point in her life, she would become one.

The long train trip to San Francisco offered Frida and Diego plenty of time together. Frida loved the ride, exclaiming, "The trip is wonderful because the train runs all along the coast, through Mazatlán, Tepic, Culiacán, etc., until it reaches Nogales, the U.S. border."[1] Although the United States created a borderline to demarcate two separate countries, it ended up being a place where two cultures gave birth to a third. Frida observed: "The damned border is a wire fence that separates Nogales Sonora from Nogales Arizona, but you could say it's all the same. At the border, Mexicans speak English very well and *gringos* speak Spanish, and they all get mixed up."[2] Nevertheless, passports had to be checked on both sides and medical exams passed before they were allowed to continue north through Arizona and west toward the next major stop, Los Angeles.

In the City of Angels, they saw friends, met the art dealer Galka Scheyer, and took in the sights. They enjoyed the beaches, architecture, and movie stars' homes, but Frida still had her criticisms:

> The *gringas* are all hideous. The movie stars aren't worth a damn.
> Los Angeles is full of millionaires and the poor people barely scrape
> by, and all the houses belong to the billionaires and movie stars,
> the rest of the houses are made of wood and they are pretty crappy.
> There are 3,000 Mexicans in Los Angeles, who have to work like
> mules in order to compete in business with the *gringos*.[3]

Already Frida was witnessing the gap between rich and poor, Mexican and *gringo,* something that raised her hackles every time. Frida felt things on a deep level. She was "direct and honest in her thoughts and in her actions," her niece Isolda observed.[4] But Frida's younger sister, Cristina, would often say, "Just try to be a little less vehement, would you?"[5] Frida knew she couldn't be so forceful when she was speaking with Diego's patrons; she would have to temper her quips, witticisms, and cutting remarks.

Back on the Southern Pacific train bound for San Francisco, Frida took out a sheet of white paper. Drawing straight lines that reached to the top in a vertical sweep, she formed rectangular skyscrapers. In front of this cityscape, she drew water and a self-portrait. This drawing, now lost, conveys Frida's connection to cities and to the ocean, to culture and nature. Both would remain important to her for the rest of her life: she associated her

father's German relatives with being an ocean away, her mother's Mexican heritage with the beauty of the land, and her father's intellectual and artistic pursuits with urban cultural centers.

She'd grown up in Coyoacán (in Nahuatl the name means "place of coyotes"), a picturesque village with trees, flowers, a river, and dirt roads. It's a place that embodies the turbulent and syncretic history of Mexico. The Spaniard Hernán Cortés made Coyoacán the first capital of New Spain. He eventually moved the capital to present-day Mexico City, where he proceeded to demolish the old sacred precinct, dominated by a twin pyramid, and replace it with a symbol of the new, a Catholic church—a move he hoped would destroy Aztec deities, philosophy, and culture. But he failed to realize one important fact: the old could not merely be toppled to make way for the new.

The Aztec notion of duality remained rooted in the land, and it shaped Frida's psyche. She loved growing up surrounded by nature, but she could also experience urban life and culture, as Mexico City was only an hour's bus ride away. It was a modern, international metropolis with a rich yet painful and layered history, from the great Aztec empire to the conquering Spanish and French, along with Bavarian, Chinese, and American influences. During Frida's adolescence, "it was a lovely, rose-colored city of magnificent Colonial churches and palaces, mock-Parisian private mansions, many two-story buildings with big painted gates (*zaguanes*) and wrought-iron balconies; sweet, disorganized parks, silent lovers, broad avenues and dark streets," writes Fuentes.[6]

Frida was quite familiar with the look and feel of a big city, but she'd never seen San Francisco. After she finished her self-portrait with a city scene and water on the train, she showed it to Diego without any explanation. He later recalled that upon their arrival in San Francisco, "I was almost frightened to realize that her imagined city was the very one we were now seeing for the first time."[7]

On November 9, 1930, the train stopped at Third and Townsend as a crisp breeze whipped across San Francisco Bay. Frida stepped off the train wearing black ankle strap shoes. They were barely visible under her long skirt, which made it appear as if she were "floating," as friends often observed.[8] At five feet three inches and ninety-eight pounds, Frida appeared

even tinier next to her six-foot, three-hundred-pound husband, who wore a suit, a broad-brimmed Stetson hat, and heavy work boots. They were a distinctive-looking couple, easily spotted by those who had come to meet them.

Although the gregarious, cigar-smoking Diego was in his element in a group, the observant Frida scanned the crowd like a cat wary of possible predators. Frida was unsure what type of reception she and her husband would receive. When Diego's mural commission had been announced two months earlier, many in San Francisco had wanted to know why struggling local artists hadn't been hired instead. The shaky economic times and the uncertain future that lay ahead fueled a collective feeling of resentment. And for a while it looked as though the local artists had won the day. The State Department initially denied Diego's visa based upon his former ties to the Communist Party. But San Francisco sculptor Ralph Stackpole, who had been friends with Diego for several years, made sure his friend prevailed.

The mural commission had been Ralph's idea. He felt that someone like Diego, with his fame and genius, would bring prestige to the local art scene and spawn a mural movement—an art for the people. He even managed to get Diego an additional commission for a mural at the California School of Fine Arts (today the San Francisco Art Institute). Ralph, known to his friends as "Stack," also used his business savvy to help cement Diego's reputation with powerful art collectors.[9] One of those, Albert Bender, the most influential art patron and donor in the Bay Area, shared his enthusiasm for Diego's mural and easel paintings. So when Diego's visa application was denied, Stack turned to Albert and used his connections to get the State Department's decision reversed. This was a huge victory for Diego and Frida, but it only further fueled the anger and resentment of the protesters. *Art Digest* lamented, "All is not quiet on the San Francisco front. A storm unprecedented in recent years is shaking the art colony to its very foundations."[10] Two days before Diego and Frida were scheduled to arrive in "The City by the Bay," stock prices fell to a new low on the San Francisco Stock Exchange. Diego was undisturbed by the controversy, however, as he was used to such battles back home; one might even say he courted them.

As Frida and Diego walked along the train platform, some reporters approached them for interviews. Diego, a great storyteller who made sweep-

ing movements with his hands when he spoke, was prepared to charm them. But some, like the American critic Rudolf Hess, were suspicious of Diego's sincerity: "I should say that his predominant characteristic is a conscious showmanship. He is the P. T. Barnum of Mexico."[11] There was a tinge of prejudice as well in a *San Francisco Chronicle* article that described Diego in stereotypical terms. He was referred to as a *"paisano* [peasant] with a broad-brimmed hat of distinct rural type" who "piled domestically suitcase after suitcase into [the] car. One looked for groceries or a canary cage to complete the 'bundle' picture." After setting Diego up as a "rural type" who had a "reputation for sarcasm," the reporter seemed relieved to conclude that this foreign artist was an *"hombre muy agradable* [a very nice man]."[12]

Fortunately for this very nice man, there were no signs of any disgruntled artists. Instead, Stack and architect Timothy Pflueger stepped forward to greet Diego and Frida. At one point a photographer snapped a picture of Pflueger smiling and shaking Diego's hand, while Stack extends his hand. The men frame Frida; they look toward one another while she looks straight at the camera. She wears a distinctive short jacket with two large *hombrera*-like shoulder flaps—à la matador—over a long dark skirt. In her hand she holds a beret.

Frida once said, "I have broken many social norms," but her choice of an androgynous outfit on this occasion wasn't an echo of fashion trends in the United States, where actresses such as Marlene Dietrich and Greta Garbo had popularized the look of Coco Chanel–type pantsuits.[13] Frida had always felt a strong affinity with her "male" side, especially after her father had taught her at age six how to box, wrestle, play soccer, and swim long distances. He hoped to strengthen her right leg, which had been weakened by polio. She also learned to toughen up on the inside. When children teased her with taunts like "Frida peg leg," she hurled curses at her tormentors. As an adult, Frida had matured into someone athletic and tough, but also graceful, though prone to leg pain and other health issues. As she looks out beyond the men in this photo, she seems poised to make her mark.

San Francisco was a small city in those days, with two distinct odors permeating the waterfront: fish and coffee. In this maritime market, fisheries

were a prominent feature, but Hills Brothers and Folgers also had their headquarters near the Embarcadero. Cargo ships came in from around the world—Hong Kong, Oslo, Calcutta. With many different languages spoken there, the waterfront became the lifeblood of the city.

Stack lived nearby. His place at 716 Montgomery Street was in the Financial District, not far from the North Beach Italian section and from Chinatown. When Frida and Diego arrived at his doorstep, the building—constructed from the hull of a schooner—did not look tall and imposing. But when Stack opened the door, Frida and Diego glimpsed a steep flight of stairs. At the top they spied three doors, each leading to a separate space. Studio 1, directly to the left, had a heavy wooden door. This was to be Frida and Diego's living space.

Entering what would be their new home for the next six months, they saw four large rectangular windows facing Montgomery Street and a pyramid-shaped skylight above.[14] It was a decent-sized room for one person, with a small, old brick fireplace providing the only warmth. A separate bedroom through a door near one of the windows facing the street would double as Frida's studio. A Mexican-style *equipal* (leather-covered chair) sitting in the corner was a nice reminder of home, something that offset the bed, which they soon discovered was "as soft as chewing gum," preventing Diego from getting a good night's sleep.[15]

If Frida and Diego had been confined to this one studio, they probably would have filed for divorce by the time their San Francisco stay was over. Fortunately, they also spent time across the hall in Stack's place. Ginette, Stack's wife, spoke fluent Spanish, making Frida feel at ease. It was here at the Stackpoles' that the foursome, often joined by two other couples living in the building and writer John Weatherwax, would gather. In the Stackpoles' kitchen, a window ledge was filled with canned fruit—"peaches, prunes, and pineapple."[16] To Frida, who grew up with fresh fruit and oranges grown in the courtyard of her family's home, the idea of canned fruit was probably odd. But she was impressed with the warm showers and two-burner gas range: "I don't have to light a fire or anything because it all runs with gas, it's really no bother at all."[17]

Frida quickly settled into a routine. For breakfast, she drank two glasses of milk with two oranges and bread with butter. After breakfast, she and Diego would return to their studios. Frida only had to go across the hall to their living quarters, but Diego would go downstairs to Stack's

huge studio (facing the alley on Jessop Place), which worked well for the sizable preparatory sketches Diego was creating for his mural at the Pacific Stock Exchange. At noon they would stop for lunch, which was a bit too early for Frida, as she complained to her mother: "The *gringachos* eat very early here."[18] They would go to an Italian restaurant down the street along with Stack, Ginette, and Diego's mural assistants and their wives, Clifford and Jean Wight and John and Cristina Hastings. After lunch, it was back to their studios until dinner at seven o'clock. But the couple didn't work every day; there were sightseeing outings, with the nights reserved for parties, posturing, and puppet shows.

Stack and Ginette invited the tennis celebrity Helen Wills Moody to one of their parties. Dubbed "Little Miss Poker Face," she hadn't lost a set or match since 1927. She was a star, having been on the cover of *Time* magazine twice, in 1926 and 1929. Several months before the party, she'd won both the French Championships and Wimbledon. Diego was attracted to this striking twenty-five-year-old who had the finely chiseled features of an ancient Greek sculpture. He decided she would be the perfect model for his mural, explaining to the *San Francisco Chronicle*: "Since I feel that California is a second Greece, I think Miss Wills typifies the young womanhood of this state."[19]

By December, Diego was drawing Helen. Sometimes she posed nude in his studio; at other times he caught her in action at the California Tennis Club. On the court, Diego would waddle his way up to the umpire's chair to get a good view of Helen's body in motion. The unlikely duo—Helen athletic and fit, Diego overweight and out of shape—could be seen driving up and down San Francisco's hills in Helen's green Cadillac convertible.[20] Diego was fascinated by the athlete and her world, made clear by the opening line of a *San Francisco Chronicle* article: "Diego Rivera, noted Mexican artist, likes the modern American girl."[21]

Frida was not as enthusiastic about the modern American girl. She preferred the company of Cristina Hastings, who was Italian, and Ginette, who was French. Like Frida, Ginette was an artist. Cristina was an Oxford-educated, dramatic, passionate woman with an "explosive temper," as one family member observed.[22] But she also played the ukulele and danced a mean tango. She proved to be an excellent model for Frida, who created a lifelike drawing of her face. It's an exquisite rendering of this high-spirited woman.

Frida enjoyed being surrounded by artists and available models, as well as having a regular routine. It forced her to stay focused on her work. Living in a new environment alongside other artists in a "Paris-style" studio infused Frida with an energy that ignited her painting process. Within two months, she boasted to her mother: "I've done six paintings already and people have liked them quite a bit."[23]

Frida saw a lot of Diego's assistant Clifford Wight and his wife, Jean, who lived in studio 3. She also socialized with Lucile and Arnold Blanch, artists who occupied a downstairs studio. They were itinerant artists from an upstate New York art community known as the Maverick. Arnold had been lured out west by a one-year teaching position at the California School of Fine Arts—the same place where Diego was commissioned to paint his second mural.

Diego's presence in San Francisco had caught the attention of *Vanity Fair.* The magazine sent Peter A. Juley to take photographs of Frida and Diego to accompany a short article on Diego's new murals for the September 1931 issue. Señora Rivera, as the article calls her, sits in front of the brick fireplace with her legs crossed, folded hands resting on her crossed knee. She sits up straight and looks directly at the camera with a serious expression. Diego, standing next to her, looks unkempt in his wrinkled shirt and pants. Their static poses contrast sharply with the dynamic reclining female nude relief hanging above the fireplace behind them. She is the only visual clue hinting at the unconventional life of Señor and Señora Rivera, who were living in a flat that had once served as a brothel.

But the 716 Montgomery Street building had also been a Chinese laundry and the sanctuary of writer and journalist Bret Harte, known as the master of Gold Rush fiction. He had not been the only writer to take up residence in this area; others included Mark Twain, Ambrose Bierce, Jack London, Robert Louis Stevenson, and Emma Goldman. These five had lived and worked in the top three floors of a massive four-story brick building located down the street from Stack's flat. Known affectionately as the "Monkey Block," it had presided over the area since 1853. The restaurants, shops, and offices on the ground floor provided spaces to meet, socialize, and conduct business.

Montgomery Street attracted artists and writers due to its cheap rents and colorful and gritty reputation, which harked back to before the 1920s, when it was part of the infamous Barbary Coast, known for prostitution,

alcohol, lewd dancing, "hoodlums," and "the low and the vile of every kind."[24] It was a rough area that combined the undesirables of society with the hardy fishermen living and working nearby. At the time Frida arrived, there was still a thuggish element mixed with the strong presence of the sea and its fishermen.

One evening when Frida and Diego were coming home late after a night of *añejo* tequila shots, impassioned philosophical conversations, boisterous singing, and dancing the *huapango* with its intricate footwork, they came upon a young man lying in their doorway who looked as if he were dead.[25] Diego grabbed a milk bottle for a weapon. Frida, with her own milk bottle in hand, yelled in English: *"What do you want?"* No answer. Then she shouted, *"Go away,"* but there was still no response. A drunk Diego started yelling random words at him: "Mister, *zócalo, merced,* mister, *zócalo,* you can go to h . . . I'm from Guanajuato! Mister!!" After Diego's ludicrous rant, Frida burst out laughing.

Finally, the man woke up and emitted a disturbing cackle. With the whites of his eyes prominent, this man with blond hair might have been handsome under other circumstances but tonight looked to Frida "like a nightmare." She thought he must be more than just drunk. He'd probably taken something stronger, she mused, something like cocaine, because his bluish lips were trembling. The man stumbled off howling with crazed, gut-wrenching laughter after Diego gave him a swift kick. Frida saw the absurdity of it all, but the experience still left her unnerved.

Though Frida witnessed the squalid side of San Francisco, she also felt the aura of the sea: "The bay is gorgeous and I was very impressed to see the ocean for the first time. [It] can be seen from everywhere."[26] Frida was lucky to live near the area of San Francisco where steep hills abound, providing vistas with spectacular views of the bay in this pre–Golden Gate, pre–Bay Bridge era. Writing to her mother on a postcard featuring Fisherman's Wharf, Frida noted: "The wharf is close to our house. There are pure Italian fishermen and it is very interesting. On Sundays there are many people fishing. There are also many seals, but killing them is prohibited. Here is where all the fish enter San Francisco and where they are sold."[27]

Frida enjoyed not only the wharf but also the area known as North Beach, where Italian restaurants provided tasty, informal, home-style meals at a reasonable price with the ambiance of old-world Italy.[28] The Italian restaurant owners in San Francisco brought to the locals their family-style

approach to food, in which dining was deemed essential for maintaining relationships and a happy life. This complemented the artists' bohemian lifestyles, providing the warmth and familiarity of an extended family.

When twenty-four-year-old photographer Dorothea Lange met forty-four-year-old painter Maynard Dixon in 1919, the tall, lanky artist with the rugged mustached face and broad-brimmed cowboy hat was living in a studio at 728 Montgomery, just down the street from Stack's place.[29] When Frida and Diego visited eleven years later, Dorothea and Maynard had tied the knot. They introduced the visitors to their favorite places, including an Italian restaurant. The foursome talked art, politics, and the bleak times. Dorothea was a portrait photographer, but her photos of well-to-do families were starting to seem inconsequential as the effects of the economic downturn became more obvious. She was deeply disturbed by the view from her studio window of destitute longshoremen, railroad workers, and carpenters wearing dirty, ragged clothing.

Dorothea's need to respond to these desperate times appealed to Frida and Diego's working-class sympathies. Diego was so taken with Dorothea's passion for social justice that he gave her some of his drawings. Frida and Diego must have marveled at Dorothea's creative transformation. Three years later, she printed *White Angel Breadline,* her first major image documenting the ravages of the Depression era.

Dorothea's compassionate nature helped smooth over the abrasive gestures of her husband. Maynard was one of those who had objected vocally to Diego's mural commission on the grounds that a Communist who caricatured American capitalists should not paint a mural at San Francisco's Stock Exchange building.[30] But by the time the two met, Maynard had warmed up to the jovial prankster. In Dorothea, Frida found an older successful female artist and chronic pain sufferer—a fellow "polios," as polio survivors called themselves. Like Frida, Dorothea had contracted polio as a child, leaving her with a stiff calf and twisted foot.[31] Dorothea, who felt imprisoned in an imperfect body, thought her experiences ultimately provided her with the compassion and empathy needed to photograph strangers in dire straits. For Frida at this point in her art and life, her "defective" right leg was something to camouflage.

Dorothea's persistent leg and foot pain had been eased through the

help of a remarkable doctor in San Francisco, Leo Eloesser. Dorothea had known Leo, who was an artist at heart, for at least four years. He owned the Montgomery Street flat Stack rented, and Dorothea had previously rented a studio from him.

She was not the first to mention Dr. Eloesser to Frida. Diego had also previously met Leo, who had come with Stack to Mexico in 1926 and been introduced to the muralist. In San Francisco, Frida took to Dr. Eloesser right away. She was impressed by his fluent "old world" Spanish and keen intelligence.[32] And she saw in him a compassionate physician and trustworthy friend.

Frida had been experiencing lethargy, irritability, and an increase in leg and foot pain, and sought the doctor's opinion. He performed a thorough examination and confirmed a past diagnosis of scoliosis, a congenital malformation of the spine, causing it to curve.[33] But he also discovered she had spina bifida, a birth defect causing an incomplete closing of the backbone and membranes around the spinal cord.[34] The doctor also made note of her polio-afflicted right leg and the retraction of tendons in her right foot. In the atrophied leg, diminished blood flow and nerve damage had resulted in a small trophic ulcer on her toe. Also, since coming to San Francisco, Frida had been experiencing more swelling in her legs, and her right foot turned out even more than before.

Frida lamented in letters that it was difficult for her to walk for long periods of time, but the doctor noted that she could run, walk, and dance.[35] Fatigue seemed to be the culprit impeding her ability to walk distances. To help her feel better, Dr. Eloesser began giving her injections, a treatment Frida said boosted her energy. He also gave her a medicated cream to apply daily to the ulcer on her toe and recommended she wrap the toe with cotton to protect it from rubbing against the inside of her shoe. The doctor also suggested she consider having the toe surgically removed, saying that the lack of blood flow and nerve damage would always cause problems. By December 4, however, Frida reported to her mother: "I'm doing much better, my toe is completely healed."[36]

Still, walking long distances caused Frida's energy levels to plummet. For this reason, she didn't accompany Diego on a trip to the Sacramento area to sketch mines as part of his research for his mural at the Pacific Stock Exchange, which was to have as its subject the history and riches of California. Instead, she stayed with Ginette at her weekend house in Fairfax,

then a small rural town in Marin County. Frida enjoyed the four days of tranquility in nature with Ginette, "a very nice person" who "makes fun of the local rich and conceited old bags. . . . She is very unpretentious and easygoing."[37] On day five, Dr. Eloesser rolled into the driveway in his large convertible with his trusty companion—a dachshund he always brought along.[38] Frida must have been smitten with the dog and the beautiful drive back to Sausalito, where they caught a ferry to Oakland.

From here, they boarded an airplane Leo had chartered. Frida was excited, exclaiming to her mother: "I loved the trip because you can't imagine what a beautiful thing it is, it's very comfortable and you don't feel bad at all, just the opposite. We took a small mail plane and they are wonderful."[39] Frida was able to fly at a time when commercial airlines were few and far between. To observe aerial perspective from the sky was a relatively unique experience for an artist. After that December 7 flight, Frida had to come back to the reality of gravity. But being airborne lifted her spirits and improved her physical well-being: "I'm in very good health, I'm hungry, and I eat quite well," she declared.[40] By the end of the month, Frida marveled at how much better she felt: "It's much easier for me to do things without getting so tired and I'm also more cheerful."[41]

Frida often explored San Francisco on her own or with Ginette and Cristina. She was fascinated by the city and its "colonies of foreigners from all over the world."[42] Like Mexico City, it had an international feeling, but with less of a French influence. San Francisco also had distinct neighborhoods where people of particular ethnicities lived. She eagerly wrote to her mother: "In the Russian colony they dress as they do in Russia and the girls dance on the hills. The Greek colony is also very interesting, and the Japanese, but most of all the Chinese."[43]

Frida's greatest joy came from experiencing Chinese culture. Early on in their stay, she and Diego dined with the Chinese ambassador to the United States. A group gathered at a Chinese restaurant, where Frida delighted in the ambassador's company, describing him as "very intelligent and charming."[44] Of this get-together, Frida exclaimed to her mother: "Two old *gringos* who were a little drunk had me in stitches all night. It was a fun gathering, but all the other ones are dull and stupid."[45]

Frida also feasted her eyes upon magnificent ancient art from China

and Tibet at Albert Bender's home.[46] His collection included Chinese brocade robes, golden statues, and Tibetan scrolls. But she was most excited about Chinatown: "We live near China town [sic]. I imagine there are ten thousand Chinese here!"[47] She had easy access to this enclave, where the sounds of Cantonese filled the air and stores were crammed with items packaged in bright yellow, deep red, and emerald green. Looking at the beautiful clothes and feeling the "hand made fabrics made of very fine silk" elicited a hedonistic pleasure.[48] Strolling down Grant Avenue was electrifying, from the gold-dragon-entwined lampposts to the Chinese-style architecture, the multitude of fragrant restaurants, the markets with fruit and vegetable stands lining the sidewalks, and the herb stores filled with large glass jars emitting a distinctive earthy smell.

Frida had always favored candy and toys.[49] The ones she found in Chinatown were new and unusual to her because they were made in China. "You can find everything they have in China, beautiful things," she exclaimed. Frida was equally in awe of the people. Writing to her mother, she rhapsodized: "The Chinese walk around like in the pictures with their traditional outfits. So far I've only seen old Chinese women and children, who are gorgeous."[50] There were far fewer Chinese immigrants in Mexico; some lived in Mexico City, others in Sonora and Chihuahua. In this part of northern Mexico, "Chinese merchants developed a monopoly over the grocery and dry goods trade," writes historian Robert Chao Romero.[51] But in Mexico City and Coyoacán, there were no Chinatowns.

The Mexico where Frida came of age was one that celebrated the *mestizo* and *mestiza,* people of mixed racial and ethnic backgrounds. José Vasconcelos, the man responsible for overhauling the country's education system after the revolution, even went so far as to proclaim that this mixing of people would produce a "cosmic race."[52] It sounded like a grand utopian ideal. But there was also a negative current underlying racial fusion—it would rid Mexico of its so-called inferior races (Africans, Asians, and indigenous Mexicans).[53] This would be achieved once these "inferior" peoples assimilated into Mexican culture by marrying and producing children with the allegedly superior Iberoamericans.

Vasconcelos would not have promoted the creation of a Chinatown in Mexico because he believed that the Chinese "reproduce[d] like mice," "proof of [their] lower zoological instincts."[54] But in Sonora, "anti-Chinese laws banned Chinese-Mexican intermarriage and ordered the segregation

of Chinese into racially restricted neighborhoods," according to Robert Chao Romero.[55] Frida didn't subscribe to Vasconcelos's theories or endorse such anti-Chinese laws, but her father might have, as Guillermo revealed his trepidation concerning his daughter's safety living near San Francisco's Chinatown. In a letter Frida wrote to her father, she talked about just how deep his fears ran: "Diego laughed really hard at what you told me about the Chinese, but he says he will take care of me so they won't kidnap me."[56] In contrast to her father, Frida gushed: "What is especially fantastic is Chinatown."[57]

In spite of prejudice, both in Mexico and the United States, the Chinese, like all the other dreamers who came to California during the 1848 Gold Rush era, sought riches and a better life. Gold nuggets were hard to come by, though. And the locals, as well as the U.S. government, responded to the Chinese with hostility. The various Exclusion Acts that limited and at times prevented immigration from China were a testament to such rancor.[58] For the large numbers of Chinese living in San Francisco's Chinatown, it was comforting to avoid the hostile glances by living in a largely Chinese community.

However, Frida had arrived at a pivotal moment of change. The Chinese community had reached out to the San Francisco Chamber of Commerce to make Chinatown a major tourist attraction. The year 1930 saw the beginning of a more open exchange with outsiders. Nevertheless, it was still common in this period to hear "the older people . . . always talking about going back home" where "there won't be any more discrimination," as journalist Iris Chang reports.[59] With one foot in the United States and the other in China, Chinese immigrants did not necessarily see assimilation as the goal.

Frida too found herself straddling different worlds. Just speaking English forced Frida out of her comfort zone. "As for my English, I do not even want to talk about it, since I'm stuck. I bark what's most essential, but it is very difficult to speak it well. However, I make myself understood, at least with the damn shopkeepers."[60] The language barrier certainly emphasized Frida's outsider status, but despite her self-deprecating comments, her facility with the English language was probably better than she admitted—at least it appears so, based on her many letters written in English. Of course, writing in another language is not the same as speaking it.

But language alone wasn't the only source of Frida's outsider status.

She couldn't speak Cantonese, but when she stepped into Chinatown, her feelings of not fitting in disappeared. As she told childhood friend Isabel Campos, "The flock of Chinese are really *simpáticos*."[61] To her mother, Frida was even more explicit: "I'm more convinced every day that Mexicans descend from the Chinese, for we are exactly the same kind of people."[62]

When Chinese New Year's celebrations were under way for two weeks in February, Frida relished the revelry because it felt familiar: "You can't imagine how similar their festivities are to Mexican ones. They set up booths on the streets identical to the ones in the Alameda; they've been lighting firecrackers for three days, and there are many colored lights. It's just like a Mexican fair."[63]

Frida's admiration for Chinese culture had begun at age fourteen when she made a group of friends at school who opened new worlds for the shy teenager. She began, at the behest of her friend Miguel N. Lira, nicknamed "Chong Lee" for his interest in Chinese literature, to read books on the art and poetry of China.

Soon Frida's admiration of Chinese culture turned into an identification with Chinese people, as an early watercolor reveals—*Frieda in Coyoacán*, ca. 1927 (prior to 1935, Frida sometimes spelled her name with an *e*). It foregrounds the then twenty-year-old wearing a light blue printed dress with her dark hair pulled back, emphasizing her exaggerated, upward-slanted eyes and her brows. Around this same time, Diego's former wife, Lupe Marín, commented, "She wore her hair Chinese style."[64]

Digging a bit into Mexico's history reveals a story about *china poblana,* the name given to a popular style of dress said to come from Asia in the seventeenth century. The *china poblana* appears at folkloric dance performances as groups of women swirl their long sequined skirts in unison, their white scoop-neck blouses shimmering with colorful silk embroidery.[65] Bobble-trimmed shawls, beaded necklaces, earrings, and multihued hair ribbons add more color. The legend recounts how a nine-year-old girl from India named Mirrha (who was referred to as "Chinese") was sold into servitude in Puebla, where people loved her for her generosity and exotic beauty. By the time Mirrha died she had become known as La China Poblana, or "the Chinese woman from Puebla," and local women honored her by adopting her style of dress, or so the story goes.[66]

Frida adored the *china poblana* style, exclaiming about her niece Isolda: "Mati told me in her letter how cute Isoldita was in her *china poblana* outfit dancing the *jarabe*."[67] Frida also marveled at the similarities between the Chinese women she saw in San Francisco and indigenous women from Mexico, telling her mother, "The girls between 18 and 25 are identical to those in Mexico who dress in very colorful outfits, purple-red, yellow, etc."[68] Walking through San Francisco's Chinatown, a place overflowing with people wearing traditional outfits and stalls selling colorful material, Frida found the *cheongsam,* a long fitted embroidered dress, quite stunning. With a discerning eye for aesthetics, she hired a Chinese seamstress to use the colorful, shiny materials seen in the *cheongsam* to create the long, flowing Mexican-style pleated skirts and dresses she favored.[69] By transforming Chinese-made material into Mexican-style skirts and dresses, Frida became her own version of La China Poblana.

Rather like Mirrha in Puebla, in San Francisco Frida was seen as an exotic foreigner. "The *gringas* seem to like me a lot and they are really impressed by all the dresses and wraps I brought with me, they gape at the jade necklaces and all the painters want me to model for portraits," she commented.[70] These types of positive sentiments about *gringos* and *gringas* are scattered throughout Frida's letters, but as we've seen, the insults also flowed from her pen when she wrote home.

Shortly after arriving in San Francisco, she expressed her conflicted feelings about the strangers she'd briefly encountered: "Even though the *gringas* I've met are good people, I don't really trust them."[71] A week later, her feelings had softened a bit: "They are a pack of dopes, but they are good people."[72] Just a few short weeks before she departed San Francisco, Frida informed her friend Isabel Campos: "I don't like the *gringos* at all, they're very insipid and they've all got faces like unbaked biscuits (especially the old women)."[73] She also complained to her mother that *gringas* were "wretches who don't give a damn about anything . . . but we are not like that and I for one suffer terribly being far from all of you and only knowing what's going on with you through letters."[74] For Frida, maintaining a close bond with her extended family, especially her mother, was a Mexican trait. Diego, she admitted, made fun of her longing to keep in touch with her family, calling her a homesick schoolgirl, but she felt it was a testament to her good upbringing and strong Mexican identity.

Still, Frida often acknowledged of *gringos* that "they are good people." She praised Stack and Ginette, as well as Leo. In one letter home, she even took a broad swipe at both Mexicans and *gringos,* recognizing everyone's shortcomings: "People here have been very nice to us, you wouldn't believe what big dunces the Mexicans who live here in San Francisco are, but there are idiots everywhere and you should see some of the *gringos,* they are total blockheads, but in general they have many advantages, they are not such scoundrels as they are in our beloved Mexico."[75]

While it is not clear what provoked Frida's negative reaction to Mexican Americans in San Francisco, it likely expresses only how she felt in the moment. By contrast, her ambivalent feelings about *gringos* were more enduring. They stemmed in part from her father, who trusted few people, and in part from her identification as a loyal Mexican daughter and nationalist. The five-year-old who had watched her mother hide and feed Zapatista revolutionary fighters believed strongly in the ideals of the Mexican Revolution—a fair system for all, including land reform and more rights for the workers.

Frida's nationalist identity was only reinforced by the propaganda war the United States had unleashed in the newspapers between 1925 and 1927, alleging that Mexico had come under the influence of the Soviet Union and threatening to invade its southern neighbor.[76] With tensions high, Mexicans perceived the United States as a baffling bully, with some nicknaming the country Gringolandia. *Gringo* probably derives from the Spanish word for Greek—*Griego*—implying the well-known expression "It's Greek to me." *Gringos*, in other words, are strangers who are unknowable or confusing. Although the threat of war eventually dissipated, the shadow of the United States loomed large with its tight rein on business interests in Mexico, inviting characterizations of *gringos* as selfish materialists. Frida understood the impact the powerful United States had on her homeland, and she sympathized with the underdog.

When she'd entered Gringolandia, she'd carried this consciousness with her. Just as the Chinese in San Francisco had found themselves in the midst of an unknown place and an often hostile population, Frida, under very different circumstances, was also encountering the complexity of being a stranger in a strange land.

One night when Frida walked into the National Hall at Mission and Sixteenth Streets, the feeling of being in a strange land overwhelmed her. She saw two African American couples dragging themselves around a large wooden floor. These two couples had been on the move for two months trying to win a walkathon. This was the last night of the "colored" competition, and by early morning the winners would be crowned.

This peculiarly American phenomenon had taken off in 1923 when Alma Cummings, a thirty-two-year-old white woman, danced without stopping for twenty-seven hours at New York's Audubon Ballroom. Alma became famous, and others, desiring a morsel of that fame, set out to beat her record. By the 1930s, these endurance contests—some walkathons, some danceathons—had become even more popular among both whites and blacks, as the dreary times created desperate people who needed the food and shelter the marathons offered participants. The competitions also offered the promise of money and notoriety for the winners. But most contests were rigged, as each major contest promoter had his own dancers, known as "horses" due to their endurance. Pretending to be real contestants, they provided entertainment throughout these grueling events.

For twenty-five cents, spectators could watch as long as they pleased, but it was at night when a band played and contestants were expected to walk or dance with gusto. This odd sight allowed viewers to feel superior toward the wearied participants, but Frida didn't feel that way. She was horrified that the individual couples were chained together, a reminder of the brutal treatment of slaves. Still, she recognized that the prize of $1,000 each was too great a sum to pass up, even if, as Frida recounted, a woman had to walk with a baby in her arms and "two people died."[77] Another "woman lost her mind for walking" and her husband didn't even stop to tend to his ailing wife.[78] Instead he removed his chain, "grabbed another woman and kept on walking," Frida reported to her mother.[79]

As midnight approached, the couples were walking "without resting for a second" and it was becoming more and more challenging for them to stay awake.[80] To help the worn-out walkers and to keep spectators interested, "some black women danced wonderfully, others sang," Frida wrote.[81] The tension kept building as the night turned into a new day and the walking became more like shuffling.

Eventually one of the men dropped out, leaving his female partner to continue on her own. Soon thereafter, the other man fell by the wayside. The two remaining women partnered up, and they were declared the winners, having walked for 1,680 hours. Frida found this bizarre spectacle fascinating, but it was ultimately the brutality that left its mark on her. She exclaimed to her mother, "It is terribly cruel for it is the misery in which these poor people live that forces them to do all those frightful things. Can you imagine walking for two months?"[82]

Around the same time Frida witnessed this cruelty, she created a drawing of Eva Frederick, an African American woman she said had modeled for Diego.[83] Most likely they met Eva through local photographer Imogen Cunningham, who photographed her.[84] Frida invited Eva into her studio to be sketched and had her pose nude, seated on the *equipal*.

Both as an artist and as a sometime model, Frida understood the importance of making her sitters feel comfortable, especially if they were posing nude. Sometimes Frida would pull out a guitar Dr. Eloesser had given her and sing Mexican songs in a raspy voice, filling the room with the vibrant and warm energy of her home. The Mexican *equipal* chair also reminded Frida of home and in the drawing, it's the only obvious indicator of place.

Eva sits up tall in the chair, her eyes looking off to the right as if in a daydream. What's on her mind? There are few clues. Besides the *equipal*, the only other object in the drawing is a long chain necklace, most likely one that belonged to Frida. She often provided jewelry for her models in order to achieve a certain look. And in this case, the necklace, like the chair, references Mexico. The design, with one chain around the neck linked by a round medallion of a face in profile to a second, dangling loop of chain, is the type of necklace worn by the Zapotec women of Tehuantepec in the state of Oaxaca. A very similar style is found in Diego's easel painting *Dance in Tehuantepec* (1928). The women of this area wore plain gold chains and necklaces decorated with gold coins, as they were the ones who controlled finance and trade in the marketplace. This had personal significance for Frida, as her mother, who was from Oaxaca, controlled the finances in the Kahlo household.

Frida, like many "children of the revolution," was drawn to the Zapotec women of Tehuantepec, who were viewed by Mexicans as powerful,

beautiful, and elegant. By placing the necklace on Eva, Frida alters the chain of bondage she saw at the walkathon into a chain of aesthetic beauty. The jewelry adds to Eva's striking good looks. She sits with crossed legs, her left hand covering her pubic area. It recalls the modest Venus pose, something Botticelli used in his painting *The Birth of Venus,* a work Frida knew quite well. The classically inspired standing Venus places one hand, entwined with her long hair, over her pubic area and one over her breasts. In Frida's version, a seated Eva covers her pubic area but not her breasts, as if to convey both modesty and an ease with her body. The faraway look in Eva's eyes also echoes Botticelli's Venus, who possesses a similar look. With these similarities, Frida hints that Eva is a black Venus, a beautiful Afro-Mexican woman.

Given the common stereotypes of the period, such as African Americans depicted as hypersexualized, Frida's representation stands out. African American women were typically characterized as "Jezebels," femmes fatales, or asexual mammies, and these stereotypical images were exported to Mexico.[85] Although people of African descent were present in Mexico due to the slave trade, "Mexican intellectuals 'whitened' the imagined Mexican, simultaneously writing Africans out of Mexico's history," says historian Galadriel Mehera Gerardo.[86] By and large, darker-skinned Mexicans were seen as *mestizos* rather than Afro-Mexican.

Frida would have been exposed to attitudes toward black people both in Mexico and in the United States. Her cross-cultural vantage point comes through in her creative choices: she places an African American woman in a Mexican *equipal* and has her wear a Tehuana necklace. Her depiction of a nude black woman is far more nuanced and sensitive than many well-known images by her fellow artists. Pablo Picasso, for example, played up the stereotypical attributes of ugliness and hypersexuality in his celebrated *The Women of Avignon* (1907), a massive (8-by-7-foot) painting of a brothel scene. It presents five nude female prostitutes, with two wearing African-looking masks. They're presented as frightening creatures with abstracted, angular body parts and contorted postures; one has a head that spins around, *Exorcist*-like. Frida rejected the Cubist and Primitivist styles, as Eva's body parts are intact, and she doesn't appear threatening or hypersexualized. Nor does she look like a "noble savage," the peaceful "primitive" who lived according to the rhythms of nature, which French artist Paul Gauguin popularized with his images of Tahitian women.

In contrast to images of the "Old Negro," a stock figure perpetuated as historical fiction, Eva looks more like a "New Negro," defined as "an enlightened, politically astute African American."[87] The concept of the "New Negro" sprang from a younger generation of African Americans in the early years of the twentieth century—they were the hope for the future and possessed a "new psychology," one that involved "positive self-respect and self-reliance." In short, they exuded a sense of "race pride," as Howard University philosophy professor Alain Locke put it in his groundbreaking essay "Enter the New Negro," first published in *Survey Graphic* in 1925.[88] Carl Van Vechten's photo of African American writer, anthropologist, and filmmaker Zora Neale Hurston is an example of the "New Negro."

In drawing Eva nude, Frida was faced with a challenge: how could she show a black woman naked with a sense of "self-respect" given the stereotypes of black women as untamed, sexual animals? Even within popular culture, images of the New Negro woman were fraught with challenges. Miguel Covarrubias, a friend of Frida and Diego's, admired the musical and dance talents found in Harlem nightclubs. He made a name for himself creating drawings of African Americans, which were published in *Vanity Fair* and *Vogue*. They were popular among some black intellectuals he'd befriended in New York and among the largely white readership of the magazines. But his "New Negro [was] a type that came straight out of white fantasies, with all the old traits of the savage and the erotic," says scholar Deborah Willis.[89]

Frida seemed determined to avoid these "white fantasies," both in her drawing and in a second image of Eva Frederick, a painting that amplifies her strength and beauty. In *Portrait of Eva Frederick* (1931), Eva is clothed, and she is seen from the chest up. Her brown eyes are strong as she looks directly out, as if listening, her mind active. Frida's voice comes through: "All types of people interest me, but I am attracted to the intelligent ones."[90] Eva wears a Mexican-looking green shirt with black lacelike sleeves and one strand of emerald-colored beads around her neck, ones Frida had used in *Portrait of a Young Girl* (1929).

Placed above Eva is a decorative green banner—a *banderole*—that is inscribed in red cursive letters with "Portrait of Eva Frederick, who was born in New York, painted by Frieda Kahlo." This tradition of using a banner in art was popularized in Mexican colonial-style portraits. Generally, the information on the banner provided a person's name and lineage,

reaffirming an upper-class status. When the sitter was *mestizo/a*, the information legitimized the person, since during the colonial era those born to mixed-race parents were considered illegitimate. In the case of Eva, a black American whose ancestors were most likely slaves, providing a name and place of birth bestowed upon her an identity, something missing in the dehumanized images found in American art and popular culture.

New York, Eva's place of birth, her twenties-style cropped hair and her ultra-thin Greta Garbo–style eyebrows all connect her to sophisticated cities, but without reducing her to the stereotype of the scantily clad dancer or singer. But Frida complicates the portrait by showing the outlines of Eva's breasts and her nipples. The sheerness of Eva's blouse isn't obvious at first, due to the dark hues, but it's clear Frida took pleasure in revealing Eva's body. As she said: "Breasts are aesthetic. When women's breasts are beautiful, I like them very much."[91] Sitting in front of a golden brown wall that sets off her warm brown skin, Eva, wearing a forest green shirt, looks more like a natural woman of strength, beauty, and intelligence than a hypersexualized black woman. But the potential to see her as such is possible, as a braless woman can connote many things; being shown without a bra marks her simultaneously as a natural woman, as a loose woman, and as an independent "New Woman."

Frida didn't understand what it felt like to be a black woman in the United States or Mexico, but because of her physical disabilities she understood what it felt like to be an outsider. And she understood how race pigeonholed people. Skin color determined how people were perceived, with lighter skin automatically creating the impression of intelligence, beauty, and sophistication. On the other hand, lighter-skinned African American women and *mestiza* women bore the marks of a violent history—rape in the United States, "sleeping with the enemy" in Mexico (as seen in the historical account of the indigenous woman called La Malinche who translated for Cortés and became his mistress).

Just as Frida was trying to find a new way to depict a black woman, she was also trying to refine her own persona as the wife of a famous artist. In San Francisco, she was the exotic Mexican señora, a persona she enjoyed—"they are really impressed by all the dresses and wraps"—yet she also wanted to be seen as capable, intelligent, strong, and beautiful. "I would like to think I am useful; to give the impression of cleanliness and beauty, to come across as intelligent," Frida said.[92] These were traits not

commonly associated with Mexican or black women in the United States. The concept of "Mexicanidad," a reevaluation of what it meant to be Mexican, was intrinsic to Frida's developing identity, making it easy for her to understand the concept of the "New Negro." Ultimately, she combines the two philosophies in her depiction of Eva Frederick.

Frida was beginning to use her experiences as a woman straddling two cultures and apply what she'd learned and observed to her art. This new city offered a new visual language, one that pushed her art in a slightly different direction. Working in such close proximity to Diego also presented an opportunity to deepen a visual dialogue with him that had begun in Mexico. While Diego was drawing and painting a nude white woman to embody classical Greek ideals, Frida was drawing and painting a black woman, challenging those ideals. Like Frida, the painting of Eva sits at the crossroads between a modern United States and an "old world" Mexico.

Frida would be reunited with her family in several months' time, making her crossroads fluid. But even back in Mexico, her struggle to feel a sense of belonging—to be an insider rather than an outsider—would remain because these emotions didn't just arise in San Francisco. She remembered these feelings of isolation and self-consciousness as a teenager in Mexico when, like John the Baptist, she was a lone voice crying in the wilderness.

II

REMEMBERING MEXICO

Collision, Recovery, and Rebirth: 1925–1927

*There are moments of sentimental and mystical experience
that carry an enormous sense of inner authority and
illumination with them when they come. But they come
seldom, and they do not come to everyone.*

—WILLIAM JAMES

 As the morning light crept in through her bedroom window on September 17, 1925, Frida awoke to a groggy but elated Mexico. For the past two days, Mexicans had been celebrating their 104 years of independence from Spain. The fiesta had begun on the evening of September 15, when President Plutarco Elías Calles ignited the Mexican people with the famous call to arms "Viva México! Viva la independencia!" Throngs of people in crowded town squares throughout Mexico responded with thunderous pride. Eighteen-year-old Frida had been energized by the green, red, and white flags waving with gusto, the swirling skirts of dancers, the confetti flying through the air, the music reverberating off buildings, and the smell of chicken with mole sauce lingering in the streets.

By the morning of September 17, Frida had to get back to her school routine, so she rolled out of bed, ate breakfast, and got dressed. She was on her way to the prestigious National Preparatory School in downtown Mexico City, about a one-hour bus ride from her home in Coyoacán.

Three years earlier, after passing the difficult entrance exam, Frida had been one of thirty-five girls to be admitted into a student body of two thousand. She was part of a new energy that had erupted in the five years since Mexico's revolution had ended. Her generation was redefining what

it meant to be Mexican. The Prepa, as they called the school, was at the center of this change, with education minister José Vasconcelos at the helm transforming the public education system from one with a Eurocentric curriculum to one that included all of Mexican history and culture. Antonio Caso, the school's philosophy teacher, for example, challenged his students to "turn your eyes to the soil of Mexico, to our customs and our traditions, our hopes and our wishes, to what we in truth are!"[1]

Discovering this truth required some digging, as Cortés and his conquistadors had leveled virtually all physical signs of the reigning Aztec empire when they conquered it. Evidence of this was found just outside the Prepa's three-story colonial-style arcaded structure in the Zócalo—the central plaza in Mexico City—where the massive Metropolitan Cathedral and the National Palace stood as reminders of conquest.[2] Sequestered under the dirt and concrete lay fractured Aztec pyramids, sculptures, serpent walls, and ball courts. But these were starting to be unearthed in an attempt to recover Mexico's indigenous past.

Frida's sense of self also waited to be unearthed. When she first entered the Prepa, with its aura of greatness—a college prep school filled with the smartest teachers and students in Mexico—she felt insignificant. One of her friends from this period, Agustín Olmedo, recalled that his first impression of Frida was of a scared and insecure person.[3] Some of her insecurities stemmed from her mother's nervousness concerning Frida's growing independence. Matilde understood that the Prepa offered important educational opportunities, but going to this prestigious school also required her daughter to leave parochial Coyoacán for the big city five days a week.

In a note Frida sent her mother from school the year she began attending the Prepa, she reassured her that she was fine.[4] She also mentioned a lecture about Russia by Diego Rivera that she was planning to attend at the school and invited her mother to make the one-hour trip into Mexico City to join her. Perhaps to entice her, Frida also wrote that Diego was beginning his beautiful mural (called *Creation*) in the school's amphitheater. Matilde is usually described as an illiterate and devout Catholic woman, caring primarily about molding her daughters into proper young ladies by taking them to church at San Juan Bautista in Coyoacán. But she was also an intuitive mother who Frida said was gifted intellectually and "very loving in every way."[5] As is true with many teenage daughters and mothers, theirs was a complicated relationship that had its high and low points.

As the school year went on, Frida made more friends, which helped her feel more comfortable in her own skin. She initially tended to float from one group to the next, but the Cachuchas—a small band of politically radical students who took their nickname from the modern cloth caps they wore—eventually became her mainstay. Although the Cachuchas were known more for their pranks than for their studiousness, they loved to debate fiction, poetry, philosophy, history, and art with a passionate, know-it-all attitude. Frida remarked to a friend about the philosophy teacher, Antonio Caso: "We can't take it anymore. He talks and talks, very beautifully, but without substance. We've had enough of Plato, Aristotle, Kant, Bergson, Comte, and he doesn't dare get mixed up with Hegel, Marx, and Engels. Something must be done!"[6] The group once lit a firecracker with a twenty-minute fuse outside the windows of the large assembly hall where Caso was giving a lecture on evolution. The explosion shattered the windows, and gravel and stones flew into the air, pelting the teacher. As one student recalled: "The eloquent orator reacted with perfect aplomb. He casually smoothed down his mussed hair and went right on lecturing as if nothing had happened."[7]

Manuel González Ramírez, a member of the Cachuchas who later became a lawyer, journalist, and historian, felt that "it was the joking attitude we had toward people and things that drew Frida to us, not because she had the habit of laughing at other people, but because it captivated her, and she began to learn it, and ended by becoming a master of pun and, when they were called for, of cutting witticisms."[8] Being involved with this group of predominantly male friends and one female friend—the brilliant Carmen Jaime, who later became a seventeenth-century Spanish literature scholar—bolstered Frida's confidence and allowed her inquisitiveness and love of mischief to blossom. She declared as an adult: "That has been the only happy period of my life."[9]

It wasn't difficult for Frida to throw herself into this well-read group, as she'd grown up surrounded by her father's extensive library. As a professional photographer, Guillermo Kahlo had a studio in Mexico City, a place Frida enjoyed with its photography equipment and rows of books on science, geography, literature, history, and philosophy. He was particularly fond of Arthur Schopenhauer and had a "beautiful portrait" of the philosopher

hanging in his photography studio, as one Cachucha remembered.[10] Guillermo spoke German, Spanish, and, according to one friend, fluent Yiddish. Frida always referred to her German father, who was born Carl Wilhelm Kahlo, as Jewish, but recent research has revealed that he was baptized in the Lutheran church in Pforzheim, Germany.[11] Whatever the actual facts, Frida identified as part Jewish, and as art historian Gannit Ankori has shown, she possessed many books dealing with Jewish subjects.[12]

Like her father, Frida became a bibliophile. She often sat in his library paging through Georg Hegel's leather-bound volumes on dialectical philosophy or absorbing the anatomical illustrations in medical books. She had tastes that ranged widely, from Plato and Paracelsus to Schopenhauer and Mallarmé, and she could read in Spanish, English, and German.[13]

Frida had the ability to recall detailed information after reading a book.[14] At one point she memorized several pages from Marcel Schwob's *Imaginary Lives*, a collection of twenty-two fictive biographies. Frida was particularly drawn to the story about Paolo Uccello, the fifteenth-century Florentine artist. She marveled at Schwob's description of Uccello as an alchemist painter who dropped geometric shapes into a furnace to melt and mold them into their transmuted ideal. As a fellow Cachucha put it, "She took Uccello by the hand and loved him."[15] She created her own magical world in her school knapsack, filled with notebooks, drawings, dead butterflies, dried flowers, textbooks, and a book from her father's library printed with stunning and mysterious Gothic symbols.[16]

Frida's agile mind, urge to discover life, and rebellious nature attracted the leader of the Cachuchas, Alejandro Gómez Arias, a charismatic orator with tender deep-set eyes accentuated by prominent eyebrows. His intensity emerged in his criticisms of stupidity, vulgarity, and abuses of power.[17] Frida was drawn to Alejandro's passionate nature coupled with his gentle manner. Both had lofty ambitions. He wanted to be a lawyer; she aspired to be a physician. While walking down the street, the pair would be locked in intense discussions of the philosophies of Kant, Marx, or Spengler. They shared photographs and letters on the sly—"My Alex, I have loved you since I saw you"[18]—revealing a deepened relationship in the summer of 1923 when Frida was sixteen, despite their parents' disapproval.

Matilde attempted to rein in her spirited daughter. She worried about sex before marriage. Her eldest daughter, Mati, had run away with her boyfriend to Veracruz in 1914, when she was only fifteen. The two eventually

married, but it was a scandalous situation for a predominantly Catholic culture. Matilde was so upset that she disowned Mati.[19]

To head off any improprieties, Frida wasn't allowed to visit Alejandro at his home in Mexico City. Most of their time was spent together at the Prepa, the nearby Ibero-American Library, or exploring the city after school.

The late afternoon of September 17, 1925, was no different, except that confetti littered the streets in downtown Mexico City as evidence of the lively celebrations of Mexican independence. When Frida and Alejandro left the Prepa, they felt a light rain on their faces. They loved exploring the bustling downtown area around the Zócalo. Frida looked through the stores and stalls until she found a parasol. Her love of toys and child's play prompted her to buy it. Afterward, Frida and Alejandro stepped back outside onto the noisy street. It was time to head home, and as a bus approached its stop, the two jumped on. Suddenly Frida realized her little toy was missing. She and Alejandro got off the bus to search for it, but to no avail. To replace the parasol, Frida decided to buy a *balero*—a cup-and-ball toy.[20] The two then got onto a second, crowded bus. Frida noticed that the "bus driver was a very nervous young man."[21]

Frida and Alejandro sat toward the back on a long bench. Frida felt her body sway as the bus rounded a corner in front of the San Juan market. In an instant, an electric trolley moving at breakneck speed slammed into the bus's center, splitting it into pieces. People screamed, and blood and bodies spilled out onto the street. A housepainter's gold powder flew into the air. People, wood, glass, and metal were thrown every which way.

Alejandro pulled himself out from under the debris and looked for Frida. When he found her, he was shocked to see that the violence of the accident had stripped Frida's clothes from her. What remained was her nude body drenched in blood and the housepainter's gold powder, giving her the appearance of a dancer in iridescent tights and leotard. "La bailarina, la bailarina!" he heard people chanting—the dancer, the dancer![22]

Alejandro's vision of the hallucinatory beauty of Frida's glistening red-and gold-covered body morphed into a Bosch-type image of freakish horror when he picked her up and saw that a metal rail had impaled her pelvis. A man at the scene said it had to be removed, and he placed his knee

on Frida's body and pulled out the piece of metal.[23] Her screams ripped through the air.

Meanwhile, in Coyoacán, Matilde had gone out to the balcony that looked down over the inner courtyard filled with plants and trees. There she waited for her daughter to return from school, a ritual she performed five days a week. As she stood overlooking her garden, an ominous feeling suddenly came over her. "Something terrible has happened to Fridita!" she shouted, panic spreading through her body.[24] Less than an hour later, a doctor sent word of the accident, adding that he didn't know if her daughter would survive.

At first Matilde was "speechless" and immobile. After her catatonia-like state finally wore off, she "cried like a madwoman for three days."[25] She couldn't will herself to set foot in the hospital. Frida's father, Guillermo, also distraught, retreated into illness. The parents didn't see their daughter for twenty days.[26] Frida's older sister Adriana fainted when she heard the news. She never visited the hospital. Alejandro, recovering at home, couldn't make it to the hospital in those first few days. Ironically, it was Mati, the estranged daughter, who came as soon as she read about the accident in the newspaper.[27]

Frida's "spinal column was broken in three places."[28] She also had a broken collarbone, pelvis, and ribs, and numerous other injuries. The doctors had operated, but they didn't know if she would ever walk again. Mati stayed with Frida during the challenging month of her recovery in the hospital as she lay in a plaster body cast, confined to bed. She sweated profusely inside the cast, intense pain shooting through her hips and pelvis.

Frida was fortunate to have Mati as well as the many friends from school who eventually came to visit. A crowd of family friends from Coyoacán also stopped by. These visits temporarily distracted her from the physical pain, but the absence of her parents caused emotional scars. It wasn't just the fact that they weren't there to comfort her, but also the guilt and worry she felt concerning their own already fragile health. Guillermo suffered from epilepsy, and Matilde too had developed epileptic-type seizures. Both were nervous people who lacked the emotional reserves needed to respond to something as traumatic as their daughter's horrific accident. "I have suffered very much emotionally, since you know how ill my mom was, just like my dad, and dealing with this blow hurt me more than forty wounds," she wrote to Alejandro.[29]

Nearly a month after the accident, Frida wrote again to Alejandro, "Everybody tells me not to lose my patience, but they don't know what being bedridden for three months means to me. That's how I need to be [in bed] after having been a real street wanderer all my life. But what can one do? At least *la pelona* [death] did not take me away [drawing of skull]. Right?"[30] (The term *la pelona,* which literally translates as "the bald woman," is used as a personification of death.)

But on October 17 Frida was released from the hospital—far sooner than expected. Exactly thirty days after the accident, she returned to her home in Coyoacán to finish the recovery process. Being home wasn't always easy. She was still confined to bed and had to endure her mother's irritability and "hysterical" fits, her father's silences, and the heavy sadness that hung over the house.[31] Matilde and Guillermo were happy to have their Friduchita home, but their prickly nerves and anxious natures made it difficult for them to create any kind of nurturing environment.

Alejandro was the one person Frida could confide in, relaying in letters how she couldn't move her arm forward or backward due to a contracted tendon, couldn't sit up, and couldn't walk; she was confined to one supine position. Then one night Frida wrote, "My mother had an attack and I was the first to hear her shout, and since I was asleep I forgot for a moment that I was sick and I wanted to get up. I felt a horrible pain in my waist and an anguish more terrible than you can imagine."[32]

Frida was determined to break free from her physical and emotional prison. She insisted on practicing movements, no matter how painful: extending her arm, sitting up in bed, sitting in a chair, standing from a seated position with help, then without help. She longed to walk like everyone else, but her first steps were more of a slow waddle, as she wasn't able to completely stand up straight.

Finally, after three months, all her hard physical and mental work paid off, and Frida was able to walk. She would always have trouble with her spine due to three vertebrae being out of place, horrible shooting leg pain from damage to the sciatic nerve, as well as problems with her right leg, foot, and toe. Like the Aztec ruins, Frida's fractured body would never be the same again.

She worried that Alejandro's feelings for her had waned while she had

been recuperating.[33] In one letter he had accused her of being loose. It's impossible to know the depth of Alejandro's feelings for Frida after the accident, but her letters make clear she wanted to see more of him. In response to Alejandro's accusations of sexual impropriety, Frida responded, "Although I have said I love you to many, and I have had dates with and kissed others, underneath it all I have never loved anyone but you."[34] While it seems that Frida's flirtations before the accident were supposedly responsible for the crumbling of the relationship, Alejandro had also confessed, pre-accident, his attraction for Anita Reyna, which involved "caresses." But if Alejandro distanced himself from Frida because of her dalliances, then he held her to a much different standard than he did himself. Besides Anita Reyna, he was also attracted to fellow Cachucha Jesús Ríos y Valles, nicknamed "Chucho Paisajes."

When Frida went to Mexico City after regaining her ability to walk, she sought out Anita. Anita said she didn't want to hang around Frida because Alejandro had "told her that she [Frida] was the same or worse than her," implying that both teenagers had been promiscuous.[35] In a letter to Alejandro, Frida defended herself, concluding: "I love myself the way I am. The fact is that no one wants to be my friend because I have such a bad reputation, which is something I can't help. I'll just have to be a friend to those who love me as I am."[36]

As an adult, Frida reflected upon her complicated relationship with Alejandro: "Gómez Arias and I were sweethearts. But Alejandro was in love at the same time with Chucho Paisajes, whom he screwed. Chucho Paisajes and I would talk of our mutual infatuation with Gómez Arias, and we would give each other advice. It does not seem bad to me that Gómez Arias screwed Chucho Paisajes. I have never had anyone who loved only me. I have always shared love with another."[37] This was a theme in Frida's life that continued until the end. Yet right after the accident she desperately needed Alejandro's devotion, but did not receive it.

Instead, she said, "The only good thing is that I'm starting to get used to suffering."[38] But, like Christ, Frida knew she had to ultimately rise from her torment and reimagine a life without her school routine, her boyfriend, and her dream of becoming a doctor. She wrote: "A short while ago, maybe a few days ago, I was a girl walking in a world of colors, of clear and tangible shapes. Everything was mysterious and something was hiding; guessing its nature was a game for me. If you knew how terrible it is to attain knowl-

edge all of a sudden—like lightning elucidating the earth! Now I live on a painful planet, transparent as ice. It's as if I had learned everything at the same time, in a matter of seconds."[39]

Frida had loved the mystery of life, the world of colors mixed with shadows hiding aspects she longed to decipher. It was exciting to ponder the meaning of life, to read about the magical process of transformation at Uccello's alchemist hands, to create her own playful language filled with puns that only a few of her cohorts could comprehend, to debate the urgent philosophical questions of the day regarding Mexico's future. The bus accident changed everything. It altered not just Frida's bodily existence but also her inner life. She'd gained a knowledge that few were privy to, and it had happened in an instant—like lightning elucidating the earth, as she put it. Despite this powerful metaphor, Frida didn't go into detail about what knowledge she'd gained. What's clear is that the mysterious aspects of life were gone for her, and she needed to figure out a way to resurrect them.

It's not surprising that Frida used a visual metaphor to describe her life before the accident. Photography and painting were a central part of the Kahlo household. Frida, acting as assistant, had helped her father take photographs. She'd retouch photos in his darkroom, where she also observed the seemingly magical developing process, with glass plates that had been exposed to light immersed in a chemical bath. As developer flowed over the glass plate, a photographic image would emerge, becoming more defined within seconds. Frida witnessed time and again the interplay of mystery and clarity.

Watching her father paint landscapes by the river in Coyoacán also intrigued her. As a child, hanging around her father's photography studio, she'd spied a box filled with oil paints and an old vase holding paintbrushes alongside a palette.[40] She was fascinated with the box of colors and what her father could do with them. When she took art courses at the Prepa, she expanded her knowledge, becoming familiar with Adolfo Best-Maugard's method, which was taught in schools throughout postrevolutionary Mexico. A modern artist and filmmaker, Best-Maugard had lived in Europe, where he admired the elongated figures created by El Greco in the sixteenth century and the abstracted figures of Modigliani

from the early twentieth century. When he returned to his homeland he began uncovering the ancient cultures in the Valley of Mexico, working with Mexican anthropologist and archaeologist Manuel Gamio and American anthropologist Franz Boas. He made detailed drawings of the excavated objects and architecture, ultimately turning his experience into a theory, a design method, and a book.

Drawing Method: Tradition, Renaissance, and the Evolution of Mexican Art detailed his theory that Mesoamerican art utilized seven basic motifs: spiral, zigzag, circle, half-circle, S-curve, wavy line, and straight line. These motifs were also found outside of Mexico, providing "a philosophical framework that linked Mexico to the East and West."[41] It was a universal theory, emphasizing the significance of creation for the evolution of humanity. Best-Maugard concluded that a dormant seed of creativity was buried within the unconscious mind, awaiting its awakening. His method was less about faithfully reproducing an object and more about expressing emotion and ideas.

Frida's creative impulses had first sprouted before the accident, when she'd experimented with different media and styles. But after the accident her interest in drawing and painting took on greater significance, as her physical movements had been curtailed and her intense emotions stamped down. In the Kahlo household, it was natural to create while being "sick." She had witnessed this combination of creativity and illness firsthand due to her father's epilepsy. Frida understood the way in which her father's ailment limited his creative profession. It was Frida, after all, who accompanied him on photo shoots to provide help in case he had a seizure, to give comfort, and to ensure that no one stole his expensive photographic equipment. It was a lot for a child to take on. Her multiple roles of photographic assistant, caregiver, and confidant shaped the father-daughter bond.

Given this history with her father, it's not surprising that one of her first drawings re-created her accident. This pencil drawing on paper was made on the one-year anniversary of the accident—September 17, 1926. It shows Frida's recumbent body, wrapped in bandages, lying on a Red Cross stretcher in the foreground. Her eyes are closed, but at waist level there's a second head that looks off to the left as if in a daze. This head has short hair with bangs, a style she'd worn three years earlier when she first became a student at the Prepa.

The bus-trolley crash, with loosely drawn figures strewn about on the

ground, fills the upper part of the composition. The squiggly, wavy lines of the bodies, reminiscent of Best-Maugard's design method, convey movement, even though the bodies are flattened on the ground. Likewise, the wavy and spiral lines of the trees in the background create the illusion of a vibrant, alive nature, which is also felt in the round darkened sun occupying the left corner.

The movement in the upper part of the drawing is contrasted with the stillness of Frida's three-dimensional body, drawn largely with straight lines. That stillness and her closed eyes suggest she is either unconscious or dead. The disembodied head conveys that she is in an altered state of reality due to the extreme trauma; the medical term might be shock. Her short haircut indicates she could be undergoing a past life review, one that has taken her back to a period of her life before the accident, when she was "innocent" and "pure."

Her family home, seen next to her head as if the head is leaning on it, shows the protective walls her mother sought to create for her teenage daughter. Including her home in the drawing doesn't make sense in terms of what actually happened—the accident occurred in downtown Mexico City—but Frida incorporates it for symbolic purposes. Frida's body may be in the process of dying, but her head is not. Another type of consciousness has been awakened.

At the bottom, under her body, Frida wrote the date of the accident, her name, and the title: *Accident*. This early drawing sets the stage for Frida's signature style, one that foregrounds her physical and psychological state alongside important aspects of Mexican art and culture.[42] She utilizes Best-Maugard's straight and wavy lines, as well as spirals and circles, and she incorporates a sun in the sky, a significant image for the Aztecs (and many other Mesoamerican cultures) and alchemists. But perhaps most significant is her subject: a life-threatening accident with the written word at the bottom, recalling *retablos,* small Catholic paintings that express thanks to Jesus or Mary for intervening on behalf of a loved one who had come close to dying.

Matilde saw how important it was for Frida to have some sort of creative outlet. She had a carpenter make a special lap easel for her daughter's bed.[43] She also suggested placing a mirror inside the top of the bed's canopy for self-portraits. Soon Frida began meticulously applying pigment to canvases with her small sable brushes. She started by painting the subjects

she knew best: herself, her friends, and her family. Her early works were informed by influences that ranged from Renaissance art to modern art to Best-Maugard's work and his design books.

Leonardo da Vinci was one artist who loomed large in Frida's psyche at the beginning of 1926—a new year and a new life. Despite Alejandro's attempt to end their relationship, the two were still writing letters and seeing each other, and Frida had hopes for their future together. She was also beginning to embark on a creative journey now that she'd decided not to pursue medicine. She marked her new life by creating a birth announcement. Most scholars interpret this written statement as Frida's desire for the child she might not ever have due to her pelvic injuries. Biographer Hayden Herrera states that it was written for a doll that she'd been given while recovering in the hospital.[44] These are literal interpretations and probably have some truth, but the symbolic reading is quite different and more telling.[45]

The announcement was handwritten in calligraphy with embellished letters, such as S's that curve above and below the other letters. It reads:

LEoNARDo
WAS BORN AT THE RED CROSS
IN THE YEAR OF GRACE, 1925, IN THE
MONTH OF SEPTEMBER
AND WAS BAPTIZED IN THE
TOWN OF COYOACÁN
IN AUGUST OF THE FOLLOWING YEAR
HIS MOTHER WAS
FRIEDA KAHLO
HIS GODPARENTS
ISABEL CAMPOS
AND ALEJANDRO GÓMEZ ARIAS[46]

From a symbolic perspective, the named child, Leonardo, is the reborn Frida. The birthdate, September 1925, is the month and year of Frida's accident. The hospital where the birth took place is the Red Cross, the same one in Mexico City where Frida was taken after the accident. Red Cross can also double as a coded reference to Rosae Crucis, which translates as "Rose

Cross"—the Ancient and Mystical Order Rosae Crucis, or Rosicrucian Order, a movement that developed in Europe in the seventeenth century and was influenced by alchemy, the art of transformation. Frida would have understood the significance of this confluence of Red Cross and Rose Cross in light of her transformation from near-death to life while in the hospital. Leonardo's baptism occurred in Frida's hometown, Coyoacán; this spiritual cleansing allowed Frida to reemerge from the baptizing water as an androgynous being named Leonardo. Frida is named as the mother because she gave birth to her new self, something she acknowledged years later: she was "the one who gave birth to herself."[47] She's nurtured by godparents, her good friend Isabel Campos and her boyfriend Alejandro Gómez Arias.

Although Frida had been introduced to alchemy before the bus accident, it took on a deeper meaning afterward, when the world had lost its mysterious qualities. There was much to learn about this enigmatic philosophy, dating back to the ancient Egyptians, that incorporates chemistry, physics, medicine, spiritualism, psychology, art, and astrology. The general scientific and spiritual aim of alchemy was to purify and perfect chemical substances and the human spirit. The alchemist in his laboratory trying to transform base metals such as lead into gold is the defining image of this art of transformation. For Frida, alchemy's emphasis upon transformation and its use of esoteric texts and a system of symbols called ciphers modeled a complicated means of expressing feelings and ideas. After her accident, she focused more intently on creating her own cryptic language, both visual and written.

This influence is obvious when looking at the first word at the top of the birth announcement: *LEoNARDo*. Frida made the first *O* in the name much smaller than the other letters, and she placed a dot in the center. This could easily be overlooked as a nineteen-year-old's playful flourish, but if you know alchemical ciphers, it's clear that it represents both the sun and gold. The sun is deemed a male principle and gold the highest ideal of perfection within alchemy. This was a symbol Frida never let go of; her favorite ring featured the alchemical gold circle surrounding a dot, and can be seen in her painting *Me and My Parrots* (1941).[48]

At the bottom of the announcement, Frida drew a turtle with wings, a hybrid creature, like her new androgynous self. The turtle is a water animal on earth, and the wings, indicating a flying creature, symbolize the air. There is alchemical significance to the image as well. In alchemy, some

of the vessels used—containers of transformation—were made to look like turtles. The turtle with wings also highlights one of the foundational aspects of alchemy: "as above, so too below." The world of spirit, in other words, is just as important as the material world, making them interdependent. For Frida, it wasn't difficult to exist within two parallel planes—the mythic/spiritual of the above and the everyday material of the below.

She'd been living within these two realms since childhood, when she'd created an imaginary friend: a six-year-old girl who lived in a magical world. This friend came into being after two disquieting experiences Frida had when she was six years old. The first was contracting polio. The second involved María Luisa, her older half sister from her father's previous marriage. While María Luisa was sitting on a chamber pot one day, the prankster Frida sneaked up and pushed her over, causing her to fall backward. Angry, María Luisa yelled at Frida, "You are not the daughter of my mother or my father. They picked you up out of a trash can." These words were seared into young Frida's mind. As she wrote later, "This statement impressed me so much that I changed into a completely introverted creature. From then on I had adventures with an imaginary friend."[49]

This made-up friend appeared one day through a pane of glass. Frida's breath on her bedroom window condensed into a fog, and with her finger she drew a door that allowed her to go through to the other side, where there was an imaginary land. In her diary from later in life, Frida drew and described this altered reality:

> With immense happiness, I would cross all the field I could see until I reached a dairy store called PINZÓN . . . Through the "O" in PINZÓN I entered and descended impetuously to the entrails of the earth where "my imaginary friend" always waited for me. I don't remember her appearance or her color. But I do remember her joyfulness—she laughed a lot. Soundlessly. She was agile and danced as if she were weightless. I followed her in every movement and while she danced I told her my secret problems. Which ones? I can't remember. But from my voice she knew all about my affairs. When I came back to the window, I would enter through the same door I had drawn on the glass.

Every time Frida returned through the door after her trip to this land of make-believe, she would run through the house to a cedar tree in the cen-

tral courtyard, where she would shout and laugh with joy at the memory of the little girl she'd just visited.

Just as Frida highlighted the *O* in *Leonardo,* she'd conceived of the entry point into her imaginary friend's realm as an *O* in the Spanish word *pinzón,* meaning "finch." The bird allowed her to descend into the interior of the earth, where this laughing, dancing imaginary girl resided. This realm was perfect and whole, something a circle or *O* as entry point symbolizes.[50] The finch was the ideal bird to act as a portal for Frida on this journey because it too is a lively creature that sings and "dances" in the air with twists and turns. The bird, which might be considered a totem animal for Frida throughout her life, figures in both her alternate reality as a child of six and in her (re)birth announcement as an androgynous artist of nineteen with her winged turtle.

Leonardo da Vinci also identified with birds. He couldn't stand to see them for sale in the market, so he opened up the cages and freed them. But Frida's choice of Leonardo for her new name goes deeper than a mutual identification with birds. The Renaissance man was an outsider in many ways, a lone voice with his futuristic ideas, vegetarianism, and love of men. In fact, the mysterious circumstances surrounding the creation of the *Mona Lisa* have led some to speculate that it's a self-portrait. French modern artist Marcel Duchamp riffed on this theory when he drew a mustache and goatee on a postcard reproduction of the revered *Mona Lisa* in *L.H.O.O.Q.* (1917).

Four years later, Duchamp took cross-dressing a step further by collaborating with Man Ray on a series of photographs in which Duchamp dressed as his female alter ego, Rrose Sélavy, wearing fashionable hats and fur collars with elegant hands sporting rings or holding a perfume bottle. Rrose was seen on the cover of an art journal and discussed within the pages of several.[51]

When pronounced, the name Rrose Sélavy sounds like "Eros, c'est la vie" (Eros, that's life). What are we to make of a male artist's female alter ego referencing the Greek god of erotic love? It's the quintessential Duchampian play on words, images, and gender, something Frida prized. (Later in life she met Duchamp, and he was one of the few European artists she liked.) She thought both eroticism and love were essential, but she ultimately declared: "Love is the only reason for living."

Her declaration of love and use of the *O* to enter her imaginary world

in a search for wholeness connects to another Greek whose work she read, the philosopher Aristophanes. In Plato's *Symposium,* Aristophanes lays out the nature of love, explaining why people feel whole when they fall in love. This is because at one time, there were three types of humans: female, male, and an androgynous being that was half male and half female. But Zeus, fearing their power, had each type cut in half. After this, each half longed for its other half: female for female, male for male, and female for male. Aristophanes says that love is the pursuit of wholeness, as each of us seeks to recover our original natures. Aristophanes's story normalizes homosexual love and androgyny.

This desire to recover one's original nature and find wholeness is something Frida desperately needed post-accident. Taking on Leonardo as her reborn self allowed her to create a new androgynous balance. Many French writers were fascinated by androgyny in the late nineteenth and early twentieth centuries. Frida read these authors in her teen years, including Joris-Karl Huysmans (*Against Nature*), Théophile Gautier (*Mademoiselle de Maupin*), Stéphane Mallarmé (*Hérodiade*), and Honoré de Balzac (*The Girl with the Golden Eyes*).

The nineteenth-century French novelist and art critic Joséphin Péladan was one author Frida read who drew connections between androgyny and Leonardo da Vinci. Péladan also created his own Mystic Order of the Rose and Cross, a name borrowed from the Rosicrucians. Androgyny figured prominently within his order, where it was cast as the ultimate expression of unity and perfection. Like Aristophanes, Péladan reveals the importance of love to restore humans to their ancient joined state. He thought Leonardo's painted figures, particularly his St. John the Baptist, looked androgynous, revealing an important metaphysical union of man and woman.

Even more important, Péladan incorporated Leonardo into the initiation process for new members of his Mystic Order of the Rose and Cross. At every stage, initiates shed their former identities and took on the protection of a "patron saint." After completing the first level of the initiation process, the neophytes took an oath and received Leonardo as their new name, hearing, "Artists who believe in Leonardo . . . you will be the Rose and Cross."[52]

When Frida took on the name Leonardo to announce her (re)birth, she too had undergone an initiation. But in her case, it was a near-death experience that forced Frida to shed her former identity. Afterward, she

created her own mystical and mythic world; it was a way to reinsert the mysterious aspects back into life. And art, whether Frida's own paintings or her role as photographic model, became the conduit to this mystical and mythic realm.

In February 1926, one month after the (re)birth announcement, Guillermo and his daughter collaborated on a photographic series that recast Frida in her new identity as Leonardo. Guillermo, as he often did, gathered his extended family for a photo shoot in the outdoor courtyard of their home. In an alcove, he placed a Persian-style rug on the floor in front of a floor-to-ceiling wooden door and arranged potted plants on either side to give the picture a formal look. Then he lined people up in three rows, with everyone wearing their finest dresses or suits for this seemingly conventional photo. All look typical for the time period, except for Frida, who is standing off to the left clad in her father's three-piece suit and tie.

In another photo taken that day, the women in the family and a younger male cousin are standing in a line, and Frida is in the middle with an added prop—now she holds a cane like that of an Oscar Wilde dandy. With her unwavering gaze, she stares intently as if to say: *I dare you to scoff at me.*

That same day Guillermo took a solo picture of Frida in a satiny dress. In this new photo, her face still has an androgynous look, but her dress marks her as female. Guillermo turned the small Persian style rug 90 degrees, with Frida seated on a chair and the rug's mandala-like octagonal-shaped designs visible in front of her. The potted plants, placed up high on long rectangular tables on either side of the chair, frame Frida as if she's being presented for an important occasion. She looks straight out with her penetrating gaze; the books in her lap underscore her active, intelligent mind. But the whole picture has a mysterious quality to it. Frida has the look of someone in touch with the esoteric world of the occult. Later in life "she referred to herself as the 'great Occultist,'" as Kahlo scholar Teresa del Conde notes.[53]

The intriguing cover of one of the books and the abstract curvilinear insignia on her dress further emphasize this. Herrera calls it a "strange dress that has nothing to do with 1920s fashion."[54] Del Conde identifies the dress's insignia as a "double oriental emblem," but she doesn't clarify what type of emblem.[55] It has the look of an abstract floral pattern and, as

del Conde said, it's doubled—one part goes upward and the other, mirrored, part goes downward. In alchemical terms it means the spirit world above is interconnected with the earthly world below.

The cover on the top book Frida holds adds to the mysterious mood. It shows a square within a circle, which recalls Tibetan and Hindu mandalas (her good friend Miguel Lira authored a book about Chinese mandalas). Whatever the actual meaning of the book's cover design, in many spiritual traditions a square symbolizes the earthly realm (four elements), whereas a circle represents the perfection or unity of the universe. This symbolism overlaps with the "double oriental emblem" in that both reference the interplay between two distinct but interrelated realms. Leonardo da Vinci revealed this as well with his *Vitruvian Man*, a figure that possesses "divine proportions," allowing the male body to fit within both a square and a circle.

Perhaps Frida as the androgynous Leonardo displayed this book cover to convey her new role as an artist intermediary between the earthly and divine realms.

All three photos from that day in early February reveal Frida's male and female sides, the perfect balance desired in alchemy and promoted by Aristophanes and Péladan. To outsiders, the photos may appear odd, but it probably felt just as natural for Frida to wear a man's suit as a dress. While she "formally" took on the Leonardo identity after her accident, as a child she'd embraced her male side, and she was used to wearing both "male" and "female" attire.

Frida was born shortly after her brother, Wilhelm, died, becoming in some sense a replacement son for the grieving parents. In many ways her father treated her more like a boy than a girl, nurturing her physical prowess as much as her intellectual acumen. Her father openly admitted that of all his children she was the most like him, and she was the only daughter called by a German name.[56]

An important turning point in the father-daughter relationship was when Frida developed polio at age six. As she recovered, Guillermo trained his daughter to be a strong athlete and taught her to fight back verbally when teased. In this way, he provided her the freedom accorded males, something noted by peers and adults. Her friend Alicia Galant recalled

Frida wearing blue overalls while riding her bike with a group of boys through the streets of Coyoacán. The neighborhood mothers watching would exclaim, "Que niña tan fea!" (What an ugly girl!). If such comments bothered Frida, they certainly didn't prevent her from continuing to look and act like a boy, even when Alejandro asked her to wear skirts more often. Such confidence was probably bolstered by a supportive father.

And it's significant that he aided her in this staged photographic presentation one year after her accident, once again helping his daughter to recover her health. But now, like Duchamp and Man Ray, they'd collaborated on an artistic series of gender-bending photos. As a professional photographer who had created many portraits and self-portraits, Guillermo understood the importance of lighting, poses, props, and clothing. According to a handwritten note on Frida's copy of the family photo where she appears in drag, it was her father who supplied the suit. Father and daughter were close because they saw themselves in each other.

In March Alejandro broke off their relationship. He told Frida to "carry on," but she wrote back saying she was hurt that he thought she was "worthless."[57] With great confidence, she defended her dignity, saying she was "an exceptional girl," as he had once proclaimed.

Despite the strength of Frida's words, Alejandro's rejection hit her hard. Frida continued to write Alejandro to win him back—"I beg you with all my soul not to leave me ever"—but he kept his distance.[58] Her body relapsed, with pain restricting her ability to walk, which resulted in her becoming more housebound. It must have been daunting to realize that she hadn't finished working through the painful psychological forces affecting her, those hidden aspects of herself that, according to alchemy, one must suffer through to emerge transformed. These combined elements— her feelings of rejection, her lack of mobility, and her desire to probe the self—prompted Frida to paint her first self-portrait. It was a gift for her former boyfriend.

Just as Frida had created her own written language, her ability to absorb and synthesize new information in a flash aided her in the creation of a sophisticated and coded visual language. With her first painted self-portrait, she combined disparate stylistic elements to create an alluring image for Alejandro. *Self-Portrait in a Velvet Dress* (1926) shows her from

the waist up in a maroon gown with a decorative collar and a plunging neckline that emphasizes her small breasts and nipples. But it is Frida's eyes that capture our attention first.

She'd taken some cues from the sixteenth-century German artist Albrecht Dürer, who was known for his commanding self-portraits—one shows him pushed up against the picture plane, looking androgynous with long hair cascading down over his fur-trimmed coat. Frida also borrows from the seventeenth-century Mannerist style of Parmigianino, with the elongation of her neck and fingers, as well as Best-Maugard's emphasis on the linear quality found in his 1923 *Self-Portrait* and the art of early cultures.

Frida creates a blue and black seascape with arabesque brushstrokes that look similar to Best-Maugard's wave patterns with an S-line in succession from his design book.[59] But the intensity of emotion is reminiscent of Vincent van Gogh's swirling strokes of thickly applied blue and white paint in *Starry Night*. In Frida's painting, the dark black and blue waves of the sea symbolize the depth of her feelings for Alejandro, but she also told him in a note that "the sea, symbol of my portrait, synthesizes *life,* my life."[60]

Even though Frida is clearly borrowing features from different European styles and aspects of the Best-Maugard method, she also hits upon a signature element that will come to define her self-portraits.[61] She emphasizes her black eyebrows by connecting them and creating a birdlike V-shape that frames her enticing eyes. This birdlike shape alludes to both her totem animal and her androgyny. (Later in life, she creates a drawing with a black bird as her eyebrows.)

When Frida gave the painting to Alejandro, there was an accompanying note with instructions: "I implore you to put it somewhere low, where you can look at it as if you were looking at me."[62] Frida wanted him to be seduced by her alluring image. And when she instructed Alejandro to place her painted image low so he could look at her straight on, she knew details mattered. She paid great attention to her facial expression, the waves in the background, and the floral designs on her dress's collar. Although Alejandro would see her face first, catching her penetrating eyes, the line of her neck pulls the eye down to her dress's heart-shaped collar and her breasts. She's saying: *My heart aches for you, just as my breasts long for your touch.* Frida's collar is embellished with flowers, and they add another layer to her coded message. In a letter she sent Alejandro after she'd given him

the painting, she acknowledged: "In the triangle you know in the garden, the plants have grown, they will surely be ready by spring, but they won't blossom until you arrive."[63]

If Frida's painted image was designed to entice Alejandro, then this note was used to intensify the act of seduction. The world over, flowers symbolize women's sexuality and their genitalia.[64] Frida's note is both innocent (*I won't bloom into my happy self until you come to see me*) and seductive (*I won't blossom or come alive until you and I are reunited sexually*). A double flower linked by a golden stem on the left side of Frida's collar illuminates this idea, as the thick stem looks phallic.

Frida also mentions "the triangle" Alejandro knows in the flower garden. This refers to the triangles embedded in the center of the flowers, an important cipher in alchemy, indicating water or fire, depending upon the triangle's orientation. In Frida's self-portrait, she places the triangle's point upward, indicating the male principle of fire, representing Frida's intense, fiery (male) emotions for Alejandro.[65] The water in the background, a female symbol, "synthesizes" her life.

This clever dualistic perspective serves to create harmony for the alchemists. Male and female energies together, when balanced, produce the highest form of energy, understood in chemical terms as gold. Frida painted her triangles gold.[66] Alejandro understood this private language of alchemy, which Frida had discovered three years earlier as a student at the Prepa when she'd read about Paolo Uccello, the artist who drew squares, pyramids, and circles to find the ideal, perfect forms of alchemy and sacred geometry.

The alchemical triangle became synonymous with Frida's androgynous self. After the accident, she used the triangle as her signature on letters. In the drawing of her accident, she placed a triangle on her gauze-wrapped chest, perhaps to indicate her transformation into Leonardo. The triangle was the perfect symbol to express Frida's androgyny because she could manipulate it to convey both her male and female sides. She did this when signing her letters—sometimes Frida signed with an inverted, "female," triangle, and at other times she signed with the "male" triangle, point facing up.

Frida's message to Alejandro is simple: *Love me.* But her set of signs and symbols is complicated. Frida's dress and delicate hand connote femininity, but her short, cropped hair, unibrow, and small, prepubescent-appearing

breasts lend a boyish quality, producing an androgynous image. This is significant given Alejandro's accusation that Frida was loose, a common criticism of women who express their sexual desires. She was a free spirit who didn't fit the norm. She was neither a virginal Mary nor a sinful Eve, and the well-read and cultured Alejandro would have understood many of the symbols; they were tailor-made for him. As an adult reflecting back on his time with Frida, he said: "From her teenage years she was concerned about the most unusual things."[67] Frida's use of an esoteric visual language worked; she won Alejandro back.

Frida's (re)birth announcement, Guillermo's photographs of her as Leonardo, and *Self-Portrait in a Velvet Dress* reveal a creative intellect with the seeds of genius waiting to emerge full force. Frida's *Self-Portrait in a Velvet Dress* is the first attempt to use her alchemical powers as Leonardo to work her magic as an artist.

In 1927 Frida's new self emerged again, but this time it was in a pencil drawing, significantly called *The First Drawing of My Life*. With her *Self-Portrait in a Velvet Dress,* she'd placed water behind her, but in this drawing, she's immersed in it. Frida's head, resting just above the water's surface, obscures parts of the background, placing her joined, bushy eyebrows front and center. Her upper body is visible, but it's submerged under clear, still water. She looks calm. Her newfound tranquility is emphasized by the contrast with the sailing vessels in the right background, which look as if they're losing control from the swaying movement of the water.[68] She remains rooted in the watery realm that "synthesizes" her life. She creates herself wearing an androgynous-looking shirt that's open to reveal her chest, but because the drawing is cut off right at the point where her breasts would show, her chest doesn't display signs of "femininity." Instead, her choker necklace symbolizes her female side.

Considering Frida's horrific accident, it's easy to imagine her divorcing herself from her broken body. Instead, she reaffirms her bodily existence in this drawing and her carnal pleasures in *Self-Portrait in a Velvet Dress.* It's also remarkable how calm, centered, and self-possessed Frida looks given what she'd been through since September 1925. But part of her developing personal style involved creating a mythic image that paralleled—but did not always intersect with or simply reflect—her personal life.

In the spring of 1927 Frida's life began to sputter when she discovered that Alejandro was leaving for an eight-month visit to Europe. He couldn't bring himself to say goodbye in person, so he penned her a letter from Veracruz telling her he'd left on a journey. Intuitively Frida knew the relationship was over, but intellectually she couldn't accept the truth. She told Alejandro she would never stop loving him.

Despite her transformation into Leonardo, abandonment was Frida's greatest fear. She admitted later in life: "I am more afraid of being abandoned than of being disappointed."[69] She crumbled from the intense emotional pain of desertion, as if her body couldn't maintain the balance she'd fought so hard to gain. This tension between the mythic, alchemical ideal of balance and the physical and emotional cauldron of chaos defined Frida's art and life. It would always be a struggle. That summer of 1927 saw the first of many physical collapses, requiring her to wear a plaster corset. In theory, the corset was designed to straighten her spine and keep her upright. But in reality, it fit so tightly she felt as if she were suffocating.

This feeling was intensified by her parents' physical and emotional problems. Frida consoled herself by daydreaming about Alejandro, but it was only a temporary escape from the complex psychological enmeshment in the house: "No one in my family really believes I am ill, since I can't even say it because my mother, who is the only one who feels any distress, falls ill, and says it's my fault, and that I'm very imprudent. So I and I alone suffer, and feel hopeless and all."[70] At one point Frida beckoned to *la pelona,* saying: "If I don't get better with this [corset], I sincerely want to die."[71]

THREE

Communism, Marriage, and Mexicanidad: 1928–1930

Each friend represents a world in us, a world possibly not born until they arrive, and it is only by this meeting that a new world is born.

—ANAÏS NIN

 On January 29, 1928, Guillermo gathered his family for another photo shoot in the central courtyard of their home. He again organized everyone into three rows, with plants in the background and a rug and two French-style footstools in the foreground. This time Frida stands in the center of the last row wearing a dark dress that highlights a necklace with a large cross resting on her chest. This traditional symbol of Christianity is offset by her short hair, crossed arms, and stern expression. There's no visual evidence of Frida's plaster corset, yet the sad expressions on almost everyone's face hint at the psychological wear and tear of the recent past.

At twenty-one, Frida had to take a long look into her future. She had decided not to finish her studies at the Prepa, which had been interrupted by her accident. All her friends had graduated and moved on, and she didn't have the same passion and stamina for studying. German de Campo, a former Cachucha who was now a law student, introduced her to a group of politically engaged Communists and artists. They congregated on the fifth floor of Tina Modotti's red brick apartment building on Abraham González Street in Zamora, just fifteen minutes from the center of Mexico

City. Tina, an Italian American photographer and political activist, had lived in Mexico since 1923 and had ensconced herself within the political and artistic circles of her new home.

Through Tina's influence, Frida committed herself to a love of country that was connected to the ideals of communism and art, exchanging her cross necklaces for hammer-and-sickle pins. But Tina and her circle didn't introduce Frida to Communist ideas.[1] She'd already taken an interest, having read a series of newspaper articles about the Russian Revolution by Alexander Kerensky, a Russian lawyer and politician. She also read the news trickling out of China concerning Chiang Kai-shek's violent suppression of the Communist Party in Shanghai. It wasn't a good time to support the ideals of the Communist Party in China. Similar tensions were beginning to erupt in Mexico and Frida found herself supporting the underdog.

The Mexican government's tolerance of the Communist Party had dwindled to the point that many committed activists in Mexico felt they had to be willing to risk their lives in order to effect social change. For Frida, Tina's group offered a second chance at an interesting and meaningful life. Diego Rivera socialized with this group, and one night at Tina's he caught Frida's attention when he took out a pistol and shot at a phonograph to emphasize a point. Such outrageous antics beguiled Frida.[2]

She had previously met Diego while he was painting a mural at the Ministry of Education and she boldly asked him to come down off the scaffolding and look at her art: "Look, I have not come to flirt or anything even if you are a woman-chaser. I have come to show you my painting. If you are interested in it, tell me so, if not, likewise, so that I will go to work at something else to help my parents."[3] Frida's candor had impressed Diego, and he was intrigued with a self-portrait she showed him (probably *Self-Portrait in a Velvet Dress*), commenting, "You have talent."

Her paintings, he said, "revealed an unusual energy of expression, precise delineation of character, and true severity. They showed none of the tricks in the name of originality that usually mark the work of ambitious beginners."[4] This was a huge compliment because Diego was not a fan of the Best-Maugard style Frida had been influenced by, with its emphasis upon decorative patterns and elongated figures. He had harsh gendered language to explain why, opining that this style was "preferred by hysterical old women who confuse painting with the impossible aspirations of a

uterine complex."[5] Maybe if Frida had been an old woman, he would have cast her aside. Instead, this feisty young woman fascinated Diego.

In the summer of 1928 he'd separated from his second wife, Lupe Marín, and had begun playing the field like never before.[6] Frida could have easily ended up as one of Diego's many conquests, but there was something about her that kept him coming back. Maybe it was her blunt honesty, or her talent as a largely untrained artist. Perhaps it was her gaze that pierced his façade, or her unconventional beauty, or her quick mind and intelligence, which allowed her to spar with such a masterful pontificator. Most likely it was all of these qualities that entranced Diego, who, like Frida, was easily bored.[7]

Theirs was never a boring relationship. Both espoused the importance of a down-to-earth existence peppered with imagination, creativity, irony, black humor, deep laughter, fantasy, and a passion for social justice. They rejected "bourgeois morality," yet both could erupt in jealous tirades.[8] Each had enormous appetites for the sensual pleasures in life. Frida's philosophy was "Make love, take a bath, make love again."[9] Many wondered why a young, attractive woman like Frida would be with a man who was almost twice her age, potbellied, and often described as ugly. However, Diego was undergoing a transformation when he met Frida.

Around the same time that Diego's marriage to Lupe was ending, his fame was growing. His ego was growing as well, and it was in this period that his persona as the irresistible lover began to take shape. Despite his insecurities and physical unattractiveness, women were drawn to Diego. His fame and power certainly helped, but it was also the way he made women feel as if they were important, a rare quality in a man at the time. Diego told a reporter his unconventional views:

> Men are savages by nature. They still are savages today. History shows that the first progress was made by women. Men preferred to remain brutes who fought and hunted. Women remained at home and cultivated the arts. They founded industry. They were the first to contemplate the stars and to evolve poetry and art.[10]

Diego's praise for women's important contributions to society and art spilled over into his celebration of female sexuality. Women, he said, were more "civilized and sensitive than men because men were simpler sexu-

ally," as they had a sexual organ only "in one place." Women, on the other hand, felt pleasure "all over the body."[11]

Frida found Diego's nonconformist attitudes refreshing. She was flattered when he sought out her opinions on his art. Diego's biographer and good friend Bertram Wolfe observed about Frida's role: "So far as I know, he never thus consulted any other person, man or woman, in the years of his maturity. Expressed shrewdly, with tentative interrogation, her verdict was at times quite unfavorable. Then he would grumble or grow bearish, but in a few minutes, or the next day, he would alter the offending detail. In the course of succeeding years he became more and more anxious for her approval and dependent upon her sensitive judgment."[12]

Unlike many of Diego's relationships, theirs evolved as that of two compatriots who shared a passion for art and politics. Besides encountering Diego at Tina's parties, Frida said she began "to see him paint in the afternoon, and afterward he would take me home by bus or in a *Fordcito*—a little Ford that he had—and he would kiss me."[13] On these visits to Frida's house in Coyoacán, he would see how her art was progressing. They enjoyed talking about painting and its importance for Mexicanidad, a new postrevolutionary indigenist movement. Frida had been privy to discussions of this concept at Tina's due to the influence of Frances Toor and her magazine, *Mexican Folkways.* Diego, as the publication's art editor, loved to expound upon many of the subjects within its pages: articles on excavations of Aztec sites, regional craft and musical traditions, Catholic *retablos,* children's art, and photographs of the diverse people and regions of Mexico.

Frida's participation in Tina Modotti's salon and her relationship with Diego strengthened her political commitment and her identification as an artist for the people; she joined the Communist Youth League in 1929. It was around this time that she began to sport a new outfit—jeans or khaki skirts and red or black button-down shirts adorned with an enameled hammer-and-sickle pin, a treasured gift from Tina. She no longer displayed the crosses of her Catholic upbringing or spoke of God as she had in the past.

Frida and Diego participated in a May Day protest in 1929, just two months after the Mexican government had outlawed the Communist Party. Violence erupted when protesters surrounded the U.S. embassy and the police quickly infiltrated the crowd. Riot squads beat the protesters, and gunshots were fired.

These events rattled Frida and intensified Tina's rage and sorrow. Four

months before the May Day protest, Tina had been walking with her lover, political activist Julio Antonio Mella, when he was gunned down and killed. Authorities accused Tina of the killing, saying it was a crime of passion. The murder investigation ultimately put Tina's sexuality on trial in an attempt to ruin her reputation and embarrass the Communist Party. The accusations were unfounded, but descriptions of Tina as a femme fatale disturbed some leftists. Even though they were fighting for revolutionary ideals, "Communist men liked their Communist women respectable," as Tina's biographer Patricia Albers put it.[14] In the end, there wasn't enough evidence to convict Tina of murder, but the trauma of the trial and the inflammatory newspaper articles took a toll on her.[15]

The fact that Tina's bohemian attitudes toward sexuality were demonized in the press must have felt eerily familiar to Frida. Her own reputation had been smeared when Alejandro had accused her of being loose just a few years earlier. Now, as she was stepping into a public role as Diego's "girl" and ultimately wife, she needed to think again about her persona.

Diego depicted an androgynous Frida in his mural *The Distribution of Arms* at the Ministry of Education (1928). In this period, she certainly dressed in a gender-neutral fashion, often wearing overalls or her worker's outfit. But most of the paintings Frida herself produced in 1928 and 1929 do not convey this unconventional, cross-dressing artist with the bold stare. Instead, Frida focused on portraits of friends and the people of Mexico painted in a style that pays homage to Mexican folk artists, colonial painters, modern artists working in a Primitivist style, and modern photographers.

In her painting *The Women* (1928), which depicts her mother's servants Salvadora and Herminia, the women stand in a three-quarter pose looking off to the left, highlighting their facial features. Behind them, a profusion of densely packed green fruit trees fills up the entire canvas, making it clear that Indian women are the foundation of Mexican culture, one that is intimately connected to the sweet beauty of the landscape. It's as if Frida put Antonio Caso's verbal challenge into visual form: "Turn your eyes to the soil of Mexico, to our customs and our traditions, our hopes and our wishes, to what we in truth are!" Diego, and many other muralists, also painted the customs and traditions of Mexico in an attempt to create an art

for the people as an expression of Mexicanidad, which revived the religion, philosophy, and art of Mexico's indigenous people as a means of redefining Mexican identity after the revolution.

Frida was clearly influenced by the murals and easel paintings depicting indigenous people, showcasing their beauty and rich traditions. But as the daughter of a photographer, she had also looked closely at Tina's powerful black-and-white photographs, many of them featuring Mexico's indigenous women and children. Tina's 1929 photograph *Sugar Cane,* in which the stalks are seen from a close-up perspective, filling the frame, resembles the crowded background of green leaves in Frida's *The Women.* The beauty of the long stalks of cane is captivating, yet Tina's photo also repels with its claustrophobic look. The same could be said of Frida's densely packed leaves. Of course, Diego incorporated the natural world into his work with easel paintings, such as *Flower Seller* (1926), but his depiction of nature lacks such claustrophobia. The style of Frida's impenetrable "wall" of leaves is a device she would return to in later paintings.

Frida's choice of subject matter in *Indian Woman Nude* (c. 1929), however, recalls Diego's easel painting *Bather of Tehuantepec* (1923). Like Frida's painting, it features a dark-skinned nude female from the waist up. Both paintings emphasize the connection between indigenous women and nature, giving life to the popular myth that Indian women were in touch with a "natural sexuality," one that was supposedly unaffected by the repressive attitudes of Catholic Spain. But a major difference between the two paintings is that Frida emphasizes the woman's face, while Diego obscures it.

The modern nude (or partially nude) indigenous woman in nature has its roots in the French painter Paul Gauguin's work. He'd traveled to Tahiti to escape the repressive attitudes of Catholic France. His paintings of nude and topless Tahitian women made him famous as the father of Primitivism, that modern European movement that looked to non-European art and culture for inspiration. For Gauguin, the challenge was to create what he called the "New Eve," a sensual woman untainted by sin.[16]

On some level, this is what Frida had tried to achieve with *Self-Portrait in a Velvet Dress,* sans "primitive" nudity. Now she'd turned her attention to a topless indigenous woman. Even though she draws upon the stereotype of the indigenous woman as part of nature, the way Frida lovingly details the woman's bone structure and strong gaze indicates she was striving to give her dignity.

Frida and Diego were married on August 21, 1929. For a couple that eschewed bourgeois morality, this was a bourgeois act, yet Frida's mother wanted nothing to do with it, even if Diego could provide economic stability for her daughter. She distrusted the overweight Communist, atheist painter and refused to attend the wedding. Frida's father, who had warned Diego at the beginning of their courtship that his daughter had "a demon inside," approved of the marriage—but only after offering one last blunt forewarning: "Notice that my daughter is a sick person and all her life she will be sick; she is intelligent, but not pretty. Think it over if you want, and if you wish to get married, I give you my permission."[17] Guillermo Kahlo attended his daughter's civil ceremony in Coyoacán's ancient city hall, but during the service he expressed his quirky, eccentric personality again when he stood up and proclaimed, "Gentlemen, is it not true that we're playacting?"

Perhaps Guillermo, who had helped Frida create her new self, thought her "wedding gown" and marriage indicated she was acting a part, one that was quite different from her androgynous days and her attraction to women. Guillermo may not have known anything about his grown daughter's bisexuality, but according to one author, Frida had an intimate sexual relationship with Adela Formoso de Obregón Santacilia in 1929, before she married Diego.[18] This would have been a time when she was still living at home with her parents. Not much is known about Frida's relationship with Adela, but it's understandable that these two remarkable young women would have been drawn to each other.

Adela was an independent woman who played violin, and later became a conductor, creating the first women's orchestra in Mexico. She also wrote plays and books, including *The Mexican Woman in the Social Organization of the Country*. Frida conveyed some of her feelings in a loving tribute to Adela, an unfinished painting titled *Portrait of a Lady in White*. One aspect that sets Adela apart from Frida is her outfit. She wears a beautiful white gown with long white gloves to match. With her bobbed haircut, Adela looks like a modern Mexican woman who has been influenced by European styles.

Frida, in this transitional period, chose a very different type of outfit to signal her new status as the wife of Diego Rivera. Her wedding marks one of the first times she was photographed as a woman of the people. Frida's

wedding dress consisted of a long ruffled skirt, blouse, and *rebozo* (shawl) that she had borrowed from her family's maid. The local newspaper *La Prensa* made note of her outfit: "The bride [was] dressed . . . in very simple street clothes." This signaled Frida's desire to align herself with working-class indigenous women. As historian Rick A. López explains, "To be truly Mexican one was expected to be part Indian or to demonstrate a concern for the valorization and redemption of the Mexican Indian as part of the nation."[19]

Frida transposed the "simple street clothes" of the Mexican woman onto canvas in her second self-portrait, *Self-Portrait: Time Flies* (1929), where she stands in an interior setting with green curtains opened to reveal an airplane flying in the sky over her head. A column behind her holds a round clock on top that reads 2:53. Frida commands the central space; her white blouse with lace trim stands out against the emerald green curtains. But her gaze isn't commanding. Unlike in earlier photographs and in her self-portrait for Alejandro, her eyes aren't directed toward the viewer. Instead, her eyes are inward-looking, as if she is pondering something. The European flourishes of *Self-Portrait in a Velvet Dress* have given way to the Mexican nationalist bride.

Her prominent jadeite necklace engraved with an Aztec symbol, the *olin,* speaks to the complexity of Frida's thoughts. This symbol is found on the carved basalt Aztec Calendar Stone, also known as the Sun Stone. The Aztecs believed there were four past cosmological eras that had already ended, and at the time of the Spanish conquest they thought they were moving into a fifth era.[20] The Calendar Stone, with the fifth era carved in the middle, shows this shift from the past four worlds into the fifth world.[21] Four dots on the outside of the *olin* glyph are read as *nahui*, the glyph that translates as "four."

The *olin* glyph is carved on the stone to represent movement, or the movement required to shift from one world into another. It's an appropriate symbol for Frida because she made this self-portrait shortly after her marriage to Diego. She'd moved out of her parents' house for the first time and was living at Diego's place on Paseo de la Reforma in Mexico City. This physical move coincided with a psychological shift from being Diego's girl to being Diego's wife.

Part of the psychological shift involved deepening her role as manager of Diego's chaotic life, one that involved past and present lovers, including a young woman named Nahui Olin. Born Carmen Mondragón, this free-spirited poet with the Louise Brooks bobbed haircut and large green eyes changed her name to Nahui Olin after meeting fellow artist Geraldo Murillo, better known as Dr. Atl. After the two became lovers, Dr. Atl had been the one to suggest the name change because of Carmen's fiery, complex nature, which was akin to the intense, pulsating movement (*olin*) required to shift from the fourth (*nahui*) world to the fifth.

Diego had asked Nahui to model for the figure of Erotic Poetry in his *Creation* mural for the amphitheater at the Prepa some six years earlier. At that time, Diego was married to Lupe, but it was rumored he'd begun an affair with Nahui. Frida, the mischievous student, had witnessed Diego painting Nahui while she modeled in the amphitheater. Frida tells the tale of teasing Diego while he painted Nahui. She would hide in the darkened amphitheater and shout, "Watch out, Diego, Lupe's coming!"[22]

Frida was aware of Nahui's reputation as a "trollop" and her likely affair with Diego. When Alejandro had accused Frida of being loose, she was indignant that he could think of her as a "sort of Nahui Olin or even worse than her, who is an example of all that type."[23] As a schoolgirl Frida knew she didn't want to be known as "that type," which was despised. Nahui, like Tina, dared to defy the traditional social norms. Both women, while admired by some, paid dearly for their independent spirit.

By the time Frida created *Self-Portrait: Time Flies,* her life had changed. She'd become acquainted with Nahui through Diego and Tina. Around the time Frida met Nahui, in the late 1920s, she'd lived up to her "type" once more by posing for nude photos taken by Antonio Garduño. Nahui wasn't ashamed of these photos; she wanted them to be seen, not hidden away.[24] But the photos cemented her reputation as a wild woman/witch. In some she stands naked for all to see, with her abundant pubic hair visible, breaking a long-held taboo in the art world and Mexican culture in general. (Though Mexicanidad involved a rethinking of what it meant to be Mexican in this post-revolutionary atmosphere, it didn't necessarily include women's liberation.)

When Frida was contemplating what persona she wanted to paint for *Self-Portrait: Time Flies,* images of radical women who had been punished for their beliefs and actions must have appeared somewhere in her con-

sciousness. She had to find the appropriate image. She chose her outfit carefully. The necklace she wears is rife with public and private associations. Publicly, it places Frida within the milieu of those who embraced pre-Hispanic cultural and artistic traditions. Privately, the necklace, a gift from Diego, bears a symbol evoking the name of one of his lovers, a woman who was labeled loose, wild, and crazy.

By wearing the necklace, Frida simultaneously flaunts her own free-spirited sexual nature and conceals it. This is part of a complex, two-tiered visual language that allowed Frida to express some of her radical ideas and deep feelings within the constraints of a society that often punished women for expressing their sexuality, defiance, and independence. Frida's choice of a simple peasant-style white blouse also connotes two different images. It emphasizes both her leftist leanings as a woman of the people who identifies with the indigenous—underscored by the Aztec glyph—and her purity as a young bride. Ultimately, the painting is designed to showcase Frida's new identity as the *mestiza* who is proud of her country's revolutionary ideals, something the color scheme underlines—green, red, and white, like the Mexican flag.

This nationalistic identity reaffirmed Frida's new public role as Diego's wife, but she also hints at a private world with Diego. In this first self-portrait as a married woman, Frida lays out, on a symbolic level, the intricate mythic framework of her desired alchemical union with Diego. It hadn't worked with Alejandro, but now Frida had a second chance to co-create this mystical union. Diego was a good candidate because he too was fascinated with esoteric traditions, as well as Aztec cosmology.

Diego's connection to esoteric principles came through his father, who had been a Freemason; Diego's time in Paris, when he met artists interested in the occult; and his membership in the Quetzalcoatl Rosicrucian Brotherhood, which he'd joined upon his return from Europe in the early 1920s. He'd joined a fraternity of highly respected men within Mexican society who dressed up in Egyptian-style headdresses with the intent to preserve ancient knowledge. This secret society looked to the teachings and symbols of the Aztec deity Quetzalcoatl, as well as the esoteric traditions of the Rosicrucians, whose philosophy dates back to ancient Egyptian times and the birth of alchemy.

Diego, the resident artist of the group, designed a cover for the periodical *El Maestro* ("The Teacher," a title used by the Rosicrucians) that shows a five-pointed star with an all-seeing eye at the center. For the initiated, this cover image conveys important aspects of the Rosicrucian philosophy: if individuals pay attention to nature, the universe, and the spiritual realm, they can attain enlightenment.

Frida's first exposure to Diego's use of Rosicrucian, Mesoamerican, and esoteric symbolism came from watching him paint his first mural, *Creation* (1922–1923), while she was attending the Prepa. The mural was given the prestigious main wall of the lecture hall in the amphitheater. José Vasconcelos, the new minister of education, deemed the amphitheater the most significant place on the school grounds. This was where the future leaders of Mexico would gather to hear music, poetry, and lectures. It's where, according to sixteenth-century German physician and alchemist Heinrich Khunrath, the seeker of wisdom is transformed from a passive spectator into an active agent. Although Khunrath discussed the amphitheater in metaphorical terms, his book *Amphitheatrum Sapientiae Aeternae* was illustrated with hand-colored engravings that, like Diego's mural, allowed viewers to meditate upon the nature of the universe.[25] At their young age, the students were open to a plethora of ideas and images, and Vasconcelos, with the help of Diego, put forward a metaphysical philosophy that differed from the scientific positivism promoted under the regime of Mexico's longtime president Porfirio Díaz.

Diego's *Creation,* referring to the creation of the universe and the place of humans within it, aspired to elevate a philosophy grounded in the mystical beliefs of Pythagoras and the Rosicrucians, while folding in aspects of Catholicism and indigenous Mexican beliefs. It's a beautiful painting that dazzles the eye of anyone walking into the amphitheater, especially with all its gold highlights. As an allegorical painting, it can be interpreted in various ways.

Frida and her fellow Prepa students were immersed in all schools of philosophy, making them ideal viewers. For Diego and Vasconcelos (as well as Leonardo da Vinci), Pythagoras, the early Greek mathematician and philosopher, provided the blueprint for a combined mathematical and spiritual approach to art and life, as in ancient Greece there was no distinction between these two bodies of knowledge.

Pythagoras said the universe was harmonious and "governed by laws discernible to human reason."[26] Human destiny is part of a mathematical order based on the numbers 1, 2, 3, and 4, which when added equal 10. Destiny was important to Frida, and Diego referenced it in his ordered and balanced mural. The Pythagorean key to the harmonious universe is found at the top center, where a semicircle divided into four equilateral triangles by thin rays of golden light dominates. Golden stars shimmer in each of the triangular sections. Pythagoras's influence is seen in the use of numbers: beginning with a golden orb in the middle, the number of stars in each triangular section ranges from one to four, with the last section containing ten.

Just outside the semicircle Diego placed three hands, which line up perfectly with the ends of the three thin golden rays of light coming from the central orb. The hands, facing up, have the pointer and middle fingers extended while the other three fingers are bent, a gesture used as a secret Pythagorean greeting for initiates of the sacred knowledge. It's a gesture that goes back to ancient Egypt, where it was a sign of parental protection. Such gestures or handshakes were common among subsequent secret societies, such as the Freemasons, as they helped members identify one another in a potentially hostile world. In Diego's mural, a similar dynamic is at play. Those who recognize the hand gesture as a Pythagorean greeting will interpret the images in the mural differently than those who don't recognize it as such. And this is key to understanding how Frida and Diego, from early on in their relationship, developed their own private language, both in art and in life. (Later in their marriage they used a special whistle to find each other in a crowded public space.)

Frida had already attempted to create a private language with Alejandro by using the alchemical cipher of the triangle. Curiously, even while Frida had been attempting to forge a bond with Alejandro, she had wondered if her destiny lay with Diego. She told school friends that one day she would have Diego's baby. They scoffed at this idea, thinking Diego too old and unattractive. This proclamation can be seen as a teenage girl's fantasy or an attempt to shock her peers, but it was prescient. Had Frida looked closely at Diego's mural and seen a kindred spirit underneath his persona as a womanizer? Had she recognized the esoteric symbolism, such as the serpent depicted at the bottom right near a seated nude male and female?

Most would guess that the triad represents the temptation of Adam and Eve. However, Diego wrote the word *centurion* in the body of the serpent.[27] Juan Rafael Coronel Rivera, Diego's grandson, says it's a reference to an important ceremony within the Masonic tradition. Snakes or serpents within alchemy and the Masonic tradition symbolize renewal due to their ability to shed old skin and emerge anew. Within the Masonic tradition, initiation is likened to a process of death and rebirth. This coupling of change and renewal is a theme Frida embedded into *Self-Portrait: Time Flies*.

The phrase "time flies" and the airplane flying above convey that time has passed quickly now that she's married to Diego. But the color combinations on the airplane also allude to alchemical principles of transformation. The white body corresponds to mercury, also known as quicksilver due to its ability to easily change form, and the red nose corresponds to sulfur, considered an active principle that can create change. When these two chemicals are mixed together they have the potential to create gold, visible as the gold propeller. Alchemists often convey this chemical combination in human terms with illustrations of a White Queen (mercury), a Red King (sulfur), and the desired Golden Child (gold).

This isn't the only alchemical reference in the painting. Just behind Frida's head stands a gold clock with white trim. The round shape conjures up images of both the sun and moon, as do the colors of gold (sun) and white (moon), again alchemical references to male and female energies and the ultimate balancing of these energies into a higher and more purified form.

The time on the clock—2:53—is significant for Frida and her relationship with Diego, but it's not clear why. Frida would return to this time later in life to symbolize another significant moment in her relationship with Diego. In the later example, she took a ceramic clock from Jalisco, in western Mexico, and painted 2:53 on its face, along with the word "September," the month of her bus accident. Perhaps 2:53 marks the time of the accident. Kahlo scholar Luis-Martín Lozano connects the time to Christ's extreme suffering while on the cross around "the ninth hour," or three o'clock.[28]

Frida said she felt Diego had accepted her, broken body and all, when they first began their courtship. And in her alchemical mythmaking, perhaps the time of her accident and Diego's acceptance of her coalesced into a mythic time. The numbers 2:53 also connect to Pythagoras and

his number symbolism of 1, 2, 3, and 4 adding up to 10, revealing the mathematical order underlying human destiny: Frida's numbers also add up to 10 (2 + 5 + 3).[29] You might say she was destined to come close to death at 2:53, only to be reborn as Leonardo and Diego's lifelong partner. Yet Frida's challenge as Diego's wife, according to Pythagoras, was to find her place alongside him in harmony with the natural order of things. Her relationship with Diego and their shared esoteric knowledge and use of hermetic symbolism seemed to be a central anchor from which all else flowed, at least for Frida.

Frida took her private musings and new public persona with her to Cuernavaca, where she and Diego spent their honeymoon from January 2 to September 15, 1930. Strictly speaking, the honeymoon was really an opportunity to get out of Mexico City for one of Diego's mural commissions. The American ambassador to Mexico, Dwight Morrow, and his wife, Elizabeth, had a weekend home in Cuernavaca, known for its serene beauty and temperate weather. Morrow, whose time in Mexico was coming to an end, wanted to leave with a goodwill gesture, and he offered Diego the opportunity to paint the walls of Cortés's former palace in Cuernavaca. Accepting a mural commission from a capitalist *gringo* might have proven problematic for Diego had he still been a Communist Party member, but several months prior he'd been expelled from the party for agreeing to paint murals in the National Palace.[30] (In protest, Frida quit the Communist Youth League.)

Furthermore, Diego liked this particular capitalist. He and Frida enjoyed an evening with the Morrows dining, socializing, and discussing the mural details at an exciting time in the Morrows' lives—it was just eight days after their daughter, Anne, had married the aviation celebrity Charles Lindbergh. Frida must have been fascinated because of her interest in flight and Anne's boldness as the first woman in the United States to receive a glider pilot's license. Throughout the 1930s, Anne, as co-pilot, flew around the world with her husband.

While the Lindberghs enjoyed their first year of marriage in the air, Frida and Diego spent their initial year of matrimony grounded at the Morrows' Spanish-style villa surrounded by expansive green lawns and a

proliferation of gorgeous flowers. Cuernavaca—the City of Eternal Spring, the area the Aztecs associated with the goddess of love, Xóchiquetzal—seemed like a perfect place to spend their honeymoon, especially after the Morrows left for London, giving Frida and Diego privacy.

Diego spent a good deal of his time at Cortés's former palace painting the history of Cuernavaca going back to pre-Hispanic times. Frida often stopped by to watch him work, provide her critiques, and make sure that her workaholic husband took meal breaks. Prior to leaving Mexico City in early January, while working on murals at the National Palace, Diego had collapsed due to exhaustion. His doctor had prescribed a strict diet and stress-free schedule to ensure his recovery, and Frida played nursemaid. The new bride was learning what was required in her role as Señora Rivera.

Lupe, Diego's former wife, was an unlikely coach, but before leaving for Cuernavaca, she had given Frida a cooking class designed to teach her Diego's favorite meals. But Frida, who admitted she wasn't a good cook, didn't spend all her time catering to Diego's needs. She painted and socialized with one of their visitors, art historian Luis Cardoza y Aragón. The nights were lively, with endless conversations that began at a restaurant.[31] Drinking tequila, that gold elixir, loosened the already loose tales Diego loved to tell. Bertram Wolfe put a poetic spin on this talent: "The tall tales for which Diego was famous, improvised effortlessly as a spider spins his web, their pattern changing with each retelling, were fables wrapped in fables, woven so skillfully out of truth and fantasy that one thread could not be distinguished from the other, told with such artistry that they compelled the momentary suspension of disbelief."[32]

In the mornings, Diego rose and went off to paint, while Frida and Luis would sleep in. Once they awakened and their stomachs were full, the two would take off in search of adventure. Besides visiting nearby towns in the state of Guerrero, such as Taxco and Iguala, they went to Cuautl, the first city conquered by Emiliano Zapata, the revolutionary leader of the peasant class. Zapata was from the state of Morelos, where Cuautl was located, and had witnessed the poverty of the peasants, who couldn't afford to own land, which meant that a small landowning class was able to monopolize agricultural profits. Cuautl is the heart of sugar cane cultivation, a lucrative crop brought to Mexico by the Spanish. The complex history of this area would not have been lost on Frida.

The sugar industry, built upon the backs of African slaves in order to feed a European desire for sweets, funded Cortés's palatial dreams in a conquered Cuernavaca. He brought six thousand African slaves with him to Mexico and put them to work along with the defeated Indians. They were forced to build his palace and cultivate the cane fields surrounding it, providing needed income to build up an empire. Diego depicted this in his mural at Cortés's palace, showing a conquistador on horseback, whip in hand, overseeing the hunched-over Indian laborers who cut, haul, and bundle the sugar cane stalks. In another section of the mural, Zapata, dressed in white, symbolizes the free native who liberated his fellow laborers.

Diego's mural demonizes Cortés, his men, and the church fathers, while idealizing the indigenous people—and apparently deleting the African slaves (at least, it's not obvious if some of the slave labor is supposed to be of African descent)—because for Diego, the pre-conquest past represented a time before the interference of Europeans, when the people of Mexico controlled their own destiny. In retelling the colonial history of his country, Diego, like many Mexicans, appears to have erased or downplayed the African contribution.[33]

Frida shared the perspective that the pre-conquest past represented the time of Mexico's autonomy, when many cultures created great art. That made her visit to Tepoztlán, a town nestled into the jagged cliffs of the Sierra de Tepoztlán, an important experience. A small thirty-one-foot-high pyramid called El Tepozteco peeks out above the mountains. This pyramid with one temple at the top was dedicated to Tepoztecatl, the Aztec god of pulque—an alcoholic beverage made from agave sap—who was connected to fertility and good harvests. After a night of drinking, Frida and Luis were connected by day to the roots of Mexican culture with its integration of alcohol, agriculture, fertility, and ritual. This link to the past was strengthened by the myth that Tepoztlán was the birthplace of Quetzalcoatl, referred to as the creator of humanity and the son of the androgynous primordial god, Ometeotl.

Both deities are known for their hybrid natures. Ometeotl is part male and part female, while Quetzalcoatl is described as part quetzal bird with its dazzling green feathers and part snake with its dull, scaly skin. While images of this beautiful plumed serpent were depicted in art and

architecture before the Aztec empire formed—the most famous being the six-tiered pyramid dedicated to him at the sacred site of Teotihuacan, from the third century CE—the Aztecs built their philosophy of duality upon the shoulders of Ometeotl and Quetzalcoatl. Frida began to understand more fully the Aztec origins of her dual male/female nature.

When Frida and Luis returned to Cuernavaca after a day of exploration, they could see the remains of another pyramid known as Teopanzolco, an Aztec construction with two temples at the top instead of one.[34] This link to the Aztec past was discovered accidentally by Zapata's troops during the revolution when cannons placed atop a high mound shook the earth loose from the ruins of the pyramid, which lay beneath the mound. It was as if the spirits of the deceased Aztecs were revealing that their culture would once again rise in importance. One year after the revolution ended, the first excavation took place at this site. Led by Alfonso Caso, the brother of Frida's philosophy teacher and Diego's friend, it brought an important archaeological site to the consciousness of the Mexican people.

Frida, who as a child used to sing revolutionary *corridos* (narrative ballads) in Coyoacán's town square and watch the Indians dance, began to integrate aspects of her past into her new *mestiza* identity. Luis Cardoza y Aragón's perception of Frida at this time, when she was in her early twenties, bespeaks this growing sense of self: "She was grace, energy, and talent united in one of the beings who has most stirred my imagination to enthusiasm."[35]

Frida's artistic abilities continued to grow in Cuernavaca as she completed several paintings of Mexican children and a third self-portrait. It's an extension of the second self-portrait in that she's also wearing a simple Mexican-style outfit, but this third painting reveals a simplified interior— Frida sits in a wooden chair against a light pink stucco wall. Her face is rendered in a more naturalistic style due to the use of modeling. Her steady gaze, accentuated by those dark, thick eyebrows, grab our attention in this otherwise plain interior. Diego emphasized the significance of her eyes and eyebrows when identifying them as "the wings of a blackbird, their black arches framing two extraordinary brown eyes."[36]

Around the time Frida created her third self-portrait, she was struggling emotionally with three painful experiences. The first involved a gutsy,

good-looking American artist named Ione Robinson, who had sought out Diego in 1929 and found him working on murals at the National Palace in Mexico City. Diego, who had a soft spot for intelligent and pretty women, took her under his wing and introduced her to Tina. Through Tina's circle of friends, Ione met Joseph Freeman, a New York correspondent for the Soviet news service, TASS. A committed Communist, Joe had co-created and edited *The New Masses*. Ione and Joe fell in love and married right away, but Ione, like Diego, had a roving eye, and rumor has it that they began an affair.

Joe resented the affair and published a scathing article on Diego in *The New Masses*, laying out a thorough argument with detailed examples of Diego's collusion with the anti-Communist Mexican government and American capitalists. Frida didn't have the same opportunity to vent her anger in a public forum, but almost ten years after the affair, her bitterness is still evident in a letter sent to a friend in New York: "Do you know who came to Mexico? That awful wench of Ione Robinson. I imagine she thinks that the road is clear now!"[37]

But Ione was not the only woman with whom Diego was having an affair. Diego's wandering eye had also landed on Dolores Olmedo, a seventeen-year-old he met one day at the Ministry of Education building in downtown Mexico City. Dolores, who was with her mother, stepped into an elevator to find the immense Diego Rivera standing before her.[38] The artist began to chat up Dolores and during the conversation asked her mother if he could make drawings of her daughter. She agreed, but didn't realize this meant Dolores would pose nude. Diego made twenty-seven drawings and a lithograph based on one of the drawings. In the lithograph, a nude Dolores sits on a window ledge with her arms tucked behind her back; her huge eyes look off to the left as if she's caught in thought. But it's her long, wavy black hair, cascading over her shoulders and framing her breasts, that first catches the eye. Black hair is every-where, including her pubic area and nipples, all detailed to resemble one another. Like the photos of Nahui, this lithograph breaks the traditional rules by emphasizing hair on Dolores's genitals, symbolic of animalistic desires.

Certainly there were many modern artists who were breaking the rules in art, but Diego's lithograph was not just an artist's attempt to be radical. It was made as a companion piece with another lithograph of Frida. Art

was now mimicking life as Diego pitted these women against each other. He literally placed the women back to back, as the lithograph of Dolores appeared on the reverse side of the same lithographic aluminum plate he had used for a print he had made of Frida in the same year. To complicate matters, the lithograph of Frida is also a nude—one side of the aluminum plate possessed an engraved image of a nude Frida and the other side an engraved image of a nude Dolores. They're depicted in opposite ways: Dolores looks like a curvaceous force of nature, whereas Frida looks asexual. The lithograph of Frida sounds erotic—she sits on the edge of a bed with only her high heels and nylons still on, implying that she's just removed her clothing. Her head gazes downward as she holds her arms up behind her neck while unfastening a necklace. But Diego makes Frida look distant and cold. Her diminutive body looks thin and hard; her hair is pulled back and restrained. Her face, with strong outlines and contrasts of light and dark, has the appearance of a mask. Diego's love of the female form is absent; he's made Frida less sexually appealing than Dolores.

But there's another odd element to the lithographs complicating the triad of Diego, Dolores, and Frida. In this same year of 1930, Diego created a lithograph of himself, which he then turned into a "lithomontage," printing his head three times superimposed in different positions.[39] According to biographer Patrick Marnham, Diego repeated this montage by placing his head over the nude he'd made of Frida, as if proclaiming her to be his property.[40] This interpretation is not far from reality in that Diego was known for his incendiary rages, especially if he suspected Frida of having an affair with a man.

There's no evidence Frida was taking other male lovers in this early stage of her marriage, but she always had male friends, including Alejandro. Frida and Alejandro maintained a friendship until the end of Frida's life, and according to her niece Isolda, Diego always felt threatened by it.[41] It didn't matter that he was having affairs. If Diego suspected Frida of having a fling, he responded with a temper tantrum. Isolda, who loved her uncle, put it this way: "Diego had working against him a rather infantile personality."[42] Diego's childish reactions to emotional pain and his propensity to set up situations in which two or more females fought over him can be traced back to childhood trauma.

It began at the time of Diego's birth. To his parents' surprise, Diego's mother delivered twin boys. The new parents weren't prepared for this turn of events because they'd hired only one wet nurse, Antonia, a Tarascan Indian. She had to breast-feed both boys until another wet nurse could be hired, setting up a rivalry from the beginning.[43] When Bernarda, the new wet nurse, entered the Rivera home, she took over the breastfeeding of Diego's brother, Carlos. But Patrick Marnham says the Riveras speculated that little Carlos was never as strong as Diego because he didn't receive enough milk in that first twenty-four hours of life when there was only one wet nurse.[44] At the age of one and a half, little Carlos died.

Diego's mother, Maria del Pilar Barrientos, became distraught, taking up residence at Carlos's gravesite. Her need to stay beside her deceased son prompted Diego's father to rent "a room for her in the cemetery keeper's lodge, where he joined her at night."[45] Diego was left at home with Antonia. Although he was young, he felt the intensity of his parents' grief. In his autobiography, Diego writes about how the doctor feared his mother would never recover from this loss, warning his father to find something that would occupy his wife's mind.[46] If he did not, the doctor said, "she would become a lunatic." The trauma of Carlos's death and Maria's nervous breakdown left one-and-a-half-year-old Diego in a state of confusion and anxiety, resulting in weight loss and rickets. His parents decided to send him to the countryside with Antonia.

As an adult, Diego recalled how much he enjoyed living with Antonia for two years.[47] He declared his immense affection for her, saying he loved her more than his mother.[48] When little Diego returned home, his mother noticed a change, saying he'd turned into "another Diego." He'd bonded with Antonia, who became his idealized Indian mother.[49] In turn, Maria became the "bad" mother who'd abandoned him. Before the age of five, Diego had already experienced his first triangulated relationship with females, a dynamic he re-created throughout his adult life.

The loss of his twin brother at such a young age may also account for his ambivalent feelings concerning fatherhood, particularly as the father of a son.[50] When Diego lived in Paris, he and his common-law wife, Angelina Beloff, had a son, Diego Jr. When the baby became ill, Diego stayed away,

even when Angelina kept vigil around the clock for fear he would die. Strangely, Diego Jr. died at the same age as Diego's twin brother, at age one and a half.

Frida sometimes talked about wanting to have a little Diego. Talk morphed into reality toward the end of their Cuernavaca stay when Frida discovered she was pregnant. Without journals to convey what the couple felt, it's difficult to know. As it turned out, Frida had an abortion in her third trimester, when abortion was legal in Mexico (something that changed in 1931).[51]

According to her medical history, Dr. Jesús Marín, Lupe's brother, performed the abortion due to "poor pelvic formation."[52] But another account states that the fetus wasn't in the correct position. Frida told a friend years later that she cried inconsolably when she couldn't have a child.[53] An incomplete oil painting shows Frida's complex reaction to her abortion with a curious title—*Frida and the Caesarean Operation*. Why the title uses the term "caesarean" is a mystery, because later in life Frida used the word "abortion": "The unfinished self-portrait of my first abortion was my first Surrealist painting, but not completely Surrealist."[54]

The painting's dreamlike or illogical aspects, as well as some of the free-flowing lines, have a Surrealist look. André Breton and the French Surrealists found inspiration in Sigmund Freud's psychoanalytic writings on dreams and the unconscious, as well as writings on alchemy.[55] But Frida wasn't interested in psychoanalytic theories, and she focused on something atypical for this predominantly male movement: the female experience of undergoing a surgical abortion.

Frida's nude body, with a fetus inside her belly, seems to float in space "above" a loosely defined bed with a reddish brown color indicating blood. But there's a white undulating line just above Frida's breasts, making it look as if she's simultaneously suspended in water, that important symbol of synthesis for Frida. In this context, surely there is some connection to the watery womb.

With closed eyes, Frida "sees" her own body being worked on in the upper left corner by a group of five doctors who appear ominous with long white coats and hoods covering their faces. These ghoulish-looking figures standing hunched over the body on the operating table recall Diego's de-

pictions of an operation (probably a caesarean) he drew on paper, painted on canvas, and made into a grisaille panel within his mural cycle at the Ministry of Education. Frida owned the drawing, a gift from Diego. Jesús Marín, the doctor who performed Frida's abortion, owned the painted version, entitled *The Surgeon*.

Frida may have been influenced by Diego's depiction of an operation scene, but while he made an image from the vantage point of someone observing the procedure, Frida created an image from the vantage point of someone experiencing it. The otherworldly look of Frida's painting hints at an out-of-body experience, a common recollection among those who have come close to dying or who have been pronounced dead.[56] Most describe the phenomenon of existing in an in-between state of life and death. In this liminal state, a person has what's been called "extracorporeal perception," whereby a nonphysical self has "heightened qualities of perception."[57] While the unconscious physical body is undergoing extreme stress, the nonphysical "self" can see doctors working on his or her body, hear doctors talking, see and hear loved ones not in the room, and feel a variety of emotions on an intense level. Frida too seems to "see" outside the operating room because her mother, Diego, and a baby are nearby.

Matilde's scowling face appears on the left side of Frida; the white outlines of her eyes make her look preternatural. Her unfinished body, still a white underpainting, increases her unearthly appearance. Matilde's scowl could reflect her negative feelings about Diego and the abortion, as if to say, *I told you so.*

Diego's large disembodied head is seen on the other side of Frida. His unfinished eyes, with two white dots for pupils, make him look ghostlike. Below Diego's head, a baby is suspended by a thin, black vertical line running from Diego's chin down to the frame at the foot of the bed in the foreground. The baby's facial features appear to have been painted out, giving it the look of an apparition.

Frida incorporates several spirals into her painting, something that could be seen as a Surrealist flourish. But spirals are particularly potent universal symbols the world over, according to Best-Maugard. They possess an energy and rhythm representing life, an appropriate image in Frida's painting, which depicts life and the loss of it. In alchemy, spirals symbolize water or boiling when working in the laboratory to transmute base metals into gold. And Frida has one black spiral moving up toward what looks

like an alchemical laboratory. There's a cabinet/table to the right of the bed that holds two alembic vessels, used by alchemists to mix their various chemicals.

Alchemists use different-shaped vessels, but the alembic vessel with its round base and tall flute was designed by one of the few well-known female alchemists, Cleopatra. This Cleopatra, not to be confused with the famous queen of Egypt, was a Greek-Egyptian philosopher and alchemist from the third century. She became well known for her vessel design and her ability to create the Philosopher's Stone, the alchemical substance capable of turning base metals into gold. Her writings on the subject emphasize bringing inanimate substances and chemicals to life and, as alchemist scholar Dennis William Hauck states, "she compared the work of alchemy to the creation of a fetus in the womb."[58] Frida visualizes this comparison by placing the alembic vessels to the right of the fetus in her womb. Is Frida saying that she and Diego created what the alchemists would call a Golden Child? There are no clear answers, but this unfinished painting allowed Frida to sift through her convoluted emotions concerning the abortion and a possible out-of-body experience, ultimately transmuting raw feelings into a powerful image.

This is the first painting Frida attempted that depicts a personal event in a woman's life, a subject that was considered taboo. Diego had painted indigenous women as fertile beings who are intimately connected to nature. Frida too had painted a nude indigenous woman in a natural landscape, but her abortion painting depicts an otherworldly experience for a woman undergoing the "unnatural" medical procedure of ending a pregnancy. Creating it in a Surrealist-like style and giving it a confusing title makes it more acceptable, but that doesn't take away from its radical content. As an unfinished work of art, it was probably never shown publicly in Frida's lifetime, making it a first step in Frida's creative development, as she would go on to create more paintings in the United States depicting the unspoken events of a woman's life.

Once again Frida was in limbo. She was in Mexico, yet soon she would be leaving for the United States. She wanted to embody the celebrated persona of the indigenous woman who was in sync with the natural rhythms of life, yet her pregnancy did not end naturally. She wanted to be the wife of a great man and artist who adored her, but her husband's affairs around the time of her pregnancy most likely inflicted pain. The married Frida

was beginning to learn that changing her inner attitude of mind and creating an alchemical union with Diego did not necessarily change Diego's behavior or the outer aspects of their lives. Instead, Frida's psychological and alchemical revelations aided her in the act of creation. For it was only in this arena that Frida had total control.

III

SAN FRANCISCO

Rules of Matrimonial Engagement

Power is a substitute for love.

—GABRIEL GARCÍA MÁRQUEZ

By the time Frida and Diego arrived in San Francisco, in November 1930, their relationship had already endured at least two infidelities and the loss of a child. The city surrounded by water promised a new beginning; perhaps the couple's troubled past could be washed away. Frida knew no one there, and Diego's friends were in the dark about the couple's difficulties. But if Frida thought going to another country could erase their problems, she quickly became aware of a new set of challenges.

While in San Francisco, Frida had only Diego to anchor her. And Diego was too unpredictable and often too busy to provide the kind of time and attention Frida needed. In this new world, his celebrity status intensified. Frida grumbled: "The poor guy can't even go to the bathroom in peace because they're bugging him all day long."[1] Married to a man who courted media attention and who, as Frida quipped, was treated like a "gran caca" (big shit), her developing identity could have been shaped by the public's perceptions of her as the young, exotic wife of the famed muralist.[2] With all eyes on Diego, this "little doll" of a woman could have faded into the background behind her famous husband while living in a place where no one knew her. But Frida fought back, attempting to carve out her own identity through the act of creation.

In December, only a few weeks after arriving in San Francisco, Frida made a drawing of the two of them. In it, she contemplates her status in relation to her larger-than-life husband. In her Mexican-style dress with two ruffles at the hemline, and a beaded necklace echoing the shape of her scoop-neck bodice, Frida stands in the foreground with her head tilted to the left. She looks out with sad eyes, but her gaze follows the same line as her angled head, as if she's staring into space. With one arm hanging at her side and the other enfolded in Diego's hand as if she were his child, there is noticeable space between this husband and wife.

Diego faces forward, standing tall with a slight smirk; his dark heavy-lidded eyes fix on us. One of his work boots faces forward and the other is turned out. Although he is larger than Frida, his corpulence is not emphasized. The drawing conveys a complicated, uneasy relationship; they do not look like a happy couple.

In the first few weeks, they'd spent time together sightseeing with Stack and Ginette. This brought Frida joy, and she exclaimed to her mother, "Diego hasn't started to work yet and I spend almost all day long with him."[3] But by December 8 he could usually be found in the studio making sketches and working from his live model, Helen Wills Moody.

While Diego was absent, Frida worked in her studio. She wrote her mother: "I'm painting quite a lot, almost all day long."[4] She needed solitude to allow her mind to wander and provide the uninterrupted time required to create her drawings and paintings. When she was in the midst of creation, like most artists, she was focused and in the present moment.[5] In this altered state of creative consciousness, Frida was free from the emotional pain of separation.

Her intensified focus on her art began to change people's perceptions of her. In a letter to her mother she said, "I am painting because they want me to have an exhibition before we go. It's a good opportunity for me to sell some things and help you more. And if I lose this chance I will kick myself, don't you agree? We will probably move to a hotel so I can paint all day instead of spending my time sweeping floors and stupid stuff like that."[6]

An exhibition of Frida's work never materialized while she was in San Francisco, but she worked hard to create enough paintings for one. Art

was more important to her than "stupid" domestic duties. In another letter, Frida made her ambitions clear: "I think this is my only chance to see something new and to make myself known to people who may later on help me to sell paintings."[7]

Arranging for an exhibition and acquiring patrons were challenges for a female artist, particularly one who was in the shadow of a famous husband. But Frida knew it was possible because fellow Mexican artist María Izquierdo was forging her own career despite her romantic involvement with Rufino Tamayo, the well-known Mexican modernist painter. In a December 1930 letter to Frida and Diego in San Francisco, María wrote with excitement: "I had the good fortune to open my exhibition in New York quite successfully."[8] This was cause for celebration: it was the first time a Mexican female artist had a solo show in the United States.

Frida did not see herself primarily as Diego's wife in this period, even though societal pressures, both in Mexico and in the United States, stipulated that wives should be devoted to their husbands above all else. Those pressures can be heard in letters from Frida's parents, who repeated statements such as "I am very happy that you are always right beside him," "Always get along with your husband," and "Say hello to him and take very good care of him."[9]

In these early years of their relationship, it was important for Frida to forge a strong bond with her relatively new husband and attempt some semblance of an ordered life, but this didn't preclude her from identifying as an artist. From the beginning of their relationship they'd related to each other as painters, and this didn't change in San Francisco. Diego said he liked when Frida was nearby while he was painting.[10] Likewise, he would comment on her paintings. One day he walked in after a portrait session, looked at Frida's latest work on her easel, and exclaimed, "*Bueno.* A pure and strong woman's spirit is as precious as the light of the stars."[11]

Frida repeated Diego's poetic statement to their friend John Weatherwax, emphasizing every word as if to provide more gravity, and concluding, "Funny man."[12] Her ambiguous take on the maestro's words—half in jest, half serious—was Frida's posture toward many things in life, but most certainly toward herself as a painter in this early gestational period. She identified as an artist, but she had her doubts, avoiding the look of pretension at any cost. She attempted self-portraits in San Francisco but never completed any because she was "dissatisfied with them."[13] She had high

standards, verging on perfectionism. In this experimental creative period, it was safer to paint others, so by and large she stuck to portraits. As with her portrait of Eva Frederick, she could merge artist and model, projecting aspects of herself onto the sitter.

Despite Diego's respect for Frida as an artist, theirs was not an equal creative partnership. Diego, a sought-after painter, enjoyed the power and privileges accorded male artists. And this included the sexual availability of female models. When he wasn't holed up in his studio with models, he'd be spending a great deal of time in public working with assistants on his murals, an art form deemed appropriate for male artists. Diego often hired female assistants, an important opportunity for them, but one that kept them in a secondary position. Working in public, he would encounter admirers and reporters interested in his sweeping histories of Mexican culture. He was someone who loved to work a crowd, so this public aspect suited him.

Frida primarily acquired interested patrons through Diego. Emily Joseph, the *San Francisco Chronicle* art writer who wrote about Diego and became friends with the Riveras, purchased one of Frida's paintings, according to a letter Frida sent home. Sometimes Frida made connections through her role as "secretary" for Diego, taking care of the paperwork accompanying the sale or exhibition of his work. As an easel painter, she worked primarily on portraits and self-portraits—a genre deemed appropriate for women—in the privacy of her studio. When Frida finished painting or drawing for the day, she put away her materials and stayed in the same small space, or she'd go across the hall to Ginette and Stack's place. Diego, on the other hand, had Stack's large studio, which provided him a refuge from their living quarters and also allowed him to work late into the night if he pleased.

On the evenings Diego stayed away, Frida passed the time writing to family while sitting in a big armchair by the fireplace. She often expressed how homesick she was, telling her father: "I miss you very much, you have no idea how much I wish I could be with you all, but I will come back soon and we'll see each other again."[14] Her letters to her parents reveal little overt information about the changing dynamics in her marriage now that Helen Wills Moody was in the mix, but she knew not to divulge

the recognizable signs of Diego's growing infatuation with a model. It was something she'd already been through with Ione and Dolores. As Diego's obsession with his creative process increased, so did his passion for his female models, resulting in more time spent in his studio alone with these other women. Furthermore, Frida couldn't get away from Helen: if Helen wasn't excitedly bounding into their flat, then the enormous red crayon and chalk portrait of her Diego had drawn on the wall was a looming presence.[15] When Diego and Helen would leave together and not return for hours or days, Frida was left only with this huge red image of Helen.[16]

Frida used the time to work on her drawing of her and Diego, adding an important element: she penciled in a small Diego over her torso. The child's hairstyle looks almost identical to Diego's in the drawing, but instead of standing, "little Diego" sits Buddha-like with legs crossed and arms folded in his lap, making him more a man of wisdom than a fetus. It's as if Frida wanted to convey Diego's dual nature: the controlling man and the enlightened, alchemical Golden Child. But "little Diego" also refers to Frida's pregnancy in Mexico a few months earlier and to the child suspended by a black line under Diego's head in *Frida and the Caesarean Operation*. In the painting, Frida brushed out the baby's features, making it look like an apparition. In the drawing, she erased "little Diego," leaving behind a faint shadow, symbolizing the abortion she'd undergone.[17]

In the same month Frida made her drawing, she had to share Diego not only with Helen but also with his adoring public, as he enjoyed the success of a retrospective exhibition at the Palace of the Legion of Honor in Lincoln Park at 34th Avenue and Clement Street. When Diego gave a talk in French at the museum on December 10, with Emily Joseph translating into English, he was welcomed by a "ton of people" who "congratulated him," as Frida wrote.[18] Two days later, the public had the opportunity to meet the artist at a reception. The 129 works of art in this exhibition, the largest to date in the United States, provided a broad overview of his output.

After the excitement of Diego's retrospective had calmed down and the crowds had receded, Frida enjoyed Christmas with him. She gushed to her mother: "The streets and houses in San Francisco are full of lighted Christmas trees and it looks beautiful. Everybody sings and the families gather for dinner until twelve midnight."[19]

Frida and Diego spent the evening with Stack's good friend and mentor Gottardo Piazzoni, a Swiss-born American painter and muralist. The two men had known each other for years, traveling to France together in the early 1920s, where Stack introduced Gottardo to Diego, who was living in Paris. It was at this time that Stack met Ginette (born Francine Mazen), a still-life painter and model. Ginette returned with Stack and Gottardo to San Francisco, marrying Stack a few years later while on vacation in Mexico.

The old ties between friends made the Christmas gathering at the Piazzoni household warm and spirited, easing Frida's homesick heart. A few days later Frida rang in the New Year with Diego, Jean, Clifford, and Leo at a German restaurant.[20] Afterward they went back to Leo's place on Leavenworth Street, where they sang German, Mexican, Russian, and French songs while Leo played viola and guitar. After a few too many tequila shots, things got raucous as Diego "started sending all the generals and rulers of Mexico to the devil, speaking in French about European painting," and dancing.[21] The fun lasted until three in the morning, when the foursome left Leo's and headed toward the Embarcadero.

A drunken Diego was determined to take a sailboat across San Francisco Bay to Berkeley. The more sober threesome worked hard to convince him that this was not a good idea at three-thirty in the morning. Diego fit in with the locals on New Year's Eve, as Frida observed: "Here in San Francisco everybody gets drunk as hell in spite of 'prohibition,' it's essential and most important. Besides that, they are just like drunks everywhere (and they don't eat fire). They go out on the streets and sing and dance and everybody yells from one side of the sidewalk to the other 'Happy New Year!!'"[22]

January began with a renewed spark between Frida and Diego, as the holidays had given them a reprieve from separation. Time spent together could feel divine—sweet kisses, Frida perched on Diego's lap, Mexican songs sung to Frida's guitar playing, intimate quips, and inside jokes—erasing all the tension and jealous ruminations.[23] Acquaintances observed a loving and playful relationship between the couple, but closer friends could also witness the combustible energy when the mercurial Diego battled the passionate Frida. If Frida expressed dissatisfaction or frustration with Diego or their situation, he often retaliated by accusing her of not loving him. This ploy often worked because Frida was ashamed of her irritable moods and angry outbursts, something she'd seen in her father as well.

In letters home, she constantly referenced her father's foul moods, re-

minding him to treat his wife well. To her mother, Frida wrote: "Tell my
dad I send him a thousand kisses and to listen to my advice (to not be so
quick-tempered) and to behave."[24] Frida tried to take her own advice, but
when she blew up over something Diego did or said, she attributed it to
the Kahlo curse. Frida confided to her mother about Diego: "He's good
to me. I'm the one that sometimes gets the Kahlo in my head and throws
tantrums, but he is good tempered and at least it seems like he loves me;
I love him, *buten, buten*" (a word Frida made up, meaning "very much").[25]

Frida's reference to getting the "Kahlo in my head" runs deeper than
merely possessing her father's cantankerous temperament. In one letter,
Guillermo opened up about his inner turmoil, explaining to his daughter
that he and Matilde both suffer from "neurasthenia," something that the
nineteenth-century American neurologist George Miller Beard described as
a disorder of the nervous system. Psychoanalysts such as Sigmund Freud
defined neurasthenia in men as a psychoneurosis resulting in symptoms
of rapid heartbeat, unexplained physical pain, anxiety, irritability, restless-
ness, and dizziness. Women could also suffer from neurasthenia, but "hys-
teria" was often the term associated with females. It presented with similar
symptoms, but they were often more bizarre and theatrical, such as faint-
ing, convulsive crying, and over-the-top, inappropriate sexual behavior.
The term "hysteria" carried with it a negative connotation—the English
word comes from the Greek *hystera,* meaning "uterus," and therefore tied
a woman's mental illness to her biology. So during World War I, when
medical officers started treating soldiers with idiopathic conditions such as
twitching limbs, they avoided diagnosing the men with "hysteria," which
would imply the soldiers were out-of-control women. Instead the term
"shell shock" was used to describe physical trauma to the nerves, as Mark
Micale, professor of the history of medicine, notes.[26]

Although Matilde didn't address her mental and emotional state of
mind in her surviving letters to Frida, Guillermo went into detail about his
own internal struggles and feelings of isolation. "It is a terrible disease, only
understood by those who have it. There's no medication for it; sometimes
will power can overcome it a bit. I'm constantly looking for a tranquil-
izer, but I can't find one. Only at night, when I read a little in bed, I find
some relief in that divine silence."[27] Guillermo's insight into his behavior
and feelings is remarkable. Yet it didn't help him control them, and there
were no effective medications either. Isolda, Frida's niece, tells a story of

her grandfather and "his obsessive preference for a soup spoon. He would become irritated whenever my grandmother Matilde used another piece of silverware. In those situations, my grandmother would confront him and say, 'Memo, that spoon is completely worn out.' But he did not care for my grandmother's reasons and insisted on having his beloved spoon."[28] Frida knew her father's feelings and fixations well. She also understood his need to take refuge in his books, shutting himself off from the rest of the family, "only to re-emerge for dinner."[29]

In San Francisco, Frida felt shut off from her family, particularly her mother. Addressing her as "darling Mamacita," she told her: "I've been crazy with anguish about you these days and in a beastly mood."[30] She fretted if she didn't hear from her mother: "Darling, write me very often because I want to know how you're doing." The pleas intensified as her level of agitation increased: "Write me more often. Don't be mean. When I get a letter from you my whole mood changes and I feel very happy."[31] Frida needed the reassurances of her mother; it was a connection she valued. Her deep bond with Matilde can be heard in these words: "I'm always sad because of you and will never get used to not being with you."[32] To compensate, Frida the worrier expressed constant concern for her mother's physical well-being, taking on the role of motherly protector: "My darling, take good care of yourself, don't pretend to be strong by running around on your own lest something bad happens to you, God forbid, for I'm worried sick about you. Be good and listen to me, will you?"[33]

Besides her mother's physical safety, Frida also worried about Matilde's state of mind, often suggesting elaborate plans to make sure her mother had fun outings with the family:

> Mommy dear, listen to me, take very good care of yourself, don't spend too much time alone and try to go out on Sundays to have some fun even if it's just at the town's filthy movie theater, otherwise you'll get really bored. You can also take dad to Cuernavaca on a Sunday. Tell Kitty to have González take you and I will send you money for the fare so at least you can see what Diego painted at the Cortés Palace.[34]

Mothering Matilde from far away allowed Frida to continue to be an inte-

gral part of the family and soothe her pangs of separation. But guilt may have played a part as well.

Upon marrying Frida, Diego paid off the family's mortgage, and the Coyoacán house was placed in Frida's name. Frida and Diego began having the house cleaned, some of the doors painted, and certain rooms changed to accommodate Diego and his art. The house was slowly transforming from a colonial-style home into an indigenous-inspired one, expressing Mexicanidad. Letters from Frida to her mother are filled with directions for upgrades and information on money matters, as well as talk of a second house that apparently was for Guillermo and Matilde: "Tell me how your house is going."[35] In another letter Frida asked: "Did you pick up your title and mine?"[36] Two things emerge in discussions over these two houses. One was that Frida's father felt anxiety due to the changes. The other was that Frida was concerned about her father's discomfort and didn't want to burden her mother with too many requests.

If Matilde felt overwhelmed, it doesn't come through in her responses to her "darling girl, my Friduchita." Upon receiving a letter, Matilde wrote, "I was so pleased I started crying and talking to you as if you were there with me."[37] After learning that Frida had the flu, she advised her: "I want to know how you're feeling from your [flu]. Here in Mexico it's been pretty bad. Try to go see the doctor to get some medication to regain your strength. Don't let yourself go and be careful for a while."[38]

Matilde even expressed tenderness toward Diego, the man she'd initially rejected as unsuitable for Frida: "Tell Diego that I admire him more with each passing day. Say hello to him and take very good care of him."[39] And, just as Frida signed off many of her letters to her mother with "your daughter who adores you," Matilde replied: "Receive many kisses from me and God bless you. Your mother, who adores you, Matilde."[40]

Frida's complex relationship with her mother set the stage for her equally complicated relationship with Diego. This was expressed visually in *Frida and the Caesarean Operation,* with the large image of Matilde on one side of her and the large head of Diego on the other. Matilde and Diego possessed dominant personalities—Frida called her mother "mi Jefe" (my Chief) as a teenager—and her relationships with both were filled with intense love, pain, and worry.[41] Frida, with her strong personality, had to find ways to relate to these two people, who demanded a lot of attention.

One role she slipped into with both was that of mother, even referring to Diego as her child: "I feel I have left my child alone and he needs me."[42]

Just as she worried about her mother's physical health, she always expressed concerns over Diego's grueling work schedule and health. "Diego started painting three days ago. The poor guy is exhausted when he comes home at night because the work is more fit for mules than humans. Can you believe yesterday he started at eight thirty in the morning and he came back today at nine? He worked more than twenty-four hours, without food or anything, the poor guy was so worn out!"[43]

In letters Frida wrote to Diego years later, her feelings of anguish due to separation sound similar to the ones expressed to her mother: "I can't stop thinking about you even for a second and I suffer enormously. . . . You have no idea, my darling Diego, how I adore you. I send thousands of kisses in this letter from your Frieducha."[44]

Diego could express love and concern for Frida, as we see in letters he wrote, but the day-to-day interactions of the couple were another story. Diego tended to put himself first, deflecting responsibility for his actions. It's impossible to understand the depth and nuance of someone else's relationship, but an unpublished short story about Frida's life in San Francisco provides a glimpse into Frida and Diego's marriage at this time.

Their new friend John Weatherwax, a California writer, penned a thinly veiled fictional account called "The Queen of Montgomery Street." In the story, Weatherwax portrays the dynamics between Queen Frida and her husband, Don Diego: "He gets up . . . putting an arm around the Queen. He bends down to her. His lips move out, making a delicate little noise. The Queen laughs, hugs him, and kisses him on the neck. Don Diego straightens up, slowly. The Queen is still clinging to him, her feet now twelve inches from the floor. She bites his ear, laughs, and lets go."[45]

There's no overt sign of trouble brewing for Queen Frida, but her ear biting could be seen as a passive-aggressive gesture, perhaps conveying her anger over Diego's time spent with Helen. If so, Her Majesty doesn't let on. She merely says, "Mrs. Mooney [sic], a tennis player, has been posing for Don Diego's mural."[46] In real life, Frida had little control over Diego and Helen's relationship, but Weatherwax's story empowers Frida by bestowing

on her a royal title and by capturing her witty personality, something she used to wield power, both in the story and in life.

Lucile Blanch, the downstairs neighbor, recalled Frida's humor and the cunning way in which she conveyed her anger or disgust, adding, "She scintillated in her talk, made fun of everything and everybody, laughing at things sportively and perhaps snobbishly. She was very critical if she thought something was pretentious and often laughed at San Franciscans."[47] Humor was second nature to Frida. She enjoyed the films of Laurel and Hardy, Charlie Chaplin, the Three Stooges, and the Marx Brothers—comedians who were "at odds with the law," as Carlos Fuentes put it.[48] Frida was at odds with arrogance and with the double standard applied to men and women.

If she knew how to tone down the beast of jealousy by sublimating it into mischievous ear biting or by using her wit to cut someone down to size, then Diego, the serial adulterer, was an "experienced actor" skilled at playing the part of the innocent.[49] He'd had many opportunities to practice this role, as he was already on his third or fourth affair since marrying Frida. Although he didn't necessarily tell Frida he was having an affair with Helen, he loved to boast that he was physically incapable of monogamy, a fact he claimed his doctor had verified.[50]

It's quite possible Frida wasn't capable of monogamy either. But she was far more discreet about her private life. Diego tended to live his life out loud. And, deep down, he wanted to inflict pain upon Frida, as he admitted later in life: "If I loved a woman, the more I loved her, the more I wanted to hurt her. Frida was only the most obvious victim of this disgusting trait."[51]

When Diego chose the famous and beautiful Helen as both the object of his desire and the ideal model, he magnified the bite of his betrayal. He got caught up in all the adulation, enjoying being the *gran caca,* but as writer Gabriel García Márquez warns: "Fame unsettles your sense of reality, almost as much as power perhaps, and it continually threatens your private life."[52] Diego's fame and resultant power blinded him to many of the realities of his relationship with Frida.

As January slid into its second week, Diego was even more focused on Helen's nude body.[53] His drawings turned into two large-scale works that

formed the central images for his mural, *Allegory of California*. Helen dominates the wall along the Art Deco stairway that leads to the Pacific Stock Exchange's Luncheon Club—today called the City Club of San Francisco—at 155 Sansome Street.

She is the enormous Earth Mother figure who holds the natural bounty of California's farms in one hand and pulls back the soil with her other to reveal miners underneath the ground. Throughout the mural, Diego places nature and industry side by side, with woman symbolizing nature and man industry and science. On the ceiling, the same nature/industry dynamic is at play, with Helen's nude, outstretched body enveloped in a gold ray of light emanating from a blue sky, representing nature, and four airplanes in flight, symbolizing industry. Diego thought Helen, a California native with "classic Grecian features," the best choice for his model.[54]

His creative decision to use the fair-skinned, blue-eyed Helen to represent California as a second Greece contrasts with an origin story of California that portrays Calafia, a regal black woman who is courageous, strong, and beautiful. In the sixteenth-century Spanish writer Garci Rodríguez de Montalvo's book *The Adventures of Esplandián*, this warrior queen, who ruled over a queendom of black women, lived on the mythical island of California, known for its untamed and bountiful land.[55] In 1770, when the Spanish officially designated their holdings on the western coast of North America as California, they slightly changed the spelling of the queen's name, making Calafia the official representative of this region.

Diego would have been familiar with this black warrior queen because he always immersed himself in the history of his subjects before painting them. And, as an acquaintance of painter Maynard Dixon, Diego most likely would have seen Dixon and Frank Van Sloun's seven-foot-high mural of a black Calafia painted in the Room of the Dons at the Mark Hopkins Hotel on California Street in San Francisco's Nob Hill district.[56] In Dixon and Van Sloun's mural, the bare-chested Calafia, wearing an ornate headpiece, jewelry, and a long flowing skirt and robe while flanked by two dark-skinned female warriors holding shields, stands tall in a landscape of flowers.

With this origin story featuring a strong black queen, Diego had an opportunity to elevate the status of African Americans at a time when segregation and brutal lynchings were the norm in the United States.[57] Instead, this Communist sympathizer chose to do the exact opposite—to

reaffirm Western concepts of beauty and power by emphasizing a Greek connection. Perhaps he wanted to appease the predominantly white stock traders who would have seen the mural on their way to lunch, or perhaps he simply wanted to depict the woman to whom he was attracted. He put it this way: "The almost classically beautiful tennis champion Helen Wills Moody served as my model. In portraying her, I made no attempt to formalize her features, but left them recognizably hers."[58]

When the press was allowed to view Diego's progress at the Luncheon Club, they saw a full-scale reddish brown sinopia drawing on the wall of the stairwell. At this early stage, they raised questions concerning Diego's choice of model. The huge female dominating Diego's thirty-foot-high mural was supposed to be an allegorical figure representing California, but instead she was a tennis star. It was too specific an association, bordering on portraiture, and it was of the moment, rather than timeless. One reporter for the *San Francisco Chronicle* wrote: "The figure of California is not any one individual woman, but a composite, an idealized conception of the perfect type of California womanhood."[59]

Helen didn't embody the idealized conception of womanhood, which combined sexual purity and fertility. She was more of a "New Woman," the label applied to the liberated modern woman. She was physically strong, driven, successful, beautiful, intelligent, artistic, childless, and mysterious. She was the poster girl for Coco Chanel's comfortable sportswear, and her "masculine" traits, combined with a mysterious persona, led others to dub her the "Garbo of tennis." The actor Charlie Chaplin said Helen playing tennis was the most beautiful sight he'd ever seen. And California senator James D. Phelan was so transfixed by Helen that he commissioned sculptor Haig Patigian to create a marble bust of her, later donating it to the de Young Museum in San Francisco's Golden Gate Park. Her fame, beauty, and physical strength were intriguing. Unlike Nahui Olin, who lacked the same type of financial and public star power, Helen was able to walk the tightrope of admired modern woman versus sexually promiscuous vamp.

Posing nude for art could be deemed scandalous, however. Most great male painters going back to the Renaissance had featured female nudes in their work, but historically women of the lower classes who became models were considered prostitutes. It was a given that male artists had affairs with their models. A "respectable" woman of the middle or upper classes, therefore, would never submit to such a "lowly" position unless she wanted

to shirk the norms of her class and family upbringing. For Helen, the amateur artist, posing nude for Diego was an opportunity to further the great ideals of Western art and culture. What woman wouldn't want to represent California?

In the end, Diego painted Helen in the guise of the bountiful Earth Mother, whose naked body is modestly covered by the landscape and the men who use it. Diego was particularly drawn to images of the Earth Mother, something evident in murals he'd previously painted in Mexico, such as in an auditorium (a former chapel) at the university in Chapingo. In Mexico, Diego's brown-skinned earth goddesses hark back to a premodern era, emphasizing the foundations of Mexican culture, but in San Francisco, a place that had once been part of Mexican territory, Diego modernized her by whitening her skin and giving her Helen's features.[60]

While Diego had been preoccupied with depicting Helen as an Earth Mother, Frida had been alone in her studio tinkering with the drawing of herself standing next to Diego. In her Mexican-style dress with a faded image of her aborted child over her stomach, she is neither the independent "New Woman" nor the fertile woman of nature.[61] She looks sad and alone, even though her husband stands beside her. Instead of showing herself as a young, fertile bride ready to have children with a loving husband, she depicts her troubled relationship and her abortion. She rejects the stereotypical image of a woman in sync with the natural rhythms of life.

It must have been distressing for Frida to have the high-profile couple of Diego and Helen reveal publicly the space between herself and her husband. In a letter home, Frida hinted at this uncomfortable situation: "People are like everywhere else in the world, bigmouthed, gossipy, and so on, but if you mind your own business you can work in peace and live well."[62]

It's quite possible that the critics' desire for "an idealized conception of the perfect type" of womanhood was linked to gossip about Helen and Diego's improper relationship, because in the end Diego was pressured to downplay California's likeness to Helen.[63] As Anthony Lee points out, he changed the shape of her face, darkened her hair, broadened her eyes, and angled her jawline and chin.[64] Diego even altered his rhetoric, saying, "California was an abstraction and should not be an identifiable likeness to anybody."[65] Yet everyone knew it was Helen.

More important, Frida knew. She couldn't control her husband or her jealousy, but she could create in art the relationship she wanted with her husband. Three months after the Helen affair had dissipated, she painted *Frieda and Diego Rivera* (1931), dubbed the "marriage portrait." While there are some similarities to the drawing she made at the close of 1930, the two are quite different. The drawing conveys Frida's private feelings, whereas the painting represents her public presentation of their relationship.

In the painting, Frida switched the figures. Now she stands on the right side and Diego is on the left, altering the implications of her angled head. In the drawing, Frida's head tilts away from her husband, but in the painting her head tilts toward him. On the surface, this creates the illusion that Frida defers to her husband, and her small size accentuates the stereotype of the "little woman" who supports her important husband. However, the placement of her hand belies such an interpretation—it rests over his in a gesture that indicates a connection, but not a tight one. He no longer grips her hand like a child, as seen in the drawing; instead, her hand is on top.

Frida's red *rebozo* glistens with a Communist vibrancy that leaps off the canvas, making her the dominant figure in terms of color. It's obvious she spent a lot of time on her shawl, because it's the most detailed object in the painting. Its folds fall in a succession of ripples that caress her shoulders, and the diamond-shaped designs embellishing the end of the shawl look as if they are etched onto the surface, requiring steady hands and patience. This was something Frida had learned at a young age while helping her father retouch photos. The thin strands of slightly uneven fringe, hanging at knee level, look so real it's easy to imagine how these delicate wool strands would feel brushing against the skin.

The tactile quality of the red strands is made more prominent by the deep emerald green dress beneath them. The dress color is dark enough to showcase the red, and the long vertical pleats are complex enough to sustain our attention. The green also serves to set her dress apart from Diego's smoky black suit.

A thick woven headband with a blue bow on top dresses up Frida's hair. Pulled back in a bun, it allows the gold hoop earrings—the type worn by the women of Tehuantepec—to stand out. A two-strand green jadeite necklace with an Aztec glyph in the middle encircles her neck, recalling the necklace she wore in *Self-Portrait: Time Flies*. This *olin* glyph, representing

movement, has a double meaning in this context. Frida moved herself from the left of her husband in the drawing to the right in the painting, and she has moved from Mexico City to San Francisco. Yet this move to another country has not diminished her connection with her homeland, as every detail of her painting emphasizes. Even the heart shape of her *rebozo* as it drapes around her neck points to her love of country, a shift in message from her heart-shaped dress collar in *Self-Portrait in a Velvet Dress,* designed to seduce Alejandro.

The Frida of 1931 has left the European style of clothing and androgynous hairdo behind. She's now the proud Mexican woman who's aligned herself with working-class indigenous women. Her dress, shawl, jewelry, and hair embellishments give her prominence within the painting. But tucked under her grandiose ruffle at the hemline appear tiny green shoes with red flowers painted along the toe, the type of shoes La China Poblana wore and the style of Chinese slippers Frida admired and purchased in Chinatown. If not for the red flowers, Frida's minute green slippers would all but disappear next to her green dress. In a clever move, Frida uses the eye-catching red to emphasize her dainty feet, which appear to be on tiptoe.

Diego is rendered in the opposite manner. If Frida's feet are tiny, Diego's are huge, emphasized even more so by his brown worker boots. Whereas Frida seems to hover slightly above the ground as if she could "float like a bird in flight," as one friend observed, Diego's feet are solidly placed upon the ground in a turned-out position.[66] Standing in a black suit with his legs slightly apart, his blue denim button-up worker's shirt is the only color illuminating his body. This same shade of blue is echoed in his light brown paintbrushes with their blue metal ends surrounding the white tips. If Frida's heart belongs to her country, then Diego's belongs to his art, revealed in the heart-shaped palette he holds.

Frida renders Diego's face with an amazing amount of naturalistic detail, making it look three-dimensional. His deep-set eyes are contrasted with his sculpted forehead and nose bridge. The nasolabial folds that curve downward from his nose to his mouth, along with the supple flesh hanging from his jawline, creating a double chin, convey he's a middle-aged man.

Frida paints her face in a completely different style, one that creates the illusion she isn't capable of re-creating a naturalistic likeness. While in Mexico, Frida had begun employing this so-called simplistic style to align

her paintings with folk art, handmade objects created for the masses by craftspeople. By painting her face in this folk style and wearing an Aztec necklace, along with Tehuana gold hoops, Frida proclaims herself to be a proud Mexican woman. It's a nationalist image for an audience in the United States, one that is completely different from Diego's depiction of Helen as California.

Maybe Diego's infatuation with Helen and life in San Francisco help to explain why Frida painted him in a different style with a contrasting persona. His worker shirt, paintbrushes, and heart-shaped palette connect him to the important role of the artist/worker participating in the rebuilding of Mexican culture, but his firmly planted shoes and suit allude to his strong connection to San Francisco. Diego's vestless suit is a clue to his Americanization, as the Mexican newspaper *La Prensa* pointed out when it published a photograph and blurb about Frida and Diego's 1929 wedding: "The bride was dressed, as can be seen, in simple street garb, and the painter Rivera as an American without a vest."

Despite the obvious differences between Diego and Frida's painted personas, Frida inserted a private visual message that could be interpreted as: *Even with our differences, we are held together by the invisible string of alchemical principles.* The opposites within the painting—Frida's floating, birdlike figure next to Diego's firmly planted feet—are balanced by the four elements and the alchemical aphorism "As above, so too below." Diego's earthbound nature, with eyes poised to confront the world, and Frida's spiritual nature, with eyes looking off into space, are in sync with and balanced by the four elements surrounding them. They are found in the green earth of Frida's dress, the fire of her red shawl, the water of Diego's blue shirt, and the air of the dove flying above Frida's head.

But the dove, a bird, also refers to Frida's totem animal, as well as her parents' assessment that her marriage to Diego was like that of a dove and frog. The dove also functions as a messenger because it holds a pale pink ribbon, or *banderole*, in its mouth. In beautiful black cursive letters, Frida wrote in Spanish on the ribbon: "Here you see us, me, Frieda Kahlo, with my beloved husband Diego Rivera. I painted these portraits in the beautiful city of San Francisco, California, for our friend Mr. Albert Bender, and it was in the month of April of the year 1931." This statement might sound benign, but it was a savvy career move on Frida's part to include it because she grasped the significance of Albert's status as an important art patron.

Albert, a Jewish immigrant from Dublin, became a successful insurance broker after moving to San Francisco.[67] Here he fell in love with his cousin Anne Bremer, a modern painter. She introduced him to the avant-garde art world of painting, music, dance, and literature. When she died of leukemia in 1923, he dedicated his life to the promotion of modern art, donating money, books, and art to almost all of the important museums, universities, and libraries in the Bay Area. Anne had championed the underdog, so Albert particularly empathized with struggling artists who lacked patrons because of a cutting-edge style or gender bias.

Frida understood that Albert could promote her work by loaning it to the many American museums featuring Mexican art exhibits, something that was popular at the time due to the efforts of Frances Flynn Paine and Abby Rockefeller. These two women had acted as a bridge for Diego's introduction to the United States. Frances, who grew up in Mexico, was a fluent Spanish-speaker with an interest in the arts. An expert on Mexican folk art, she promoted this genre in the United States, influencing Abby Rockefeller. The women formed the Mexican Arts Association in New York with the intention of promoting cultural relations between Mexico and the United States.

Frances also became Mrs. Rockefeller's personal art dealer, acquiring Mexican art objects for her growing collection, which included Diego's easel paintings and drawings. Frida, always a great observer of human interaction, gleaned the power dynamics of the U.S. art world by watching how her husband's art was promoted. She incorporated her cunning business sense into the conception of the marriage portrait as a gift.

Most discussions of Frida's marriage painting view it as a depiction of the couple's unequal relationship, with Frida as the docile wife, but this interpretation begins to disintegrate when one takes into account Frida's naming of Albert Bender and her autonomous self, "Frieda Kahlo," seen in the *banderole,* as well as her "act of friendship." It's understandable that Frida wanted to thank Albert for everything he'd done for them, because he was a generous man who bought Diego's work, but an artist typically painted a portrait of the friend to show thanks. To give Albert a marriage portrait is a bit unusual, but in terms of Frida's career, it makes sense. Museums were more apt to exhibit this painting of a famous artist and his wife than a portrait of Albert Bender done by an unknown female Mexican artist.

Most likely this is the reason the painting was given the title *Frieda and Diego Rivera,* to connect this unknown artist to her renowned husband and to emphasize the image of the traditional, supportive wife. But in the *banderole* Frida identifies herself as "Frieda Kahlo," not "Frieda Rivera."

Even with Frida's access to the most powerful art patron in San Francisco, her marriage to Diego was used against her in a negative review. H. L. Dungan, art critic for the *Oakland Tribune,* wrote of *Frieda and Diego Rivera*: "Interest in the canvas lies mainly in the fact that it was painted by the wife of Diego Rivera rather than any value it may have in the world of art."[68] Despite these disparaging comments, typical of the period for women artists, a large reproduction of Frida's painting was emblazoned across the Sunday edition of the *Tribune*'s "Art and Artists" section on November 8, 1931.

Frida's painting was one of many discussed in the article, which reviewed the annual exhibition held by the San Francisco Society of Women at the Palace of the Legion of Honor. Albert had loaned his painting to this exhibition, which took place six months after Frida left San Francisco, almost one year after she first arrived in the city, and nearly one year after Diego's retrospective at the same museum. It's remarkable that this novice painter had achieved this type of visibility in such a short amount of time.

Frida's marriage portrait continued to be shown alongside those of the most renowned Mexican artists of her day in exhibitions such as the 1935 "Mexican Painting and Drawing" show at the San Diego Museum of Art and the 1941 "Modern Mexican Paintings" show organized by Boston's Institute of Modern Art.[69] The catalog for Boston's exhibition lifts Diego's shadow by acknowledging that Frida "has *independently* found inspiration in native provincial and folk sources" (emphasis added). The *Oakland Tribune* (May 10, 1942) reviewed the Boston exhibition, and this time the newspaper didn't disparage Frida's work. Instead, Frida's marriage portrait is mentioned as one of many works in the show, equating her artistic talent with the best of the modern Mexican artists.[70]

By the time these two important exhibitions of Mexican art took place, Frida's painting was owned by the San Francisco Museum of Art, which opened in 1935. Albert had donated Frida's marriage portrait to its permanent collection. Today the museum, known as the San Francisco Museum of Modern Art, considers the work one of its most prized pieces. Frida's smart business move and the friendship she cultivated with Albert led to her initial exposure in the art world.

A year after Frida left San Francisco, her relationship with Albert was still filled with warmth, something she conveyed in a letter she wrote to him. She asked when he'd be visiting them, adding: "Don't be bad boy, Will you?"[71] After apologizing for her poor English, she ended the letter: "I want to send you our best wishes for the New Year and a very nice kiss. Frieda la Chicuita" (a drawing of lips appears under her name). Frida signed many letters with "Chicuita" (little one), a nickname she reserved for friends as a term of endearment, but also as a play on words—instead of *q* in *chiquita,* she uses *c*. In the process she chuckles at the perception that she is merely a small woman. As Fuentes writes, "Mexican diminutives are a form of defense against the arrogance of the rich and the oppression of the Mexican authoritarian tradition."[72]

Frida subverts this authoritarian tradition in her painting as well. Most see her as the petite, doting wife next to her larger-than-life artist husband because they view the marriage portrait literally instead of symbolically. But Frida, the alchemical queen, was developing her vocabulary of hermetic messages, taking pleasure in stumping people with her hidden "truths." In this context, Fuentes's comment that diminutives fake "submission before the powerful" is highly relevant.[73]

Frida applied this fake-out to her marriage portrait. Her tilted head and small size might, at first glance, indicate her submission to Diego, but the significant changes she made to the initial drawing portray a different story. The most telling alteration is that Frida's hand is no longer submerged within Diego's grip. Instead, it rests above his hand, changing the power dynamic seen in the drawing. Now Frida is in control, not Diego, something that is underscored in the pastel pink *banderole* announcing "Frieda Kahlo" as the creator. Within the fictive space of this painted canvas, she reigns supreme as Queen Frida.

FIVE

Photogenic Frida

*I photographed Diego again, his new wife—Frieda—too:
she is . . . petite, a little doll alongside Diego, but a doll in size
only, for she is strong and quite beautiful.*

—Edward Weston

Frida knew how to pose for the camera. As the daughter of a photographer, she'd been the subject of his family portraits since she was three years old. Posing was natural to her, it was something Frida and her family did on a regular basis. When Frida became a teenager, she learned how to best pose to camouflage her slightly shorter and withered leg, how to use her intense facial expressions to draw attention to her emotions, and how to dress with aesthetic flair. Whether donning men's attire or a large cross necklace, Frida stood out. While some middle-class Mexican fathers might have scorned their daughters' eccentric ways, Guillermo Kahlo identified with his daughter's simultaneous desire to shake things up and find her place in the world.

For Guillermo, this dual desire manifested when he was nineteen years old and forced to abandon his plans of entering university in Nuremberg, Germany, due to a bad fall that left him with a brain injury producing epileptic seizures. He sank further into despair when his mother, Henriette Kaufmann Kahlo, died shortly thereafter. It didn't help that his father, Jakob Heinrich Kahlo, remarried a woman Guillermo disliked. To ease tensions, Jakob, a jeweler, gave his son enough money for passage on a

steam liner bound for Mexico. In 1891 he left the old country as Wilhelm and entered his new country as Guillermo.

He had very little money and few reminders of his homeland. But marrying María Cardeña Espino and starting a family helped him find a place within this new world. After several short-lived jobs, he eventually found work in a jewelry store owned by the Diener brothers, Germans he'd met on his journey to Mexico. Here he worked with Matilde Calderón y González. Guillermo's German accent felt familiar to Matilde, who had been madly in love with another German man before their relationship ended in tragedy when he committed suicide in front of her.

Guillermo soon faced a tragedy of his own when his wife died shortly after giving birth to their second daughter, Margarita. Guillermo turned to Matilde and her parents, Isabel González and Antonio Calderón, for emotional support. In 1898 Guillermo and Matilde married. Matilde is often described as a coldhearted woman who immediately sent Guillermo's daughters from his first wife to a convent.[1] But recently discovered documents show that Guillermo's eldest daughter, María Luisa, lived with her father and stepmother for some twelve years, at which time she was sent to a boarding school to get a good education. While there's no written record to confirm whether Margarita, Guillermo's second daughter from his first marriage, stayed with the Kahlo family after her mother died, a 1906 photograph taken in the courtyard of the family's house shows a young Margarita standing next to her stepmother, Matilde, and stepsisters Mati and Adriana (Adri). In later years, letters written by Margarita and María Luisa to Frida attest to their closeness. It seems that Guillermo and Matilde tried to create a familial bond with Guillermo's two daughters to heal their traumatic pasts. Yet Matilde did not completely let go of her own past. She held on to a leather-bound book filled with letters from her previous boyfriend. The adult Frida theorized that her mother had never fully recovered from the loss of this first love. Her father, however, was very much in love with Matilde when they married.[2]

Early pictures of the couple show their joy as young lovers. Even though their happiness lessened over the years, Guillermo and Matilde forged a relationship that informed the rest of their lives. Matilde, whose Indian father, from the state of Michoacán, was a professional photographer, encouraged Guillermo to take up the profession.[3] Guillermo eventually set up his own studio in Mexico City, which became an oasis for him. He felt at home with

his large German-made cameras, lenses, and glass plates, as well as books by German authors and a scale-model train that he tinkered with constantly. As a photographer, he specialized in architecture, landscapes, and factories. He avoided portraits if at all possible because, as he dryly remarked, "he did not wish to improve upon what God had made ugly."[4]

At home, however, it was a different story. Guillermo liked to set up photo shoots in the courtyard of the family's house. He was fastidious about his backdrops and the photographic process. In this way, he displayed the attributes of a serious professional photographer. But when it came to photographing Frida in her various guises, he exhibited a creative openness.

When eighteen-year-old Frida showed up in her father's suit, he didn't make her change. He seemed to understand her desire to create a new androgynous persona after adjusting to a new body image. Controlling the outer was one way to harness the inner turmoil and mine it for creative potentialities, something Guillermo had modeled for his daughter. A self-acknowledged nervous man who struggled to find a sense of inner peace, he had created numerous personas through his photographic self-portraits.

These personas took shape while Guillermo was still in his twenties and thirties. He sometimes appears as the "dapper photographer," wearing a suit and a slight smile as he holds on to his large camera propped up on a tripod at his side. Other times he's the "everyday man," dressed casually and standing at the top of an outdoor staircase, his hand shading his eyes as if he's looking far off into the distance. He can also be seen as the "revolutionary," wearing a Pancho Villa–style sombrero while sitting atop a horse, or the grinning "man of intelligence" with sparkling eyes, seated in front of a row of books in his library while holding a pocket watch.

As Guillermo progressed in age toward his fifties and beyond, his self-portraits changed; the variety of colorful personas morphed into photos showing a forehead with incised lines, a downturned mouth, eyes with a hardened gaze. In one taken at the age of fifty-three, he's in a suit with his gray-streaked hair brushed back, looking off to the left with a fixed, worried stare. His furrowed brow and serious expression emphasize his gruff temperament. Across the bottom of the photograph he printed in Spanish: "From time to time try to remember how much your father loves you. Guille Kahlo 1925."

Guillermo's words of love are striking because the image they accompany does not convey a loving father. His use of text turned the photograph into a type of mnemonic device designed to reinforce the message *I love my daughters.* If his children looked at this photograph without the inscription, they might see only a serious, discontented father.[5] But viewing the portrait with the message of love serves to create the association of a severe father who also possessed tender emotions for his children. This oppositional association stuck in Frida's brain. As an adult looking back, she commented, "My father was benevolent and severe, rather violent but very kind-hearted."[6]

Frida, like her father, used photographic images—often with written words accompanying them—much the way she used painted images: as a repository for her profound and sincere emotions and ideas. When Frida was in San Francisco she continued this photographic tradition. The calculated image she projected for the camera was intended to shake things up, and the photos she sent her parents, sometimes with inscriptions, were meant to reaffirm her place within the family. But the photographs of Frida that stand out from her stay in San Francisco were taken by two professional photographers, Edward Weston and Imogen Cunningham.

The first photo shoot occurred on a cool December day, a few weeks after Frida had arrived in San Francisco. She stepped down into Stack's sculpture studio, where Diego and Edward were catching up on the news of each other's lives since the heady days of the 1920s, when Edward had lived with Tina Modotti in Mexico. Frida had never met Edward because by the time she'd joined Tina's salon Edward had returned to the United States, though she would have heard about him from Tina.

Tina and Edward had had a complicated romantic relationship that paired a married photographer with his muse and model, a woman who would go on to create a life for herself as a photographer and political agitator. Edward wasn't as interested as Tina in the life of an activist, and he certainly didn't want his photographs to carry political messages. He was content to focus on images of nature, nude women in natural settings, close-ups of vegetables and people's faces. He became a leading figure in the fine art of "straight" photography—photos with a crisp, clear focus.

Edward eventually settled in the Carmel coastal area of California but remained close to San Francisco–based photographers such as Imogen Cunningham and Ansel Adams.

In 1930 Edward made the short trip from Carmel to San Francisco to see Diego and meet Diego's new wife. When he saw Frida in her ethnic attire, her dark hair pulled back to showcase her striking features, he was transfixed. "She is quite beautiful," he wrote, and "shows little of her father's German blood."[7] He knew a good photographic subject when he saw one and began taking some black-and-white pictures of her. In a candid shot, Frida steals a glance at the camera lens, with a slight smile that hints of a coquettish yet mischievous woman, while Diego's eyes are fixed on Frida, who stands next to him in a three-quarter pose. All eyes are on Frida; she's probably just made one of her witty comments, employing vulgar language to punctuate a point. Whatever she's said, it has evidently caught Diego's attention, because he turns his head toward her and smiles. She wears a full-length dress, a European narrow silk shawl with fringe, three large jadeite Aztec beaded necklaces, and dangling metal earrings with a floral design.[8]

When Frida walked with Diego and Edward to an Italian restaurant in the Montgomery Street neighborhood, she caught the eye of locals who stopped to admire her outfit—huaraches peeking out from under a long, full skirt, a deep purple, mauve, and green striped silk shawl with dangling amber-colored fringe wrapped around her shoulders. Even in this bohemian section of San Francisco, the sight of this unknown Mexican woman created "excitement," as Edward marveled.

But Edward also commented on Frida's strength, something he captured in another photo taken before the threesome had departed for the restaurant. A solo Frida sits with her hands resting in her lap, looking off to the left as if she's caught in thought. This photo showcases the dark striped *rebozo* draping her upper body, with its thick folds highlighting the contrast of light and shadow, drawing the eye to its beauty. The shawl frames the three strands of large, heavy jadeite Aztec beads, emphasizing Frida's strength, both literal (her strong neck and back muscles) and political (her alliance with Aztec culture). Even if San Franciscans didn't understand the political level, the photo makes clear that Frida is a thoughtful, strong woman who is aligned with indigenous women.

Edward must have liked this contemplative pose because he took another photograph of a pensive Frida. In this photo, however, he moved in closer to show her from the chest up. Her head is angled to the left and she looks down, creating an intimate moment, as if we are able to peer into the internal workings of Frida's mind. Her downcast eyes make it easy for us to feel comfortable staring at her because she doesn't look back. And there is much to gaze upon: Frida's features (thick eyebrows, long eyelashes, high cheekbones, wide nose, prominent lips) and the same heavy, three-stranded jadeite necklaces and gold metal earrings. Both pieces of jewelry display pride in her indigenous heritage: the earrings link Frida to the state of Oaxaca, the region where her mother grew up, and the necklaces connect her to the fierce Aztec warriors. As Edward noted, Frida's German side isn't obvious.

Frida was as meticulous about what she wore as she was about what she painted. She made her choices based upon aesthetics and symbolic meaning. It's therefore of note that in this third photo, her shoulders are covered by a different *rebozo* than in the previous two shots. A Mexican woman's *rebozo* conveys different messages depending upon its material, the area where it's from, and the way it's worn. It can be draped over the head to enter a place of worship, to protect from the sun and wind, or to mourn the loss of a loved one. It can be wrapped tightly around the body to indicate unmarried status or it can be used to carry a small child.

In the first two photographs, Frida's *rebozo* is made of silk, and its design derives from European shawls; both these aspects connect her to the upper middle class. The shawl she wears in the third photo is probably made of rayon; a similar one from Guanajuato was found in Frida's closet after her death. Women in rural areas typically wore rayon shawls with a mottled pattern of white specks.

The *rebozos* Frida wore conveyed her allegiance to the indigenous women throughout the various regions of Mexico. They became an important symbol of her identity while in the United States. Although the *rebozos* differ in Edward's photos, what remains the same is the focus on Frida as a striking, thoughtful, indigenous-looking woman. Beauty and intelligence were traits not commonly ascribed to Indian women, so by combining these various traits, Frida was creating a new persona of the indigenous Mexican woman, one she felt good about, informing her mother: "I had

some wonderful pictures taken of me, as soon as I have copies I will send them to you."[9]

Frida controlled what she wore in the photos Edward took of her, but he determined the pose, composition, and lighting. In the two photos of Frida alone, which emphasize her ethnic attire, Edward's style recalls Edward S. Curtis's "ethnographic" photographs of Native Americans. Curtis's signature images were well known due to a massive project funded by financier J. P. Morgan to photograph North American Indians from eighty different tribes. A twenty-volume photographic series, totaling some 40,000 prints and with a foreword by Teddy Roosevelt, was published between 1907 and 1930.

Curtis was on a mission to document the so-called vanishing race before it was too late, but some scholars took issue with the idea that North American Indians were vanishing when the 1910 census counted 276,000 Native Americans, a number that showed an increase of 39,000 since the 1900 census.[10] Curtis argued with the criteria used by the census to obtain these numbers and, from his perspective, 276,000 was still way down from some 20 million in the eighteenth century. He photographed various tribal members standing in nature or performing ceremonies, but he also created portraits. Many photographs show the person from the chest up, emphasizing facial features—some look straight into the camera lens and others look off to the side. The subjects are dressed in native attire, often with jewelry, elaborate hairstyles, or headscarves. Curtis was promulgating the image of the "noble savage," the "primitive" who was pure of heart, living in nature until corrupted by society.

Curtis felt nostalgic for this lost paradise and sought to romanticize the "primitive" disconnected from the negative effects of modernization and forced assimilation. To achieve this, he placed his subjects in front of a black curtain, allowing them to exist in a timeless, neutral space. He also eliminated modern objects or items of clothing, replacing them with native attire and traditional objects.

Even if Frida wanted to craft a new persona of the indigenous woman, the style of Edward Weston's photos, particularly his tight close-ups, places her into the category of the Curtis-like "noble savage." It wasn't the first

time Edward had revealed his affinity for such ethnographic-style portraits. Eight months prior to his photo shoot with Frida, he had used a similar pose and tight composition when photographing Tony Luhan from Taos Pueblo in New Mexico.

Tony and his non-native wife, Mabel Dodge, who had created an art-ists' community in Taos, knew many painters, photographers, and writers. In the spring of 1930 they visited Edward in Carmel. Edward asked Tony if he would pose for him, and when he grudgingly agreed, the two went outdoors. Tony was wearing a suit and tie but covered his modern outfit with a "native" ceremonial-type robe. His vibrant attire, two leather-bound long braids, and serious facial expression dominate the photograph. Ed-ward took three dozen negatives that day, but in the most well-known prints, Tony looks off either to the left or to the right. There are some striking similarities between Edward's photos of Frida and Tony—both look away from the camera lens in closely cropped compositions that eliminate any background, emphasizing their "ethnic" garb and serious facial expressions.

In Edward's journal, he marveled at his ability to transform Tony from a "flabby Indian" into a heroic Indian of great strength—qualities, Edward said, Tony didn't possess.[11] Edward, like Curtis before him, used his cam-era to change Tony into *his* vision of a Native American. And when Tony didn't agree with Edward that the close-up photos of his head were "extraordinary," Edward was dumbfounded. Eventually Tony informed Edward that he didn't like them because they made him look too old. But perhaps the underlying tension—he had to be persuaded to pose and then he wasn't happy with the results—had to do with being photographed as a "type" rather than as a human being. One year earlier, Ansel Adams had created a similar romanticized photo of Tony—his lit face, shrouded by a "native" blanket, emerges from darkness.

For Frida, her style of dress was an expression of Mexicanidad and the valorization of a traditional Indian way of life.[12] But her "modern" attitudes concerning Mexican nationalism and women's roles, as well as her propensity to punctuate a point with swear words or long drags off a cigarette, set her apart from tradition. Weston's candid photo of Frida and Diego captures some of Frida's complexity, but it's Imogen Cunningham's prints that stand out because they show an indigenous-looking woman in a different light.

Imogen was sensitive to her position of power as a photographer, especially when photographing someone from another culture. In 1926 she had spent the summer on reservations in what she called "Indian country." Although Imogen had hoped to take some photographs of the Native Americans she met, she told an interviewer she didn't take any because "they don't like being photographed."[13] Until 1933 Imogen used a 3¼ × 4¼ Graflex camera, which she felt was too bulky and awkward to put people at ease. Not everyone feels comfortable being photographed, but Imogen had a sixth sense about it, saying: "I can tell the minute I talk to people whether they are going to let me photograph them as they really are or not."[14] Imogen must have realized right away that Frida, the experienced photographer's assistant and model, felt comfortable facing a large camera.

Imogen was taken with Frida, whom she found charming, sweet, and talented. She was also intrigued by this "beautifully dressed" woman who "stopped the traffic."[15] In an interview from the early 1970s Imogen recalled: "She had trunks and trunks of clothes and they were all exactly alike except for color. They were all big, wide peasant skirts and a *rebozo,* and tons of jewelry. And then she braided ribbons in her hair, and she was really lovely. And I think—this is a terrible thing to say—that she was a better painter than Diego. She never got any credit. This is the second-class status of women."[16]

Imogen understood from personal experience what it felt like to be considered second-class. As one of the few professional female photographers of the early twentieth century, she struggled to keep her career afloat in a world where she was expected to focus on her husband, children, and household chores. At the time she met the twenty-three-year-old Frida, the forty-seven-year-old Imogen was married to Roi Partridge, an etcher who taught at Mills College in Oakland. The couple and their three sons lived nearby on Harborview Avenue in Redwood Heights, a rustic area in the hills. This is probably where Imogen took her photos of Frida.

Frida would have loved the natural setting surrounding Imogen's domestic world in Oakland. They certainly shared a deep understanding of the photographic experience, yet Imogen didn't speak Spanish and Frida felt self-conscious speaking English. Imogen knew some German and asked: "What about German?" Frida responded in English: "Oh no. My father always scolded me in German."[17] So the two women communicated with

a combination of bits of English mixed with nonverbal cues. Despite the language barrier, Imogen's spunky, offbeat, chatty personality must have come through, charming Frida and making her feel at ease. At least this is what stands out in many of the most well-known photographs Imogen took that day.

She experimented with different compositions before she got them right. In some, Imogen placed Frida in a confined space with no defined background and photographed her from the chest up. Frida's neck and head look stiff as she stares off into space. These closely cropped prints, devoid of a particular setting, recall the Curtis, Weston, and Adams portraits of Native Americans.

Imogen knew Weston and Adams's photographs well. She also knew Curtis's photographic style because she'd worked for two years in his studio as a darkroom assistant at the pivotal moment when he was beginning to photograph North American Indians. Imogen must have been taken with his powerful photos, but by the time she photographed Frida, she was a seasoned photographer herself with her own philosophy. She understood in 1930 what contemporary Navajo photographer Hulleah J. Tsinhnahjinnie emphasized in 2003: "The over-romanticizing and simplification of Native existence have been and continue to be two of the greatest assaults on Native existence."[18]

Curtis had definite ideas about what types of images he wanted to create. Imogen, on the other hand, didn't have an overarching objective, such as preserving Mexican indigenous culture, when she photographed Frida. She was focused on this woman she'd recently met and wanted to elicit her best interior qualities. Imogen told an interviewer it was critical for her to approach her subjects without any preconceived notion of what constitutes external beauty. Above all, she said, it's vital not to worship it. She explained: "To worship beauty for its own sake is narrow, and one surely cannot derive from it that aesthetic pleasure which comes from finding beauty in the commonest things."[19]

Imogen wanted to bring out Frida's complexity in an unsuspecting moment. It's easy to imagine the photographer, with her large round glasses and light-colored wispy hair pulled back under a headscarf, chatting away while trying out different angles and poses until the magic of the moment coalesced. This was tricky to achieve with portraits due to the sitter's own emotional reactions to the imposing Graflex camera and to the photogra-

pher's personality. In the years preceding her session with Frida, Imogen had been focused on photographing close-ups of flowers, a subject that didn't require the same type of psychological interaction. Yet she wanted to achieve similar results with both subjects—to allow viewers to see something or someone in a novel way.

The magic moment struck when Imogen stepped back and allowed for the living room space where Frida sat to be just as important as Frida's outfit, pairing her "exotic" look with a modern context. Frida doesn't appear to be cut off from the world in a timeless space. She either sits up high with her arm resting on the back of a wicker chair or sits on a couch staring directly into the camera with those captivating eyes. Not surprisingly, these are the prints that have become well known.

In these photos, Imogen's control is less obvious because they have the appearance of being taken in her home. The illusion is that Frida allowed Imogen to take some photos of her while visiting, giving Frida more power in this illusory context. Her eyes are locked with ours in an exchange, as if she's trying to communicate something.

The key to Frida's message comes through in her outfit and jewelry—they can be "read" like a text. As in Weston's photos, she wears distinctive jewelry, but this time her long metal earrings are round Aztec battle shields with dangling stylized feathers.[20] Aztec warriors acquired wooden shields with various painted designs based upon their rank and feats of bravery. In the middle of Frida's metal shield earrings is an abstract Quetzalcoatl, the ancient Mesoamerican deity Frida knew quite well from visiting Tepoztlán, the mythic birthplace of the plumed serpent. The dualistic Aztecs were drawn to Quetzalcoatl's twin nature, symbolized by the feminine sphere of the earth (the serpent) and the masculine sphere of the sky (the feathers), and both shapes were present in Frida's earrings.[21]

Frida's Aztec shield earrings complement her Aztec necklace, the gift from Diego featuring the *olin,* the same necklace she wore in *Self-Portrait: Time Flies.* In Imogen's photograph, however, Frida pairs the Aztec necklace and warrior shield earrings with a rayon *rebozo.*[22] One side is tossed over her shoulder, creating the look of a *soldadera,* a revolutionary female soldier who wore bullet-filled bandoliers crossed in front. Sometimes when not in uniform *soldaderas* wore their *rebozos* crossed in front to distinguish themselves as soldiers.[23]

Frida identified with the *soldaderas,* who were known for their strength

and tenacity. When some women were belittled and even rejected for their desire to join the revolutionary troops, they fought back by wearing men's clothing and passing as males. The *soldaderas* weren't just an anomaly; they played a crucial role in the revolution, as Mexican journalist and writer Elena Poniatowska stresses: "Without the *soldaderas*, there is no Mexican Revolution—they kept it alive and fertile, like the earth."[24] Their fame grew in Mexico as the popular *corrido* "La Adelita," about a *soldadera* who fought for Francisco Madero's troops and fell in love with him, came to symbolize the revolutionary spirit. In the song, a sergeant idolizes and respects Adelita because she is both brave (a quality rarely accorded a female) and pretty.

After the revolution, the name Adelita became synonymous with any woman who fought for her rights. Frida loved belting out this *corrido* dedicated to strong Mexican women. At a Mexican restaurant in San Francisco consuming food from home—mole, tortillas, and enchiladas—Frida's soul was fired up, and out came "La Adelita." She proudly recalled to her mother: "I was a hit."[25]

Frida understood that by arranging her *rebozo* in a similar fashion to the *soldaderas* and wearing jewelry recalling the fierce Aztec warriors, she evoked the persona of the politically engaged nationalist. For Frida, who was still coming into her own, that identity was bound up with the image of the strong, independent, and at times cross-dressing Adelita, a persona her mother had modeled for her in a photograph.

Before Guillermo and Matilde were married, Frida's father took a photo of Matilde, then twenty-one years old, dressed as a *soldadera*. She stands barefoot, hands on hips, wearing a long peasant-style skirt, white short-sleeved blouse, crossed *rebozo*, and jewelry, with flowers and ribbons adorning her long braids. A large brimmed cowboy hat tops the outfit as a young Matilde looks off to the side with a slight smile. The fake backdrop behind her, a snow-covered scene with alpine trees and a Swiss chalet, makes it clear she's playing a role. Nevertheless, this image, part of Frida's vast photo collection, must have meant a lot to the daughter, who was proud that her mother had helped the revolutionaries by feeding them and tending their wounds.

As a public figure in the United States, Frida had the potential to influence people's perceptions of Mexican women. In these early years, she

was continually manipulating aspects of the indigenous Mexican woman's persona, but always highlighting a mixture of intelligence, strength (sometimes emphasizing her androgyny), and beauty, traits that were unusual to ascribe to an indigenous woman, especially in conjunction. Although the full significance of these traits probably escaped most people in the United States, in Mexico the attribution of beauty, strength, and intelligence to the indigenous woman was a radical rethinking that helped shape the new Mexican identity.

After the Mexican Revolution, the image of the "noble savage" was applied to indigenous Mexicans, who were viewed as simple and naturally good. This was a shift from pre-revolutionary days, when indigenous people were caricatured as dirty, unsophisticated, hunched-over, and blank-eyed. Frida's persona rejects both the Primitivist "noble savage" stereotype and pre-revolutionary caricatures. She created an image that brought together an indigenous pride with a modern twist. Frida was the perfect person to embody these two seemingly contradictory notions because she grew up with both.

But Frida's creation of the beautiful indigenous woman also has roots in an influential public event that took place when she was fourteen. It was 1921, a year of great change and upheaval for Frida and her country, when the former revolutionary Félix Palavicini came up with an inspired idea. Why not have his prominent newspaper, *El Universal Ilustrado,* sponsor a beauty pageant for indigenous women, to be called La India Bonita? Crowning the most beautiful Indian woman would make a political statement, since at the time the Miss Mexico contest allowed only white women to participate (as did the Miss America contest). There was no concept of beauty for nonwhite women within Mexican society, which had assigned aesthetic ideals only to fair-skinned women of European descent.[26] Palavicini wanted to change this prejudice by validating Indian female beauty within a public forum that would take place in Mexico City, seat of the new government and a hub for education, art, and culture.

El Universal Ilustrado announced the India Bonita contest in January 1921, arguing that it was a novel idea for a newspaper to feature the "strong and beautiful faces" of indigenous women of the Mexican "lower class."[27]

Yet from the start the contest was flawed because of the inability to conceive of, let alone judge, an indigenous woman as beautiful or possessing a "strong and beautiful" face. The discomfiture was so great that the archaeologist and anthropologist Manuel Gamio, who at the time had been uncovering Mexico's pre-Hispanic cultural patrimony, felt compelled to write an article explaining the need to break down European canons of beauty:

> The classic model of physical beauty, the Greek model, does not exist, nor has it ever existed in Mexico. For lack of this physical ideal, we have substituted the White physical type of Hispanic origin. But this is a crass error because Whites make up only a small part of the Mexican population, and they are physically different from the majority; moreover, there is no evidence that Whites are more attractive than Indians or Mestizos. We should not establish exclusive canons of beauty.[28]

But not a single woman whom Gamio would have characterized as an "authentic" Indian contestant entered the pageant. The organizers were forced to go out and find indigenous women to produce a pool of finalists. When they did, the ten finalists had their pictures published in *El Universal Ilustrado*.

The judges chose as the winner María Bibiana Uribe, a fifteen-year-old from Sierra Norte de Puebla who spoke Nahuatl, the language of her Nahua (better known as Aztec) lineage. Her picture was on the cover of the August 17 edition of *El Universal Ilustrado*. The colorized photo shows a young girl with brown skin and eyes wearing a blue pleated skirt with a white peasant-style blouse decorated with blue embroidered patterns at the neckline and on the short sleeves. She wears three strands of red, yellow, and green colored beads, as well as gold dangling earrings. With a long, dark braid cascading over her shoulder, she holds a red lacquered bowl made from a gourd and decorated in a well-known style from Olinalá in the state of Guerrero. María was not from Olinalá, but the bowl was used as a prop to emphasize her "authenticity."[29]

María appears posed and a bit stiff, but this probably pleased the organizers because it lent an air of the authenticity they were searching for—as if María, who the organizers indicated "lives in peace and tranquility," had been plucked out of her natural environment. She was described as shy,

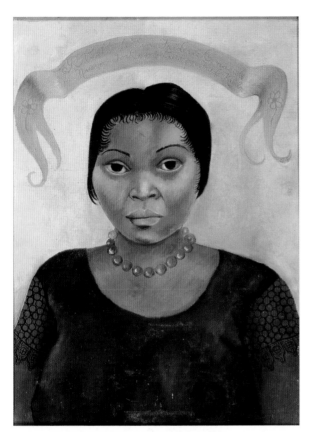

Frida Kahlo, *Portrait of Eva Frederick*, 1931

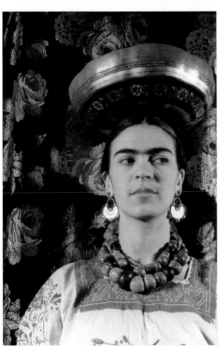

Carl Van Vechten, *Frida with a Tehuantepec Gourd on Head*, 1932

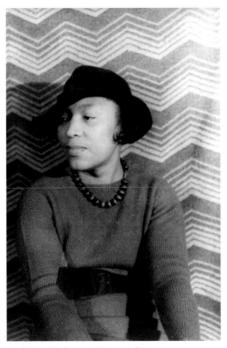

Carl Van Vechten, *Portrait of Zora Neale Hurston*, 1938

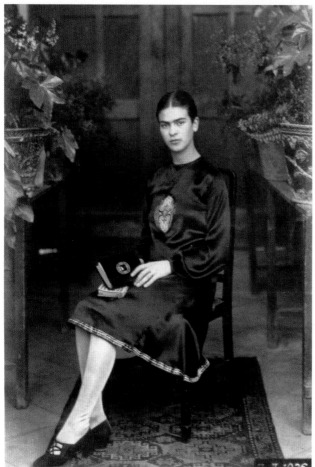

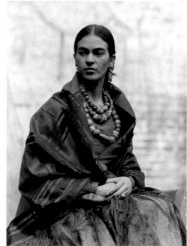

Frieda Kahlo, 1930. Photograph by Edward Weston.

Guillermo Kahlo, *Frida Kahlo*, 1926

Imogen Cunningham, *Frida Kahlo Rivera*, 1930

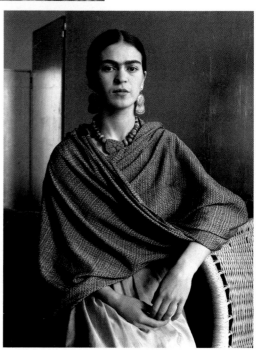

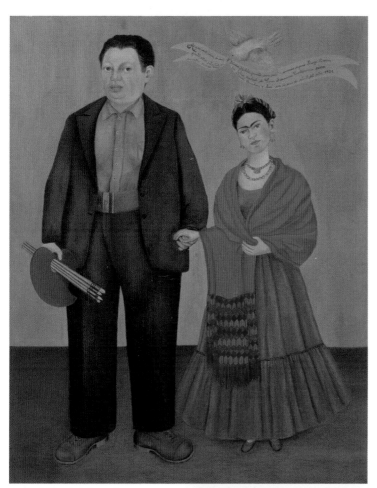

Frida Kahlo, *Frieda and Diego Rivera*, 1931

Frida Kahlo, *Portrait of Mrs. Jean Wight*, 1931

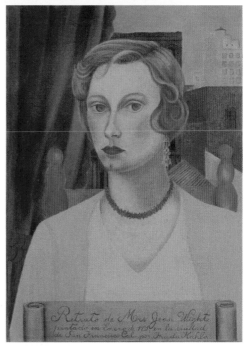

Frida Kahlo, *Portrait of Luther Burbank*, 1931

Frida Kahlo, *Window Display on a Street in Detroit*, 1931

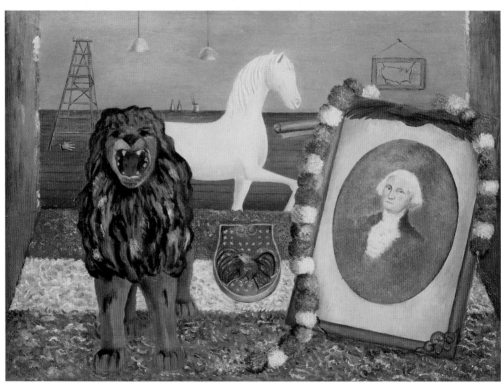

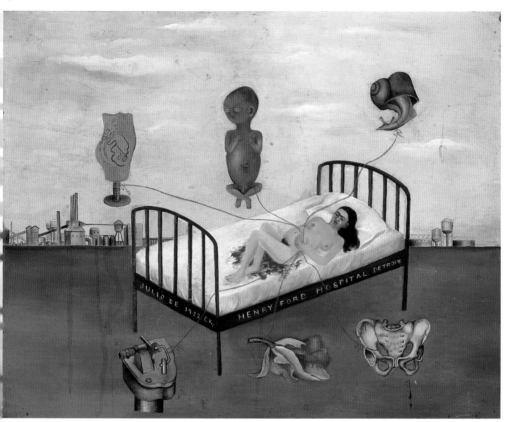

Frida Kahlo, *Henry Ford Hospital*, 1932

Anonymous, *Mexican retablo*, 1927

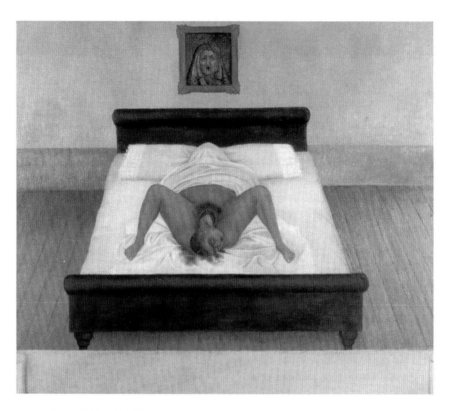

Frida Kahlo, *My Birth*, 1932

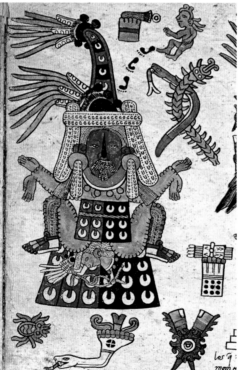

Aztec Goddess *Tlazolteotl*,
c. 1519

Frida Kahlo, *Self-Portrait with Necklace*, 1933

Lucienne Bloch, *Frida Under the Sign "For Negroes,"* 1932

Frida Kahlo, *Self-Portrait on the Borderline Between Mexico and the United States*, 1932

Frida Kahlo, *My Dress Hangs There*, 1933

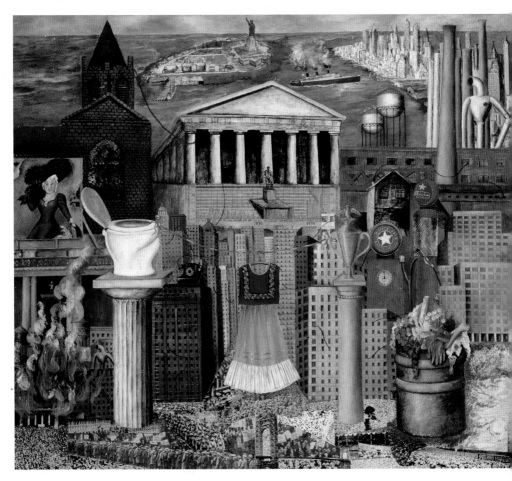

passive, innocent, awkward, rural, and provincial, with little if any ability to speak Spanish. She lost some of her innocence when she was thrust upon the urban stage of Mexico City, becoming a celebrity. She was turned into a symbol of Mexicanidad, even if the pageant didn't ultimately empower María or transform her life.[30]

As Frida's homeland was attempting to create a new identity with fifteen-year-old María as the representative of indigenous female beauty, fourteen-year-old Frida was in the midst of an identity crisis. La India Bonita with all its fanfare was everywhere, particularly in the Mexico City area, where Frida was attending the Normal School for Teachers during the 1920–1921 school year, before she transferred to the Prepa. It was the first time Frida had left Coyoacán and the authority of her mother on a daily basis. Her father, who commuted to his photography studio in Mexico City, took her to and from school, calming Matilde's fears.

Frida enjoyed the feeling of freedom attending a beautiful school in the big city, but she had some experiences that further intensified her identity issues. She recalled being in a play called *The Blue Bird* by Maurice Maeterlinck and how excited she was about the prospect of acting until the teacher in charge, Josefina Zendejas, turned her excitement into shame.[31] Señora Zendejas commented to a fellow teacher in class: "This girl has talent but we need to dress her up so her leg won't show."[32] This insensitive comment made the already self-conscious schoolgirl painfully ill at ease. "It already bothered me a lot," Frida said, "the thing with the leg."[33]

Even though Frida had been self-conscious about her thinner, shorter right leg, she had sometimes worn below-the-knee fitted skirts on days when she wasn't wearing boys' overalls or pants. Aurea Prosel, a fellow student, brought a long, full skirt and *huipil* for Frida to wear, along with bows to adorn her braids. The outfit sounds similar to María's as La India Bonita. But wearing it didn't instill a sense of nationalistic pride in Frida at that time. Rather, she felt "defective." At this awkward age, she had been dressed up like a doll to hide who she was.

Around the same time, an incident with her anatomy teacher compounded Frida's feelings of inadequacy. Señorita Sara Zenil conducted a physical examination on Frida and concluded that she wouldn't be capable

of performing PE exercises because of her leg. The athletic Frida felt uneasy about being singled out and ultimately withdrew from her schoolmates, drawing closer to Señorita Zenil because she went to her classroom while the other children were at gym. Frida would help the teacher organize paperwork. But these mundane activities were accompanied by Señorita Zenil's affectionate gestures, sometimes going so far as to sit Frida on her lap. Frida loved the feel of her teacher's skin and the smell of her perfume.

Such hedonistic pleasures turned to sexual attraction. When Frida learned her friends Ana Carmen del Moral and Lucha Rondero were also attracted to Señorita Zenil, her feelings intensified. These forbidden emotions, shared in secrecy, strengthened the three friends' bond.[34] But at the same time, Frida said, they "were jealous of one another." In this jumbled mix of emotions, they all plotted to find ways to see their teacher, both individually and together.

Letters between the three friends brought this taboo situation to the attention of their parents. Frida was mortified. It led to her parents taking her out of the school, magnifying Frida's feelings of shame. What actually took place between this teacher and her three pupils is difficult to ascertain, but the adult Frida made two different statements that convey the importance of this relationship for her. The first comes from her friend Jean van Heijenoort, who said Frida had confided to him that her introduction into homosexuality was with a schoolteacher and that this experience had been traumatic because her parents had found out.[35] The other is a comment Frida made to an interviewer years later: "I fell in love with her."[36]

If Señorita Zenil seduced Frida, then she had abused her position of power. From a psychological perspective, she sent mixed messages. First, she singled Frida out for her "defective" body, but then expressed physical affection for her. Most likely it was the first time Frida had felt this potent sensation of desirability. These intense feelings would have been amplified by anxiety due to the taboo nature of this teacher/pupil lesbian relationship.

Four years later, Frida hinted at such complex emotions and exhilarating sensations when she made a print of two women—one wearing clothes, the other topless.[37] The women, with abstracted, masklike faces, stand side by side in nature, with the clothed woman on the left about to pinch the topless woman's nipple. Frida indicates this with open fingers and three lines radiating out toward the other woman's breast. Frida's

words later in life come to mind: "During sex, my breasts play an active role. I become excited when they are touched, even by some women." Despite this titillating moment, the women's faces do not belie any emotion. Instead, an intense energy is conveyed in the lines emanating from the open fingers of the woman on the left, and from the repetition of triangular shapes throughout the print, creating wave patterns like those seen on modern EKG machines showing the electrical activity of a human heart. In the print, these patterns replicate the sexual excitation the women feel but can't express outwardly. Frida hints that the women may be bound by religious mores, as the woman on the left wears something like a nun's habit and both women have halo-like headdresses.

A prominent flower in the right foreground below the topless woman can be read in this context as a reminder that sexual feelings between two women are natural. To emphasize the association between flowers and women's sexuality, Frida made the slits down the middle of the flower's thin leaves resemble a woman's labia. As an adult, Frida expressed positive sentiments about lesbianism, stating, "Homosexuality is very correct, very good."[38]

But when she was fourteen and outed for her clandestine relationship with her teacher, she felt humiliated. She also continued to struggle with her self-image regarding her shorter and thinner leg. At the Normal School for Teachers, she had learned to cover up her body with the loose-fitting blouses and long skirts of indigenous women, the same type of outfit she would have glimpsed on the postcards and posters of María as La India Bonita. The potential for creating beauty out of her perceived "ugliness" was now possible, even if it would take several years to manifest.

By 1929, when Frida was looking for a public persona in her new role as Diego's wife, she chose one that resembled La India Bonita, "the beautiful Indian." In San Francisco she solidified this persona. It was a significant move at this moment in time because the promotion of the beautiful, indigenous female was actually waning in Mexico. In an ironic twist, "Anglo tastes were at the height of fashion for women of her [Frida's] class at home [Mexico]."[39] By contrast, Frida, an unofficial Mexican ambassador in San Francisco, wore her indigenous apparel with great pride.

The friends and acquaintances Frida met in San Francisco marveled at the coexistence of an indigenous pride with a modern sensibility. In combining the two, Frida had shaken off the stereotypes of the naive, pure,

awkward, dirty, hunched-over Indian woman and simultaneously found a way to cover up her thinner right leg and injured foot. Through fashion and the photographic image, Frida gave the illusion that she'd taken control of her inner demons; she'd succeeded in creating beauty out of "ugliness."

And just as Frida was experimenting with her persona as La India Bonita, she was continuing to explore the creative possibilities for a new style of portraiture.

Portraiture and New Friendships

What is it we see when we look at an object and how can we present or represent what we see to others?

—Leo Eloesser

 "Let's draw the bloodiest thing we can think of," Frida said in English.[1] Bursts of belly laughter echoed in Lucile Blanch's smoke-filled studio where Frida, Lucile, and Pele deLappe began drawing on paper. Frida enjoyed these evenings at Lucile's downstairs studio; it was fun expressing her indecent side. Frida and Lucile always invited fourteen-year-old Pele to join them. She was one of Arnold Blanch's students at the California School of Fine Arts. By day, Pele was excited by the smells of turpentine and oil paint at art school, but at night, in Lucile's studio, she was in awe of these twenty- and thirty-something female artists who enjoyed pushing the envelope.[2] Wearing warm sweaters, they chain-smoked, swore, and chortled the night away.

Pele recalled that Frida and Lucile's drawings "were usually very obscene or horrendous and bloody or sensuous in some way."[3] That night when Frida suggested drawing the bloodiest thing possible, Lucile made two drawings, one of a man standing in his pajamas stabbing his wife, and another of a man hitting his wife over the head with a hammer while a baby lies on the floor with his head bashed in. Frida's showed a man stabbing a woman with many little cuts.[4]

At these soirées, Frida, Lucile, and Pele reveled in their freedom, encouraging each other to break the rules. One time they agreed on the theme of maternity for their drawings. Not the Mary Cassatt version of mothers tending to their children with tender love, but the taboo version, inserting what Pele called "a witty, wicked touch."[5] For Pele, this meant drawing a "voluptuous woman with flowing, red hair and five breasts, nursing five babies of different races."[6]

On some nights, the three made composite drawings. One person began by making marks on a piece of paper, then passing the unfinished drawing to someone else, who added her own marks in crayon, watercolor, or ink.[7] They always used an array of colors, making them quite vivid and at times gory, remembered Pele.[8] These collaborative drawings, inspired by the Surrealists with their focus on Freud's use of free association to create automatic drawings, were intended to free up their creativity by allowing the rational mind to take a backseat to the intuitive mind.

Although Frida and Lucile introduced Pele to a radical new way of making art, she wasn't completely shocked by what she referred to as a "salty" approach to subject matter.[9] At fourteen, Pele had already been exposed to more than an average young teenager. She had been raised by "nutty bohemian" parents. Her professional illustrator father, Wes deLappe, had pulled her out of middle school to attend art school.[10] There she encountered an adult environment, including drawing from the nude female model.

Pele was not naive, but Frida and Lucile probably took pleasure in exposing her to some renegade ideas at their get-togethers. Pele was the only one free from the overshadowing presence of an artist husband. Like Frida, Lucile was an aspiring artist who had followed her husband, Arnold, to San Francisco for his one-year teaching position. Lucile and Frida may have depicted men brutally hurting or killing their spouses because on some level the women felt "beaten up" by their subservient roles in life, art, and marriage. Frida later famously said that she felt "murdered by life." Pele observed: "The painter's world was still a man's world. I liked Lucile's painting better than Arnold's but she played a distinctly second fiddle to the maestro."[11] This was certainly true of Frida as well.

But both Frida and Lucile enjoyed breaking the rules. Lucile reveled in creating erotica, something frowned upon by the male art establishment, yet she'd studied painting with Robert Henri and John Sloan, rebel artists

who depicted the marginalized.[12] At that time, the then twenty-seven-year-old Lucile had made a powerful androgynous self-portrait showing herself with short hair, wearing a gray artist's smock resembling a man's suit, and with a stern, confrontational expression. She looks like someone who would bond with Frida. But, according to Lucile, they didn't discuss their artistic ambitions or the challenges they faced as women artists.[13]

This isn't surprising. Most women artists of this period didn't talk about their work with one another or their shared experiences of living in a "man's world." But they certainly understood that they faced greater challenges than their male counterparts since few galleries, museums, or art schools would take them seriously. Dorr Bothwell, an artist who studied at the California School of Fine Arts, said Ralph Stackpole, who taught there, told the female students "the place they really belonged was in bed."[14] If a woman artist was lucky, she'd receive the common backhanded compliment from a male art teacher: "This is so good you'd never know it was done by a woman."[15] Despite such denigrating sentiments, many female artists still wanted feedback from their male counterparts. They knew that if they were going to get a break in the art world, it would most likely come through a man. Whenever an opportunity arose, women artists had to take advantage of it since they were often barred from the environments where deals were made.

In San Francisco, the all-male Bohemian Club offered a space where male artists could rub shoulders with some of the most well-connected men in the country. Women had little access to such clubs and there were few equivalents for female artists. But in this city, known as a lawless, rule-breaking place, women artists banded together and created their own group, the Sketch Club. It was here that women artists began to take each other's work seriously by sketching together and offering critiques. By 1925, with a change in name to the San Francisco Society of Women Artists, they branched out by organizing annual exhibitions held at the Palace of the Legion of Honor. Frida, though not a member of the society, benefitted: her American art debut took place at one of the society's annual exhibitions, where her marriage portrait was shown.

Frida's artistic collaborations with Lucile and Pele, two fiercely independent spirits, offered her a pivotal experience: a space where she could let loose and allow the creative juices to flow in an atmosphere of playfulness devoid of judgment.

The freedom to delve into taboo topics with creative abandon also allowed Frida to imagine the open possibilities of portraiture. She was part of a long line of modern artists who had explored new styles of painting through portraits. Previously, portrait artists were largely seen as copyists, people who had a good eye for faithfully reproducing a person's physiognomy but who weren't necessarily seen as innovative or brilliant painters. This changed in the modern period as fewer portraits were commissioned due to the advent of photography. Painters, from the Impressionists to the Surrealists, began experimenting with portraiture. They asked friends, lovers, and spouses to pose for them, expanding the parameters of portraiture with abstract and dreamlike styles, symbolic imagery, and unusual color combinations.

The dynamics of the modeling session changed as well. "It implied a lived intimacy between painter and sitter," art historian Joanna Woodall points out.[16] Depicting a friend or lover rather than a stranger eroded the boundaries between artist and sitter, often making the portrait as much about the artist's own feelings and ideas as the subject's. Jean Wight, who lived in the same building as Frida, eating and socializing with her and her friends, became an integral part of Frida's life. It seemed natural to ask Jean to pose.

One damp San Francisco day, Frida, with a short black sweater buttoned up over a long white dress, got to work. It was easy for Jean to come to her studio since she and Clifford lived "across an intervening roof" in the Montgomery Street flat in their own studio apartment.[17] Frida was thrilled to have the time to focus on her art, writing to her mother: "I'm fine, painting all day long."[18] However, Jean, a former fashion model, often impeded Frida's concentration by talking to her about the latest fashions. The tall, lanky Jean, with "blue open eyes and flaxen hair," had a "ready smile," John Weatherwax observed. She wore stylish clothes and hats along with an equally stylish hairdo she'd spent time perfecting. Frida wasn't as interested in discussing the latest fashion trends in such detail, but she tolerated Jean's chitchat.

When the topic turned to Jean's health, Frida became more attentive. She was curious to hear Jean's take on the best vitamins or the latest health regimes prescribed in the United States. Typically, however, the topic of

health led Jean into a diatribe about all of her ailments, making Frida's interest wane.[19] And Jean didn't speak Spanish. Frida had to concentrate hard to understand her English. Still, despite some of Jean's annoying habits, Frida was always nice to her, and in return Jean adored Frida.

Frida had Jean, dressed in a white shirt and pastel pink jacket, sit in a wooden chair with seat caning. In this portrait Jean is placed in front of a green, velvety-looking curtain pulled to the left and secured with a red tieback, revealing a city scene behind her. But it's her tight-fitting coral necklace that stands out.[20]

The red choker around her neck, with its spiky coral beads pressing up against her skin, heightens the feeling of constriction and alludes to tiny pricks that could produce blood. In Europe, parts of Africa, and Mexico, coral is associated with blood. At this stage of Frida's personal and creative life, it was the closest she could come to expressing her hot feelings in a painted portrait. Her choice of colors tells a symbolic tale. Jean's white shirt and light pink jacket connote Christian purity and femininity, while her red lips and choker convey intense "male" emotions, such as rage and passion, deemed unacceptable for a "lady." These taboo emotions are so strong that Jean is choked by them, but her cool facial expression attempts to put on a stoic and beautiful face for society.

Frida probably took pleasure applying red paint from her small brushes to Jean's necklace, knowing red is a potent color with many associations, including blood. Years later, she said, "I like to paint blood."[21] She must have thought the spiky coral added to the illusion of blood, because earlier versions featured a different type of necklace. The violent drawing she'd made with Pele and Lucile was an expression of unedited feelings created in a playful and experimental environment, just like the drawing she'd made back in December showing her standing next to Diego with physical distance separating them. The drawings allowed for more private musings, while the paintings are highly constructed images made with a public in mind, especially as Frida was trying to amass enough work for an exhibition. It was necessary to use a coded visual language to conceal some of her raw feelings, and hiding behind Jean also distanced Frida from exposing too much.

Frida was a passionate person who could have a physical response to injustice or Diego and his philandering. She "would remonstrate with a crescendo, culminating in hysterical screams," Dr. Eloesser observed.[22]

Frida commented on the double meaning of the Spanish word *coraje,* which translates in Mexico as "tantrum" but in Spain as "courage." "It is becoming violent when one feels offended or mistreated or when one sees an injustice," Frida said.[23] She had the courage to express her feelings, going into a furious rage when she felt mistreated by Diego.

Her fury is better understood when taking into account an observation made by Olga Campos, a psychology student in Mexico who became good friends with Frida in the late 1940s. She called Diego an "erotomaniac," someone with a psychological disorder marked by excessive sexual desire and the delusional belief that he or she is the object of another's sexual desire. "Diego was a kind of erotomaniac. When we would meet, and Frida was present, he would try to kiss me and force his tongue into my mouth. He would get a kick out of my repulsion and Frida's reaction. Frequently, he offered to paint my portrait on condition that I posed nude. I refused each time, so he never painted me."[24]

Given this statement and Diego's own admission that he was sadistic with the women he loved the most, Frida's intense reactions are understandable. But she lived in a world where men's philandering was by and large seen as normal and where women's strong emotional reactions were often denigrated as hysterical. Frida acknowledged in a tongue-in-cheek manner a Mexican saying that you can't trust a dog's limp or a woman's tears, implying that women dramatize their pain to wield sympathy. She wanted to reject this patronizing idea and embrace the understanding of *coraje* as courage, but Diego and Dr. Eloesser still viewed her as a hysterical screamer. After the intensity of her reactions subsided, Frida's guilt often kicked in. It was a lot of jumbled-up emotion to carry around, especially in the United States, where she felt like a stranger. At this point in her relationship with Diego, it was safer to project her own pain and anger onto Jean's "bloody" necklace.

The coral choker tightly wound around Jean's neck expresses a tension that lies just below the surface. It's similar to the mood Frida created in her Cuernavaca self-portrait, and it's a feature she will come to emphasize in her most famous self-portraits of the 1940s. In Frida's Cuernavaca self-portrait, the hint of emotional pain underneath a stoic face comes through her sad brown eyes. In the portrait of Jean, it's more challenging to read her emotions, because her blue eyes with small pupils lack the obvious white specks commonly used to create the illusion of light. This reflection of light

is crucial because it adds the "spark of life" to a painted portrait. Without it, Jean lacks depth. In a letter Frida wrote a few years after making this portrait, she complained that Jean didn't understand how the world worked. She didn't *see* how her words and actions could cause problems: "Out of sheer stupidity, she has complicated the situation, instead of shutting up about things she doesn't know."[25]

Frida understood, as she said, that "men are kings. They direct the world."[26] Therefore, it was imperative for women to understand how things worked. Jean might do well as a young, attractive beauty, but as Frida told Dr. Eloesser, "You know perfectly well that sexual attraction in women fades quickly, and afterwards they have nothing left but whatever happens to be in their thick heads to be able to defend themselves in this filthy rat race."[27] There's a biting poignancy in this observation. Carlos Fuentes thought Frida's "humor, her language, her own very personal *chutzpah,* were ways of defending herself against the bastards—*Defenderse de los cabrones.*"[28] But Jean, according to Frida, didn't know how to defend herself, and her vacuous eyes convey this.

The architectural landscape seen over Jean's shoulder provides further clues about Jean and her place within a man's world. A cream-colored high-rise, a brick façade, smooth-faced red and rectangular cubes, and pink triangular roofs fit together like a puzzle outside Jean's window. The red buildings match Jean's red necklace, and the light pink triangular-shaped building echoes Jean's pink pastel jacket. To contemporary eyes, the comparison of a woman to architecture might seem innocuous, but in 1930 it posited a radical idea about women's independence. Georgia O'Keeffe understood firsthand how the ownership of architecture was perceived as a male domain.[29] Some five years earlier, she'd been told she couldn't paint the "male" subject of modernist buildings. Georgia, the sole woman in the New York Stieglitz circle, proved her male colleagues wrong when she created a bold series of paintings depicting a variety of high-rises from multiple perspectives.

Frida, like Georgia, rejected the standard image of woman as nature. As a lover of verbal/written wordplays, inside jokes, and coded visual imagery, Frida made a creative choice to paint a decorative motif at the top of the high-rise in the shape of a breast and nipple, literally marking her high-rise female (originally, the building was made to look like a church with a cross at the top). By declaring Jean part of the "masculine" world, Frida

offers the flip side of Diego's *Allegory of California* mural, where woman symbolizes nature.

Frida's interest in the shapes of the buildings behind Jean connects to a larger fascination with geometric shapes and a respect for the ancient mathematical underpinnings of compositional structure that the Renaissance painters employed. For example, she experimented with organizing her compositions to draw the eye to certain areas of the painting. Renaissance artists such as Leonardo had turned to the golden rectangle (also referred to as the golden ratio and golden section), a mathematical ratio going back to ancient times. Pythagoras said the golden ratio was the basis of the proportions of the human body, a theory Leonardo proved with his *Vitruvian Man*.

For some unknown reason, art that employs the golden rectangle seems to be more pleasing to the eye. Frida, like Leonardo before her, was drawn to this ratio. Both artists experimented with different ways of eliciting strong responses from viewers. Even at a young age, Frida observed: "I liked geometry class because everybody would draw very pretty angles and spheres in colors."[30] Years later, she drew the golden section in her diary to try to figure out a still-life painting. She sketched fruit within a rectangle and used lines and drawn eyes to convey where the eye would focus.[31]

Without a preliminary drawing for her portrait of Jean, it's difficult to know if she used the golden section to organize it. But the eye is drawn to Jean's earring, necklace, and lips. The section just behind and to the right of the gold earring holds the symbolic shapes of red squares, rectangles, and pink triangles.

Diego shared Frida's interest in the golden section; he used all the same geometric shapes in his *Allegory of California* mural. Discussions of how to best organize his wall and ceiling murals were ongoing just before Frida began her portrait of Jean. The writer John Weatherwax remembered Diego and Albert Barrows, an architect and mathematician who taught at the California School of Fine Arts, pondering some of the geometric challenges inherent in Diego's mural designs at the Luncheon Club.[32] They figured out how the eye would move around the space of the wall mural as well as

the mural on the ceiling, and they used the golden section to balance and harmonize the two murals.[33] The wall mural approximates a rectangle; the ceiling is a square with a diagonal figure bisecting it to create two triangles with their bases touching.[34]

Color symbolism furthered this idea of harmony and balance in Diego's mural. One example is found on the wall (considered the earthly realm). A young man (the model was Stack's son Peter) stands just right of center holding a model airplane with a white body, red nose, and gold propeller, the identical colors seen on the same parts of Frida's plane in her *Self-Portrait: Time Flies* created in Mexico. These two airplanes bring together the alchemical colors of the Red King, the White Queen, and their Golden Child.

Diego said the young man holding an airplane symbolizes the future.[35] And the airplane, held in a downward diagonal, creates a line that leads to James Marshall in the far right panning for gold, the highest form of matter in alchemy. In Frida's portrait of Jean there's no airplane, but white, red, and gold are strategically placed just right of center, like the young man's airplane in Diego's mural: Jean's gold earring dangles right of center and the red necklace and white shirt are seen below. Perhaps this is mere coincidence, but looking at Frida's and Diego's bodies of work, it's clear that they participated in a visual dialogue throughout their lives.

Similar to Frida's questioning of gender norms by symbolically connecting Jean to a "masculine" architectural landscape, Diego used a coded language to question racial violence. Behind the young man holding an airplane in his mural, a large lumberjack sits next to a huge tree stump. This coastal redwood stump, with its distinctive knotty, ropelike base, conveys some of the ills of the modern world, the most obvious being the destruction of nature for profit. But Emmy Lou Packard, one of Diego's mural assistants, observed that hidden within the tree stump are decapitated black male bodies.[36] Although such body parts are not obvious when viewing the mural, the trunk's knotty base, particularly on the right side, possesses sections that resemble black penises, perhaps alluding to mutilated, lynched black male bodies. Indeed, the high-profile Scottsboro

case was headline news thirteen days after Diego finished his mural on March 12.[37]

Nine black youths were accused of attacking a group of white teenagers and raping two white women while traveling on a Southern Railroad freight train from Chattanooga to Memphis. When the accused were taken off the train in Paint Rock, Alabama, they were arrested for assault and rape and brought to a jail in Scottsboro, Alabama. Word spread fast, igniting rage. A lynch mob surrounded the jail, demanding to take justice into their own hands, but they were turned back.

The court battles involving the nine young men, known as the "Scottsboro Boys," lasted years. It was one of the most important legal fights for racial justice, ultimately leading to the civil rights movement. The case galvanized an already divided country, intensifying schisms along racial, geographic, and political lines. For Frida and Diego, it was one of many inflection points they experienced while living in the United States. Despite the disquieting body parts in Diego's mural, his assistant Emmy Lou saw hope. In the far right section of the tree stump that most resembles two penises, she noted a small evergreen sprouting new life. This *Sequoia sempervirens* with its extensive underground root system, she said, was "the only redwood that grows new trees after being cut down." She sees this as "Rivera's prediction that these people [African Americans] will grow again."[38]

Diego did not portray a regal, courageous, and beautiful black woman as the allegory of California. Instead, he seems to have snuck in cryptic images of mutilated black men—a sign of the times, as lynchings were on the rise, giving birth to the Association of Southern Women for the Prevention of Lynching.

Frida and Diego were both working out complex ideas on the formal and symbolic levels. The syncretic system that allows for more than one philosophy and one set of symbols to coexist is central to Diego's and Frida's creative processes, but neither had succeeded in creating their best work with these two paintings. Instead, they incorporated new ideas and images during their time in San Francisco and attempted to commingle them with ideas and imagery grounded in Mexican traditions. Ultimately, Frida

wanted to be an authentic artist, to paint for the people of Mexico. This meant utilizing a style informed by a variety of Mexican traditions with a particular emphasis on "popular paintings"—colonial-style works and Catholic *retablos* created by untrained artists. Hermenegildo Bustos and José Maria Estrada were two of her favorites.[39]

As much as Frida strove to create authentic art, she wasn't able to express her feelings and ideas in a direct manner. As a result, she hides behind Jean, which is one reason the portrait lacks the emotional intensity and the creative sophistication seen in her self-portraits of the later 1930s and 1940s. But Jean's portrait is important in Frida's development as an artist. In this painting she tried out many of the ingredients that she'd go on to utilize in her later work.

Frida's *Portrait of Dr. Leo Eloesser* is another example of a modern portrait that erodes the boundaries between artist and sitter. She was still experimenting, trying to create a heartfelt expression of endearment for her new friend. If her friendship with Jean involved mixed feelings of annoyance, empathy, and delight, her friendship with Leo was filled with admiration, respect, and love. It was also intimately connected to her relationship with Diego, something she highlights in the portrait.

When Frida first arrived in San Francisco, she had to contend with the frenzied pace of Diego's activities and with *his* friends and new female flirtations. When Dr. Leo Eloesser entered her life that first day, he immediately became a stabilizing force. Regarding Frida's health, his thorough examination and recommendations proved to be beneficial to her overall physical and mental well-being. But he found that as much as Frida respected his opinion, she didn't always follow his suggestions or stick to them. If she skipped an appointment for her injections or drank too much alcohol, her *queridísimo doctorcito* (dearest little doctor), as Frida liked to call him, was there to steer her in a healthier direction.

But when the doctor took off his white lab coat, he became Frida's confidant, a comrade who felt the sorrows of humanity as deeply as she did. They had a lot in common. He possessed an analytical mind that helped with his diagnostic acumen and his proficiency in many languages, but he also had a sensitive artist's soul. Frida too had an analytical mind, and

she'd had a lost dream of becoming a doctor. She read books on a myriad of subjects and constructed small painted worlds filled with the symbols of many cultures and religions. She too had the type of mind that could retain many languages. Dr. Eloesser was a Renaissance man and Frida a Renaissance woman. To show her appreciation for her *queridísimo doctorcito's* friendship and medical care, Frida painted a portrait of him.

He posed for her at his flat at 2152 Leavenworth Street, a place where he'd welcomed a multitude of artists of all backgrounds, re-creating the environment in which he grew up. Leo's father, a successful businessman who manufactured Can't Bust 'Em overalls, had played the piano.[40] Young Leo and his three siblings took music lessons, with Leo devoting himself to the viola. His German immigrant parents surrounded themselves with friends who were artists, writers, architects, and musicians, providing their children with a stimulating intellectual and creative environment. Leo's sister, Helen, studied art and married a sculptor; his aunt, Julie Heyneman, became a professional artist and studied in England with the renowned painter John Singer Sargent.[41] Through her connections Leo visited England and other parts of Europe, where he visually devoured art and architecture.

Leo, at the urging of a family friend, decided to study medicine instead of music. He opened a private practice and eventually became chief of Stanford's Thoracic Surgical Service at San Francisco County Hospital (today called Zuckerberg San Francisco General Hospital), as well as a clinical professor of surgery at Stanford's School of Medicine, then located in San Francisco.

When Frida met Leo, he was described as a workhorse. Carl Mathewson, Leo's junior associate at the hospital, said he had "no concept of time, day or night."[42] His colleagues respected him as a physician, teacher, and surgeon. His patients adored him because they could depend upon him to provide care, even if the patient couldn't pay.

But the middle-aged man with boundless energy always made time for his first passion: music. Every Wednesday night, he held a soirée at his flat with members from the San Francisco Symphony Orchestra, including the brilliant young violinist Isaac Stern. With Leo on viola, they played into the wee hours. When not playing with others, Leo practiced bowing long, even notes while gazing at one of Gottardo Piazzoni's landscapes propped up on a table.[43] Leo adored this Swiss-born painter who had grown up in Carmel

Valley and devoted his life to capturing California's landscapes, especially the sunburned hills of Marin County.

On the nights when Leo wasn't playing music, he might be found sailing his thirty-two-foot schooner on the bay with a female companion, sometimes casting off from the dock around midnight, when his medical duties ended. As a physician, he was devoted to his patients. As a man, he led an independent, bohemian lifestyle, saying, "I hate domesticity."[44] Like Frida, he was a renegade, and some of this is hinted at in Frida's portrait of him.

Just five feet tall, Leo stands in the corner of his Leavenworth Street flat wearing a black suit with a nineteenth-century upturned stiff white collar and maroon tie. With one hand in his pocket and the other resting on a green table next to him, he looks elegant in an "old world" manner. Yet his head juts forward and his eyes are filled with intensity. His large, worker-type boots look similar to the ones Frida painted on Diego in the marriage portrait. Dr. Eloesser may have worn these boots, but they seem at odds with his dapper suit. Perhaps Frida inserted them to convey Leo's commitment to working for the people, taking care of the needy without pay.

Forty-nine-year-old Leo, the child of German immigrants, would have felt familiar to Frida because of her fifty-nine-year-old, first-generation German Mexican father. In addition, both men possessed detail-oriented minds, an appreciation for aesthetics, and compassion for the dispossessed. Frida was the same.

Even though Leo was American, he spoke Spanish like a native and empathized with Frida's consternation concerning the disparity of wealth between the rich and poor in the United States. He also understood her identification with alchemy, referring to her as "my soul of gold . . . and quicksilver (to [melt] gold)."[45] They had a soul connection, and in the portrait Frida connects Leo to Mexico by utilizing the colors of the Mexican flag—the green table, the red and green of the model schooner, and the whites of the three sails. The model sailboat sits on the table to the left of Leo, and a drawing signed "Diego R." hangs on the wall to the right.

Frida's interest in a triangle as a stand-in for her identity comes through in this portrait with her repetition of the number 3. She wrote "Los Tres Amigos" (the three friends) across the red hull of the sailboat, which possesses three sails. The one on the far right is the largest (Diego); the one on the far left is the second-tallest (Frida); and the one in the middle is the shortest (Leo). Leo is placed in between Frida and Diego because this is the

role he played in their lives. He was the peacemaker and a loyal friend to both. With this threesome, Frida had found more balance than with Helen and Diego, as Leo had a cooling effect on the tumultuous energy between Frida and Diego.

It helped that Leo knew Diego quite well by the time Frida made his acquaintance in San Francisco. Leo had first met Diego when he accompanied Stack on that 1926 trip to Mexico. The doctor found Diego mesmerizing, witty, and perceptive, with a tireless energy. He could talk anyone under the table. While arguing about an issue, he would throw out a "barrage of lies and false statistics against which a scholastic opponent had no parry," Leo recalled.[46] He also, Leo said, told tall tales, such as the one about fighting in the Boer War in South Africa.[47]

When Leo met Frida four years later, he could see why Diego was drawn to her. At a dinner in Diego's honor, Frida mesmerized Leo because, even though she spoke little English, she unleashed a "candescent barrage of wit, story and Mexican song that wilted" the guests, he said.[48] Diego, Leo, and Frida were well suited to one another in terms of their temperament, intellect, wry sense of humor, and artistic sensibilities. The three would remain close for the rest of their lives. And even after their deaths, this trio remains intact in the lobby of Zuckerberg San Francisco General Hospital, where Frida's *Portrait of Dr. Leo Eloesser* hangs alongside Diego's *La Tortillera*. Both paintings had belonged to Leo and were donated to the University of California, San Francisco with the provision that they permanently hang at the hospital.[49]

Frida's *Portrait of Dr. Eloesser* reminds visitors to the hospital that this man once played a central role tending to the sick and vulnerable. Such a portrait, created to give thanks for friendship and good medical treatment, is not new within the history of Western art. There are several well-known examples, but Vincent van Gogh's *Portrait of Dr. Gachet* is probably the most famous work of modern art intended to thank a doctor. Just as Dr. Eloesser was more than a physician for Frida, Dr. Gachet did more than provide good medical treatment for Vincent. Frida's homage to her doctor and confidant shares with van Gogh's portrait of his doctor and friend the desire to recognize a man with whom she felt a deep connection. But her cross-cultural style ref-

erences two other artists close to her heart—Henri Rousseau and José Maria Estrada.

Both of these painters demonstrated what it meant to be an authentic artist. Rousseau, a French artist, was considered an intuitive genius, and for this reason was labeled a "primitive." Frida, Diego, and Leo admired Rousseau's fantastical "Mexican" jungles and his unusual spatial relationships. Leo and Rousseau had some things in common: Leo played viola, Rousseau had played violin; Leo held weekly music soirées, Rousseau had done so as well. Perhaps this connection to music explains why there are some striking similarities between Frida's portrait of Leo and Rousseau's *Self-Portrait as Orchestra Conductor* (1907).

Likewise, there are some similarities between Frida's portrait and Estrada's *Portrait of Don Antonio Villaseñor Torres,* which Frida and Diego owned, and which still hangs in Frida's Coyoacán studio today. Estrada was a nineteenth-century Mexican artist who had studied European styles of art at the Academy of Mexico City but rejected the academic style in favor of a popular art form found in his native state, Jalisco. He was meticulous with details, yet didn't use linear perspective, making his style look as if it were guided by intuition—qualities that were important to Frida. Even though Estrada's portrait features a young boy and Frida's a middle-aged man, the subjects' formal attire and small stature, as well as the sparse interior spaces with slanted floors, lend them an unmistakable similarity.

Despite being only twenty-three years old, Frida had the soul of a sage, especially after the transformational experience of nearly dying as a teenager. After the accident, she longed for the mysterious aspects of life. Art fulfilled that longing. In the process of creation, Frida retrieved some of the magical and mysterious aspects of life, because as conscious as she was about her sources, she never knew exactly how an image in her mind would live on the painted surface. In an essay Leo wrote called "Form and Color in Medicine," he asked what it is we see when we look at an object, and wondered how we go about representing it for others.[50] It's a central question about perception. Frida was a seer. She saw beyond the surface of objects and people. In her painted worlds, she represented both surface reality and the underpinnings of a symbolic realm, one informed by the language of

alchemy, Pythagoras, the golden section, Aztec duality, Mexican colonial paintings, *retablos,* and European art.

Frida's portraits of Jean and Leo are the stepping-stones of her mature style. San Francisco was a time of creative freedom, allowing her to use the drawing sessions with Lucile and Pele to delve into taboo topics, and the studio time to synthesize her disparate influences for emblematic painted portraits. And, whether she knew it or not, all of her experimentation was about to pay off.

Luther Burbank's Hybridity

Heredity is nothing but stored environment.

—LUTHER BURBANK

Little did Frida know that when Stack and Ginette whisked her and Diego off to see what treasures lay north of the bay, she would have two of the most powerful experiences during her stay in Northern California. They were headed toward Monte Rio, some seventy-four miles away. Driving along the winding road that follows the Russian River, Frida was surrounded by redwood trees. Many San Franciscans flocked to the Russian River area by train to see big bands such as Horace Heidt and Glenn Miller, who played at the theaters there. The area was so popular that some ten years later the movie *Holiday Inn*, starring Bing Crosby and Fred Astaire, would be filmed at the Village Inn Resort.[1]

Stack took Frida and Diego to a locale not far from that resort: the Bohemian Grove, an offshoot of the Bohemian Club in San Francisco, of which Stack was a member. The men-only club, which opened its doors in 1872 at Taylor and Post Streets, was a place where journalists, artists, actors, writers, wealthy businessmen, and politicians gathered to drink, smoke, chat, relax, and make connections. Twenty-seven years later it expanded with the purchase of 2,700 acres of land in Monte Rio, which became the Bohemian Grove.[2] Now these club members could completely

leave life's stresses behind when they entered a forest of tall sequoia redwoods.

Early on, the Bohemian Grove began sponsoring an annual three-weekend-long July gathering, which continues to this day. Activities include noontime talks beside a man-made lake, drama and comedy performed on one of the two outdoor stages, and meals served in a large, circular open-air dining hall with tables and benches made from cut logs.

The Bohemian Grove was, by and large, forbidden to women; Frida would have been permitted to visit only as Stack's guest at certain times (not during the July retreat) and was allowed only in certain areas. But she felt a reverence as she stepped onto the grounds on a lovely autumn day, exclaiming to her mother: "Yesterday, Sunday, we went to . . . eat at a divine forest. You and Dad would have loved it. There are huge trees that are over 1,000 years old, a frozen lake and two theaters made from tree trunks. Something divine, we were very happy."[3]

Another time Stack and Ginette took Frida and Diego to Luther Burbank's house in Santa Rosa, also north of San Francisco. The famed botanist and horticulturist had been dead for four years, but his widow, Elizabeth, still lived there and was happy to entertain visitors and discuss her husband's legacy. When Frida, Diego, Stack, and Ginette arrived at the Burbanks' modest brick home, they would have seen a large prickly pear cactus—but sans spines. Frida must have been overjoyed to see this cactus, but perplexed when she noticed the lack of sharp needles. Luther had experimented for nearly twenty years to develop the thornless cactus, and it hadn't been easy. He often talked to the cactus, saying: "You have nothing to fear. You don't need your defensive thorns, I will protect you." Gradually he made progress: "The useful plant of the desert emerged in a thornless variety." Luther thought the new cactus might make it possible to raise cattle in the desert, but in the end "cactus as cattle forage proved impractical."[4]

Luther was not a typical horticulturist. Self-taught, he gained renown by creating more than eight hundred varieties of hybrid fruits, flowers, vegetables, trees, and other plants.[5] He had been inspired by Charles Darwin's theories and applied them to his work, writing, "Nature selected by a law the survival of the fittest; that is, inherent fitness—the fitness of the plant to stand up under a new or changed environment."[6] This intrigued

the scientific world. Scientists wanted to know what Luther was doing to produce these new and heartier varieties. Yet his methods were a bit mysterious, as he recorded them in a cryptic language that only he understood. It frustrated his fellow scientists, who wanted to re-create his experiments and the groundbreaking approach that had helped transform agriculture.

Frida and Diego wanted to see his gardens and feel his presence. The grounds were magical, the trees bursting forth with many unusual fruits, including the plumcot—part Japanese plum, with its soft flesh, and part California apricot, with its distinctive scent. Most had said it was impossible to cross two trees with such different types of fruit, but Luther accomplished it. He also created a blight-resistant potato, the russet Burbank; a white Shasta daisy hybridized from four different daisies; a winter rhubarb; a soft-shelled walnut; and a crimson California poppy. Luther was already well known in the United States when in June 1893 his work became recognized internationally with the publication of an illustrated fifty-two-page catalog called *New Creations in Fruits and Flowers*. Newspapers began referring to him as "the Edison of horticultural mysteries" or "the Wizard of Horticulture."[7] Even artists such as Georgia O'Keeffe subscribed to the catalog for its beautiful illustrations of these crossbred fruits and flowers.

In Frida's eyes, Luther must have seemed an alchemist, transforming existing varieties of plants into new ones. He sought to improve the quality of vegetables and fruits by selecting for desirable characteristics. And he used cross-pollination to create "the widest possible range of variation."[8] He eventually came to see his theories as applicable to humans as well. He stressed the importance of combining heredities "so that we get variations—powers and characteristics and capabilities and possibilities that could not come to us from one straight and undeviating line of ancestry."[9] This was a controversial perspective in the United States at the time, as many prized preserving a small, so-called superior gene pool, understood as Nordic and Anglo-Saxon. The idea that there were "superior" genes was no doubt something Frida had heard before, as Minister of Education José Vasconcelos had articulated a similar theory, with Iberoamericans as the "superior" group, though he had promoted the spread of those genes through racial mixing, something that was anathema to those who wanted to keep the races separate.

In the United States, the desire to protect the "superior" races from becoming infected with "inferior" genes prompted the creation of the American

Eugenics Society in 1921. The society lobbied for forced sterilization laws as one means to prevent cross contamination; restricting immigration was another. A new Immigration Act in 1924 limited the number of immigrants allowed into the United States and established national origins quotas that favored those coming from the British Isles and Western Europe over those from areas such as southern Europe, Eastern Europe, and Mexico, with Asians completely excluded.

Luther's perspective on hybridity made him a radical, something Frida would have admired. For Luther, heredity was important, but environment was also crucial, and especially when it came to personality traits in humans. He likened the relationship between environment and heredity to a building: heredity provides the foundation, the shape of the edifice, and its position in the ground, but "environment is the architect of the structure."[10]

Luther's ideas became public as a result of the 1925 Scopes trial in Dayton, Tennessee, a case that in its larger implications pitted Darwin's theory of evolution against Christian creationism. John Scopes, a Tennessee substitute high school teacher, was accused of violating the state's Butler Act, which made it unlawful to teach evolution in state-funded schools. The trial featured high-profile lawyers—Clarence Darrow defended Scopes and William Jennings Bryan argued for the prosecution—and a huge number of journalists from around the country swarmed the small town. Famed journalist H. L. Mencken dubbed it the "Scopes Monkey Trial," a reference both to the circus environment and to Darwin's idea that humans and apes had evolved from the same ancestors. While Scopes was initially found guilty, the verdict was later overturned on a technicality. Still, the trial did not close the door on the science-versus-religion debate. Rather, it brought the contentious battle to the forefront of political discussions, as thirteen states considered similar legislation to Tennessee's Butler Act, barring teachers from discussing evolution with their students.

Luther felt the trial was making a mockery of Darwin's groundbreaking ideas and was disturbed that science was under attack, and so the usually private man began to express his opinions. When *San Francisco Bulletin* reporter Edgar White interviewed him, Luther made many points in favor of science and critical thinking, but the statement that received the most attention was when he commented of Christ: "As he was an infidel then, I am an infidel today." He used such language in order to wake people up,

wanting to encourage self-reflection, especially in relation to the debate over teaching science in schools.

While this controversial declaration may have sold many papers worldwide, it ultimately incited a "whirlwind of hatred," as his friend Wilbur Hall recounted. Within twenty-four hours, Luther was inundated with angry letters. Yet he also received bagfuls of mail from supporters. Although he was seventy-seven at the time, he tried to answer every single letter, but the task was too exhausting, and he died of a heart attack a few months later. Those who deplored Luther's "blasphemous" words wished him forgotten. But for those who supported his perspective, he became a brave defender of independent thinking. Frida saw him as a hero.

Luther was not an atheist. He felt a reverence for the natural laws of the universe and for Christ's teachings, such as "Love thy neighbor." But he also saw religious dogma as a negative force blinding people to facts. In his eulogy, given by Judge Ben Lindsey, Luther was quoted as saying: "I love everybody. I love everything! I love humanity—I love flowers—I love children—I love my dog—I am a lover of the man Jesus—I am a lover of all things that help." This sounds like the pantheist Frida: "Love is the only reason for living." Both Luther and Frida knew that all living things were intimately connected and that humans needed to work together to honor the laws of nature. This is why Luther wanted to be buried in nature, so that his body could be reabsorbed back into the great mother earth. He said he wanted to "feel that his strength was flowing into the strength of a tree. He wanted his memorial to be a living one."[11] His wishes were honored: he was interred in his yard under a huge double-trunked cedar of Lebanon, one he'd planted from a seed he received from the Holy Land.

Frida and Diego were photographed standing in front of the massive twin trunks, the evergreen branches hanging over them like huge arms of protection. In the photo they both look happy; Frida's smile is so wide that her teeth are visible, a rare event. Was she thinking about the cedar tree she used to take refuge under as a child, shouting and laughing at the memory of her imaginary friend? It was a journey young Frida had cherished. Now her pilgrimage to Luther Burbank's charming garden filled her with a spontaneous joy rarely seen in photographs of her. Perhaps she was

also thinking of Luther as akin to the ancient Mesoamericans who saw an intimate connection between humanity and the natural rhythms of life.

After touring the gardens and the interior of the house, Frida, Diego, Stack, and Ginette stayed for dinner with Mrs. Burbank and her niece Betty Jane. They had a wonderful time, and before heading back to San Francisco, Frida wanted to take a picture of the group. As she readied her camera while Diego, Ginette, Mrs. Burbank, and Stack stood waiting, Luther's beloved dog Bonito ran into the picture frame. On the back of the photograph, Frida listed everyone's names and a short note for her mother, stating how much she liked Mrs. Burbank, who was "very simple and nice."

In another photo with Frida, Diego, Mrs. Burbank, the Stackpoles, and Betty Jane, Frida's complexity stands out, as she's the only woman wearing pants and a man's button-down shirt, embellished with a kerchief.[12] To top it off, her hair is pulled back close to her head in a "boyish" style. In contrast, the other women wear dresses and sport fashionable hairdos. Here her look harks back to the defiant young girl, clad in overalls, riding her bicycle as fast as she could through the streets of Coyoacán with a group of boys. It's also reminiscent of the outfit she wore after joining the Communist Youth League. Perhaps she wore her boyish, proletarian outfit to show solidarity with Luther, a fellow radical ahead of his time.

Frida told her mother that Luther was "a wise local man." Back in her studio, she turned her identification with Luther into an otherworldly painting where the horticulturist stands tall as a hybrid—half human, half tree. From the thighs up, he looks like the genial Luther Burbank seen in photographs, wearing a suit and holding a plant. But from the knees down, he has sprouted a tree trunk that ends with many roots growing into the skeletal remains of a body—understood as his own—lying underground. This portrait is a major departure from any Frida had painted up to this point.

Most connect Frida's abrupt shift in style to an encounter with Surrealism and the Italian artist Giorgio de Chirico, who inspired the Surrealists. De Chirico's work was on view at the Palace of the Legion of Honor from January 20 to February 19, 1931. Frida was certainly at the museum in December 1930 for Diego's exhibition, but she doesn't men-

tion seeing the de Chirico exhibit in any letters home. Nevertheless, it's easy to imagine her admiring de Chirico's dreamlike paintings and his unusual juxtapositions. But there's one problem with this theory. Even if Frida had seen the de Chirico exhibit before painting her portrait of Luther, that would not clarify her shift in style. Her painting doesn't share obvious stylistic characteristics with the works shown at the Palace of the Legion of Honor. If Frida was influenced by an exhibition, then it's just as likely that Utagawa Hiroshige's Japanese woodblock prints had resonated with her.

Hiroshige's exhibit (November 20 to December 31, 1930) overlapped with Diego's (November 15 to December 21, 1930). From letters she sent home, Frida revealed she was at the museum on two occasions while Hiroshige's exhibit was on view, December 10 and 12. Although Frida's *Portrait of Luther Burbank* does not look derivative of Hiroshige's prints, it shares a love of nature. For example, Hiroshige foregrounds trees in a landscape, sometimes placing them in the center, just as Luther, the tree/man, stands tall in the center of Frida's composition.

But neither Hiroshige's prints nor de Chirico's paintings explain Frida's creative breakthrough. Instead, it seems more plausible that de Chirico's dreamlike imagery and Hiroshige's foregrounding of trees and nature appealed to Frida because she was already steeped in several Mexican traditions: the use of nature as a nationalist motif in modern Mexican paintings, the dreamlike scenes found in Mexican *retablos,* the hybrid imagery seen in Aztec art, and the fantastical bird figures and painted beasts of Paolo Uccello described in Marcel Schwob's *Imaginary Lives.* This book, which Frida had adored before she ever considered being an artist, declared Uccello was not concerned with the reality of things. And it's important to remember that Frida had already attempted to paint a subject outside of reality—in *Frida and the Caesarean Operation,* she depicts what looks like an out-of-body experience. With this unfinished painting, she'd attempted to incorporate aspects of a Surrealist style. If she did see de Chirico's paintings in San Francisco, they would not have been a complete revelation.

Like *Frida and the Caesarean Operation, Portrait of Luther Burbank* is not concerned with the reality of things per se. It too is a metaphysical musing on the intimate connection of life and death, but in this portrait Frida makes Luther Burbank the focus. Kahlo scholar Sarah Lowe says

that Frida "ingeniously combines different levels of knowing and being" in this painting of Luther.[13] Frida's levels of "knowing" concerning the delicate and reciprocal relationship between life and death had taken hold six years earlier when the bus accident forced her to look *la pelona* in the eyes. Miraculously, she came back to life. But this portrait of Luther was one of Frida's first paintings to explicitly depict a metaphysical subject in an otherworldly style. Why now?

Sometimes a leap in style isn't the product of merely seeing another artist's work. It can happen for many reasons, some conscious and some not. Frida, at a formative period in her creative development, had been exposed to many new sights, experiences, artists, and ideas while living in a foreign country. Her encounters with the unusual environments of the Bohemian Grove and Luther's home and gardens had a major impact on her. Additionally, her creative experimentation with Lucile Blanch and Pele deLappe opened her up to new possibilities. As one looks at Luther Burbank's bloodied skeleton, Frida's words come to mind: "Let's draw the bloodiest thing we can think of."

The blood in her depiction of Luther's skeleton isn't from violence, like in one of the drawings created during her sessions with Pele and Lucile. But it's also not simply hinted at, as in Jean's red coral necklace. Instead, the blood courses through the skeletal remains under the ground. The roots of the tree/man flow into Luther's skeleton as if receiving nourishment from it. Frida's placement of the skeleton underground with a tree growing out of it was surely taken from Luther's actual burial spot under the Lebanon cedar in his yard, the same tree in front of which Frida had stood, feeling the soil under her feet.

Frida would have loved Luther's eulogy. It's possible that Mrs. Burbank gave her a copy or showed her a memorial card where some of it was printed. One paragraph in particular stands out, as it is the written equivalent of Frida's painting: "He lives forever in the myriad fields of strengthened grain, in the new forms of fruits and flowers, and plants, and vines, and trees, and above all, the newly watered gardens of the human mind, from whence shall spring human freedom that shall drive out false and brutal gods."

In Frida's preparatory drawing for the Luther painting, she visualized

this statement with Luther in the center as a tree/man surrounded by flowers, carrots, a fruit tree, and a leafy plant. Disembodied hands, presumably Luther's, are shown digging and planting. In the end, Frida simplified the imagery for her painted version, but she retained the idea that Luther lives forever in the new hybrid trees and fruit he created, as there are two fruit trees on either side of him. Her painted memorial, with his name across the bottom under his skeleton, allows Luther to live on as a "newly watered garden of the human mind."

It's understandable why Frida wanted to memorialize him. Her engagement with the magical forest of the Bohemian Grove, a place where men undergo a metamorphosis into primal beings, and her visit to Luther's gardens, the alchemical den of transformation, inspired her. She was "very happy," just as she felt after delving into her childhood world of make-believe. This childhood ability to slip into an alternate universe never left the imaginative artist. With her *Portrait of Luther Burbank,* Frida allowed this metaphysical world to live on the canvas. And the innovative nature of this rendition of Luther is even more striking when viewed in relationship to Diego's image of Luther.

In Diego's *Allegory of California* mural, Luther, who is featured on the right side, is shown in profile as he kneels to cross-pollinate a plant. He is one small part of a large painting featuring a huge Earth Mother. In contrast, Frida offers a frontal image of Luther standing in the center of nature. Instead of depicting an Earth Mother, Frida subverts the norm and gives us an Earth Father. The central figure/tree hybrid allows her to highlight his connection with nature, life, and death. Diego hints at Luther's powers of procreation, but it's subtle and connects to a joke about Luther that the architect Michael Goodman said was popular at the time: "He should cross a banana with a zipper."[14] According to Goodman, Diego thought this was quite funny, presumably because the banana is a stand-in for a penis—the implication being that Luther needed to find a way to keep a man's zipper closed to prevent sexual promiscuity. In Diego's mural, the tall brown plant Luther is pollinating has a phallic look.

Ostensibly, both artists were exposed to the same information and experiences while visiting Luther's home and gardens. Yet once again it's Frida who breaks with tradition and creates a more innovative image. Perhaps

Diego felt hampered by his stockbroker audience. He was certainly capable of creating inventive images, such as in his earlier mural at Chapingo, where he'd painted the deceased revolutionaries Emiliano Zapata and Otilio Montaño underground as if they were asleep in a sealed coffin-like space with corn growing above.

Frida's unconventional take on this life/death continuum is a testament to her brilliant mind and the way in which she was able to draw upon a plethora of information, images, experiences, feelings, and earlier art to create her own visual expression. Certainly, growing up in a society that honors the deceased during Day of the Dead celebrations and pokes fun at death and the upper classes with José Guadalupe Posada's animated skeletons laid the groundwork for Frida's use of the skeleton as both a representation of the deceased Luther and the receptacle of nourishment and life for the tree/man. These sources of inspiration were important for Frida in her quest to create authentic art for the Mexican people. An American friend, Rosamond Bernier, summed up Frida's love of Posada: "His point of view was all that was most Mexican."[15]

Images of life intertwined with death abound in Mexican culture, dating back to pre-conquest times, and Día de los Muertos is an extension of an Aztec tradition, a time when Mexicans acknowledge the intimate relationship between life and death. Frida's idea to make Luther a tree of life and death (*árbol de la vida y la muerte*) can be traced back to the Aztecs, who visualized the tree as a central component of their conception of the cosmos. Images of these trees can be found in their books, known as codices. Scholar Barbara Braun says some of these codices were preserved and reproduced in Lord Kingsborough's nineteenth-century *Antiquities of Mexico,* "a lavish nine-volume encyclopedia."[16] The Tree of the East from the Vaticanus B codex, re-created in Lord Kingsborough's book, has some striking similarities to Frida's painting of Luther.[17]

For the Aztecs, trees represented the four directions and the three realms of the universe—the heavens, the earth, and the underworld. In the Aztec design, a tree with a deity holding on to it connects the underworld of the dead to the center realm of earth and the top realm of the sky and heavens. Luther too connects all three realms. His skeleton, placed underground with the roots of the tree, represents the land of the dead;

the ground above, where the tree/man resides, is earth; and the upper sphere, in the form of a dark blue-black sky filled with white apparition-like clouds, is the heavens.

Frida overlays another Aztec symbol onto Luther, who is holding a philodendron, a plant native to Mexico. There is a photograph of him holding that plant, but in her painting Frida made changes, such as to the shape of the leaves. The Mexican philodendron or "basket flower" was prized by the Aztecs because of its medicinal and ceremonial properties, says art historian Lucretia Giese.[18] Frida makes explicit that this philodendron is a transplant by having its roots dangle in the air, something missing in the source photograph. Symbolically, it shows that the plant has been uprooted from its native Mexico and will not survive unless it is planted in Luther's garden. In his alchemical hands, there's the possibility for a new hybrid—this Mexican plant could be crossed with an American plant to create a new species, since Luther believed that both hybrid plants and hybrid humans "are what make the world go forward."[19]

Luther, the promoter of hybridity, was the perfect portrait subject for Frida, who was a *mestiza,* a person of mixed racial and ethnic backgrounds, part German on her father's side and part Spanish and Indian on her mother's side. While living in San Francisco, she too was a transplant. Like the philodendron in her painting, she wasn't putting down permanent roots. Frida, the *mestiza* living in a foreign environment, found in Luther Burbank a subject that could express some of the complexities of race and ethnicity within a landscape setting, a place that often symbolized what is natural. In Frida's painting what is natural consists of hybridity and the life/death cycle, which shows humans and nature working in concert with each other.

Frida wasn't alone in her depiction of an American in relationship to the land. Grant Wood's *American Gothic* (1930), the iconic image of a dour Anglo-Saxon farming couple, took the nation by storm after it was shown at the Art Institute of Chicago's annual exhibition of American paintings and sculptures. It won the Norman Wait Harris bronze medal, and its popularity led the Art Institute to purchase the painting. It was reproduced in numerous newspaper articles in 1930 and 1931, making it a well-known image.

It's also a painting that became tied to a group of artists, known as the Regionalists, who dominated American art during the 1930s. Their art focused on the people and landscapes of what they felt were underrepresented regions of the United States, such as the Midwest. In the isolationist thirties, when hard economic times had Americans looking within themselves and within their nation's borders for some type of respite, Regionalist art was supposed to be authentically American. In depicting the landscape of the United States and inserting people who were part of this landscape, the Regionalist paintings promoted a nationalist pride.

Because of the popularity of *American Gothic,* it's likely Frida would have seen a reproduction of it in a periodical or newspaper or heard of it from artists in San Francisco. Even if Frida never saw *American Gothic,* the different depictions of America created by these artists just one year apart are worth noting—it reveals just how groundbreaking Frida's image of Luther Burbank was for its time.

Grant Wood specialist Wanda Corn has written extensively on the artist's depiction of small-town folks who cling to the values of the past in an attempt to resist modernization.[20] But they also represent the backbone of America, as these Anglo-Saxon farmers were seen as steady, stoic, and thrifty—important traits during the Depression, when money was tight and issues of race were central to the eugenics movement and the restrictive immigration laws designed to keep America white.

Frida's painting, on the other hand, depicts a particular man, not a type. But, like the farming couple, Luther is white. The difference is that he is part tree and part human, and thus the embodiment of hybridity. In addition, the plant he holds is native to Mexico, emphasizing the importance of cross-cultural connections and ultimately recognizing that Americans were created from mixing (a controversial topic for many Christians; as scholar Gannit Ankori points out, many types of cross-breeding were "strictly forbidden in Scripture," such as Leviticus 19:19).[21]

Furthermore, Frida's tree, with its distinct roots growing into Luther's skeletal frame and the ground beneath, bears some resemblance to the tree in the American Eugenics Society logo. That logo shows the trunk of a tree in the center with the top of the branches cut off. The massive roots dominate the image and they flow outward and down toward the ground, just like the roots in Frida's painting.

Frida's design of the root system going into Luther's skeleton, however,

inverted the Eugenics Society's purist perspective, replacing it with Luther's emphasis on mixing. She was carrying on Luther's radical ideas, memorializing this man and his philosophy, which just four years earlier had provoked a cascade of hate mail. For Frida, his Mesoamerican, alchemical, and scientific approach to life and death was an inspiration for a completely new type of portrait.

Frida wrote her childhood friend Isabel Campos shortly before leaving San Francisco, expressing how living in this foreign place had been good for her because it had opened her eyes to new things.[22] That awakening had produced, in her *Portrait of Luther Burbank,* a culmination of creative sophistication. She drew upon a vast body of knowledge rooted in her Mexican upbringing, but synthesized it with the new experiences and information she had gained in California to create a powerful painting complex in its simplicity. This seeming contradiction sets the stage for the mature paintings to come.

IV

MEXICO

Interlude

It's impossible to take <u>more than four suitcases</u> when traveling with Diego or else arguments are guaranteed to flare up all trip long, which I would rather avoid, don't you agree?

—FRIDA KAHLO

 Portrait of Luther Burbank was one of the last paintings Frida created in San Francisco. At some point in late May or early June she returned to Mexico. A letter to her mother dated May 21 says, "I'm just waiting for the day when I can get on the train to go to Mexico."[1] Frida thought they would arrive "the 5th or 6th of June."[2] But another letter has come to light suggesting Frida returned earlier than her husband.[3] It's a love note on ornately decorated stationery with "paper doily" flourishes, and it is dated "May 31, 1931, Coyoacán."

Frida sent this love letter to Hungarian-born photographer Nickolas Muray, who lived in New York.[4] Nick, as friends knew him, had been going through a nasty divorce, so Miguel and Rosa Covarrubias invited him to visit at their home in Mexico. Miguel and Rosa, mutual friends of Frida and Nick, must have introduced the tall, thin, athletic Nick to Frida. Nick was an acclaimed photographer working for such magazines as *Harper's Bazaar, Vogue,* and *Vanity Fair,* but Frida was drawn to this charming, good-looking man for his lack of pretension.

Nick, like most men, was entranced by Frida. She was an unusual combination of a deep soul with a vivacious love for life. Nick, who had a

reputation as a ladies' man, had met his match. In one of Miguel's carica-
tures, Nick is depicted as a literal ladykiller. He is portrayed as a fencing
champion (he had been on the U.S. Olympic fencing team in 1928), illu-
minated by a photographer's spotlight. With one arm raised and the other
holding a saber, a smiling Nick, with his beguiling eye, large heart, and
bulging penis, is triumphant. His opponent lies underfoot: a nude, faceless
woman. The caricature emphasizes the lethal quality of Nick's love and
charm. But Frida was no ordinary "lady."

This is quite evident in the package she sent Nick on May 31.[5] She
made him a detailed collage of a bouquet of flowers with hearts and fish
on stationery with designs around the edges, mimicking a paper doily.
Frida cut out different types of flowers for her bouquet: daisies, lilies-of-
the-valley, and small pink blooms in the shape of hearts.

Frida makes clear in her note that the lily-of-the-valley represents
Nick—an interesting choice, as the flower both has a sweet smell and is
highly poisonous. It's the perfect metaphor for a woman embarking upon
an affair with a big-hearted ladykiller. As a lapsed Catholic, Frida was
surely aware that the bell-shaped flower symbolized the anguished tears of
Mary, a reminder that hearts could be broken and tears shed in this fraught
relationship.

On the other side of this carefully constructed flower collage, Frida
wrote in beautiful cursive and broken Hungarian: "Nick, I love you like an
angel. You are the lily of the valley, my love. I will never forget you, never,
never. You are my whole life. I hope you will never forget that. Frida."[6]
Then in English she added: "Please come to Mexico as you promised me!
We will go together to Tehuantepec, in August." At the very bottom of this
love note, Frida added a lipstick imprint, writing next to it: "This is espe-
cially for the back of your neck."

Frida's note shows that she'd been enticed by Nick's dangerous power.
But she added a unique component to this love note: she included the
drawing she'd made in San Francisco of her, Diego, and their aborted
child.[7] At the top of the drawing Frida wrote in pencil: "San Francisco
Calif., Diciembre 1930." Below, in red ink, she wrote a dedication: "For
Nick with love, Frida." Frida was telling this dashing lady-killer that she
was complicated, and any relationship between the two would be tricky
since Diego would always be in the mix. The way Diego's hand possessively
holds Frida's says to Nick: *Be careful with my jealous husband around.* Per-

haps Nick got the message; it doesn't appear that he returned to Mexico in August.

As it turns out, August was a busy month. Diego had two upcoming exhibitions and commissions, one in Detroit and one in New York. William Valentiner, the director of the Detroit Institute of Arts, had arranged for Diego to paint murals in the museum's courtyard. Frances Flynn Payne, an art advisor to Abby Aldrich Rockefeller, the creator of the Museum of Modern Art (MoMA), extended an invitation on behalf of that museum for a retrospective of Diego's work. It was a great opportunity to increase his visibility as a major modern artist outside of Mexico. And there was an added bonus for Diego: Frances offered to act as his dealer (with a 20 percent commission), arranging sales of his oils and watercolors to interested patrons.[8]

Frances was in Mexico helping Diego make arrangements for the exhibition. She was enthusiastic about his work, but as MoMA curator Leah Dickerman observed: "She also maintained a certain condescension toward her Latin American subject."[9] Frances indicated in a letter that she thought Mexican artists who were "Red" would trade in their convictions for recognition in the United States.[10] Frida must have picked up on this attitude, because she was always a bit suspicious of Frances.

As summer turned to fall, Frida was feeling uneasy about returning to Gringolandia, but in November she and Diego began their journey by ship to New York via Cuba, accompanied by Frances and Diego's assistant Ramón Alva Guadarrama. Diego loved the three-day trip, making art along the way—the easel painting entitled *The Rivals* was purchased by Abby Rockefeller.[11] Frida, on the other hand, discovered she didn't take well to the open seas. A terrible bout of seasickness made her feel as if "the grim reaper was going to take" her. A storm near Havana tossed the boat so violently that Frida threw up for two days. While Diego made fun of her, Frances acted as nursemaid, giving Frida enemas in an attempt to stop her vomiting and placing ice bags on her head and stomach. Both helped, and by the time they arrived in Havana, Frida felt much better. They spent the day walking around the island, and Frida rejoiced to her mother: "Havana is beautiful, very different from Mexico and from what I expected, and the people are very nice."[12]

On November 13, the SS *Morro Castle* sailed into New York Harbor. Diego was giddy, taking in the morning sunlight reflecting off the skyline. He admired the 1915 Neoclassical Equitable Building, with its two identical towers side by side shooting forty stories straight into the air. The new Art Deco Chrysler Building (completed in May 1930) rose even higher, at seventy-seven stories, and had just become the tallest building in the world. The silver spire at the top, made to look like a sparkling crown, must have dazzled Diego and Frida as they neared the dock. This Machine Age wonder may have seemed far removed from the pyramids of Mesoamerica, but Diego told a reporter for the *New York Herald Tribune,* "There we are on our earth, for whether the architects knew it or not, they were inspired in that design by the same feeling which prompted the ancient people of Yucatan in building their temples."[13]

In this proclamation, Diego was espousing the same Pan-Americanism that the sponsors of his MoMA exhibition were putting forth: that the United States and all of North and South America could emerge within this tumultuous and oftentimes divisive period with an authentically unified cultural and artistic voice. Diego affirmed, "We are all striving toward that perfection—all of us are, in all classes. I feel that we will succeed in this effort at cooperation."[14]

It was an exciting moment to be Diego Rivera. For Frida Kahlo, however, it was an uncertain time, and she braced herself for the winter to come.

V

NEW YORK

Duplicitous New York

*Everything here is pure show but deep down it's all real shit.
By now, I'm completely disappointed by
the famous United States.*

—FRIDA KAHLO

The heat was stifling, "worse than Cuernavaca," Frida told her mother.[1] Yet, it was mid-November in New York. If Frida was expecting to feel a chill in the air, she was mistaken. Not only was it warm outside, reaching into the seventies, it was even warmer inside. No fresh air, she complained, not even in the taxis.

Frida and Diego's room at the Barbizon-Plaza Hotel, at 106 Central Park South between Sixth and Seventh Avenues, was on the twenty-seventh floor. For $175 a month, they had a lovely view of Central Park, an electric stove Frida found "beautiful," a bathtub, a desk, a built-in cupboard, a sofa, three armchairs, a radio, and easy access to the Museum of Modern Art.[2] Frida drew a picture of the room in a letter to her mother, detailing every inch.

What she didn't tell her mother was that the new thirty-eight-story hotel was designed with artists in mind. It had opened in May 1930 as the first music-art residence center in the United States.[3] There were three large concert halls for music, dance, and theatrical performances, artists' studios, exhibition spaces, a glass-enclosed roof for indoor-outdoor athletics, and a library.[4] This luxurious hotel seemed to be cut off from the hardships of

the Depression. Frida admitted it was expensive to stay there, but Diego liked the proximity to MoMA.[5]

One of the first things Frida and Diego did after getting settled in their room was to go to MoMA, just two short blocks away, to see Diego's exhibition space and the studio where he'd be painting movable murals. At that time the museum was housed in six rooms on the twelfth floor of the Heckscher Building on Fifth Avenue and Fifty-Seventh Street. There the two spoke with Conger Goodyear, the president of MoMA. In a photograph of the three in what looks like Conger's office, Frida is perched up higher than the men on the arm of a couch, while Diego sits below and Conger is on a chair next to the sofa. Once again, Frida is the focal point, given her elevated position and lighter-colored outfit. In contrast to the men's dark suits, Frida wears a knitted European-style dress that covers her legs. Her large beaded necklace is the only sign of her love for the indigenous. Although Frida was always wary of the "bigwigs," thinking them pretentious, she hit it off with Conger.

Soon she and Diego were swept up into the social lives of some of the most prominent people in the United States. They all wanted to meet Diego and his lovely wife, and Frances, as Diego's art agent, wanted to make sure he met potential buyers. Frida's attitude about these get-togethers varied, depending upon whom she met. As she complained to her mother: "The high society lifestyle here is more stupid than you can imagine, the old bags bore me to death . . . On top of that you need to have a lot of dresses and shoes and everything since you can't appear shabby lest they eat you alive. They talk pure nonsense and their millions are always coming out of their snouts."[6]

If Frances had arranged the event, Frida was even more apt to gripe, as she did to her mother on November 23: "These past few days have been a real drag with old bag Paine who wants to make us *bizcos* [green-eyed with envy] by showing off her millionaire friends, but Diego and I just guffaw and don't pay her any mind, even though for Diego it's a real nuisance after working all day to have to don black-tie attire to go have dinner with a bunch of intellectuals."[7] Whether this really bothered Diego is debatable. He loved socializing, especially when he was the man of honor. Even Frida had to admit that overall, Diego was "in a very good mood."[8]

When Frida went to lunch and dinner at the Rockefellers' at 10 West Fifty-Fourth Street, she enjoyed meeting Abby and her son Nelson, saying,

"The old man's son is quite intelligent and pleasant."[9] Frida found Abby easy to talk to, especially since they shared many interests in terms of art and their disdain for what Abby called "race hatred or race prejudice."[10] She thought it one of the greatest causes of evil in the world. Featuring Diego's work at MoMA was one means of trying to combat anti-Mexican feelings. For Abby's husband, John D. Rockefeller Jr., who didn't care for modern art, smoothing over relations between the United States and Mexico was good business.

The Rockefeller family was a significant shareholder in Standard Oil of New Jersey, which had ties in Mexico going back to the nineteenth century. In 1931, Mexican oil companies represented only 1.04 percent of the total capital in oil production, with the majority owned by foreign companies such as Standard Oil and Shell.[11] The tense relations between the two countries posed a threat to these foreign-held oil companies, especially if Mexico chose to nationalize the industry (which it did in 1938).

Considering John D. Rockefeller Jr.'s business ties and his lack of interest in Diego's work, it's surprising that Abby requested that Diego re-create, on one of the walls of her home, a scathing mural he'd made in Mexico featuring her husband, Henry Ford, and J. P. Morgan.[12]

The mural, *Wall Street Banquet,* presents American capitalists dining on gold ticker tape emerging from a gold cash register set on the table in front of a closed vault. The tape runs down the long table, looping its way around a Statue of Liberty lamp at the far end. It's clear that the people at this table revere the gold cash register, preserved under a glass globe. Lady Liberty, Diego implies, symbolizes the liberty to indulge in and gorge on money. The caricatures of the men's faces—shriveled and grimacing—convey heartless capitalists.

Diego understood the potential problems that could arise with John D. Rockefeller Jr. if he took Abby up on her offer. He decided it was wise to turn her down. Nevertheless, it's curious that Abby would even suggest that Diego re-create such a controversial mural. It's possible that she felt some resentment toward her husband because of his refusal to completely fund the Museum of Modern Art, requiring her to find donors. And as the museum's treasurer, she struggled with making the museum's rent payments every month. Perhaps Abby also understood another message Diego had embedded in his mural—the third eye looking out toward the viewer from the side of the gold cash register. With the placement of this

eye, Diego hints that gold, prized by the alchemists as the ultimate form of spiritual and psychological purity, has been denigrated in the modern world, turned into mere currency to indulge the pleasures of the wealthy.

This was certainly Frida's observation while in New York, as she experienced the huge disparity between the wealthy and the poor. On the one hand, in her short time in this city she'd been surrounded by millionaires, socializing in their spacious homes, partaking of food and drink served by the hired help. On the other hand, she told her mother: "Witnessing the horrible poverty here and the millions of people who have no work, food, or home, who are cold and have no hope in this country of scumbag millionaires, who greedily grab everything, has profoundly shocked [us]."[13] Frida and Diego even visited a homeless shelter, where they saw people "sleep like dogs in a pen."[14] The experience inspired Diego to portray this grim reality in a painting called *Frozen Assets,* where bodies are placed side by side as if in a morgue, hidden away beneath the cranes of industry.

What Diego's painting doesn't show is the dearth of shelters for the large numbers of people in need—1.2 million people across the country had lost their homes in the first few years of the Depression.[15] In New York, roughly two thousand homeless people wandered the streets.

For some New Yorkers, the only way to survive was to build their own shacks out of wood or bricks. Soon encampments began popping up in various parts of the city. The most notorious was known as "Hoover Valley," named after President Herbert Hoover. This shantytown, comprising seventeen shacks, was set up in Central Park north of Belvedere Castle in the area known today as the Great Lawn.[16] Although the unemployed men in Hoover Valley had been arrested in July 1931, by wintertime even the wealthy residents of the new Fifth Avenue and Central Park West apartments didn't protest when the men returned. As weather conditions and the economy deteriorated, a modicum of sympathy appeared among the affluent. But Frida didn't hear much of it from the well-to-do people with whom she interacted. And even Diego, she told her mother, had started to "hate this country a little."[17]

Although the apparent contradictions between Diego's attitudes about the rich and his behavior toward his capitalist patrons didn't seem to bother him, the issue weighed on Frida's mind: "Unfortunately, he has to work for

these filthy rich asses."[18] And she acknowledged, "I have no choice but to put up with them since they are the ones who buy paintings."[19]

Frida felt more at home surrounded by art. Within the first week of exploring this "huge" city that seemed as if it could swallow her up, she found her way to the Metropolitan Museum of Art, located on Fifth Avenue at East Eighty-Second Street. She was immediately drawn to the Egyptian section, with its re-creation of a tomb "brought from Egypt stone by stone," some bas-reliefs, "magnificent sculptures from 4,000 and 6,000 years before Christ," household objects, and costumes, she wrote.[20] She also marveled at the "Greek archaic period, 3,000 years before Christ," and the "Christian, Roman, and Etruscan art."[21] She told her mother that she found "very good copies of the mosaics from St. Mark's in Venice" and saw some of the best art from the Medieval and Renaissance periods, as well as "originals by the Italian Primitive painters, German painters, and French Modern painters."[22] She enthused: "It's very interesting and one can learn a lot of new things."[23] Frida was also thrilled to see some original Goya paintings—"You have no idea how he painted."[24] She spent hours exploring the museum, her energy never waning.

Frida was spellbound when she came upon El Greco's *View of Toledo*. This oil-on-canvas landscape, which foregrounds green rolling hills and a small lake, pulls the eye up to meandering hills topped with gray-blue buildings, ultimately leading the viewer to a dynamic blue, gray, and white sky. It's a typical El Greco sky, filled with jagged, apparitionlike light and dark clouds, a quality Frida would draw on in later paintings such as *The Two Fridas* (1939). She found the colors "the most wonderful" she'd ever seen.[25] El Greco had painted his feeling of this Spanish city, and Frida responded with an exuberance that buoyed her state of mind.

A little over a month later, Frida created her own landscape. This watercolor, painted in thin washes of greens, browns, grays, and blacks, is a bird's-eye view of Central Park as seen from her window. Like El Greco, she too placed a body of water in the foreground, with sinuous lines moving through the grass and hills, directing the eye up to buildings in the background.

Frida's landscape, however, is dotted with bare trees that stand naked, while El Greco's is filled with dark evergreens, showing the constant

vibrancy of nature throughout the seasons, emphasized by the dazzling green layers of oil pigment. In Frida's view of nature, the park, like the rest of New York, possesses both a quiet beauty and a distant isolation.

That autumn in New York felt like a mix between summer and winter—warm, humid weather with gray skies, a "subtle touch of yellow and green" during the daylight hours, and fog by sundown.[26] It was an in-between time, as Frida was told that the humidity could give way to snow at a moment's notice. Frida yearned for the air and sun of Mexico, noting to her mother that even many of the affluent in New York felt the same. "Mexico has become fashionable here; everybody wants to go to Mexico and dreams of finding the Garden of Eden. In many ways they are right, because they are weary of the endless hullabaloo and the nervous tension in which the flock lives here."[27]

To flee the "nervous tension" of a world teetering on economic collapse, the white middle and upper classes could head uptown to Harlem, where the main draw for them was black entertainment: jazz clubs, speakeasies, lounges, cafes, theaters, dance halls, and cabarets. There they could simultaneously enjoy the dancing, drinking, and music of a so-called primitive culture while feeling superior in the whites-only clubs featuring black entertainers.

One November night their friends Miguel and Rosa Covarrubias, who lived part-time in Mexico and part-time in New York, took Diego and Frida out to dinner. Afterward they headed uptown to Harlem to see some dancing—"a beautiful thing," Frida exclaimed. "There are thousands of gorgeous mulatto girls and nobody in the world can dance like them."[28] Diego also loved Harlem, mentioning to the *New Yorker* that he particularly liked the Savoy Ballroom, a hot spot on Lenox Avenue between 140th and 141st Streets.[29] The Savoy's clientele was 85 percent black, with a no-discrimination policy; the legendary Lindy Hopper Frankie Manning said that at the Savoy people were judged only on their ability to dance. And dance they did, from the fast-paced swinging and aerials of the Lindy Hop to the swaying hips and intricate footwork of the mambo.

Miguel and Rosa knew Harlem well. If not for the Harlem jazz clubs and dance halls, Miguel might not have experienced success at the young age of twenty-three. Through his friendship with the white writer Carl Van

Vechten, he was introduced to the Harlem club scene. This led to Miguel making his mark in the art world with his 1920s drawings of Harlem musicians, singers, and dancers, published in *Vanity Fair,* the *New Yorker, Vogue,* and his book *Negro Drawings* (1927).

Miguel, like Carl, had embraced Primitivism with all its complications—a desire on the part of outsiders to extol the unique characteristics of so-called primitive cultures within a modern world. On the one hand, Diego said Miguel's drawings brought out "a familiar though unrecognized beauty to the city" of New York.[30] On the other, he acknowledged that the drawings were "caustic" but "implacably good-humored" and with no "vicious cruelty."[31]

Although Diego defended Miguel's images of blacks, in recognizing their biting and unforgiving approach he conceded that there was an uncomfortable edge to some of Miguel's drawings of female and male dancers, which, as Deborah Willis observed, resembled the "darky" imagery of blackface minstrel shows, imagery that was still prevalent in advertising, films, and other aspects of popular culture.

Many artists were drawn to the Primitivist impulse. Dance was an ideal venue for Primitivism because almost every culture has produced its own form of rhythmic movement, which can be appreciated and reformulated for a stage or nightclub environment. Frida, a lover of dance, enjoyed watching the dancers with Rosa, who was a dancer and choreographer. She had appeared in many Broadway revues and films under the name Rose Roland. In *Music Box Revue,* a critic noted that "Aztec blood is said to run in the veins of Rose Roland."[32] Rosa was born in Los Angeles to a white father and a Mexican mother. She was proud of her Mexican heritage, and she adopted her last name, Rolanda, from some of her maternal relatives. In her dances, she often utilized percussive elements and movements associated with "exotic" cultures. One, known as the "gold stick dance," involved striking a pair of Samoan gold sticks together to ignite the syncopated rhythms of her performances of Nautch, a dance from India that was remade for the stage by American modern dancers such as Rosa and Ruth St. Denis.[33]

Rosa had choreographed a hybrid dance. This was part of the modernist, Primitivist way—to borrow elements from various cultural traditions and synthesize them into one's own creative expression. This outgrowth of colonialism opened up the realm of artistic possibilities to modern artists,

but it muddied the waters when it came to central concepts from this period, such as authenticity, originality, and racial purity.

Frida was grappling with some of these concepts in her own cross-cultural paintings and was very aware of them as an observer of dance. Her letters conveyed a sensitivity to dancers' movements, their ethnicities, and the authenticity of the dances, particularly when they involved non-Mexican women imitating Mexican folk dances or indigenous dances. Her exuberance about the "mulatto" dancers can be contrasted with her criticism of a couple performing the Mexican hat dance at a "cabaret-like show." She wasn't impressed with their performance because the woman was "Indochinese" instead of Mexican and the man was a "somewhat awkward squirt."[34] In general, she was "weary of watching half-naked *gringas* dance the most stupid dances" because they could be so "ungraceful," resembling "dancing onions."[35]

When it came to a performance of the ballet/symphony *Horsepower,* with music by Carlos Chávez and sets and costumes designed by Diego, she was just as honest in her criticism. This ballet was promoted as a Pan-American gesture in 1932 when it premiered in Philadelphia; the message of the piece seemed to be *Let's share power.* That message didn't resonate with a U.S. audience. Perhaps this was due to the unflattering distinction made between the aggressive, industrialized United States (represented by dissonant sounds, sailors, workmen, gasoline pumps, ventilators, tickertape, and bathtubs) and indigenous Latin America (with its melodious music interpreted by dancers wearing pineapple, banana, and coconut costumes). Frida told Dr. Eloesser it had been a *porquería,* a disgusting mess, due to the choreography, which was by Catherine Littlefield. Her criticism zeroed in on white women impersonating a different race: "There was a crowd of insipid blondes pretending they were Indians from Tehuantepec and when they had to dance the Zandunga they looked as if they had lead instead of blood. To sum up, a pure and total *cochinada* [piggery]."[36] Frida's point cuts to the heart of some of the challenges inherent with cross-cultural endeavors.

In San Francisco, Frida had posed for Imogen and Edward, looking regal, intelligent, engaged, and beautiful, albeit with hints of the "noble savage" in the way she was portrayed by Edward. In New York, the writer Carl Van

Vechten, who had branched out into photography, took pictures of Frida in a Primitivist style. As a lover of modern art, Carl owned Diego's *Portrait of a Child*. He reluctantly had loaned it to MoMA for Diego's exhibition, and while it was on display there he told the museum, "I have missed it."[37] Carl's passion for modern art and Primitivism extended to photography, and he owned a "little portrait of Alvarez Bravo," referring to Mexican photographer Manuel Álvarez Bravo.[38] When Carl had the opportunity, he had Miguel teach him how to use a Leica camera. Frida and Diego were two of his first subjects, and he created separate portraits of each. With Frida, he experimented with several different backgrounds, each juxtaposed with different outfits.

The most reproduced photograph shows Frida at the apartment of Ella and Bertram Wolfe.[39] They were good friends of Frida and Diego's and spent many years in Mexico; Bertram was Diego's biographer. In Frida's portrait, she stands straight with her back against a curtainlike backdrop of rose-patterned material, dressed in a traditional Mexican-style top with two strands of thick jadeite beads and shiny Oaxaca-style earrings that catch the light. Frida the indigenous woman balances a gourd (referred to as *yecapixtle*) on her head, the type Zapotec women from Tehuantepec used for carrying fruit and flowers.

Carl must have chosen the rose-covered material as backdrop since it matches a row of roses on the underside of the gourd, but he may have also been thinking of Miguel's tender painted portrait *Cuban Woman* (1928), in which a rug decorated with abstracted flowers hangs behind the seated woman. In Carl's photograph, the roses on the gourd are supposed to integrate Frida, the "authentic" Tehuana, with the background. But Frida appears self-conscious holding the gourd on her head, as it was an object she wouldn't normally balance on her head. The whole thing looks contrived. Frida looks a bit like María Bibiana Uribe as La India Bonita, holding an Olinalá red lacquered bowl made from a gourd to emphasize her "authenticity."

Frida wasn't averse to masquerading, but for her, the constructed image had to feel genuine. This may sound like a contradiction, but when Frida carefully chose her outfits, whether they involved men's clothing or the indigenous styles of Mexico, she was bringing out an aspect of her complicated self.

The Tehuana gourd could have served this same symbolic purpose, but Frida didn't seem to feel comfortable mimicking a Zapotec woman for a

photo op, as if she were a tourist. Frida's own pattern had been to incorporate elements she'd admired from the indigenous women of Mexico, ones that felt natural for her to take on. Yet she always added her own touch. For example, her friend Carmen López Figueroa remembered how Frida would "sew jingle bells in her petticoats," which would produce a festive sound every time her long skirts swished back and forth when she walked. When Frida sat down, the bells would create a different sound, calling attention to her, and when admirers would look over, they'd see beneath her long skirt "bad words she had embroidered in bright colors along the bottom of her petticoats."[40] These touches were pure Frida.

The Savoy dancers in Harlem exuded freedom, moving back and forth in flowing motion punctuated by athletic leaps, hops, and turns. It was exhilarating. "We were happy," Frida enthused to her mother, even though it was "unbearably hot . . . sweating all day long."[41] She didn't mention Nick Muray accompanying them to Harlem, but it's quite possible he did. He was one of Miguel's closest friends and had known Rosa for almost ten years, photographing her as a dancer for *Vanity Fair*. It would have been the perfect setup for the two lovers to meet again in an "innocent" setting, but the presence of Diego would have dialed up the tension. Frida, who could be flirtatious, had to tread a fine line, given Diego's propensity for jealous outbursts.

Something seemed to have happened the night of the Harlem outing, because there was a sudden decline in Diego's mental and physical health the morning after. For the first time since coming to New York, Frida worried about him. "He's very nervous and his eyes and feet get very swollen," she wrote.[42] It's possible Diego's sudden health concerns had nothing to do with Nick, but around this same time Diego created a painting, *Landscape with Cacti*, that lays out a symbolic tug-of-war.[43] It foregrounds three cacti: a female on the right with breasts; a male on the left; and a male slightly back, as if forming a triangle. In this three-way dynamic, the female cactus (Frida) interacts with the male cactus (Nick) across from her, while another male cactus (Diego) looks on from the back. The female and male cacti in the foreground lean in toward each other, with a phallic shadow from the male cactus (Nick) bisecting the space between them, implying he has a hard-on. The smaller male cactus in the background has one "arm" raised in the direction of the female, as if attempting to get her attention. This

painting is one of the few symbolic clues hinting at a tension in Frida and Diego's marriage at this time.

November 23 began just as every day had for the past two weeks: warm and humid. Even Frida's hotel room felt hot. But a few hours later, Frida looked out her window to see Central Park covered in white powder. This didn't stop the children from playing. To them, the snow was magical. Even as it was cleared from the streets, Frida observed how the trees and rooftops continued to be "sprinkled in white."[44] On November 28 there was more snow, and Frida found herself unprepared, with no rubber shoes or umbrella.[45] Nevertheless, she went out. She'd been energized after receiving her first letter from her *mamacita* on this trip, helping her to see "everything in a better light."[46]

Frida wasn't the sole walker. Many New Yorkers took to the white streets. Later that day, Frida persuaded Diego to go see a Russian film that he enjoyed immensely. She also took him to a horror film, which she told her mother was good.[47] "She loved nothing more than to buy pounds of candy and go to a movie. . . . She loved anything where there was blood dripping and gruesome details—murder—she loved it. She made no bones about it," a friend recalled.[48] The just-released *Frankenstein* was a Frida favorite, with its macabre plot of taking body parts (including the brain) from a corpse and refashioning them into a new creature, one brought to life through electrical shock. *Frankenstein* had become a hit, resonating with audiences. Two years into the economic blight, suffering Americans could relate to the monster's predicament—he was misunderstood, a misfit who hadn't created the circumstances in which he found himself, yet he was destroyed. On a more personal note, Frida felt a kinship with the monster. Her body had been reassembled after the near-fatal bus accident, and she was forced to reenter her family and society as a "marred," misunderstood person.

Frida's transformational experience had made her ultrasensitive to physical and emotional pain in herself and others. She often encouraged Diego to take a break from painting or to seek out the opinion of a doctor. She continued to play nursemaid to her mother from a distance, instructing her to get out and see films, as "seeing something new one forgets the daily nuisances."[49]

However, she didn't hesitate to show her claws when she thought it necessary to protect someone she cared about. One time Frances Flynn Paine invited them to go to the countryside for a couple of days. Frida thought this a terrible idea, as Diego's exhibition opened in less than twenty-five days. He was still working on his first portable mural and had six more to go. "I stood up to her and she backed down," Frida proudly proclaimed to her mother, adding: "He can't waste his time with stupid old bags. He doesn't need her at all and that's what drives the crackpot crazy."[50] This assessment is debatable, since Frances was acting as Diego's art dealer, finding buyers for his easel paintings and drawings, and acting as the liaison between Diego and the Museum of Modern Art. But Frida's act of defiance was heartfelt.

It was also the first time she relayed in letters home how she had overtly asserted herself with one of Diego's art patrons. Until this point she had largely been playing the role of doting, exotic wife, but with Frances her strong will and sense of integrity were ignited past the point of repression.

The gloomy weather at the end of November mixed with some free-floating anxiety took a toll on Frida's frame of mind. She wrote, "Winter here is very sad, the whole sky turns the color of flies' wings and the streets are sopping wet with melting snow."[51]Then, in the first sentence of the next paragraph, Frida turned to the economic situation: "Rich people are *buten* scared with the situation and are hitting the roof, the hotels are almost empty, all the businesses are losing millions upon millions every year since there's no one to consume the huge amount of goods produced. New York is a madhouse and nobody knows how rich people will fix their situation or how working people and the unemployed will fix theirs."[52] Several days after Frida sent her letter, New York's Bank of the United States collapsed. With more than $200 million in deposits, it was the largest bank to fail in U.S. history at that time.[53]

From this point on, Frida's letters described with increasing frequency the underbelly of the city as she became more familiar with its different areas. A visit to a sculptor's studio on the East Side in Midtown brought her to see a new level of poverty: "I'm telling you there's so much dirt on the streets and so many junk shops that it's as if you were in Tepito or in Colonia de la Bolsa. The streets really stink and lots of kids, filthy from head to toe,

run around playing in the garbage dumpsters. It's a terrible thing, those poor people work in the factories where they earn meager incomes or they have to walk twenty to thirty blocks twice a day if they manage to get work in downtown New York."[54]

In Frida's comparison of Midtown to parts of Mexico, she was debunking the notion that the United States was superior to Mexico. She stated even more pointedly: "Everything here is pure show but deep down it's all real shit. By now I'm completely disappointed by the famous United States."[55] She had come to realize on a deeper level that though Central Park was beautiful and there were fancy shops, restaurants, and homes on the Upper East and West Sides, the working class lived in areas reeking of garbage.

In this world of two extremes, speakeasies mirrored the duality of New York's city life. These were formed in response to the Eighteenth Amendment, which outlawed alcohol at the beginning of 1920. The speakeasy—so named because one had to "speak easy" (in hushed murmurs) of these illegal places—was an illicit bar or nightclub that patrons could enter only with the correct password. The front looked like an unassuming business, but after going through a secret passageway, a bar would open up like magic, *Wizard of Oz* style, as if abruptly changing from black and white to dazzling color. The famous "21" Club, for example, designed its speakeasy with many systems in place to prevent raids—a doorkeeper, a revolving bar, and camouflaged doors. By the early 1930s, New York was said to have the largest number of speakeasies, by some estimates as many as 100,000, and quite a number were located on Fifty-Second Street between Fifth and Sixth Avenues.

Frida had the opportunity to experience this American phenomenon late one afternoon in early December. Mrs. Dunbar, the wife of a man who had commissioned a portrait from Diego, invited Frida to a "restaurant." From the street it looked like a typical eating establishment, but when Frida entered, she had to meander through an "intricate hallway" until she reached a "huge hall where there were more than one hundred and fifty tables full of people."[56] This underground nightclub had mirrors on the walls, creating a Cubist-like space, allowing for different viewpoints all in one view. Frida said it was as if one were observing the hall with "eyes on your legs and back and on top of your head."[57]

In this noisy, windowless hall, Frida had a hard time conversing with Mrs. Dunbar. The room overflowed with what Frida considered bad music and singing from a small live band coupled with the cacophony of customer voices and laughter. Even taking a drag on her cigarette didn't temper Frida's tense interaction with a woman she didn't know very well. Instead, this hall with little ventilation was transformed into a "furnace," with all the cigarette smoke visible in the air. As Frida breathed in the smoke and sipped on a drink, she felt as if her "legs were buckling" and her "head was spinning."[58] The terrible music and singing just made matters worse. A "horrible headache" and "a desire to throw up" overcame her. She felt as if she were "literally going crazy."[59] She had to get out.

Frida left the "madhouse" and began walking down the street in a snowstorm. She didn't want to take a taxi because that felt like "being inside an oven."[60] Her head still ached, but the fresh air felt good. She could actually breathe. Why, she wondered, would anyone want to spend their time and money in a speakeasy under such awful conditions? "Every day," she told her mother, "I understand these blockheads less; they spend their money on stupid things nobody else would think of."[61] When Frida made it back to her hotel around four-thirty that afternoon, she collapsed on the bed and fell asleep, leaving behind the dungeon of madness.

The Silenced Scream

*I thought of you a lot and never forget your wonderful hands
and the color of your eyes. I will see you soon...
I like you very much Georgia.*

—Frida Kahlo

Frida's growing understanding of a divided New York was connected to larger issues that would come to define both the 1930s and her American experience. The speakeasy she loathed had been a response to what many believed was an unjust law that grew out of a nineteenth-century idea to save the American family. It was thought that excessive drinking had created a crisis, with wives fearing the arrival of their drunk and violent husbands who had stopped by the saloon after work before heading home. The Woman's Christian Temperance Union had been established to work toward creating a safer home environment where more money would be spent on groceries instead of alcohol.

By the time Frida arrived in the United States, what had begun as a midwestern movement to rid the country of alcohol and its deleterious effects had acquired anti-immigrant, anti-urban elements and had picked up steam across the country. Prohibition was going to do more than outlaw alcohol—it was going to restore the fabric of American society.

The votes had been there in 1920 to pass the Eighteenth Amendment, yet with Prohibition in its tenth year and the economy tanking, the realization that banning alcohol had failed to wipe out lawlessness, immoral behavior, and alcohol consumption added to the growing fear about what the

future held. This fear often led to an "us versus them" mentality—urban versus rural, Midwest versus East Coast, "authentic" American versus immigrant, drinker versus teetotaler, believer versus atheist, moral versus immoral, "proper lady" versus "New Woman."

Frida couldn't understand why New Yorkers would want to hang out in stuffy speakeasies, but she hadn't experienced the intense moral battle that had led to the new law. Nor had she experienced the hypocrisy of politicians who publicly criticized the consumption of alcohol but privately purchased and drank bootleg liquor. For those who frequented speakeasies, it wasn't just about a love of alcohol; it was about freedom and the flouting of an unjust law. The speakeasy became the place where men and women drank together, where they listened to music, danced, and had fun. This double life became the norm in New York, signifying a refusal to allow another region of the country or politicians to legislate morality. In this city of speakeasies, Frida began a painting that encapsulates this world where "everything . . . is pure show."[1]

The painting is of a store window that features two worlds, one in front of the other, with a white horse acting as intermediary. In the foreground, a roaring lion, a crest decorated with an eagle and stars, and a framed painting of George Washington are placed on a horizontally striped red, white, and blue carpet. Directly behind these objects stands a white horse in profile facing right. Further back, a few disparate items can be seen in an otherwise empty room.

Frida dated the painting 1931 in the lower left corner and placed the title in the lower right corner: *Window Display on a Street in Detroit*. This has led to some confusion since she wasn't in Detroit until the spring of 1932. Most likely she began the painting in New York and finished it while in Detroit.

The use of the store window as a subject came to Frida when she noticed the large glass-fronted spaces designed to lure customers into stores. "Store windows held her enthralled," Hayden Herrera said.[2] On one occasion Frida displayed her excitement over the sight of a window display, exclaiming to Diego, "It was beautiful. It was like Mexico, with flower garlands and the papier-mâché figures!"[3] Another time she found funny the "incongruity of a stuffed lion, a plaster-of-Paris horse and a colored chromo of George Washington draped in garlands of red, white and blue crêpe paper, all jumbled in the same shop window."[4]

If Frida first conceived the idea of painting a window display in December, then she would have been exposed to some highly ornate window decorations. Christmastime in New York, even during the Depression, was particularly stunning, as people walked the streets just to view the elaborate tableaus of leaping white horses, six-foot-tall trees, huge sleighs drawn by life-sized reindeer, a white-haired Santa, faux snow, red and green garlands, and twinkling lights. Macy's on Thirty-Fourth Street was one of the first to create extravagant window displays, with Fifth Avenue department stores such as Bonwit Teller and Bergdorf Goodman following suit. (In the late thirties Bonwit Teller would even begin hiring artists to design its store windows, including Salvador Dalí in the late thirties and Andy Warhol in the early fifties.) The competition to create the most spectacular window display, especially during the holidays, led to sidewalks congested with spectators trying to get a look at the latest "show." Frida anticipated this marriage of art, store window design, and Americana when she re-created this world in her experimental painting.

She also tapped into a make-believe world that resembled the glass-fronted shadowboxes of American artist Joseph Cornell. His first exhibition was at the Julien Levy Gallery, on Madison Avenue at East Fifty-Eighth Street, from January 29 to mid-February 1932, when his collages and a few boxes were shown in the Surrealism exhibition.

Even though Frida culled her objects from the window she'd seen with a stuffed lion, plaster-of-Paris horse, and chromolithograph of George Washington, the way she depicted and placed them in relation to one another and the other objects came out of her imagination. For example, her lion, though based upon a stuffed one, possesses naturalistic qualities, which may have come from seeing and "listening to the roaring of the lions" in the Central Park Zoo, not far from her Barbizon-Plaza hotel room, as she told her mother.[5] These big beautiful lions were in cages; like the lion in Frida's painting, they were prisoners.

Frida's lion, which hovers somewhere between a real one and a fake, is painted with a great amount of detail. The reddish brown fur highlighted with yellows and whites appears fluffy, giving it a tactile quality. The lion's eyes capture our attention, with its gaze accented by black eyeliner. The lion can be assumed to be male, as it has a full mane, but it appears to possess "female" eyes. The flowing mane and expressive face are in direct contrast to the obviously fake white horse behind it. This horse, in profile,

has no pupil, and its mane isn't as lustrous as the lion's; yet it has one leg up as if in midstride.

Diego had been creating a white horse in December for one of his portable murals. The mural featured the revolutionary leader Emiliano Zapata, re-created from a larger scene in Rivera's Cuernavaca mural, where the agrarian leader stands on a sword next to a dead man's body and brandishes a machete while holding the reins of his white horse. Zapata and the horse occupy the foreground, but the horse dazzles with its lifelike eye, wavy mane, and detailed bridle. The horse is painted with great care, but historically it's inaccurate: Zapata rode a black horse. When Frida saw the sketch for his Cuernavaca mural, she shrieked: "But, Diego, how can you paint Zapata's horse white?"[6] Frida was alarmed on two counts: Diego would be distorting the iconic image of Zapata with his black horse, and he would be aligning Zapata with the white horses of the Spanish conquistadors. Diego replied that "the people" deserved beautiful things.[7] Although Diego accepted Frida's suggestion to make the horse's legs thinner, he kept it white.

In Frida's painting, the obviously fake-looking white horse conveys the fraudulent nature of the white horse as an emblem of revolutionary ideals. It's as if Frida is saying to Diego, *If you won't change your white horse, then I'll make mine obviously fake.* Frida's horse is seen in profile facing right with its right leg up, poised to move in the direction of another revolutionary leader—George Washington.

The father of the United States was also known as a great equestrian, a skill that helped him during the American Revolution. He was often shown on horseback in paintings, postcards, and prints. Yet instead of showing Washington on horseback, Frida pairs a lifeless horse with a lifelike image of Washington, again emphasizing the horse as a prop for the purposes of propaganda.

Washington catches our attention as he peers out from the picture frame. It's the familiar face made famous by Gilbert Stuart's many portraits of George Washington (the first created in 1795), the one reproduced on postcards, the dollar bill, and tourist memorabilia. While Frida was inspired by a colored chromolithograph of Stuart's portrait in a store window, she most likely had seen the two Stuart paintings of Washington in the New York Public Library as well.

Frida had visited the library's Main Branch (now called the Stephen

A. Schwarzman Building) in early January to see Diego give a talk, as well as on other occasions. It featured the Constable-Hamilton portrait, as it's called.[8] Another Stuart portrait, referred to as the Munro-Lenox, also hung in the library. In both portraits, Washington is shown with a scroll. In one, a seated Washington holds the scroll partially unwound with his signature on it. In the other, a standing Washington has his hand on the Constitution, which is partially unwound from a scroll lying on a table.

In Frida's store window, a rolled-up scroll lies on the floor in the background, strategically placed between the framed picture of Washington and the horse's head. In both Stuart paintings of Washington, the scroll of paper conveys his role as the first president of the new American Republic. The document imbues him with dignity. But in Frida's painting, this scroll lies discarded on the ground in a largely empty room with just a few disparate items—a ladder, a glove, two bottles, paintbrushes in a can, and a map of the United States hanging on the wall. Taken together, all these strategically placed objects add up to a symbolic world that points to Frida's perspective on the United States—that when one looks beneath the surface, all the great symbols of democracy, bravery, and justice are merely props, just window dressing.

The lion stands out, however, as its roar is the only expression of emotion in the painting. It is sounding the alarm that the ideals of the American Revolution are dead in 1931, especially with the huge gap between the wealthy and the poor. And this male lion with the gorgeous mane and eyeliner can be seen as Frida's "androgynous" alter ego. Notably, "lion" in Latin is *leo,* and the name Leonardo can be translated as "brave lion" or "lion strength." Frida has taken on the guise of Leonardo once more, but this time in the form of his animal namesake. Just as her (re)birth announcement emphasized her new androgynous form, the male lion with its female eyeliner carries on the symbolic tradition. The Frida lion tries to convey her strength by making her growl heard in a foreign city where she's struggling to find her own voice. She screams, yet her voice is silenced. This tension between speaking out and withholding intense emotion would continue to plague Frida while she was in the United States, and it would come to define a central element of her mature self-portraits.

In contrast, Diego at this time painted a menacing jaguar—or, more precisely, an Aztec warrior dressed in the flayed skin of a jaguar—that bares its teeth while on top of an armored conquistador. One hand holds

the soldier down while the other drives a flint into his heart, turning the weapon red with blood. The jaguar's eyes look bloodshot, and its open-jawed mouth reveals red gums and long white fangs. Frida's lion strikes a similar pose, with an open red mouth. But instead of being a triumphant warrior, her lion is caught within a window frame. Cut off from her home-land, Frida often felt stymied. She references this state of mind in her painting with the framed map of the United States hanging on the wall, its northern Canadian and southern Mexican neighbors cut off.

But the lion isn't completely ignored in the window. Two golden ea-gles look in its direction. One, with open wings, is seen on the crest just to the right, and the other is propped up on top of the framed portrait of Washington, its wings outspread. Given the American context of the win-dow display, one might assume Frida would incorporate the bald eagle. Her choice of the golden eagle aligns New York and Mexico, as that bird is found on both the Mexican national flag and the Bronx borough flag. She also utilized the Bronx's reddish orange, white, and blue horizontal stripes for her flag, which is draped over the table.

Frida alludes to a plethora of ideas. The glove on the floor in the back-ground under the ladder and to the left of the paintbrushes implies that the hand of the artist plays a significant role in the construction (paint and brushes) and placement (ladder) of images. And the used paintbrushes are placed under the hanging lamps, as if under the bright lights of interrogation.

While Frida was working on her painting, Diego was painting the murals for his retrospective. What images would he choose to represent Mexico and the United States, respectively? And how would they be re-ceived? In Frida's coded pictorial world, these two neighboring countries commingle in interesting and complex ways. If Diego was publicly quoted as celebrating Pan-Americanism, Frida was privately lamenting the imbal-ance of power between the two countries.

While Frida inwardly stewed about injustice, outwardly she tried to act the part of the charming wife. In some ways, Frida too was "pure show." But as time went on and she continued to observe the extreme disparity between the wealthy and the impoverished, her shock turned to anger. "High society here turns me off and I feel a bit of rage against all these rich guys here, since I have seen thousands of people in the most terrible

misery without anything to eat and with no place to sleep, that is what has most impressed me here, it is terrifying to see the rich having parties day and night while thousands and thousands of people are dying of hunger," she told Dr. Eloesser.[9]

As the date for the opening of Diego's exhibition neared, Frida felt the tension building. Problems developed with the exhibition, sending both Frida and Diego into a tailspin. When it was discovered that Diego's portable frescoes, created in a sixth-floor studio, were too large and delicate to move up to the twelfth-floor museum space, he was livid. On top of this, when assistants tried to move some of them, they scraped the bottom, affecting the figures in the compositions.

Frida blamed the problem on the "foolishness of the Paine woman." Frances was the one who had insisted that Diego paint on the sixth floor. Frida could no longer hold back. Her contempt spewed forth, making any more niceties between herself and the "old bag Paine" impossible.[10] Even when Frances tried to appease Frida with flowers, Frida couldn't go back to pretending. She didn't "trust her at all."[11]

It's unclear exactly why Frida had such disdain for Frances. It's understandable that they wouldn't become close friends, but why such hostility? Given Diego's admitted sadistic tendencies with the women he loved most and his attitude that sex with any woman he met was nearly inevitable, it's reasonable to wonder if he'd begun having an affair with Frances, or at the very least a serious flirtation.

Frida had similar intense feelings, expressed bluntly, regarding another woman as well: Lucienne Bloch, a Swiss-born American artist who had been seated next to Diego at a banquet given by Aline Meyer Liebman, the sister of Rosalie Meyer Stern, Diego's patron from San Francisco. Lucienne was fascinated by Diego's take on machines. Most artists she knew "thought machines were terrible."[12] This piqued her interest, and, as she recalled, "I took him over and talked and talked with him."[13] The two shut out the world as they spoke in French, but every once in a while, Lucienne noticed a dark-haired woman across the table giving her "dirty looks."[14] Undeterred, Lucienne went right back to her discussion with Diego. After dinner ended and the guests were milling around, Frida walked up to Lucienne, looked her in the eye, and said in English: "I hate you!"[15] Lucienne was "very impressed."[16] She realized that Frida thought she was flirting with her husband.

Lucienne was the daughter of Ernst Bloch, a well-known Swiss composer. She was sensitive to the issue of being "wife to a famous, flirtatious man," because Lucienne's mother had struggled for years with her husband's philandering. Instead of disliking Frida for her bluntness, Lucienne said, "this was my first contact with Frida and I loved her for it."[17] Frida was lucky to find in Lucienne a fellow female artist who understood how easy it was for women to be pitted against one another when the powerful men they were associated with were considered to be the ticket to success. Once Lucienne explained to Frida that she wasn't interested in sleeping with Diego, everything was fine between them.

At twenty-two, Lucienne was focused on art. With her impressive artistic training and contributions—studying painting and sculpture at the École des Beaux-Arts in Paris and pioneering the design of glass sculptures while working at the Royal Leerdam Crystal factory in the Netherlands—Lucienne was ready to try something new. The American architect Frank Lloyd Wright invited her to teach at his architecture school, Taliesin East. But Lucienne, whose green eyes widenend when she felt passionately about something, had other ideas. She suggested to Diego that she grind pigments for him. He enthusiastically took her up on this suggestion. Lucienne began working as one of three assistants to Diego. The other two were Clifford Wight, who had followed Diego from San Francisco, and Ramón Alva, who had come from Mexico on the ship with Frida and Diego. With their help, Diego was able to work long hours trying to complete his frescoes and oil paintings for his upcoming show.

The opening of the exhibition was planned for December 22, and by that time Diego had completed five Mexican-themed murals: *Indian Warrior, Sugar Cane, Liberation of the Peon, Agrarian Leader Zapata,* and *The Uprising.* They joined fifty-six oil and wax paintings and eighty-nine watercolors, drawings, sketches, and fresco studies.[18] Although he wasn't able to paint the New York–themed murals before the opening, he resumed work on the twenty-third and finished three more by January 6.

The December opening of Diego's exhibition was a grand affair attended by many art world powerhouses and creative types, including Abby and John D. Rockefeller, Frank Crowninshield, Henry and Lila Luce, Georgia O'Keeffe, Alfred Stieglitz, Edward G. Robinson, Hedy Lamarr, Paul

Robeson, and Miguel and Rosa Covarrubias. Fortunately for Frida, Lucienne was there, as well as another acquaintance, Anita Brenner, a Mexican-born Jew who had lived in the United States as a child. A journalist and anthropologist, Anita wrote about what she called the "Mexican Renaissance." *Idols Behind the Altars* (1925) is her most famous book; it expounds upon indigenous and modern Mexican aesthetic traditions. Like Frida, Anita understood the complexities of transnationalism and the scourge of anti-Semitism.

At some point during the opening reception Frida spoke to Alfred Stieglitz, the photographer and gallery owner, and Georgia O'Keeffe, the famous painter of flowers and the New Mexico desert. It must have been interesting for Georgia, who owned Diego's painting *Seated Woman,* to see this piece hanging on the wall as one part of a whole body of work.[19] As an artist herself, she was quite conscious of the overall impact of paintings hung side by side. Almost a year earlier, she'd exhibited her *Jack-in-the-Pulpit* series, with its vertically oriented images of elongated flowers, along with her close-ups of *Black Hollyhock, Blue Larkspur* and *White Iris.* The impact was different from that of Diego's exhibition because she had showed her work in a smaller gallery space (owned by her husband, Alfred Stieglitz).

Georgia always stood out in a crowd. If she wasn't recognized as that "lady painter" who created sexualized flowers, she was noticed for her androgynous, black and white outfits, sometimes embellished with a bowler hat. Frida noticed her hands, strong and elegant, as well as the color of her eyes.[20] With her long, dark hair pulled back tightly in a bun, Georgia's flashing eyes, defined facial features, and sly smile conveyed both strength and an impish quality.

When Frida met Georgia, O'Keeffe was, as the cliché goes, a rising star. Besides her annual exhibitions since the 1920s at Alfred's various galleries, her work was part of the first exhibition at the newly opened Brooklyn Museum in 1927.[21] Two years later, the Museum of Modern Art included five of her paintings in its "Nineteen Living Americans" show. Her fame had resulted in consistent sales to both private collectors and public institutions; the Cleveland Museum of Art purchased Georgia's *White Flower* the year before Frida came into her orbit.[22] Perhaps even more remarkable is that by the late 1920s, sales of Georgia's paintings supplied the largest

part of O'Keeffe and Stieglitz's household income.[23] This didn't change with the Great Depression, as Georgia's works continued to sell for large sums of money.[24] Perhaps the country's economic hardship didn't greatly affect sales of her works because over the past decade her flower paintings had become embedded within a framework that always sells—sex.

Alfred Stieglitz was an astute promoter of art. The persona he created for Georgia with her 1920s flower paintings was of a sexually free woman who produced paintings of eroticized flowers instead of babies. Art historian Whitney Chadwick sums it up: "Throughout the 1920s, O'Keeffe was forced to watch her work constantly appropriated to an ideology of sexual difference built on the emotional differences between the sexes."[25] Georgia was upset every time she read a review that cast her flower paintings within this strictly gendered light. She found it preposterous that the critic Paul Rosenfeld could write, "No man could feel as Georgia O'Keeffe and utter himself in precisely such curves and colors" because he didn't possess "her body's subconscious knowledge of itself."[26] Words and phrases such as "lusty," "bodily experience," "biological emotion," "intensely personal," and "ecstatic climaxes" narrowly defined the woman and her paintings.[27] She fought back, explicitly denying such interpretations, but to no avail. At one point she wrote: "I almost wept. I thought I could never face the world again."[28] Georgia's scream, like Frida's, was silenced.

To make matters worse, in a 1921 exhibition of Alfred's photographs, in some of the forty-five nude prints of Georgia her paintings could be seen behind her breasts or arms, solidifying the idea of Georgia's "bodily experience" of creation.[29] Her sexualized body and her art would forever be intertwined in the perception of Georgia's flowers.

Alfred, a Freud enthusiast, believed sexual repression was unhealthy. He, along with many male artists and critics, postulated that sex was a liberating force for men, especially when it came to creativity. Within this atmosphere, it was difficult for female artists to be taken seriously when women were viewed as the opposite of men: emotional instead of rational, soft as opposed to strong, intuitive rather than brilliant, sexually repressed rather than liberated. Under Alfred's control as Georgia's dealer, she came to be seen as a rarity, and this fueled an unquenchable desire among collectors and museum curators to own this scarce commodity. It was a brilliant marketing strategy, but for the private Georgia, it was a double-edged sword.

Frida saw in Georgia a woman who appeared to mirror her in many ways: a painter married to a successful artist twice her age, a lover of nature and Indian culture, and a sexually free being. After the opening of Diego's exhibition at the end of December, the two women met again sometime between December 1931 and March 1932, when Georgia's latest paintings, including some of her cow skulls from the Southwest, were on view at Stieglitz's gallery, An American Place, on Fifty-Third Street and Madison Avenue, an intimate setting with gray floors, low white-beamed ceilings, and pristine white walls.

Lucienne recalled Diego bragging about how Frida had teased Georgia in a flirtatious manner.[30] Frida, who viewed sex with men and women as a natural part of life, was drawn to Georgia's androgynous look and manner. It's doubtful Georgia would have responded with the same openness in public. Early letters to Alfred convey the sense of a woman who could write sexually explicit passages to her lover, but in public Georgia tended to be reserved. She knew all too well how her words or expressions of sexuality could be used to pigeonhole her art. (Frida, too, understood when she needed to speak or write in coded terms.) Lucienne described in her journal a couple of candid conversations she had with Alfred. One took place at a "jolly reception" for Diego at Mrs. Liebman's. Lucienne notes that "Stieglitz and O'Keeffe" were there and that "we talked birth control and lovers with him."[31] But she did not write about any such public discussions with Georgia.

While there may have been no public flirtation, Frida was clear in a letter to Clifford Wight that she and Georgia had "made love" while she was in New York that winter and spring of 1931 and 1932.[32]

The timing of Frida and Georgia's meeting was propitious. These two creative women came together at a crucial moment when both of their marriages were on shaky ground. Georgia needed to break out of the confines of an unhealthy relationship. She found freedom in going to the Southwest every summer to paint. It provided a needed respite from a congested city and a demanding husband, but her steps toward independence seemed to produce fear in Alfred. The man who needed to feel in control began an affair in the spring of 1931 with a much younger woman.[33]

Dorothy Norman, a curious-minded, married woman, became Alfred's protégé. Soon her interest in photography and in Alfred's every word resulted in her becoming gallery manager. She became more than a protégé, and Georgia knew it. Alfred, as he had done with a young Georgia, had Dorothy pose nude for him. The outcome was predictable given Alfred's philosophy: "Whenever I photograph, I make love."[34]

When Frida met Georgia some nine months after Alfred's affair had begun, the tension in Georgia's marriage had become unbearable. Just a few weeks earlier, Georgia had been at Alfred's family's Lake George home in upstate New York preparing canvases for her upcoming show at An American Place. On November 29 she'd returned to the city, and when she entered the home she shared with Alfred at the Shelton Hotel, she came upon her husband photographing a nude Dorothy in their bed.[35] Alfred was livid. He scolded Georgia like a child, chastising her for returning unannounced and forbidding her to ever do so again. Alfred, like Diego, expected his wife to accept his affairs. But also, like Diego, he became insanely jealous if he suspected his wife of having affairs with men.

For O'Keeffe, whose inner chaos was churning at top speed, Frida's overtures might well have been a needed reprieve. Georgia's reaction to such flirtations is known only from Frida's perspective. But according to some O'Keeffe biographers, it would not have been the first or the last time that Georgia sought comfort and stability via an intimate or sexual relationship with a woman under complicated circumstances.[36]

Frida and Georgia needed to navigate complicated, nontraditional marriages. The focus on freedom implied a lack of definitions and boundaries, often resulting in convoluted crossovers of sexual partners, sometimes taking an interest in the same woman as their husbands, yet without strictly identifying as heterosexual, homosexual, or bisexual. Perhaps the desire to not be categorized was in part a reaction to the theories of sexologists such as Havelock Ellis and Richard von Krafft-Ebing, who postulated that "sexual inversion" was an inborn reversal of gender traits—a female soul trapped in a male body or a male soul trapped in a female body. But that characterization didn't always address female sexual desire for women or attraction to both men and women. The label "lesbian" began to be used in medical/scientific literature and fiction in the 1920s. Krafft-Ebing consid-

ered lesbianism a neurological disease. Ellis, whose books Georgia owned, didn't think lesbianism was a lifelong condition; rather, it was a phase, with most women becoming heterosexual once they got married.[37] But, he argued, there were a few "true inverts" (lesbians), women who rejected a subservient role within heterosexual marriage and chose to be with other women, and he considered that group a "third sex."[38]

Ellis began using the term "bisexuality" by the 1915 edition of his *Studies in the Psychology of Sex*. He had come to recognize that women could be sexually attracted to both men and women without the attraction to women being a phase, since these women would have an unusual mixture of maleness and femaleness in one body.

The world of fashion contributed to the blurring of distinctions between labels such as lesbian, bisexual, and New Woman. Feminists such as Charlotte Perkins Gilman advocated the androgynous look as a response to women being shackled to an ultra-feminine style that prohibited easy movement—shoes were "sometimes instruments of torture"—and that emphasized their curves for the pleasure of men. The androgynous look made it more difficult to objectify women and clearly define them as the property of men.

Frida and Georgia utilized the androgynous look to defy stereotypical norms and to assert their own independence and power as artists. Just as Frida had consciously donned a man's suit to signify her new status as Leonardo, Georgia had taken inspiration from Gilman's *The Dress of Women* (1915) and began in her twenties to dress "like a man," as one of her students observed.[39]

Ironically, at the time Frida and Georgia met, this sense of empowerment they'd gained from their androgynous personas was waning, as each woman, in her own way, was struggling with issues of belonging versus independence.

The emotional connection and sexual attraction these two seemed to share spilled over into a creative confluence, as the younger, more inexperienced Frida took on subjects that the older and more established Georgia had boldly painted. *Window Display on a Street in Detroit* is an example of Frida working out her ideas and feelings in an indirect manner. What she achieved was an allegorical world, with objects telling a story about Frida's

impressions of the United States and her place within it at a time when there was a general interest in creating a genuinely American art.

Georgia was emerging as one of the artists who best captured what she referred to as "the Great American Thing."[40] The literary world, she commented, had the Great American Novel, but the art world was still trying to figure out what it meant to create American art. By the early thirties, the art movement dubbed Regionalism began to dominate the art of the United States, foregrounding the unique characteristics and beauty of the people and land in rural parts of the country. Regionalism was understood as a rebuke of the dominant urban art scene centered in New York City, Stieglitz's domain. Thomas Hart Benton, one of the most vocal Regionalists, attacked Alfred as an outsider Jew who promoted abstract, un-American styles of art. In his article "America and/or Alfred Stieglitz," Benton's anti-Semitic feelings came through: "Stieglitz is touchy. He cannot be criticized. He never laughs at himself as we common Americans do." If Stieglitz, as a Jewish man, wasn't a "common American," then he couldn't promote common American art. The *authentic* common American art arose from the soil, preferably the soil of the Midwest—the heartland that gave birth to the hardworking white Anglo-Saxon farmer (although Benton also created the nine-panel mural cycle *America Today,* which featured both rural and urban scenes, for the boardroom of the newly constructed New School for Social Research in New York City).

At the time Frida met Georgia, she'd been discovering the landscape of the Southwest rather than the Midwest. Her *Cow's Skull: Red, White, and Blue,* created in the fall of 1931, foregrounds a large white animal skull mounted on a black vertical line, evoking a cross. Red vertical stripes run from top to bottom on either side, framing the mounted cow skull, with gradations of blue and white forming what looks like a canyon behind it. "I painted my cow's head because I liked it and in its way it was a symbol of the best part of America I had found," Georgia told her friend Anita Pollitzer.[41] Then she added: "Just for fun I will make it red, white and blue—a new kind of flag almost."

Georgia's new painting was included in her show at An American Place during the same period as Diego's exhibition at MoMA. You could say that the now iconic image of America in *Cow's Skull: Red, White, and Blue* was a backdrop for Frida and Diego's time in New York. When they came to see her exhibit, Georgia was impressed with how Diego looked at every painting, "carefully considering it."[42] She went on: "If one person like that

came every year and looked that way, I would paint much better."[43] Diego, a Mexican artist who had come to the United States as a spokesperson for Pan-Americanism, got to see Georgia's take on what she deemed an authentic American expression.

He and Frida would have seen arresting images as they entered the gallery. In streamlined metal frames, designed by Georgia in conjunction with Peter Bayle and George Of, white horse skulls topped by white roses floated in a nondescript black space or rested on a scroll-like sheet of unfurled white paper.[44] There was also a stunning cow femur turned upside down and hanging in space against a thick, black vertical line. Although these animal remains could have come from anywhere in the country, her *Ranchos Church,* with its distinctive adobe "beehive" buttresses, alerted viewers to the New Mexico colonial context. On another long wall, cow and ram skulls alternated with close-ups of a New Mexico mountain and a large flower.

In this exhibit, just eleven months after the debut of her *Jack-in-the-Pulpit* series, it's clear that O'Keeffe wanted to steer her creative trajectory in the direction of the hard skulls of American livestock and the durable, undulating lines seen on mountains and a huge clamshell, as opposed to the delicate, "feminine" flower petals for which she was known. For the most part, this exhibition showcased the rugged, independent O'Keeffe who would come to represent New Mexico, which later came to be referred to as "O'Keeffe country."

Frida and Diego had a different vantage point compared to most American viewers. They carried with them their perspectives of indigenous Mexican culture combined with a growing awareness of Pueblo Indian culture from the Southwest. In December, just days before Diego's opening, they'd seen some "Indians from New Mexico" who were in New York for an exhibition of "their paintings, textiles, sculptures, etc." Frida noted, "They danced some beautiful sacred dances, they all speak Spanish like the Mexican Indians and they look almost the same, only these are not mixed with any white race and in Mexico they are more screwed up. They were thrilled speaking to us and very soon they were addressing us informally as if they had known us for a long time. They are very intelligent and paint beautifully."[45]

Besides being exposed to Pueblo Indian culture through this exhibition, Georgia and her friend Mary "Marina" Channing, a poet, talked up

the Southwest to Frida. They went into "ecstasy" as they described sage-brush, a pale gray shrub with yellow flowers that grows in the northern New Mexico desert. Georgia and Marina spoke of the plant's pungent odor when it is dried and burned by the Pueblo Indians for ritual purification. Frida laughed at the two women and their over-the-top exuberance.[46]

In New York, Frida and Diego absorbed some of the excitement and fascination artists felt for Pueblo Indian culture in the search for this "Great American Thing." Frida took it all in. Like Georgia, she included red, white, and blue stripes in her *Window Display* painting, only they run horizontally rather than vertically. And the white, hard-looking horse at the center of her composition, like Georgia's cow and horse skulls, functions as an important symbol of the Americas. If Georgia at age forty-four had, through an economy of means, captured the heart and soul of the American desert landscape, then twenty-four-year-old Frida was still grappling with how to synthesize her complicated feelings and ideas into a powerful image that would be instantly experienced on a gut level. Georgia's painting *Cow's Skull: Red, White, and Blue* was a success, defining her as the embodiment of modern American art on par with the Regionalists. Frida's painting was not a success, but it was another stepping-stone.

Frida's six months in New York also were a stepping-stone. It was a place where she began to try to dismantle the "window display": the persona of the artist's wife who charms the art patrons. She made closer friends in New York than in San Francisco—some of them old acquaintances from Mexico, including Rosa and Miguel as well as Malú Cabrera—and she enjoyed Harlem and the city's variety of Mexican restaurants. Christmas celebrations helped create a feeling of community, as Frida and Diego were invited to friends' homes for the festivities. They spent Christmas Eve at Malú's with Rosa, Miguel, Diego's assistant Ramón, and Malú's brothers-in-law. At two in the morning the party moved to the house of Italian-born puppeteer Remo Bufano, where the singing and noisemaking, punctuated by toasts to "Mrs. Rivera," continued for two more hours. The next day, Frida and Diego went for Christmas lunch at the home of the Onises, a "charming" couple who had a precocious four-year-old son named Juan. "Diego," Frida told her mother, "stuffed himself with paella and roasted turkey."[47] They enjoyed the food and company. Frida certainly missed her

family during the holidays—reminiscing in a letter about her mother's great Christmas Eve salads—but she didn't sound as forlorn as usual.

By January she even admitted, "I like New York more than at the beginning."[48] However, a bout with the flu a couple of days after writing these positive words kept Frida in bed. She didn't do much of anything for about a week. After the worst of her body aches had passed, she penned another letter to her mother, expressing a wide range of emotions. On the one hand, she bemoaned the fact that Diego never stopped working, even when she was in need. She didn't see him much or even talk to him because he left early in the morning and when he returned late at night he was tired and wanted to go to bed. "Bottom line," she told her mother, "is I live my life all by my lonely self."[49]

After complaining about Diego's insensitivity, Frida backtracked: "I'm not saying Diego doesn't care, it's just that in these circumstances men in general are rather useless and also they are just not so aware of what's happening, don't you agree? And they think that everything is 'nothing' until it happens to them, then the world collapses."[50] Rationalizing his behavior, she told her mother that Diego's apparent lack of concern was normal for a man obsessed with his art, and she concluded by contradicting herself, saying that he really was "magnificent with me."[51] Then she made a predictable pivot: "I'm the one who is too demanding sometimes and take advantage, and I get into frightfully bad moods, but I'll get over that as time goes by."[52] As Georgia had realized, turning away from the emotional cues that something doesn't feel right in a relationship by rationalizing another person's behavior typically exacerbates the turmoil in that relationship. It isn't generally as simple as "getting over it."

What Frida discovered, but had a hard time admitting, was that her new female friends and acquaintances were much more caring and supportive than her husband. In this city far from home, it wasn't Diego she could count on, it was women.

While Frida was ill, she told her mother that a lot of people came to see her. They also sent flowers and good wishes, she wrote. Abby Rockefeller was one who sent "marvelous" flowers, reminding Frida of Mexico. She also sent Frida a "beautiful" book written in English.[53] Frida must have felt rather chummy with "my dear Mrs. Rockefeller" because in her thank-you note she signed off with "Many kisses from Frieda Rivera." Rosa and Malú came to see her on a daily basis. Lucienne and her sister Suzanne dropped

by often, with Suzanne bringing along her lute. One day Lucienne stayed for several hours, and the two "ate candy" and "talked about all sorts of things."

Once Frida was on the mend, she and Lucienne started spending more time together, becoming silly and mischievous partners. When they went to a Tchaikovsky concert, they "acted like the worse [sic] mischiefs making drawings and paper birds and giggling awfully."[54] At the movies, they acted "coocoo"; at a Spanish restaurant, they drank something strong like vodka with lemon and salt and acted "most crazy"; at the five-and-dime store, on the streets, and in taxis, Lucienne played her mouth organ, "acting crazy"; and at a Mexican restaurant, Frida, Lucienne, and Georgia drank tequila and "sang in the toilets."[55]

Group drawings, like the ones Frida had created in San Francisco, provided another outlet for acting "coocoo." These Surrealist-inspired drawings were often made on Barbizon-Plaza Hotel stationery. Frida and Lucienne made three drawings combining human and animal as well as male and female. One of the drawings is actually given the title *Crazy Cat,* a reference to the popular comic strip *Krazy Kat,* created by George Herriman (it ran from 1913 to 1944 in the *New York Evening Journal*, and in 1925 Bill Nolan brought the character to animated short films). The wildly popular cartoon character was androgynous, referred to as both "he" and "she." In Lucienne and Frida's drawing, the cat retains an indeterminate gender, with a (female) inverted triangle covering the crotch and nipples devoid of clear breasts. The creature, with a cat head on a human body complete with knee-high socks and shoes, stands in first position with arms folded in front while holding a flower. It looks self-conscious and sad rather than crazy.

In another drawing, an androgynous figure stands wearing a bustier with breasts pushed up in an odd fashion, as the nipples are "looking up" toward the figure's featureless face. A stem poking out from between the breasts makes them look like cherries. Long, sinewy arms and hands hold thin strings attached to a fig leaf covering the genital area, which turns into a penis dripping urine or semen into a cup on the ground between the figure's feet. This figure, which possesses Frida's joined eyebrows, is labeled "Diego Rivera." It stands with feet firmly planted on the ground and one

hand placed on a hip, as if unfazed by the liquid oozing out of its penis. Without any eyes or mouth, there's no way to gauge emotion on the face. The fig leaf of shame has been transformed into Diego's power to flaunt his emissions. It's reminiscent of Dr. Eloesser's assessment of Diego: "Connubially, he had the sentiments of a Rhode Island rooster. Anything that was not too repulsive and that had the wherewithal under its skirts would do to embrace with impartiality."

A third drawing shows Diego's face, a woman's pendulous breasts with erect nipples, a prominent bottom awkwardly turned to the front, and oddly placed legs. This figure, teetering on tiny high heels, looks like a sexualized female body with the head of Diego. The figure holds a broom, an emblem of both domesticity and being a witch. On one level, these drawings that combine male and female can be viewed as the tongue-in-cheek creative expressions of Lucienne and Frida, but on a deeper level, they convey uneasy aspects of gender, power, and sexuality.

Once again, it's Frida's drawings that provide a peek into her private dreams and desires. In two Surrealist-inspired drawings created shortly before Frida left New York, she alluded to the complexity of her cravings. In one, called *The Dream,* Frida shows herself lying in bed under her covers dreaming. There are corkscrew lines that go from her head and her bedspread up into the air above, where a host of images and symbols reside. Many of the symbols look similar to a woman's vulva or shells. One snail-like form at the upper left emits tiny dots that cover a profile face, which resembles Diego.

To the right of his head there's an elongated, abstracted form, which has the appearance of a head in profile, with one eye, a nose, and a star for a mouth. This profile, with symbolic objects surrounding it, points to Georgia O'Keeffe. Miguel, who was friends with Georgia, had created a caricature of her for the *New Yorker* a couple of years earlier called "Our Lady of the Lily." Frida's drawing shares three elements with Miguel's: a profile image, an exaggerated elongation of Georgia's face and neck, and a flower. In Miguel's, Georgia holds a lily; in Frida's, a flower is placed at the bottom of the abstracted "neck," an obvious marker for Georgia's famous flower paintings, popularly interpreted as vulvas. In Frida's drawing, such vulva-like shapes are placed directly below the flower and above to the left

of it. These shapes also mirror Georgia's paintings of slightly opened clam-shells, one of which hung in the show Frida saw at An American Place.

There are more allusions to Georgia. The elongated "Georgia" profile is next to two structures: one is a smokestack emitting a looping plume, and the other is a high-rise with a distinctive top that ends in a thin point. These two buildings, side by side, look similar to a perspective Georgia painted in her *East River from the Shelton Hotel* (1928), including an active smokestack and a high-rise that ends in a needle-like point.

Through the use of spirals, squiggles, zigzags, and a diagonal line, Frida creates two connections between her sleeping self and the Georgia-looking profile, but it's not clear what Frida is dreaming about. The left side of the drawing complicates the contents of the dream with the inclusion of Diego. His head, seen in profile behind Georgia's, sets up a triangulated situation, something that's repeated with three figures walking in a line just behind Diego's head, and three *H*'s in front of Georgia's head. These cryptic symbols, though impossible to fully understand, express the complexity of Frida's desires.

A second Surrealist-style drawing from the same period, also called *The Dream,* provides further clues to Frida's state of mind in March, shortly before she leaves New York. In this drawing, Diego's role as progenitor is emphasized. This time Frida shows herself lying in bed nude with her eyes closed while lines from her head connect her to various objects above and below, turning into vines as they reach the ground. Diego's head, placed di-rectly above her torso, looks off to the left, as if unaware of Frida's body be-low. But a connection is made through a large circular pod he wears around his neck, emitting spirals, squiggles, and seeds that fall onto the bed and Frida's backside. This seems to indicate that Diego's seed is impregnating Frida, who is shown on her side with one hand on a slightly swollen belly.

Frida and Diego's assumed biological coupling is further connected to the earth, seen in the hand rising above the soil with roots reaching down into Diego's head and the roots of plantlike forms growing onto Frida's bed. The sky too is alive with circular forms, droplets and squiggles that rain down on a stepped high-rise. This drawing makes manifest what Teresa del Conde describes as Frida's view of "the life force that emanates from every single being capable of impregnating another, even inanimate objects."[56]

This coupling of the animate and inanimate comes through when Frida places side by side an inanimate lightbulb fastened to the high-rise

and an animate eye with flames coming out of it. This disembodied eye floats on the façade of the building near Diego's face. While the modern lightbulb provides illumination at night, the flame emanating from the eye, according to the ancient dharma of Hinduism, represents Shiva's third eye of wisdom and untamed energy, a polarity Frida associated with Diego. The third eye is an image she will return to.

These symbols cannot be translated into a clear narrative, but the third eye and the spirals, squiggles, and seeds connected to Diego and falling on Frida point to her being impregnated with Diego's "seed." In fact, Frida discovered she was pregnant in this same month, March.

VI

DETROIT

Independence Day

No great artist ever sees things as they really are. If he did,
he would cease to be an artist.

—OSCAR WILDE

 On March 1, 1932, just past 9:00 p.m., twenty-month-old Charles Lindbergh III was kidnapped from his bedroom in Hopewell, New Jersey. The following morning newspaper headlines blanketed streets around the world—"Lindy's Baby Kidnapped"—and the heartbreaking story riveted an anxious public. Would the adorable toddler with the big blue eyes and wavy blond hair be found?

Frida too felt the collective angst as the weeks went by without the child being found. One chilly April night when she finally felt healthier after a bout of nausea, she sat at the desk in her Barbizon-Plaza Hotel room in New York and wrote a letter to Clifford and Jean Wight in Detroit expressing her dismay: "You must know already that Lindbergh's child is not in his home yet."[1] In New York, she was close to the scene of the Lindbergh crime, but not just in terms of miles.

Frida knew little Charles's maternal grandparents, Dwight and Elizabeth Morrow. They had been kind enough to invite her and Diego to stay in their Cuernavaca home while Diego painted murals in Cortés's former palace. Although 1930 had not been an idyllic year, Frida had fond memories of the Morrows and their lovely home.

But there was an even more personal reason for Frida's distress: her

fears about her own pregnancy. The tragic Lindbergh kidnapping made it more difficult to process her ambivalent feelings about the prospect of motherhood—all she could think of was her previous pregnancy and subsequent abortion just two years earlier while living in Cuernavaca. Frida feared that her weakened spine wouldn't be able to withstand the physical demands of a pregnancy. This concern factored into her decision to not tell her family back home that she was pregnant. Diego shared his wife's concerns. But underlying his worries were most likely deep-seated fears of loss and abandonment dating back to the death of his twin brother and his mother's distraught state of mind afterward. Diego had already replayed this tragedy once when his own young son died in Paris.

By mid-April it was time to wrap up business in New York. On the twentieth, Diego and Frida headed for Detroit, where a mural commission awaited Diego at the Detroit Institute of Arts.

They had a fourteen-hour train ride to make the psychological adjustment from life in the cultural capital of the United States to a stay in its industrial capital, where cars and new technology reigned supreme. As the steam locomotive wound its way through the majestic expanse of the green Allegheny Mountains in Pennsylvania, the vertical steel landscape of New York City seemed far away. At noon on April 21 they pulled into Michigan Central Station on Third and Jefferson, a classically designed, grandiose Beaux Arts building—connected to an eighteen-story office tower—with a vast marble-floored waiting room modeled after the public baths of ancient Rome.

When Frida and Diego appeared at the train door, they were greeted by an entourage that included friends such as the Hastings and the Wights; the Mexican vice consul, Ernesto García Moreno; twenty-plus members of the Mexican cultural club; and representatives of the press. Frida climbed down the steep stairs carrying a ukulele, which she immediately passed off to Clifford Wight on her way to hug his wife, Jean, and her friend Cristina Hastings. The women hadn't seen each other since San Francisco, and a great deal had happened in the intervening year.

Frida's reunion was interrupted when a reporter asked Diego and Frida to pose for a picture. He instructed Diego to stand on the top step as if coming off the train. He then placed Frida on a lower step in a three-

quarters pose turned toward her husband, making her look subordinate to the "noted Mexican painter," as the newspaper called Diego. The article seemed to underscore Frida's ancillary role: "Petite Señora Rivera, her black hair parted, braided in two little pigtails tied with a tiny black bow, darted over to speak to her friend Lady Hastings."[2]

At one point, *Detroit News* reporter Florence Davies turned to Frida and asked if she too was an artist. "Yes," Frida said enthusiastically in English. "The greatest in the world."[3] Davies both supported and undercut Frida's statement when she later wrote: "As a matter of fact she does paint with great charm."[4] Davies acknowledged that Frida was a painter, but the word "charm" implied a dabbler rather than a serious artist. Nevertheless, it was a step up from the account in *Time,* which referred to her as Diego's "pretty little Mexican wife." Frida took advantage of this unique moment by grabbing attention with her audacious statement of artistic significance.

But behind this flippant remark lay a criticism of American culture and gender bias in the art world. Frida lamented the superficial *gringos,* with their focus on success and becoming "somebody." You "must be an *important* person. Otherwise, they don't pay attention to you at all," she wrote to Dr. Eloesser.[5] She was growing tired of being patronized as the little woman at Diego's side. Her personality, intelligence, and creative powers were too immense to be contained within the subordinate role of wife, especially next to someone as colossal as her husband.

Diego, ever the attention-getter, reveled in all the fuss made over him. If Frida secretly rolled her eyes at the reporters and wealthy art collectors, Diego became animated, expanding his gestures and projecting his hearty laugh. His inability to speak English well didn't prevent him from working a crowd; quite the contrary. His broken English, with a bit of Spanish and French thrown into the mix, along with the help of an interpreter, seemed to make him more lovable and relatable, and in turn helped to whip up a convivial atmosphere.

Beyond the gorgeous train station, Frida and Diego entered a completely different world—a city crumbling under horrendous economic pressures. Men, women, and children in threadbare clothing roamed the garbage-filled streets looking for scraps of food. Fifty percent of Detroiters were unemployed, a rate that was double the national average. Not surprisingly, Detroit

had been declared by the "U.S. Census to be the hardest hit of 19 cities," and many of its people were homeless.[6] Clark Park in southwest Detroit was filled with makeshift camps. For those working-class folks who were lucky enough to still have homes, often there was no money for maintenance, and Frida saw houses where the wood was splitting and the paint chipping as the harsh Detroit winters—at times reaching below zero—battered the exterior walls. Both people and buildings were buckling under the economic downturn, and it was only year two of the decade-long Depression.[7]

Frida and Diego's relationship was also buckling, but it wasn't due to a lack of money or creature comforts. The emotional constraints of living in a foreign country where all eyes were focused on Diego and where Frida had to monitor her behavior and words had taken a toll. The latter part of their New York stay had buoyed Frida's mood, but Detroit was a different matter. Diego had his murals and adoring fans to boost his ego and occupy him in Detroit, while Frida was emotionally encumbered by her conflicting feelings about her pregnancy. Living in a place that felt even more alien than San Francisco or New York didn't help matters. She complained about Detroit's minuscule Hispanic population, just 15,000 out of a city population of more than 1.5 million, and the lack of excellent restaurants compared to New York. At least blacks had a strong presence in the city, increasing from 1.2 percent of Detroit's residents in 1910 to 7.7 percent in 1930.[8] Too, Frida identified with the working class, and Detroit was the land of the worker.

The year 1914 had been the beginning of the influx of workers, black and white, to Detroit. They'd been lured by Henry Ford's offer to "double wages to five dollars a day" for an eight-hour shift.[9] Ford's Highland Park plant was the first auto factory to implement the assembly line, where workers repeated one action, such as tightening a bolt, throughout the long day. This repetitive movement done at rapid speed was tough on men's bodies, not to mention mind-numbing. But five dollars a day was three times what other unskilled manufacturing jobs paid, and Ford workers could rent company-owned housing near the plant.

In 1928, when Ford moved his factory to nearby Dearborn, located along the Rouge River, he expanded operations, making it the center of the industrial world. But by the time Frida arrived in Detroit, Ford's economic stronghold had begun to wobble. Many Ford workers were losing their jobs along with their Ford-owned housing. On March 7, 1932, four thou-

sand of them had demanded relief by marching in the freezing weather, holding placards proclaiming, "Don't Starve in the Richest Land." They had begun their peaceful one-mile trek at the Detroit/Dearborn line, but their ultimate destination was Gate Four at Ford's River Rouge factory. As the unarmed men, women, and children, escorted by Detroit police, approached Gate Three of the factory, Henry Ford's private security forces yelled, "Turn back!"[10] But the people of what became known as the Ford Hunger March kept going.

Henry, who "blamed the Depression on the poor," ordered his forces to disperse the crowd with tear gas, bringing on fits of coughing, while the use of high-powered fire hoses violently knocked people over and ripped their clothing.[11] Fearing for their lives, some marchers hurled stones, hitting one of Ford's men. The response came swiftly: the staccato sounds of machine guns reverberated as bullets flew, hitting many protesters and killing four. Five days later funerals were held for the four dead marchers, and ten thousand people poured into the streets holding signs such as "We Came for Bread and Were Fed Bullets."[12] Frida and Diego, who had heard about the march while they were still in New York, arrived a month later, and the heaviness that hung over the city in the aftermath foreshadowed Frida's troubled time in this "shabby old village," as she called it.[13] She was shocked by the poverty and the trash she saw in people's backyards, commenting, "I have never seen such filth in my life."[14]

During her stay in Detroit, Frida missed life in Mexico—home-cooked spicy meals, *cajeta* (a sweet gooey treat made of caramelized goat's milk), the sounds of Spanish and music in the streets, and shops filled with Mexican candy and toys. However, it pleased her to see the beautiful elm trees and green lawns that encircled the Detroit Institute of Arts (DIA), across East Kirby Street from the Wardell residential hotel, where she and Diego were staying.

Built in 1926, this high-rise luxury hotel, with its indoor fountains, high ceilings, impressive chandeliers, and fine dining, exuded elegance and modernity. But as with most hotels during the Depression, revenue was down at the Wardell. The hotel management was delighted to have Diego, his wife, and their friends staying—that is, as long as they weren't Jewish. The Wardell, like many establishments in the United States, had policies barring Jews. Quotas on many college campuses limited Jewish enrollment to 10 percent. Exclusionary signs were part of the American

landscape: "No Jews Served Here," "Membership for Gentiles Only," "No Dogs or Jews Allowed."

When Frida and Diego learned of the Wardell's anti-Semitic policy, Diego protested, saying, "But Frida and I have Jewish blood! We are going to have to leave."[15] The dire times, not a sudden moral awakening, accounted for hotel management quickly changing its policy and reducing their rent in order to keep the couple there. In the end, Frida and Diego decided to stay because the Wardell provided some of the nicest accommodations near the DIA.

As spring unfolded, Frida's thoughts turned more and more to the fetus growing in her uterus. She knew Diego didn't want any more children. He had three daughters from previous relationships: one in Paris, whom he never saw, and two in Mexico, whom he occasionally saw. But art was surely his first love. Children would just get in the way. Having a baby wouldn't help create more harmony with Diego—far from it. On top of it all, Frida would have fewer opportunities to spend time with him and to devote to her own painting.[16] She already had her hands full tending to Diego's voracious needs.

By May, her concern transformed into alarm, alarm into fear, and fear escalated into panic. It didn't help Frida's psychological state to find out in mid-May that Charles Lindbergh III, kidnapped more than two months earlier, had been found brutally murdered in the woods not far from his home. The horror of his death traumatized a public already beleaguered by the Depression. The relentless media coverage didn't help either, with its barrage of stories featuring adorable pictures of the toddler under ghastly headlines: "Lindbergh's Baby Found Murdered."

Frida's doubts, questions, and fears concerning her pregnancy played over and over in her mind, the "what ifs" that have a never-ending life expectancy. She shared with Diego an early trauma from the death of a brother. In Frida's case, when baby Wilhelm died from pneumonia and she was born soon after, it was as if she replaced him.[17]

Later, when Frida was in her early forties, she said she desired a son and a daughter.[18] But in her twenties, she seemed to be preoccupied with having a boy who looked like Diego. Perhaps this preoccupation was related to their deceased brothers—did she and Diego harbor some deep-

seated survivor's guilt? A baby had the potential to create balance within their psyches and their marriage, but Frida also knew a baby boy might provoke Diego into fleeing. It had happened before, after his common-law wife, Angelina Beloff, gave birth to their son.

Given this psychic loop of questions and fears, Frida came to the conclusion that an abortion seemed like the most reasonable course of action. The Fords and Dr. Leo Eloesser counseled her to see Dr. Jean Paul Pratt, the Johns Hopkins Medical School graduate who had created the Gynecology and Obstetrics Department at the Henry Ford Hospital in 1926. Well respected as a surgeon, Pratt was the doctor who had delivered some of Henry Ford's grandchildren—and, ironically, Charles and Anne Morrow Lindbergh's baby.

The Henry Ford Hospital had the look of an English estate, with its white-trimmed red brick buildings surrounded by vast lawns, trees, ponds, and flowerbeds. Even the hospital rooms seemed cozy, with their dark wood chests of drawers topped by mirrors and nightstands with embroidered doilies. Only the metal-framed adjustable beds announced "hospital room."

The white examination rooms were not quite as welcoming. It was here that Frida met the tall, fifty-year-old Dr. Pratt, whose kind blue eyes and slicked-back blondish white hair made him appear fatherly. Thanks to Dr. Eloesser, Dr. Pratt was already familiar with Frida's medical history. It was a relief to be able to bypass the explanations about the injuries from the bus accident, her slightly shorter leg due to polio, her crooked spine from scoliosis, and her family history of epilepsy. She could get right to the point: "Given my health, I thought it would be better to have an abortion."[19] This was a bold statement, as abortions were illegal in the United States.

Dr. Pratt didn't try to persuade her otherwise, but he also didn't agree to perform a surgical abortion. Instead, he gave her quinine and castor oil, a popular home remedy used to induce a miscarriage. Both stimulate uterine contractions, but they are extremely hard to stomach. While the castor oil has a soapy flavor, the quinine is so bitter that nothing can mask its lingering aftertaste, causing some women to vomit. Frida downed the disgusting concoction and waited. At first she felt fine. But over the following days, she experienced bleeding, leading her to believe that she was having a miscarriage. When she returned to see Dr. Pratt for an examination, though, he told her she was still pregnant.

Once again, the agony of indecision began eating away at her. Should she have an illegal abortion, or should she do nothing? When she discussed with the experienced Dr. Pratt the possibility of continuing the pregnancy, he told her he felt she was healthy enough to carry the child to term, but he recommended a caesarean section to ensure a safe delivery. Before Frida left his office, the doctor reminded her to be very careful with her health for the remaining seven months.[20] Dr. Pratt must have been an intuitive man, because Frida despised being a "patient." Her older sister Adri even felt it necessary to end a letter by urging her, "Do what the doctor tells you to do."[21]

But Frida was not about to sit back and passively do as she was told. It was possible Dr. Pratt did not have her best interests at heart; rather, his advice might have been colored by his own fear of performing an illegal abortion. According to historian Leslie J. Reagan, "the demand of women to have abortions . . . ha[d] become so insistent that physicians had become more tolerant," performing some 800,000 abortions a year.[22] Yet Dr. Pratt may have felt that Frida's case did not meet the legal exceptions that would permit him to perform a surgical abortion, as her life was not in danger.

From Frida's point of view, this premise was false. Her mind worked overtime imagining all the potential negative effects of pregnancy on her health, including the possibility of death. Even if she were able to carry the child for nine months, a caesarean would involve surgery and time spent in the hospital to recover. This weighed heavily on her mind: "An insignificant mistake, and I could be taken away by *la pelona*," she confided to Dr. Eloesser.[23] "I'm a mess!" she added. "I request that you write Dr. Pratt, as he probably did not take into account all the circumstances, and as it is against the law he may be frightened or something and later it will be impossible for me to have an abortion."[24]

Dr. Eloesser responded promptly and sent Dr. Pratt a letter in care of Frida. In the time it took for it to arrive from San Francisco, however, Frida had changed her mind, convincing herself that pregnancy is "a biological thing." "I felt the need to give myself over to the baby," she told Dr. Eloesser.[25]

At the end of May, Lucienne arrived from New York, and when she walked into Frida and Diego's apartment, she found domestic tranquility: Diego

was reading, and Frida was cooking. This was a surprising sight as Frida was a self-proclaimed lousy cook. Perhaps those maternal feelings had brought on a desire for healthful food. Lucienne compared her to a "real German house frau" who made "good food too."[26] But this German housewife made Mexican food—"tortillas and plenty of chile."[27] Lucienne was happy to be there as a friend and as a mural assistant to Diego.

In the morning, Lucienne helped Frida make coffee, and they caught up on the news of each other's lives. Frida, who was "two months pregnant," admitted to Lucienne that her uterus "hurt," and that she had some spotting, constipation, and extended periods of nausea.[28] Lucienne asked if she'd seen her doctor. "Yes," Frida responded, "but he tells me I can't do this, I can't do that, and that's a lot of bunk."[29] In fact, Dr. Pratt had recommended Frida remain in bed, but the prospect of this frightened her so much that she did the opposite.

Her state of mind at the beginning of July can be gleaned in a letter from her cousin Carito Romero. Frida had eventually told Carito and her sister Mati about the pregnancy, swearing them to secrecy. Carito's concerns for Frida's health were evident: "The only thing I feel bad about is that you are so nervous and that so many things are contributing to you not feeling well."[30] Carito emphasized the importance of finding peace because "stress affects the general health of a person."[31] She understood that Frida's nervousness might be contributing to her health issues, and she cautioned her to take it easy and not try to do "everything in one single day."[32]

Carito brought up a plan she and Mati had come up with: to have Frida return to Mexico by September. They thought it best if she spent the remaining three months of her pregnancy surrounded by family before delivering in December. She even told Frida that Mati would consult Dr. Marín to provide her with the correct treatment in Detroit, as he had been the doctor in charge of Frida's previous pregnancy and abortion. Carito also advised that while in Detroit, Frida should "follow to the letter the treatment prescribed by your doctor or else you will not get better."[33] But this was not Frida's way.

She made plans to have lunch on July 2 with Florence Miaullo, whose wealthy Michigan family supported the arts. Frida ended up having to cancel their date, stating in a telegram: "I must accompany Diego somewhere urgently."[34] At that time she'd been experiencing a "sort of putrefied bleeding almost daily" for two weeks, as she recounted to Dr. Eloesser.[35]

She'd checked in with Dr. Pratt about the bleeding, but the expert in what was termed "psychosomatic gynecology" told her not to worry. Then, on a dark Fourth of July morning with a sliver of a new moon barely visible, Frida's bleeding increased along with her pain. Lucienne, who was sleeping in the living room, heard "the worse [sic] cries of despair" coming from the bedroom.[36]

Knotted up in a fetal position, Frida felt the uterine contractions slicing through her like the blade of a knife. Tears streamed down her face, dampening her long, dark hair. Diego didn't know what to do; when he saw blood clots on the white bedsheets, he became frantic. He rushed into the living room muttering something about the doctor. Lucienne hurried into the bedroom to see Frida. "She was in this blood. In my mind was the idea that Diego had stabbed her. That they had fought and he had stabbed her and now he's saying she's sick. That was my first impression."[37] Lucienne then scrambled to the phone to call for help, but it took an hour for the ambulance to arrive.[38]

When the ambulance drove off with Frida, Diego and Lucienne followed behind in a cab. At the Henry Ford Hospital, Frida was wheeled through the emergency entrance and down a long, narrow hallway. As she was being transported, Frida glimpsed what she perceived as multicolored pipes on the ceiling, and exclaimed to her husband, "Look, Diego! *Qué precioso!* How beautiful!"[39] This was the last bit of beauty Frida would encounter for a while, including the Fourth of July fireworks that lit up the city's sky that night.

Frida's focus on the beauty she saw in the pipes indicates a change in her mood. Because of the intense pain she was suffering, it's not a stretch to think she may have received nitrous oxide (laughing gas) in the ambulance on the way to the hospital, a fast-acting anesthetic that blocks "signals from the brainstem," creating an immediate feeling of relaxation.[40]

At the hospital, she was most likely "taken to the operating room and given fluids," says Dr. Adnan R. Munkarah, current chief medical officer and chair of the Department of Obstetrics and Gynecology at Henry Ford Hospital.[41] For the pain, they probably would have given "injections of morphine," because the nitrous oxide is short-lived.[42] Dr. Munkarah also pointed out that Dr. Pratt might have ordered a dilation and curettage (D&C) to clean the uterine lining that is sloughing off during a miscarriage. If this procedure took place, Frida would have been given nitrous

oxide, perhaps with something like ether added to increase the effects of the anesthesia.

Unfortunately, for unknown reasons Frida's hospital medical record is missing, according to Henry Ford Hospital head archivist Melanie Bazil.[43] What is known, from Lucienne's journal, is that Frida's bleeding continued, because she did not expel the fetus that first day when she was rushed to the hospital. Nor had she fully expelled it on her second day in the hospital, when nurses gave her "strong injections," possibly of morphine, to ease her pain.[44]

Despite Frida's fragile state of mind, she mustered the energy to send her sister Mati a cable telling her what had happened. She didn't want to upset family members who were prone to excessive worry, so she downplayed the severity of her condition: "Bad news: yesterday I miscarried without apparent reason. It is all over without great disarray. I am in hospital for absolute rest. Do not be worried as I am well. Explain to everyone, as Adri suspects something. Letter follows with explanations. Do not worry for me, everything turned out well. Write to me at the hotel. Diego brings me letters. Frieda."[45]

Mati responded the next day: "I received the cable. Everyone is distressed by the news. If it is necessary to leave in a hurry, send us the hospital's address. Everyone knows except Mama. It is better not to distress her. I beg Diego to inform us of your state. It's distressing that you are far away and we can't see you. We are all well. . . . Take care of yourself. Obey the doctor's orders. Don't lie to me in any way. Greetings to Diego and kisses from everyone."[46]

The same day Frida received the telegram from Mati, her cramping eased, allowing her some relief on her birthday, July 6. However, lying alone in a hospital bed was not how Frida had wanted to celebrate turning twenty-five, and her mood began to plummet. When Lucienne walked in and saw her friend's face awash in anguish, she handed Frida a piece of paper and told her it was a telegram from Henry Ford. Realizing that this was Lucienne's idea of a joke, Frida burst into fits of laughter. Those abdominal contractions perhaps were a trigger, as she soon expelled the last remnants of the fetus.

But this laughter was only a temporary reprieve, and desperation followed: "I wish I were dead! I don't know why I have to go on like this."[47] Frida had been continually battered by psychic turmoil since the day she

discovered she was pregnant. Now she found herself in the hospital, a place she feared, with a fever doctors didn't know how to treat.[48] That Frida was in one of the best and most comfortable hospitals in the United States wasn't enough to calm her.

When Diego walked in carrying a deep purple orchid, Frida did not feel consoled. Her despair was still palpable. Diego, almost always ready with a quip, was speechless. His pudgy face was creased with worry like a worn-out map. He told Lucienne he was actually "worried to be worried."[49] Frida's fever and severe spinal pain indicated to Diego that she was getting worse. She had said she'd rather die than "be paralyzed in bed."[50] It was hard for him to see Frida in such a distraught frame of mind because, as Lucienne had observed, when she was "blue, she looks so hopelessly dejected."[51]

Frida's unexplained fever and spinal pain were cause for concern. The Detroit doctors, who had been through the meningitis epidemics of 1928 and 1929, wondered if those symptoms were caused by an inflammation of the membranes surrounding the brain and spinal cord.[52] They extracted spinal fluid at some point to see if there were signs of meningitis.[53] The results of the test are unknown. But five days after her fever began, it disappeared.

Being fever-free didn't mean Frida had cleansed herself of the emotional whiplash she'd undergone from the miscarriage. This experience appears to have triggered all the feelings of agitation, helplessness, vulnerability, and despair Frida had experienced after the trauma of her bus accident in Mexico City, something referred to today as post-traumatic stress disorder. As therapist Babette Rothschild affirms: "trauma is a psychophysical experience," exacting a "toll on the body as well as the mind."[54] Frida hated being confined to a hospital bed. She wanted to create art. But first, despite her mixed feelings about having a child, she asked to see her miscarried child, a boy, in order to mourn. But the Ohio-born Dr. Pratt refused Frida's request, thinking it too disturbing. He didn't understand that images of death are abundant and natural in Mexican culture, and that Frida needed to see her miscarried son in order to process what had happened to her. Diego decided to sneak in medical textbooks so she could at least see illustrations of fetuses. He knew Frida would, like an alchemist, transform the hard material of this reality into a gilded masterpiece, a work of art like no other.

After five long days in her hospital bed, Frida picked up a pencil and made a drawing of herself seated in a chair with a stiff-looking neck and a wide-eyed blank stare. Another wide-open eye is on her hospital gown, looking as though it's emerging from her chest under her right shoulder. This eye looks out directly with what appears to be a flash of light. It is reminiscent of a third eye, with its connotation of perception beyond ordinary sight.

This was the second time Frida had included a third eye in a drawing. The concept is found in several religious traditions, including Buddhism and Hinduism, and in art it is most recognizable as a third eye appearing in between the eyes or on the forehead. In *The Dream,* the drawing she had created four months earlier, the Shiva-like eye emitting flames on the façade of a high-rise next to Diego's face looks alive with passion and fury. But in the drawing of Frida in a hospital gown, the flash in the third eye is subtle, perhaps indicating her connection to an inner realm of spiritual and artistic sight.

Back in Mexico City five years before, Frida had watched Diego incorporate the third eye into his murals at the Ministry of Education in Mexico City, such as a grisaille image titled *Labor,* featuring a meditating, cross-legged Buddha-like woman with a star in the middle of her forehead. It's similar to the design Diego made for the cover of the periodical *El Maestro,* where he placed an all-seeing eye at the center of a five-pointed star, symbolizing the progression from the physical to the spiritual—earth, water, air, fire, and spirit.

Frida began using the third eye in her drawings while in the United States. It would become a recurring motif in her mature paintings and later diary entries. Two years after her miscarriage in Detroit, Frida made her interest in the all-seeing eye explicit in a drawing titled *Third Eye.* It depicts a large eye with a landscape scene embedded in it. A profile of an oversized toddler sits on the ridge of a mountain with the face of a clock above that reads ten minutes past five. This dreamlike landscape within an all-seeing eye may have been inspired by a hallucinatory experience Frida had while losing large quantities of blood and possibly receiving nitrous oxide during the miscarriage in Detroit, as the time on the clock coincides with the onset of her increased bleeding that morning on the Fourth of July while in bed at the Wardell.

While it's hard to know what drugs Frida received at Henry Ford Hospital, there are important clues that point to her altered state of mind during the acute phase of her miscarriage. When she was lying on the gurney being conveyed through the basement corridor at the hospital, she marveled at the beauty of what she thought were colored steam pipes above her. But in fact the long tubular shapes that ran the length of the basement ceiling were "gray and white," according to Melanie Bazil, the Henry Ford Hospital archivist.[55] It's possible that the rush of hormones from extreme stress could have created some visual distortion, but it's more likely that something like nitrous oxide produced the visual effect of beautiful colors and Frida's positive, relaxed state of mind.

Frida's self-portrait drawing with the third eye could have served to illustrate American psychologist William James's 1882 article "The Subjective Effects of Nitrous Oxide." Inhaling nitrous oxide produced, he said, a state of mind similar to a mystical experience, one that affected his perception of reality. Although different people had slightly different experiences, there was one feature they had in common: as the drug was wearing off, everyone had a "sense of an intense metaphysical illumination."[56] This feeling faded as "sobriety" returned and one was "left staring vacantly."

James said the nitrous oxide had forever altered his perception of reality, as in a drug-induced state he had realized that "the ego and objects are one." Others who have had similar mystical experiences report no longer seeing divisions between the conscious and unconscious aspects of the mind, between dream and reality, and even between life and death.

In Frida's self-portrait created in the Henry Ford Hospital, she looks like someone who has undergone a major psychological metamorphosis, with her stiff neck, faraway gaze, and a third, disembodied eye that looks back at us. It's as if the two eyes on Frida's face reveal the physical and psychological trauma she endured, and the third eye conveys the inner light of consciousness she has gained, one beyond material reality.

The day after Frida made the self-portrait, she attempted to bring these external and internal realities together in another drawing. With perfectly straight lines, she created a bed, placing it at a slight angle. She then drew her nude body supine on a hard-looking mattress with her legs bent at the knees and tucked in. For her face, she rendered a blank, emotionally detached stare.

The stark reality of her nude body in a hard bed is softened by five

fantastical, undulating strings surrounding her, all with symbolic objects attached at the ends. Floating in the air above her bed, a snail represents the slowness of the miscarriage. A side-view anatomical drawing of a pelvis refers to her past injuries and her womb. Propped up on the ground below the bed are the skeletal remains of a pelvis, indicating that her pelvic region has decayed or isn't functioning properly. There is the orchid Diego gave her, with sexual overtones in its resemblance to a woman's labia. And there is an autoclave for sterilizing instruments, emphasizing the cold environment of the hospital.

Having the orchid in between the pelvic bone and the autoclave highlights the delicate, soft, pliable petals of this cut flower, making the hard bone of the pelvis look even more rigid and the autoclave all the more impersonal. These objects add an otherworldly look to this otherwise somber drawing. It's possible Frida was adding a dreamlike, Surrealist touch, but it seems more likely she was giving visual expression to a hallucinatory experience she had while in the hospital.

Frida's vacant stare and the work's otherworldly mood recall similar aspects of the drawing she made depicting her bus accident seven years earlier. In this drawing, a preternatural head sprouting above Frida's supine body possesses the look of someone in a daze. From a therapeutic point of view, Dr. Irving Leon, a clinical psychologist from the University of Michigan, views Frida's collision drawing as a way "to make sense of the accident," ultimately "taking charge of it."[57] Seven years later, Frida once again used art to take charge of a disquieting experience, but this time she was on the brink of a new, mature style.

When Frida wasn't drawing, she was receiving visitors. A rabbi who had befriended Lucienne checked in on Frida, as did a young Mexican doctor who discussed his interest in studying "the medical properties of the extraordinary Mexican healing plants."[58] Mrs. Venegas, an important member of the small Detroit Mexican community, also came to visit. Frank Venegas Jr., Mrs. Venegas's grandson, said his "grandmother was a *madrina*," or godmother, to many children in the Corktown neighborhood of southwest Detroit, and perhaps this included Frida and Diego's stillborn child.[59] His grandparents most likely met Frida and Diego through his grandfather, who worked for the Ford Motor Company.[60] Seeing the motherly Mrs. Venegas and being able to speak to her in Spanish must have provided Frida with some comfort.

But, after thirteen trying days, Frida was ready to break out of her confinement. On July 17, with the moon in full bloom, Lucienne and Diego were relieved to get Frida out of "that damn hospital."[61]

Returning to her stiflingly hot apartment at the Wardell, Frida nestled herself into her favorite corner of the couch. Flowers from Lucienne and Diego sat on the table.[62] From the window, Frida could see the gilded roof of the thirty-story Fisher Building, an Art Deco tower that housed the elaborate Fisher Theater, which was done in the Mayan Revival style. It's ironic that not far from the homesick artist's window was a faux Mayan world with a proliferation of gold-accented sculptural reliefs lining the walls, ornamented staircases, and a "glyph"-patterned carpet. Joseph Nathaniel French, the chief architect, had even included real banana trees as well as macaws that patrons could feed while walking through the lobby.[63]

On Frida's first days out of the hospital, Lucienne encouraged her to draw, but Frida seemed psychologically immobilized, and negativity continually oozed out of her, specifically a tirade about how she hated Detroit. Surely the stress of her hospital experience and the physical and mental trauma she had been through were factors, but the stress of living with Diego in a foreign place had to have played a role. Just one month earlier, Frida had confided to Lucienne about how "irregular and different" Diego was compared to any other man she'd known.[64] Figuring out how best to respond to his erratic moods was a constant challenge. When Frida tried to assert herself, Diego would respond with "You don't love me."[65] And Diego's unstable behavior and all-consuming painting schedule didn't change after she got out of the hospital.

Frida's depressive mood began to lift a few days later when her maid, Lucy, came to clean their apartment with "her sweet large eyed three-year-old niece" in tow.[66] Lucienne tried to draw this little girl while she sat on the floor playing, but capturing a lively child on paper was a difficult task. Frida, always one to embrace a challenge, couldn't resist and began drawing her own portrait of the child.

Eventually Frida found her way back to painting. Given her spine and leg pain, she wanted to design and have constructed a special aluminum

easel that could be adjusted to the height she desired, allowing her to sit if necessary. To buy the aluminum and some metal sheets to paint on, Frida and Lucienne went to Larned Street in the Warehouse District, a few blocks from the Detroit River. There they found stores for "machinery and iron tools and printing implements," Lucienne wrote.[67] After Frida's new easel was built, she placed a 12-by-15-inch piece of metal on it and applied an undercoating of lead-based paint.

Once the undercoat dried, "she picked up a pen" and began to sketch on the painted surface, beginning with the objects at the top and moving down to the objects at the bottom, ultimately re-creating the fantastical drawing she'd made of her miscarriage.[68] Then Frida reached for her immaculately clean paintbrushes and, with her minute, careful brushstrokes, moving from left to right, produced *Henry Ford Hospital (Flying Bed)*.

She painted her reclining naked body at the edge of a white mattress sitting on a steel bedframe. The bed is positioned at a diagonal and the perspective is slightly tilted, making it look as if her child-sized body could roll off the mattress. She emphasized her swollen abdomen, the blood-stains on the sheet, and the gigantic tear falling from her left eye to make clear that the thirteen-week-old fetus hovering above her body had died.

Frida attached the baby's umbilicus to a red string, as she did with the five other symbolic objects she'd used in the original drawing. Now, however, three objects float above her bed, with the eye drawn to her child in the center, while the other three are firmly planted on the dirt floor. Frida holds on to the red, umbilical-cord-like strings that connect all six objects as if they are balloons. Art historian Helga Prignitz-Poda points out that "according to a love spell," red strings "serve to reinforce the inner attachment to a person."[69] The premise here is similar to the "red string of fate" in Chinese culture, but according to Chinese legend, it's the gods who hold the strings of fate. They tie an invisible red cord around the ankles of those who are destined to meet one another. And while the cord can stretch and tangle, it will never break. Seen from this perspective, fate brought "little Diego" to Frida, and even though he died, they will always be connected through the red string.

There are parallels between this painting and *Frida and the Caesarean Operation*. In this earlier work of art, a child is also suspended outside of Frida's womb, but instead of a red cord tied to Frida, a black line connects the child to Diego. In this earlier painting, the family—Frida, Diego, baby,

and Matilde—is together, but in *Henry Ford Hospital,* Frida is alone with the symbols of her pain in a desolate industrial landscape. She looks vulnerable. Her small, naked body and tearstained face are a far cry from the voluptuous reclining female nude of Western art, with her come-hither eyes. Well versed in the history of Western art, Frida understood she was stepping into the unknown. She wanted to make visible the physical and emotional pain women undergo when they lose a child in utero and the otherworldly experience of it, something that the secondary title, *Flying Bed,* spotlights.

In San Francisco, Frida had challenged her fellow female artists to create the "bloodiest thing" they could think of. A year later, Frida did just that with this painting. In the 1930s a bleeding nude woman in a hospital bed was incomprehensible as a subject for high art, something that became clear in 1938 when *Henry Ford Hospital* was shown publicly at the Julien Levy Gallery in New York. A reviewer for the *New York Times* failed to see the painting's radical nature, dismissing it as "more obstetrical than aesthetic."[70]

While the image of a reclining female in a bloodied bed was foreign to a U.S. art audience, it wasn't completely so to Mexicans, whose culture had absorbed the potent visual languages of Aztec and Catholic imagery and mythology. Frida had turned to her homeland for inspiration. Blood, for example, is central to Aztec philosophy: it feeds the gods who keep the universe in motion. For the Aztecs, everything revolved around maintaining the precarious balance between life and death, and this spawned the practice of human sacrifice, the well-known ritual of cutting out a person's heart and offering it to a pantheon of deities.[71] The heart was given prominence, for it was viewed as the seat of the individual.

Frida was aware of these Aztec ideas as well as images conveying such concepts. Spanish accounts and Aztec codices reveal that it was considered an honor to be sacrificed, because with this transformation a mere mortal rose in stature, becoming a representative of the gods. One such example in the *Codex Magliabechiano* shows a sacred rite being performed on the steps of a pyramid. A priest, referred to as a *tlamacazui,* has cut out a man's heart, which is seen floating in the air—a miraculous image symbolizing the connection between the life-sustaining human heart and the realm of the heavens above. Blood saturates the victim's body along with others strewn about on the steps of the temple.

In addition to the images from various codices, there are numerous stone sculptures that depict hearts and reference the dual nature of life and death, such as the eleven-foot sculpture of the earth goddess Coatlicue, mother of the Aztec deities. This imposing goddess wears a skirt made of intertwined serpents (symbols of fertility) and a necklace of hands and hearts with a skull prominently placed at waist level (symbols that convey the importance of human sacrifice). The Aztecs understood this symbolic outfit because they were familiar with Coatlicue's role as the earth goddess who both gave life and devoured it. Even a non-Aztec can feel this goddess's power—it is overwhelming.

Looking at Frida's painting, it doesn't matter whether you know her story or can interpret all the symbols; she has mastered her visual language, making pain, loss, isolation, vulnerability, and the precarious interplay of life and death the focus. Like the great Aztec artists, she doesn't sugarcoat anything—her direct approach creates an immediacy that's felt when first looking at the small, bloodied nude body. Frida isn't merely creating an image for its shock appeal. Rather, an immediate visceral response cracks open this private world, beckoning us to probe further. And this second look reveals the simultaneous references to Catholicism.

Viewers, particularly those steeped in the Catholic imagery of a crucified Christ, would have recognized that Frida was referencing this image of suffering, as well as the style of Catholic *retablo* miracle paintings, which depict a life-threatening event and a holy being, such as Mary or Christ, who has intervened to halt death. Such paintings lined the walls of Catholic churches in Mexico or were hung near a home altar as a way of giving thanks for a miraculous intervention. In *Henry Ford Hospital* Frida pays homage to *retablos* with the small size of the artwork, the metal she paints the image on, and the folk-art style she uses. Though she no longer practiced Catholicism, she saw in *retablos* a social statement about class, as they were a popular art form made by local artisans who sold them in outdoor markets for very little money. Likewise, Frida wanted her art to appeal to the ordinary people of Mexico, many of whom were familiar with *retablos*.

Frida transforms the strictly religious function of *retablos* by leaving out Mary or Christ in *Henry Ford Hospital*. These holy intercessors have been replaced by a procession of Ford's famous River Rouge factory buildings that stretch across the horizon line where the sky and earth meet, as if to imply that in Detroit, the industrial center of the United States,

factories are the new religion, a common attitude at the time. Frida was not anti-technology, but unlike her husband, she was not a devotee of this new religion.

With a brilliant mind capable of dissecting complex philosophical arguments, she questioned some of the faithful's technological tenets, something that is obvious in the way she juxtaposes her bleeding body with the barren landscape of so-called American industrial progress. Even Ford's mighty River Rouge plant, which had made some of the world's fastest cars with the company's breakthrough lightweight V-8 engines, couldn't provide a physically painless, quick, mechanical solution for miscarriages. Most women survived miscarriages, but those who died did so from "contracting an infection" while in the hospital, say doctors Sven Nielsen and Seth Granberg.[72] Frida was lucky to leave the hospital in relatively good physical health. Nevertheless, a mixture of feelings swirled inside of her. It was devastating to endure the prolonged miscarriage and to lose her unborn child, but if Frida were being honest with herself, she would have admitted that she had never felt certain about having a baby.

Her conflicting emotions must have made it even more difficult to process her feelings after the miscarriage, especially when it was the norm to ignore the emotional gravity of losing a child in utero. Today, psychologists understand more about the impact of a miscarriage on a woman's psyche. In Frida's time, however, few acknowledged that a miscarried child involved the same type of grieving process as the death of a loved one; nor did they understand how daunting it is to mourn without an actual body, or how common it is for women to be tortured by "crippling feelings of guilt," says Professor Annsofie Adolfsson,[73] believing they could have done something to prevent the miscarriage.

In Frida's case, she might have experienced some guilt due to her ingestion of the quinine and castor oil to induce a miscarriage. While Dr. Munkarah thought it "unlikely that the castor oil and quinine," taken in May, would have "contributed to the miscarriage in July," Frida must have wondered.[74]

The profound and disturbing nature of the entire experience of her miscarriage, including the time she spent in the hospital, unleashed a torrent of creative energy in Frida, who made not only a painting and drawings about

her miscarriage but lithographic prints as well. She had never worked with lithography before, but an opportunity arrived one hot evening in late July. An informal party had begun in Frida and Diego's apartment at the Wardell when a group of local Mexicans from a cultural club and the Mexican vice consul and his "rollicking wife" came over.[75] The cigarette smoke, laughter, and mellifluous sounds of Spanish reminded an emotionally shaky Frida of her beloved homeland. In the midst of these festivities, Lucienne and Frida met Mr. Fisher, an artist who introduced them to a friend of his, a woman who owned the Arts and Crafts Guild just down the street, on the corner of Kirby Avenue and John R Street. Discovering that Frida and Lucienne were artists, she invited them to work at the school anytime, especially in the lithography studio.

Frida and Lucienne, both lovers of imposed schedules for reading, studying, and creating, jumped at the opportunity to have a space all their own. The cramped quarters at the Wardell had too many distractions, with guests and friends dropping by to visit. Jean Wight often came by to talk about "dresses" and "fur coats."[76] This disruption and others like it annoyed Frida.

At nine the next morning, the two artists entered the "dirty, dusty and stale" Guild, ready to begin.[77] Looking at the lithography materials and listening to "a negro fellow from South America" offer them "a few hints" on how to get started, they became perplexed, as those tips were not enough to teach them the involved process of lithography.[78] The "negro doesn't seem to remember what the steps are in the chemical process," Lucienne wrote in her journal.[79] It became clear that the two novices would have to figure it out on their own, perhaps with the help of a book.

While working on the printing procedures, they reached a level of concentration like that of Buddhist monks in a meditative state. But there was one exception: when visitors walked into the studio to see the women "fool around," Frida's monklike composure melted away and she became "like the wildest animal," wrote Lucienne.[80] "They didn't realize how serious we were in the work," Lucienne reflected.[81] And while that was a common attitude toward women artists of this period, it didn't stop Frida from trying to perfect her art. When even the smallest disturbance encroached on her focus, she became upset. She "would swear each time a fly came settling on her arm," Lucienne noted.[82]

Once Lucienne polished the thick limestone blocks, the women began

to draw on the smooth surface with a waxy crayon. The limestone is especially responsive to the oil-based crayons, making them "the most luscious things to run a wax crayon over," Lucienne cooed.[83] They used razor blades to erase lines and create texture. When Lucienne felt confident, she drew "little negros playing in a playground."[84] Frida drew herself standing nude except for a necklace and a six-week-old fetus curled up in her belly. She then added various symbolic objects on either side of her—a thirteen-week-old fetus, dividing cells, plants, a painter's palette, and a crescent moon.

Finally, when Frida and Lucienne were satisfied with their drawings, the two artists began to apply various solutions of gum arabic and water to the limestone drawings. Then they applied the oil-based ink to the limestone block and inserted paper into the printing press. As they lifted the paper off the press and slowly turned it over, their high hopes took a nosedive when they saw streaks running through their images. Somehow lines had formed on the stone, and all of their hard efforts had resulted in unusable prints.

Frida and Lucienne had been working all day and into the evening when Diego dropped by to see how the printing was coming along.[85] Unfortunately, he couldn't offer any solutions because he'd never studied the lithographic process. Exhausted, Frida decided to come back another day and redo her drawing.

Several days later, Lucienne went to the Guild early in the morning, ready to begin anew. Frida arrived later. She was feeling "impatient" and on edge, ramping up the level of tension between herself and Lucienne, something that had already been escalating over the previous few days.

This friction had led to Lucienne's flight from the cramped quarters at the Wardell a few days earlier. Seeking refuge in Canada, visible just across the Detroit River, she'd hoped that time away from Frida and Diego would give them some needed privacy to reconnect emotionally after Frida's harrowing hospital experience, and give Lucienne herself a break from feeling like a third wheel. "I never felt so unwanted," she confided to her journal.[86]

After Lucienne spent the day at a park in Windsor "with leisure and quiet enjoyment of the flowers," as if she "was in another world," she returned to Detroit rejuvenated and bearing gifts for Frida.[87] The toffee appealed to Frida's sweet tooth. And a copy of the German newsmagazine *Berliner Illustrirte Zeitung* appealed to her ethnic heritage and keen interest

in politics, especially at this tense time, when eighty-four-year-old Paul von Hindenburg, Germany's incumbent president, had barely kept his position in a contentious runoff election against the rising Adolf Hitler. The German elections, Lucienne noted, were "still boiling" months later.[88]

At the Guild, Lucienne felt a nervous strain in the air and "was very distant to Frida."[89] The two focused on their prints as if they were in separate spaces, lost in their own internalized creative concentration. After working "ferociously," Frida completed her drawing.[90] Now it was time to see if the image would print without lines. Lucienne joined Frida at the printing press, and when Frida lifted up her print to realize that it was free of lines and streaks, "Frida's cross mood was cleared off as if by magic."[91]

The successful print shares many symbolic elements with the painting and drawings she made of her miscarriage, but in the print titled *Frida and the Miscarriage* she stands in nature, with the blood that drips from her vagina nourishing the earth.[92] She's a very different type of earth goddess than the voluptuous nude seen in many of Diego's murals. Instead of this earth goddess being filled with life, it's the death of her child that feeds the earth.

Much as in her seated self-portrait drawn in the hospital, Frida's hair is tucked under a netted cap, making the huge teardrops on her face even more pronounced, and calling to mind statues of Our Lady of Sorrows, with the tears revealing Mary's pain as she stands alone at the foot of the cross where her son is dying. In Christian parlance, Jesus died for the sins of humanity, making his death both worthy and necessary. In Frida's case, her son died for ambiguous reasons, and none connects her baby's death to a higher spiritual purpose, making Frida's ambivalent feelings of motherhood antithetical to Mary's idealized motherhood.

But Frida, the astute student of her country's history, favored the layering of imagery, invoking the multitiered and complex colonial traditions stitched into the fabric of Mexican society. Before being forcibly converted to Catholicism by Cortés's conquest in the sixteenth century, indigenous Mexicans had worshipped the earth goddess Coatlicue. She had multitudinous manifestations but was known generically as Tonantzin, "Our Revered Mother." A temple was built in her honor at the top of Tepeyac Hill in the Aztec capital, where present-day Mexico City is sited.

When the Virgin of Guadalupe appeared to the Christian convert Juan Diego on his trek over Tepeyac, it was no coincidence that she appeared on the same hill that was sacred to Tonantzin. It was also no coincidence that

the Christian friars built a church to Our Lady of Guadalupe in the same spot. The number of worshippers arriving from all over Mexico to visit the Basilica of Guadalupe was astounding and pleased the church's hierarchy. However, when the friars heard the faithful address the sacred Virgin as Tonantzin, they viewed this as blasphemy and as a sign that they still had more work to do on the conversion front.

What they failed to realize is that the converted Mexicans weren't necessarily being blasphemous. To hold two images or names simultaneously in their minds was not unusual for the Aztecs; they were used to a plethora of gods, each with more than one manifestation. Likewise, duality was at the heart of Aztec cosmology, a concept that's illustrated in an important story about the birth of Huitzilopochtli, the sun and war deity. Huitzilopochtli was conceived when a ball of feathers touched the chest of his mother, Coatlicue, while she was sweeping, instigating a chain of events that ultimately propelled the creation of the cosmos and an awareness of its delicate balance. Coatlicue's daughter, Coyolxauhqui, mortified by the improper manner in which her brother was conceived, plotted with her other four hundred brothers to kill their pregnant mother.

Inside the womb, Huitzilopochtli prepared for battle. When his sister and brothers beheaded their mother, he rose up, decked out in full battle regalia, and killed his siblings, dismembering their bodies and throwing them into the sky, where his sister became the moon and his brothers the stars. This cosmic family conflict set in motion an eternal battle of opposites—day and night, male and female, birth and death, fire and water—that permeated Aztec culture.

Frida too was ruled by duality, understanding its importance in both life and art. Frida's tears in the print recall the Virgin's, and to balance this Christian association there's a weeping Aztec crescent moon in the upper right corner. Both Frida and the moon shed tears, yet their facial expressions reveal no hint of the intense pain one would expect to see associated with such large tears; why, then, are they crying?

Frida designed her lithographic print to showcase duality—dark and light, death and birth/rebirth—with a standing self-portrait as the dividing line demarcating these two sides. The fetus curled up in her womb symbolizes the unifying force. As a circular form, it's touching both the light and dark sides, reminiscent of a yin/yang symbol. One side of the fetus is cast

in light because of its potential for life, illustrated by the baby's attachment to the umbilical cord on the left side of the print.

Of course, the fetus never developed past three months, and therefore part of it resides in darkness, the right side, where we see blood dripping from Frida's vagina and onto the soil, providing nourishment for plants to grow. Out of death springs life. On the dark side of the composition, a third arm has sprouted, giving birth to an artist's heart-shaped palette with two fingers peeking through the hole. Instead of a third eye, as seen in her hospital drawing, a third arm has emerged, equipped with the ability to render the "visions" or inner knowledge Frida had gained from her traumatic experiences into a new visual form. This miraculous appendage can also be traced back to an Aztec story recounted by Franciscan friar Bernardino de Sahagún, detailing the perceived magical power attributed to the left arm of a woman who died in childbirth.[93]

Hovering above the artist's palette, the crescent moon, like the third arm, symbolizes the cyclical process of life and death, just as Coyolxauhqui's death initiated her rebirth as the moon goddess. In a similar twist of fate, Frida's child had to die in order to give birth to Frida the mature artist. Is this why Frida cries? The most common interpretation is that she weeps because of her lost child. However, Frida's letters reveal a pregnant woman who was torn, confused, terrified, and in the end resigned to her biological role. Frida and Coyolxauhqui share more than tears—Coyolxauhqui attempted to kill her brother while he was in his mother's uterus, and Frida attempted a similar act when she ingested the quinine and castor oil to induce a miscarriage.

The initial title of Frida's painting *Henry Ford Hospital* was *The Lost Desire,* indicating Frida no longer had a desire for children—a rather bold admission at a time when it was believed that a woman's primary purpose in life was to give birth. Even some eighty years after Frida created these images of her miscarriage, the myth of Frida as the tragic mother who could never have Diego's baby has persisted. The trope of the suffering mother endures because it's too uncomfortable to imagine a woman making the decision to have an abortion or induce a miscarriage out of concern over her own mental and physical health. Ultimately, Frida makes the creation of art more important than the creation of a child. Notice how she makes her palette heart-shaped.[94]

The Aztecs had Coatlicue and her many manifestations to aid in their understanding of the complexity of motherhood. On the one hand, Tonantzin was believed to feast on corpses; on the other hand, as Cihua-coatl, she wept for women who died in childbirth. In the colonial period, these two images morphed into La Llorona, the woman who killed her own children after being jilted by a lover; according to a Mexican legend, she haunts the streets as a weeping woman carrying a dead child.

Frida's miscarriage was her second traumatic death/rebirth. If the bus accident at age eighteen had given Frida time, the first ingredient an artist needs to create, then this second major trauma of her life bestowed upon her the second ingredient a great artist needs—*a fearless spirit that isn't afraid to chart the unknown.*

Frida makes manifest this new knowledge in her lithographic print as she recognizes the cyclical process of birth, life, and death. The death of her child, seen on the left, gives birth to a new creative vision, symbolized by the painter's palette on the right—a gift that would never die, just like the moon hovering above.

With this new, emotionally raw, and taboo subject matter of a miscarriage and its complex associations, twenty-five-year-old Frida freed herself from conventionality, becoming an independent woman and an original artist.

Border Crossings

At the border, Mexicans speak English very well and gringos speak Spanish, and they all get mixed up.

—FRIDA KAHLO

 Frida awoke to the steady beat of raindrops pitter-pattering on panes of glass. It was September 3, and the intensity of the rain increased throughout the day and evening, the remnants of a hurricane that had blown in from the Caribbean.

It was a perfect day to paint. Frida picked up her small sable paintbrush and started work on the 12½-by-13¾-inch sheet of metal she'd begun a few days earlier. On the left side she had the beginnings of a Mexican desert landscape. Eventually the right side would depict an American city and a Ford factory. At the Wardell, Frida was painting in the living room of her apartment. She tried to focus on her brushwork, but Jean, who had dropped by, kept talking about a fur coat, which frayed Frida's nerves. She wanted to yell, *Shut up, can't you see I'm trying to work?* Instead, she remained quiet. What was the point in saying anything? Whatever she said, no matter how politely she phrased it, "Jean [always] gets hurt."[1]

Lucienne was working on her art as well—sketching a wooden house with a Coca-Cola sign in front, streetcar wires above, and a factory looming in the background. To Lucienne it felt "grand" when both artists were hard at work.[2] At lunchtime, the three women sat together. While they ate, Sarah, the maid, brought Frida a telegram from Mexico. Lucienne joked

to Sarah that she hated it when telegrams arrived because, "they generally always had bad news."[3] Following that comment, said in jest, Frida's eyes scanned the typed words: TU MADRE ESTA DESESPERADAMENTE ENFERMA. These five simple words echoed inside Frida's head: *Your mother is desperately ill.*

Frida tried to phone one of her sisters in Mexico, but she couldn't get a line. She tried again a few minutes later, but still no line. Every time she picked up the phone all she heard was silence. Three hours went by and still, no line. Turning to Lucienne, she asked her to book a flight to Mexico. Lucienne did her best, but no flights were available. This was a new form of commercial transportation, limited to the wealthy. Frustrated, Frida expostulated: "Here they talk about all this progress. Why can't we go by plane? What's the matter with all these 'modern conveniences'?"[4]

Lucienne went over to the Detroit Institute of Arts to alert Diego to the news from Mexico and Frida's state of mind. Diego was up on scaffolding, working. She told him what was unfolding at the Wardell, and he left with her to check on Frida. When they walked into the apartment, they found Frida consumed by "torrents of tears."[5]

"How come Frida can't get a telephone line to Mexico?" Diego asked. He suspected that the phone lines "had been cut" due to the abrupt change in Mexican presidents, as Pascual Ortiz Rubio had just resigned that day.[6] Many speculated that Rubio's stepping down had to do with political turmoil connected to former president Calles and his excessive interference behind the scenes. But Lucienne had read in the *New York Times* that the Rio Grande, the river separating Mexico and the United States, had flooded, disrupting telephone lines, transportation, and electricity on both sides of the border.

Frida needed to get back to Mexico right away. The train was her best option. Diego didn't want Frida to travel by herself, but he couldn't leave his unfinished murals either. He said to Lucienne, "You're going too of course!"[7] "I'd love to, but I don't have the dough," was her response.[8] Before she knew what was happening, the tickets were purchased. Now she needed a visa. Trudging through the pouring rain that Saturday night, Lucienne finally reached the Mexican consulate. With visa in hand, she returned to the Wardell and prepared some plaster casts she could work on during the trip. She also wrote a long note to Sarah detailing instructions for Diego's meals. Lucienne was thrilled to have the opportunity to see Mexico but was sorry she'd left her Leica camera in New York. Now she'd

have to bring a Kodak Brownie box camera instead. As she was packing, she tried to quell her excitement about the upcoming trip, as this would only upset Frida more.

The next evening, Frida, Diego, Lucienne, Jean, and Clifford left the Wardell and headed for Michigan Central Station. Walking into the waiting room from Roosevelt Park, Frida and her companions stepped through the mahogany-trimmed bronze doors into a huge room with a vaulted tiled ceiling. Frida was consumed by ambivalent emotions—wanting to stay with her husband, but also wishing to be with her ailing mother, who had been diagnosed with breast cancer. Lucienne, Jean, and Clifford walked ahead, leaving "Diego with a weeping Frida."[9]

When it was time to board the train, the group headed up to the track levels. The smell of steam and coal smoke permeated the air, and the screeching, huffing sounds of the locomotives reverberated off the walls. Moving briskly through the crowds, Frida, Diego, and Lucienne stepped up into the train. Diego embraced Frida for a long goodbye. Suddenly the train began to leave the station, and Diego had to alert the porter to stop the train so he could get off.

After that dramatic exit, Frida sat down in her seat, her arms bare. She held on to a fluffy white pillow that sat horizontally across her lap. The compartment was dark, but Frida directed her gaze toward the light coming through the window, looking as if she was trapped in her own world of despair. Lucienne must have felt the intense pathos of the moment, as she snapped a picture with her Brownie camera. Then she jotted down in her journal: "Frida cried . . . This time it was for leaving Diego. It's the first time. And not knowing how her Ma is either—may be dying made it most horrible for her."[10] Although Lucienne felt terrible for Frida, she wrote in her journal that she was "bursting with excitement" at the thought of seeing so many new places.[11] Eventually, Lucienne's giddiness and Frida's sorrow subsided long enough to allow them to fall asleep as the train headed south.

The next time Lucienne opened her eyes, they were moving through Indianapolis. She thought this "middle West village" strange, with an advertisement for "Reliable Hams" standing in the middle of a field of black-eyed Susans.[12] She had to admit that "some parts of Indiana are lovely."[13]

Yet the Great Depression had destabilized this once prosperous area, where the steel, iron, automobile, and railroad car industries had taken hold just a decade earlier. Now farmers were losing their land and factory workers were losing their jobs, and "the unemployment rate hit 25 percent by 1933," according to Indiana's Center for History.[14] While Lucienne may have found the billboard "Reliable Hams" odd, the advertiser was trying to reassure fearful and vulnerable Americans that this was food they could rely on.

Frida and Lucienne's train pulled into St. Louis's Union Station, one of the largest train stations in the world and one of the most distinctive. The exterior looked like a huge European medieval castle. The architect Theodore Link had modeled his design after Carcassonne, a walled medieval city in the South of France.

Here they would switch to the Southern Pacific's "Sunshine Special" Number 1, which would take them through Arkansas and Texas and into Mexico. After getting off the train with their luggage, they moved through a vast space with such architectural gems as a hand-cut Tiffany stained-glass window depicting three allegorical females representing the main U.S. train stations of the late nineteenth century—New York, St. Louis, and San Francisco. Lucienne and Frida had a long layover, so they decided to leave the station and find somewhere to eat lunch.

They headed out, looking for the Statler Hotel on North Ninth Street and Washington Avenue, where they'd been told they could find an excellent lunch menu. As they walked they saw the Mississippi River. Their first impression was that it looked yellow in comparison to its green banks. Nevertheless, it was exciting to see the largest river in the United States, an iconic body of water that had inspired artists from writer Mark Twain to composer W. C. Handy.

Handy's "St. Louis Blues" seemed perfect for the times: "I got those St. Louis blues, just as blue as I can be." But the music, with its tango-style rhythm abruptly breaking into lowdown blues, also provided a physical release, and the call-and-response scats—"hi-de-hi-de-ho"—prompted both black and white audiences to sing along with great enthusiasm.

Entering the lobby of the twenty-story Statler Hotel, Frida and Lucienne ascended a grand staircase that led them to the Crystal Ballroom, with its twenty-two-foot-high windows and large crystal chandeliers. The Statler

took pride in providing bathtubs and air-conditioning in each of its guest rooms, as well as in its dining room. It was refreshing for Frida and Lucienne to be in an air-conditioned room with spectacular views. But all these modern conveniences and luxuries couldn't take Frida's mind off her anguish, as she wondered what state of health she would find her mother in.

To make matters worse, Frida began to feel blood oozing from between her legs; she was still experiencing the aftereffects of her miscarriage. Lucienne's body tightened with worry as Frida got up to go to the restroom. When she returned to the table, her mood was somber. Frida just wanted to return to the train, fearing she might start bleeding again. But there still were hours before their connecting train would depart. Frida decided to go back to the train, while Lucienne went to the movies.

On her way back from the theater, Lucienne picked up a newspaper and read that the Rio Grande area was still flooded, and she realized that once they reached the border city of Laredo, Texas, their train wouldn't be able to cross the railroad bridge, which had been "smashed by floods."[15] For Frida, this meant one more delay, exacerbating her obsessional thoughts over her mother's condition. Lucienne, though, was filled with the thrill of Mother Nature's power as the train left St. Louis.

They slept through much of Arkansas, but by early morning their train was pulling into Little Rock. Lucienne noticed the dew on the leaves in the forest the train chugged through. She also spied "bright colors" amid the trees.[16] These colors intrigued her artist's eyes, but she soon realized that these beautiful colors were actually the clothes worn by African Americans working in the lumber industry. Her initial excitement vanished. The people looked "so oppressed," she wrote in her journal.[17]

After the train came to a stop, Frida made her way down the car's steep metal steps, bracing herself by holding on to the railing with her right hand, her left clutching her shawl around her. Walking through the brick-and-cement train station, they heard the distinctive sound of southern accents. "The drawling sound of Southern voices is grand fun," Lucienne wrote.[18]

But then Frida saw, attached to one of the brick pillars, a sign that said: "For Negroes." Lucienne photographed Frida standing under the sign, and Frida's outrage is apparent in her disgusted facial expression. According to

Lucienne Allen, Lucienne Bloch's granddaughter, "Frida insisted my grand-mother take this picture of her because they were both angered by such blatant racism."[19]

In the image, Frida faces the camera, but her head is slightly tilted to the left. Her right eye is partially shrouded in darkness, but her left glares directly at Lucienne, as if to show her indignation. Her pursed lips and crossed arms also convey her displeasure.

Frida understood that the discrimination against African Americans paralleled the denigration of Mexicans. Traveling without her famous hus-band made her more of a target. It was quite common in the thirties to see signs not only barring Jews from certain establishments but also excluding African Americans and Mexicans. One example comes from a restaurant in the South that barred "Negroes, Mexicans, and dogs without collars."[20]

Seeing the signs of segregation, Frida experienced what she'd only heard about in the well-publicized Scottsboro case, which was on appeal to the U.S. Supreme Court with marches in support of the "boys" taking place throughout the country.

Lucienne summed up their experience in Little Rock this way: "It is like being in another world to see such outrageous medievalism."[21]

Back on the train, Frida and Lucienne stayed in the observation car, where they met "some nice cowboy looking old men."[22] One was a boxer named Paul and the other two were his managers. Lucienne thought they were a "roaring bunch."[23] Things got interesting when one of the managers told Paul to take off his jacket so the women could see his impressive chest and arm muscles. Lucienne chuckled at the spectacle.

When the train pulled into San Antonio, Frida and Lucienne spied a huge cockroach running across the cement floor of the station. *Welcome to the tropics,* Lucienne thought. It was close to eight o'clock in the evening, and when they got off to stretch their legs, Frida found a telegram waiting for her from Diego. It had been two days since they left, but Frida had al-ready sent Diego telegrams from several stops. She had told him to contact Dr. Marín, who had provided gynecological care for her in Mexico. She wanted him to be "in charge of looking after her mother."[24]

Diego had written: RECEIVED YOUR TELEGRAMS. THANKS. NOTHING FROM MARIN. NEWS REPORTS FALLEN BRIDGE FORCED RAILROAD SAFETY ROUTE CHANGE. I AM WORRIED.

TELEGRAPH ME YOUR ARRANGEMENTS. SENDING MANY KISSES.[25] Although Diego's information about the fallen railroad bridge was not news for Frida and Lucienne, hearing from her *amor* eased Frida's mind a bit. Back on the train, Lucienne and Frida prepared for bed and eventually dozed off.

The next thing Lucienne knew, Frida was waking her up asking why two strange stars in the sky were red and yellow. Lucienne stared at them in a daze, as if "struck by tropic fever."[26] They had to be stars because they were up so high in the sky, but "why were they made up of such amazing colors?"[27] Lucienne then noticed the symphony of sounds audible from their train compartment: frogs croaking, insects buzzing, the sound of water gently swooshing, the train creaking, a man's voice, the rhythmic beat of oars pushing through water. Frida and Lucienne finally realized they were "crawling along in 12 inches of water in what looked to be an enormous lake."[28] As day broke on that Wednesday, September 7, they saw trees submerged in water and lightning occasionally splitting the vast sky. Lucienne, who usually adored adventure, "was a slight bit scared."[29] Frida was silent.

This was their introduction to the border city of Laredo, Texas. Just across the Rio Grande lay Nuevo Laredo, Mexico.

Laredo had been founded by the Spaniard José de Escandón as part of Spain's program to colonize this area of Mexico. Its strategic location made the place a hub for the first cattle drives of the eighteenth century. Laredo was annexed by the U.S. government in 1845. But a postcard at the time Frida and Lucienne were there emphasized its Mexican identity: "Laredo, Texas: Gateway to Old Mexico, Land of Beauty and Romance." Although the Mexican-American War (what Mexicans commonly refer to as "the U.S. Invasion") had created a border, it was a porous one, where language, food, customs, and goods flowed in both directions.[30] It was common for families on both sides to walk across the bridge and visit the other side for the day.

At seven o'clock in the morning, the women got off the train with the boxer and his managers and entered this "funny place," as Lucienne wrote.[31] The small, cream-colored Spanish Colonial–style train station with its red tiled overhanging roof seemed quaint in comparison to the huge, classically inspired Michigan Central Station where their journey had

begun three days earlier. Frida and Lucienne felt the ninety-five-degree heat blast open their pores.

They walked to a breakfast joint filled with people speaking Spanish. Lucienne noted that the population looked as if it were 90 percent Mexican. But in fact Laredo was also home to families of German, French, Irish, and Italian descent, some of whom had been in Laredo for nearly half a century. Nevertheless, everyone spoke Spanish.

Much of the chatter in the restaurant concerned the flood. A newspaper article in the *Laredo Times* caught Frida and Lucienne's attention: "The Rio Grande has set a flood record here which probably will never be broken."[32] Pictures showed buildings submerged in water with just the tops of the roofs visible. Swells of floodwater had first hit Laredo at ten-thirty in the morning on September 3, and by five o'clock the flood had peaked, with the river cresting at 52.2 feet. That had been four days earlier, but water levels were still high. Frida and Lucienne were told that they needed to stay in Laredo for about twelve hours in order to allow the Rio Grande to recede further before taking a bus over the border to Nuevo Laredo. They asked the locals at the restaurant what they should see in Laredo. Without hesitation they all responded: "The Flood."[33]

Instead, Frida and Lucienne headed inland. They took a yellowish orange streetcar toward San Agustín Plaza. When they got off the streetcar, they saw "some beautiful cow boys and Mexicans with pistols and large hats and on horse-back too."[34] Laredo was still cowboy country. Hollywood Westerns had helped solidify an image of cowboys as heroic, hardworking independent thinkers. But in truth the Americans learned how to be cowboys from the Mexicans known as *vaqueros*.

Being stuck in Laredo was not what Frida wanted, of course, but it did allow her some moments of childlike joy as she shopped for Mexican toys, candy, and cheap souvenirs. They walked for a while, checking out the *boticas,* cantinas, bakeries, and butcher shops, but Frida's bad leg grew tired and she began to feel blood running down her inner thigh.

They found a small hotel and went in to "cool off" and use the restroom.[35] As they sat in the hotel lobby, they became absorbed by the buzz of gossip swirling around them: "Did you hear about the railroad engineer who was killed in the flood?" "Can you guess how much he earned?" "Did

you know that one man was so distressed by the flood that he committed suicide?" "What about the men stranded on the rafter that fell off the broken railroad bridge who had to fight off snakes all night long!"[36] The locals' gossip made the time pass quickly.

In late afternoon Frida and Lucienne headed back to the train station to meet up with other travelers trying to get across the border by bus. While Frida stood in the glaring Texas light waiting, Lucienne snapped some photos. In one, Frida turns her head in the direction of the camera, as if she has just turned away from the three men who stand behind and beside her. Frida squints and her lips are slightly parted, a lone woman among men. Across the street from where Frida stands, a sign on the building reads: BORDER. It was a reminder that she was still in the United States, a place about which she felt ambivalent.

If Frida was ambivalent about the United States, the government and the people of the United States had mixed feelings about Mexicans as well. With no sign of a better economy on the horizon, desperation was intensifying in the United States. Unemployment had been on the rise since 1929, and the rate was increasing rapidly "in the first part of 1932," as reported in the September issue of *Fortune* magazine. With one out of every four Americans unemployed, many banks closing down, and twenty-five million people in need of help, some Americans argued that Mexican laborers were taking needed jobs from white Americans. This was a change in attitude from World War I, when Mexican workers had been welcomed as the labor needs of war-focused industries drew American workers away from agricultural jobs in the West. But now, with the Depression, there was pressure on the United States federal government, as well as on state and local governments, to lower unemployment rates, and one way to do that was to expel immigrants. In the first three years of the Depression, more than 356,000 Mexican immigrants and American citizens of Mexican descent left the United States for Mexico, as historian Camille Guérin-Gonzales has documented.[37] A large number, she said, went through Laredo, one of the main entry points into Mexico.

Frida didn't need to go to Laredo to learn about this phenomenon. She'd become aware of these tensions during her stay in Detroit when the Pro-Repatriation Committee of Detroit "requested the repatriation of

Mexican families" earlier that year.[38] Diego states in his autobiography, *My Art, My Life,* that even though he didn't think the return of Mexican laborers to Mexico would solve American workers' economic problems, he gave money to those within the Detroit Mexican community who wanted to return to Mexico.

Diego's account makes it sound as though he gave his own money to help those who wanted to repatriate. But Margaret Sterne provides a different account, stating that Rivera got the "Welfare Commission in the United States to supply funds in order to repatriate two- to three-thousand Mexicans back to Mexico." A group of Mexicans and Mexican Americans living in Detroit were repatriated to Hacienda El Coloso near Acapulco, where they found life difficult.[39]

The Mexican community in Detroit was relatively small—just 1 percent of the city's total population in 1932—so the creation of the Detroit Pro-Repatriation Committee illustrates the level of racial tension. After families had been repatriated back to Mexico, "the Detroit Mexican population decreased significantly from 15,000 to a mere 1,200."[40] Frida and Diego had gotten to know some of the local Mexican people and were most likely privy to some of their perspectives about living in the Midwest. Diego's role in slashing the local population to 1,200 must have been met with differences of opinion among the Mexican community.

Cesar Larriva knew Frida and Diego and spoke of them with conflicted feelings, according to his son Rufuyo Larriva. One time his father might say: "'They were the biggest sons of ———,' then turn around and say, 'They were family—good family.'"[41] Though Rufuyo doesn't know quite what to make of his father's mixed feelings toward Frida and Diego, he thinks the "crazy time" they were living through might have had something to do with it.

These crazy times and the impact on Mexicans living in the United States had been foregrounded in *Survey Graphic,* a magazine to which Diego had contributed illustrations. One of his drawings even graced the May 1931 cover, devoted to "Mexicans in Our Midst." It shows an Anglo worker on the United States side of the border shaking hands across the border marker with a Mexican laborer standing on the Mexican side. This image of workers looking each other in the eye with the rising sun in the background depicts an optimistic perspective, showing cooperation among workers on both sides. But the related articles, including one by Manuel

Gamio, the famed head of Mexico's Department of Archaeology and Anthropology, revealed how many Mexicans "have suffered bitterly as a result of racial and social prejudices of which they are victims during their stay in American territory."[42]

On the day Frida arrived in Laredo, Diego had written a letter to her: "Chicuitita: . . . I'm worried; this morning, restless, in a foul mood and furious . . . Even though you tell me that there won't be any difficulty, I know that there are going to be a bunch of problems because the Laredo Bridge was flooded. And knowing how devious and abusive they are there to squeeze whoever falls in their clutches."[43] It's not clear who "they" refers to, but it seems likely that it's an official. Diego might have had grave concerns about how a Mexican woman without a male escort would be treated by border agents.

Diego's fear for Frida's safety was intertwined with his own insecurities about their relationship. In this same letter, he wrote: "I'm like a soldier wounded in battle because you've gone, you've left me, even though it was necessary and I understand it. . . . Since La Chicuitita is my whole life and she left me, the only thing I saw in the mirror was just the nasty leather bag, ugly and empty without anything inside, because everything went away on Sunday night on the train to Saint Louis, Missouri." For Frida's part, the longing to be with Diego in Detroit butted up against her anguish about her mother and her need to be with her family in Mexico. Just as in her painting *Frida and the Caesarean Operation,* Diego and her mother loomed large on either side.

Finally, Frida and Lucienne were able to board a bus and go over the bridge to Nuevo Laredo. Once on the Mexican side, Lucienne wrote that it "looked like the wildest earthquake" had hit the flood-damaged town. Despite the devastation, vendors were selling food and families welcomed loved ones. Frida found comfort in her childhood favorite candy, *cajeta,* which she scooped up with her fingers. Then they boarded a train for the last leg of the trip. In silence, the women peered out the window, absorbed by the sights passing by as they headed south.

When they reached Monterrey around eight o'clock in the morning, Frida telegraphed Diego to let him know she'd finally arrived in Mexico. She also said she was distressed over her mother's poor health but wanted to know how he was: "Telegraph how you are my love."[44] And with that, she signed off: "Your Frieducha." While Frida's telegram conveyed her despair

concerning her mother, Diego's telegraphed reply, sent on the same day, disclosed his state of mind. "I'm very anxious despite the reasons to understand the situation. I feel great sorrow. Please hug everyone there in your house, especially your papa. To you, [my] pretty, I send you many kisses, Chiquita."[45]

When Frida and Lucienne got back on the train, Lucienne marveled at how the Sierra Madre "appeared so wild."[46] The next day, they began to climb "steadily and it became cold." They would arrive in Mexico City by ten o'clock on the night of September 9. Lucienne noticed that as they neared their destination, Frida "got more and more hectic."[47] Frida's sisters and cousins were at the station to greet them, and when they embraced, they were "all crying and hysterical."[48] Caught up in the cascade of emotions, Lucienne and Frida left their bags behind as they headed out of the station. Luckily, before they drove off, Lucienne realized they'd forgotten their suitcases.

Mati took Frida and Lucienne to her house in Mexico City, where they could get a good night's rest. When they arrived, Lucienne, who was used to Frida and Diego's indigenist flair, was surprised to see the European-inspired interior, with flowered wallpaper, lace curtains, and "fake Louis XVI rugs."[49] The shell-shaped white ashtrays, dotted with gold and violet, featured nude women painted to look like Venus on a half shell. Of these types of flourishes, Frida would say: "It's so horrible it's beautiful."[50]

In the morning, Frida braced herself to visit her mother in the hospital in Coyoacán. She thought things couldn't be as bad as they sounded: "I was convinced that my sisters had exaggerated everything."[51] But Lucienne's support wasn't enough to buffer the shock and despair she felt when she saw her poor *mamacita*, "yellow as an egg-yolk from her head to her little feet."[52] Frida despaired to Diego: "When I saw my mom the impression was such that I didn't know if I could make myself strong to avoid causing her more pain, but I did everything I could to cheer her up and not cry."[53]

Matilde had multiple health issues. The yellow skin was the result of liver and gallbladder disease, which, Dr. Raygadas informed them, had resulted in a "horrible bile-duct leak . . . without any way to eliminate bile."[54] He recommended an operation to open "the channels of the gallbladder," take out stones, and, if necessary, "insert rubber tubes." Even though he said it would be complicated, he thought she'd "come through in spite

of everything," meaning complications from the two-week-old bile leak and a large, malignant lump in her breast. The doctor had no intention of trying to remove Matilde's tumor because he felt "it is useless to operate on cancer."[55]

Frida agreed that her mother should have the gallbladder operation, but seeing Matilde in such dire health and "not being able to do any-thing for her," as she told Diego, made her feel as if she were "going crazy because of the immense sorrow."[56] Staying at her childhood home didn't provide the solace she was looking for. Her father was "done for" and the house was "all sadness."[57] Lucienne observed of Frida, "She . . . cries and cries and looks deadly pale."[58]

Matilde's operation took place on the morning of September 12 at eight-thirty. Frida and her family anxiously waited; Adri and Mati prayed. Although Frida could be described as a lapsed Catholic at this point in her life, she doesn't appear to be an atheist. Both she and her father have been characterized as such, but Guillermo's letters reveal otherwise. He wrote to Frida on September 4: "It's a pity I can't give you a hug but later on, when God wills it, I will hug both of you with all my heart."[59] Father and daugh-ter might not have been devout Catholics like Matilde, Adri, and Mati, but they invoked God's name in ways that true atheists would not, something Frida's niece Isolda observed later in life.

Frida wrote Diego reassuring him of her love. He needed the reassur-ance. One week after Frida left Detroit, Diego wrote: "Chicuitita: it's the first Sunday I'm here without you and it's really sad, and it's only midday."[60] The next day he emphasized, "How I miss you so much, I try as hard as I can in my work to be able to get from one day to the next and so I've worked quite a bit."[61]

In a letter he wrote on the thirteenth, he conveyed some of the push/pull in their relationship before Frida had left Detroit: "And you even thought that I was bored with you and wanted you to go away . . . That's also why I said to Luciana what offended you, that I didn't think that you would return soon, and because you know that I have a keen instinct about certain cases, like you women, and I was certain that something like this would happen."[62] It's not completely clear what Diego means by "something like this would happen." Perhaps he thought she'd end up with another man while she was away.

He had reason to feel some jealousy toward his favorite sculptor,

Mardonio Magaña. Lucienne, who knew of Magaña through Diego and his article on the sculptor in *Mexican Folkways,* met him in Coyoacán. She found him to be a "modest Indian" with "sculpture piled in his little muddy bedroom."[63] He had an incredible story: Magaña had gone from working as a janitor at the School of Outdoor Painting in Coyoacán to becoming a sculpture teacher there. He was being hailed as one of the greatest contemporary Mexican sculptors, with his "authentic" folk style. Two years prior, when Diego had published his article on Magaña, Frida, wearing the heavy Aztec jadeite bead necklaces she favored, was photographed holding one of his wooden sculptures while standing in a cornfield. She too looks like an authentic woman of the people. According to Lucienne, "He [Magaña] is supposed to have been in love with F and asked her to marry him when D would have left her as he left everyone else."[64]

It's possible Diego had concerns about Nick Muray as well. Back in mid-July, Ella Wolfe had written Frida this veiled note: "Since I wrote the other side [of the letter] I spoke to him and he tells me he will write you a long letter tomorrow."[65] The "him" is most likely Nick. Based on the passionate card Frida had sent Nick shortly after they had first met, a little over a year before, and the letters they wrote in the late 1930s, it isn't a stretch to think they were in contact with each other in 1932. Maybe the "instinct" about women Diego writes of was a reference to his knowledge of Frida's interest in other men.

Frida's father also suggests that jealousy played a role in his daughter's marriage. He wrote Frida the day she left Detroit, unaware of her plans to travel to Mexico: "You've made the right decision to stay with your husband, that way you can take care of each other and be happier, which wouldn't be the case if you had come. Imagine the end result if a thing called 'jealousy' had made an appearance; it comes easy at a short distance so imagine what it would be like if you were thousands of kilometers apart!"[66]

Matilde survived the operation, though the surgeon had had to remove 160 gallstones. Frida sent a telegram to Diego informing him that the operation was over: "Don't worry about me. My child, eat well. I miss you so much."[67] On the fourteenth, Frida was feeling better about the whole situation; Lucienne was surprised that "she was quite jolly" as they walked

to the hospital.[68] They even heard "some blind musicians sing and play guitar."[69] Their "marvelously witty love songs" mixed with tunes about "real catastrophes" seemed to externalize Frida's complex feelings.

The next day, though, Frida's good mood vanished as swiftly as it had appeared. Some seventy-two hours after the operation, Matilde's health began to plummet. Even though she had been given morphine, she was in a lot of pain from the cancer, which had metastasized. Lucienne wrote that Matilde had experienced "terrible suffering."[70] Eventually her breathing became less and less regular, and by four o'clock in the afternoon Matilde Calderón de Kahlo had died. "Frida sobbed and sobbed. It was terribly sad for her," Lucienne wrote.[71]

It's not clear if Frida was with her mother at the time of her death. In an interview some eighteen years later, Frida said: "I did not want to see her dead."[72] Some scholars have interpreted this to mean that Frida couldn't face her dying or deceased mother. But Frida's statement can be interpreted in various ways. There's a difference between seeing someone dying and seeing them dead. It's possible Frida was at her mother's bedside while she was dying and left either right before Matilde took her last breath or shortly thereafter. It's also possible Frida was referring to the funeral—that she didn't want to see her mother's dead body in a casket. If Frida left her mother's side during her last breaths, Lucienne made no mention of this in her journal.

On the other hand, Lucienne did mention Guillermo's absence from Matilde's deathbed. She noted how the sisters, wrapped in dark shawls and clothes, decided not to tell him until the next morning. He'd already been highly distraught during the previous days, asking at times where Matilde was, as if he'd forgotten she was in the hospital.

When they returned to the family home after leaving the hospital, Lucienne played chess with Guillermo because it seemed "to be the only thing that makes him forget."[73] Later, Frida and Lucienne walked with him through a garden. He marveled at nature's beauty. But these times of tranquility were pierced by extreme angry outbursts.[74] The next morning when the family told Guillermo about his wife's death, he was "done for," as Frida had predicted. His neurasthenia made him vulnerable to depression, anxiety, and heart palpitations. He had been "constantly looking for a tranquilizer" (to no avail) before his wife's death; after, he was an emotional mess.[75]

The loss amplified his erratic moods. Being hard of hearing contrib-
uted to his sense of isolation and irritability: "On the streets in Mexico I
get beastly mad because cars constantly screw you from every direction,
especially a deaf person like me."[76] Guillermo believed he was screwed in
life both because of corrupt forces beyond his control and as a result of his
own ineptitude. He wrote that in his profession of photography "he ended
up getting screwed because he didn't know how to cheat the public, an
essential element of business."[77] Losing his wife was one more example of
how he was screwed. As he philosophized: "In the end, all one takes to his
grave is what's left of all the stupid things he's done in the theater of life."[78]

The weight of sorrow and the raised voices—whether from one of
Guillermo's outbursts or Frida's sister Cristina reprimanding her young
children—made it difficult for Lucienne to be in the house, so she left.
She found "a lively feeling in the air" at an outdoor theater where she saw
dancing with castanets and heard songs sung by a clown.[79]

One month and one day after Matilde died, the physical evidence of
mourning is visible in two photographs Guillermo took of Frida. In one
she's seen from her chest up with arms crossed in front, her shoulders are
shrouded in a *rebozo,* and five small strands of beads adorn her neck. Silver
hoop earrings dangle from her ears. While Frida faces forward, her face is
slightly turned to the right, casting a shadow on the left side, except for
some light around her eye. This allows both eyes to sear into ours with
an intensity that's uncomfortable. She's not happy and she's not afraid to
show it. In a second print of this same photo that Frida sent a friend, she
emphasized her state of mind by drawing large teardrops under her eyes
and writing on the photo in Spanish: "From your friend who is very sad."

In a companion photo taken on the same day, Frida has changed
clothes. Now she wears a simple dark jumper adorned with flowers over
a black long-sleeved shirt. Her iconic *rebozo* and jewelry are gone. She
looks more like a German hausfrau. With arms folded in front, she stares
straight ahead with distant eyes. While both portraits convey Frida's state
of mourning, Guillermo's photographs ultimately show his daughter's two
sides: Mexican and German.

Lucienne also memorialized this moment in time with a photo of
Guillermo sitting in his chair, one hand gripping the chair's arm, the other

resting on it with cigarette in hand. In Spanish across the bottom, it says that he's just been crying. Seen from a bird's-eye view, Guillermo looks small, nervous, and distraught, with a faraway look in his eyes. Both Lucienne's photo of Guillermo and his of Frida lay bare devastating pain and sadness, something father and daughter felt comfortable displaying in front of the camera for "life's theater."

When she was not sitting for the camera, Frida found temporary relief from her nervous anguish in Elegante cigarettes and Diego's words. "My pretty little girl," Diego wrote, "I would have wished to be there to give you kisses and kisses and to hold you tight and not let you go; I haven't known what to say on paper . . . if I tell you that I had not been perfectly aware of how much I love you, now I would have understood it well, and of course, also, how much I loved your mama."[80]

In between long inhalations of cigarette smoke, Frida's moods traveled all over the emotional map. Lucienne felt as if she couldn't do anything right; if she was around, Frida was "terribly distant" and always seemed "bored" with her questions.[81] She often appeared angry as well. But if Lucienne tried to give her friend space, Frida became even more "angry." Lucienne understood that Frida was under an enormous emotional "strain," but being her punching bag was more than she could handle. Lucienne "started to cry" and "couldn't stop for a whole hour." Frida saw her tears and was "nice" to her.[82]

For most of the month and a half the two were in Mexico, Lucienne was on her own. She took trips into Mexico City; she saw Tlalpan, a forested borough of Mexico City, where the rain came down so hard she had to take cover under a huge cactus "while the sun shone and made a rainbow over the glistening corn fields."[83] She took a train to Texcoco to climb to the top of some Aztec ruins, and she also took a two-hour bus ride to Cuernavaca, holding her head out the window with excitement as she saw "a warm blue purple valley with Cuernavaca 5500 feet lower down, passing extraordinary forests of exotic trees with trunks like red shiny rubber."[84]

Toward the end of their stay, Frida opened up in the safety of darkness as the women were falling asleep. She told Lucienne she'd intentionally left

her alone to discover Mexico. "She wanted me to find it [Mexico] myself and that showing people around doesn't help them in the least and that now she could say that I *had* understood Mexico, for all my impressions are my own, and the finest things have struck me," Lucienne recounted.[85] These words made Lucienne feel "so happy."[86]

She was also delighted when Frida took her to a concert featuring music by two influential Mexican musicians and conductors, Silvestre Revueltas and Carlos Chávez. Lucienne, who'd grown up with classical music by way of her conductor father, was familiar with these two men, and she'd also seen Chávez's *Horsepower* in Philadelphia. Upon entering the theater with Frida, Lucienne was struck by how Frida knew "everybody in the whole place."[87] It was a joyous evening. All the friends and wonderful music had buoyed Frida's mood.

On October 18, twenty friends and family members gathered around Frida to say farewell to her at the train station. Guillermo looked "pretty lost amidst the misty crowd," Lucienne observed.[88] Frida's sisters implored Lucienne to look after Frida. When they took their places on the train, Lucienne noted that Frida "shed a few tears and went silently to bed."[89] The next morning, while the two were eating in the dining car, Lucienne leaned closer to the window to take in the landscape outside—undulating hills casting shadows, with light and dark patches alternately revealing and concealing cacti. It was an artist's delight. Not so for Frida. She complained about the "boring trip" and became "furious—really so!!"[90] At Lucienne's declaration of joy at seeing the landscape, Frida, in an angry tone, accused her friend of "never telling the truth."[91] Then she abruptly left the dining car. Once again, Lucienne was taken aback by Frida's outburst.

When they reached Monterrey, they got off the train and saw children running around "bare footed on the tracks." After they crossed the border and pulled into some "junction" place in the hot Texas evening, it still felt like Mexico. They were greeted by the familiar sound of live Mexican music, with a woman singing accompanied by two men playing instruments.

But when they woke up in St. Louis the next morning, Mexico was a thing of the past. The warm weather, the singing, the carefree children, and the smell of fresh tortillas were all gone, replaced by "autumnal colors" and

"cold weather."[92] Frida was bored, so they went to two movies during their long layover. Detroit was not far away.

Autumn had quickly turned to a bitter winter as they arrived at Detroit's Michigan Central Station early the next morning. Diego, Clifford, and Jean were waiting on the platform. At first Frida and Lucienne didn't recognize Diego, who had lost a significant amount of weight. His own clothes no longer fit and so he was wearing one of Clifford's suits, which Lucienne thought made him look "so American."[93] According to Diego's account, once he called out, "It's me," Frida "embraced [him] and began to cry."[94]

The group went back to the Wardell and "talked all morning."[95] It was a reunion filled with joy, laughter, tension, reminders of the past, and a sense of foreboding about the future. Just seeing the low ceilings and the kitchen brought back "strange recollections of summer days and food problems and boredness."[96] Lucienne and Frida had just experienced a month and a half of emotional intensity, yet here was Clifford discussing Edsel Ford and publicity like no time had passed. And, as usual, Jean talked on about shopping, but this time it was about all the suits and hats she'd bought for Diego and his new svelte body.

There was an uncomfortable air in the room. Jean had not only assumed the role of "wife," taking care of Diego's clothing needs, but, according to Lucienne, she was also flirting with Diego. There's a photograph from this time period that captures this flirtatious behavior. Jean and Diego are standing next to each other. Diego sports his "American" suit—tie and all—while Jean is wrapped in a fur coat with a cloche hat framing her face. Jean looks over at Diego with a large smile that hints of intimate secrets. Diego, his hand on his hip, reciprocates with a sly upward curve of the mouth. It all suggested an affair, especially given Diego's non-monogamous nature and Frida's assessment that Jean was only interested in "making love."[97]

Given Frida's fragile state of mind, it was disconcerting to observe this superficial game. On some level, Frida must have questioned the sincerity of the deep love Diego had expressed to her while she was in Mexico: "I am really sad here without you. . . . I don't know what to do without being able to see you. I was sure that I hadn't loved any old lady like the Chicuita,

but now that she left me, I know in reality how much I love her, she knows that she means more to me than life itself."[98]

The arduous journey Frida had reluctantly embarked upon had thrown her into a whirl of emotions. First, there was the guilt from knowing what her sister Cristina had confirmed: "since the day" Frida had "left" Mexico, their mother had begun to have health problems.[99] Then there was the shock at seeing her mother in the hospital, so severely jaundiced. Then the torment of watching her die. And finally there was the grief, compounded by helplessly watching her father buckle under the strain of it all. It was more than the twenty-five-year-old could neatly compartmentalize. On top of all that, the stress of leaving Diego's side for the first time in their three-year marriage and returning to him in a city she despised added a weight that must have felt unbearable. When Frida returned to Detroit on that frigid October 21 morning, she was a changed person.

Resurrecting Death

*What I think is that a good life is one hero journey
after another.*

—JOSEPH CAMPBELL

 The low-ceilinged apartment at the Wardell looked
the same, but nothing felt the same. Getting back
into a routine and finding a rhythm with Diego
proved challenging for Frida. His irritability affected her even more
strongly than usual. She could be said to be in a cocoon of death, with
no way out. But Frida was exactly where she needed to be. At least this is
what mythologist Joseph Campbell might have told her. He would have
recognized that she was on the hero's journey, a psychological and spiritual
quest described in myths the world over.

Frida, who would meet Campbell some six years later in New York,
was intrigued with his desire to trace similar patterns or structures in cross-
cultural myths detailing the hero's journey. She would have related to the
three major phases of such a journey: departure, initiation, and return.
Campbell found that the hero, typically male, begins life in the ordinary
world, but at some point is called to depart and enter into an unusual
place. Crossing over into this realm triggers an initiation process, in which
trials and tasks challenge the hero to attain a new and deeper level of
consciousness. After undergoing these trials, sometimes with the aid of
assistants, the hero returns to the ordinary world equipped with a new
perspective and new powers.

By the time Frida had returned to Detroit from Mexico, she'd undergone at least three major hero's journeys, beginning with the bus accident that had thrust her into a new realm somewhere between life and death. Her initiation at that time required that she fight her way back to life, learning to walk again and finding a new passion. It's at this time that she reenters the ordinary world as Leonardo, the androgynous artist.

The miscarriage in Detroit marks the second hero's journey, forcing Frida to undergo another initiation process. In the months leading up to the miscarriage, Frida had struggled with the tension between her desire to stay closely connected to Diego and her desire to be open to the transformation of her body through pregnancy, birth, and, ultimately, the embrace of a new life with Diego and the baby. As much as Frida tried to hold on to Diego during this part of the journey, she went through the life-threatening miscarriage on her own. When she came back into the ordinary world, she brought with her a new level of awareness. But this new consciousness, one tied to a specifically female experience, separated her from Diego.

Frida's solitary internal voyage centered on her unorthodox attitude toward motherhood. Her ultimate repudiation of motherhood was a rejection of womanhood; in Mexican culture, as in most cultures, a woman's purpose on earth was to provide children, says art historian Margaret Lindauer. Sarah Lowe, another art historian, agrees, writing: "In the context of Mexican social codes . . . having a child, indeed . . . motherhood itself, not only was an indispensable aspect of femininity but virtually defined womanhood."[1] Renouncing the role of mother in the ordinary world, Frida instead embraced the role of artist.

As Frida was adjusting to this new role as a creator of important art, she was plunged into another initiation, one that required her to face death again. Frida had gone to the brink of death twice and had returned to life, but she knew her ill mother might not make that return. She also understood that this would be another journey taking her away from Diego. Although she was aware of the emotional dangers that awaited her in Mexico, she had to go.

Returning to Mexico, her motherland, was akin on a symbolic level to returning to the womb—yet what she faced in Mexico was her mother's death. It marked a pivotal moment in Frida's initiation process. It was the first time she had had to face the death of an immediate family member

(excluding the brother who had died before she was born). Losing her mother in particular meant entering the world of adulthood on a different level.

When Frida stepped off the train in Detroit after being in Mexico, she was returning to the ordinary world a changed person with yet another new level of consciousness. She began to draw upon this deeper knowledge in her new role as artist. To underscore how seriously she took this role, she "set up a studio on the third floor of the DIA," according to Mary Rodrique, from the Detroit Art Commission.[2] She could no longer create in the makeshift studio of her living quarters because she needed silence to concentrate. The studio space, that coveted male arena where creative genius could flow while sheltered from the battles of everyday life, was now Frida's domain.

It may not have been a gorgeous or spacious studio, but it was hers. She needed it to stave off the annoyances of petty drama with Jean and painful tensions with Diego. She also needed a space in which she could harness her internal anguish, transforming chaos into a clear and compelling visual language. Now she could actualize the words of Helen Vinton, a friend who had written to her after the miscarriage: "I very much hope that you'll stop being so modest and begin painting again. You have great things in you, if you'll only believe it as strongly as the rest of us do."[3] In her new studio, Frida began the process of allowing these "great things" to marinate.

If life inside the studio offered some peace, life outside the studio was bleak. The frigid weather and bare trees probably felt like a memento mori—a reminder of death. Even her sister Adri worried that Frida was mired in a state of mourning, and implored her to stop wearing black.

Inside her apartment wasn't much better. Diego complained that he couldn't sleep because of the cold. As a result, Frida couldn't sleep well either. She was physically exhausted, on edge, and constipated. Her sisters worried that she wasn't taking good care of herself and that, if untreated, the constipation would lead to other problems. "Don't let it go," Adri warned, "remember it's a serious thing."[4] On top of all that, Frida's right foot was bothering her, which caused difficulty in walking. Her foot felt cold, as if she wasn't getting enough blood flow to her extremities. And

she still occasionally experienced vaginal bleeding from her miscarriage five months earlier.

All these factors created a combustible environment. Diego was filled with a "nervous tension" that, according to Lucienne, was so pronounced he seemed to "feel irritated at Frieda's presence."[5] This made Lucienne feel terrible "because Frieda gets so moody and cries so often and needs comfort."[6] What happened to those written declarations of love and repeated refrains about needing to have his Chicuitita by his side?

These feelings had apparently evaporated with the stress of his approaching deadline. Diego was busy working on sketches for his upcoming mural commission for Rockefeller Center in New York. The eruptions from his free-floating anxiety and Frida's weepy, fragile state sent Lucienne looking for another place to live. She took a room at the Seven Arts School nearby.

To escape Diego's unpredictable outbursts, Frida immersed herself in the almost daily letters from home. In early November, Mati and Adri began detailing the troubling relationship of their youngest sister, Cristina (also called Kitty and Cristi), and her husband, Antonio. The sister Frida felt most connected to had married around the same time as Frida, yet the outward circumstances of these two marriages were quite different.

Kitty had gone to live with Antonio and his family in the Churubusco neighborhood of Coyoacán and they quickly had two children, Isolda and Antonio Jr. The charming Antonio Pinedo Chambón, who had dazzled Kitty when they first met—she the "queen of the local pageant" and he a "charro" (horseman)[7]—turned out to be, according to Kitty and her family, a controlling mama's boy. Kitty confided to Frida about the complexity of the situation: "As you know Antonio offers no moral support; he only cares about his own people, so I have to live my life separately and talk to the walls since my sisters blow things out of proportion and interpret things the wrong way. They are good to me and I'm very grateful to them; they are always watching out for me and the kids, but you know you are the only one who understands me and yet we can't be together."[8]

As the two youngest, with only eleven months separating them, Frida and Kitty shared a special bond. Nevertheless, the whole family was close. In Guillermo's "life will screw you" philosophy he cautioned his daughters

against blind faith in people. Despite this warning, Adri and Mati feared Kitty had married a charlatan. Antonio's good looks had disarmed the young Kitty, but she soon discovered the cliché was true: his love of alcohol was as great as his love for women,[9] and the two were a deadly combination.

After marriage, when Kitty went to live with her husband at his family's house, she became increasingly isolated from her family. Antonio didn't like his wife going out too often. His jealousy made him fear that Kitty was up to something. Adri and Mati, as well as cousins and aunts, tried to visit Kitty often to make sure she and the children were all right. Adri referred to Antonio as a "deadbeat" of a husband who didn't give Kitty enough money to take care of herself or the children.[10] Kitty's letters reveal an awareness of her predicament, but also an inability to act. "Right now there's nothing else I can do," she told Frida.[11] After all, if she left Antonio, where would she and the children go?

It was easier for Kitty to dream of Frida taking away her troubles: "My only hope is that one day, if you can, you will get me a place of my own, even if it's just a room, where I'm not subjected to anyone and where I can live in peace with my kids."[12] Kitty longed to have some control over her life, but before Frida could provide her sister a refuge, things between Kitty and Antonio reached a crisis point.

Frida kept reading in letters that Antonio's temper, his jealousy, and Kitty's increasing isolation worried the family. Frida's cousin Carmen said they tried "to be as nice as possible to Antonio so he won't close the doors on us."[13] Carmen pleaded with Frida: "Between us, I'm begging you to tell Cristi through Matita *not to lie to Antonio at all;* you know how he is . . . Even if it's the smallest thing, he gets very angry if she says one thing instead of another, so beg her not to do it so she won't have to put up with Antonio's bullshit."[14]

The fearless Kahlo sisters, who, like Frida and their father, believed in blunt honesty, decided to confront Kitty's husband. The sisters wanted to make sure Antonio understood that his wife "is not alone."[15] If he tried to hurt her, they would take action. Mati said "horrible things to Antonio."[16] Adri recounted that Mati's strong words made Antonio "docile after that."[17]

As Adri saw it, however, nothing would change if Kitty didn't make a move. She encouraged her to save the money Frida occasionally sent her. She knew if her younger sister was ever going to break free, she'd need the finances to do so.

But she would also need resolve, something that was probably hard to come by at that time. Kitty, like Frida, was in a state of mourning; her sense of the futility of life can be heard in these words written to Frida: "You know, I think Mom is watching over me from the other world, she knows she can't leave me because she knows how much I need her, more with each passing day. Our only consolation is that the poor woman isn't suffering anymore. You know, little sister, this life is a lot of crap full of suffering and now that we see and understand everything we realize that it's just not worth it. I only wish I was closer to you to spend whatever time we have left together."[18]

Frida too was caught up in the feeling that "life is a lot of crap full of suffering." Reading her sister's words must have made Frida feel terrible. But it also might have made her feel less alone. Kitty's state of mind and her marriage mirrored Frida's in many ways. Both husbands were jealous womanizers who blew up over their wives' suspected flirtations or affairs with other men. They could be loving or controlling, calm or anxious. Both women had to figure out how to respond to their respective husbands' erratic moods.

Frida continued to justify Diego's irritability and anger by admitting fault, saying she had gotten the "Kahlo" in her head and had provoked Diego with her emotional outbursts. The other rationalization was that Diego's unpredictable, sometimes cruel, sometimes manipulative behavior was the consequence of being a brilliant artist who lived outside the norms of society. To her family, Frida acted as if Diego treated her well, even if this wasn't always true. After Frida returned to Detroit from Mexico and Diego seemed annoyed just being around her, she conveyed none of this tension to her older sister Adri, who responded: "I'm happy to see that Diego is very good to you and that you love him with all your heart, right?"[19]

Adri would have wanted the best for Frida and Diego, but because of Diego's role as financial benefactor within the extended family, it was even more important he treat Frida well—or, perhaps, that the family believe he treated her well. Frida's father often told his daughter to thank Diego for his "constant kindness" to them.[20] Frida's aunt Isabel thanked Frida for the money she and Diego loaned her. Frida's aunt Lupe owned four houses that Frida and Diego were interested in buying for "$10,000."[21]

Diego's wealth had benefitted the family, and Frida, as the liaison, was adjusting to being the financial center of her extended family. It was a role that came naturally, since she was a generous person. But she had to walk

a fine line between the needs of her family and the moods of her mercurial husband, who might reject a request for money if she didn't ask at the right moment. Ultimately, Frida straddled two roles: one financially subordinate within her marriage, the other financially dominant within her extended family. When Matilde was alive, she'd been in charge of the finances. Now Frida was the monetary matriarch.

As life and death kept dancing inside Frida's head, like Day of the Dead skeletons circling round and round in an endless tango, she kept thinking about her *querida mamacita* and how the woman who had given birth to her was now dead.

Perhaps a short trip to New York with Diego to submit his drawings for the proposed Rockefeller mural project could jolt her into a new frame of mind. Normally Lucienne would have been excited to go to New York with Frida and Diego, but this time she wasn't up to being a psychological buffer. Instead, she went to Chicago, where she stayed with her friend Lucy Ann Leighton. While there, Lucienne met some women who said she could join them on a car ride to New York. Lucienne wrote Frida to say she was off on a road trip with two women she hoped were good drivers, as the "roads [are] very icy."[22]

The single Lucienne was the epitome of the independent "New Woman," whereas Kitty might be considered an example of the downtrodden, powerless mother and wife sometimes referred to in Mexican culture as *la chingada* (the fucked one). *La chingada* is an important concept within Mexican culture that has a multitude of connotations. According to writer Octavio Paz, *la chingada* is a feminine noun, but is related to the masculine verb *chingar*. "The *chingada* is the mother who has suffered" due to "the *chingón*, the *macho*, the male," Paz explains.[23] Where did Frida fall along this spectrum between independent woman and *la chingada*?

The next painting she created placed her firmly in the category of trailblazing artist. She discovered, once again, that even if she couldn't find her voice within marriage, she could in art. Sometime after returning from New York in mid-November, Frida completed her most gut-wrenching painting to date, called *My Birth*. If *Henry Ford Hospital* was the breakthrough painting that had released her fears and allowed her to chart the unknown, it was *My Birth* that allowed her fearless spirit to soar ever higher.

"Let's draw the bloodiest thing we can think of," was what Frida had said back in San Francisco, prompting her and Lucile to draw women violently being stabbed by men. This challenge was still consuming Frida's heart and mind, and in Detroit she set up a crime scene in *My Birth*.

At the center of the painting, a large wooden bed appears to squeeze the life out of an empty bedroom. It's so large it feels intrusive. The bed is intimidating and disquieting, looking as if it could slide off the tilted wood-paneled floor and crush anyone entering the room.

Just as disturbing is the realization that a dead woman's body lies on pristine white sheets, with pink lace pillowcases shimmering in the light. The woman's head and torso are covered in a perfectly creased white sheet. How did she die? Her lower half is exposed, pried open to allow her baby to enter the world. Underneath the tufts of black pubic hair, an adultlike baby's head and neck turned to the side lie on the white sheet stained with blood.

The bright light is alarming. This is a somber moment, but the light illuminates both the beauty of the bed linens and the gory details of the crime scene. Is the baby alive? Her mouth is slightly open, perhaps a sign that she is breathing. But her eyes are closed and there are lacerations on her neck. Why?

Straight up past the dead mother's head, there's a framed painting of another female with a wounded neck: Mater Dolorosa (Our Lady of Sorrows). Is there a connection? Like the baby, Our Lady is seen from the neck up. There are two daggers piercing the sides of her neck, one plunged into her vocal cords. Her mouth is open, as if struggling to sound the alarm of pain and death. Her furrowed brow, ravaged face, tears, and rolled-back eyes hint at her slow demise. She's not the familiar face of Our Lady of Sorrows with the perfect glowing skin of youth, yet her light blue mantle and faint gold halo indicate she is indeed the Virgin of Sorrows. But no comfort is found. Something isn't right. How did the mother lying on the bed die? Does she too have lacerations on her neck?

Everything looks still except for the swirling lines from the creased bedsheet underneath the mother's uncovered pelvis and the baby's head. Could this indicate that there is still some life inside the baby in the process of being born? Where is the father? Is there a doctor? Midwives? The

woman needs help. All three females in the room have been rendered speechless.

One of Frida's favorite quotes as a teenager came from Oscar Wilde's preface to his novel *The Picture of Dorian Gray*: "All art is at once surface and symbol."[24] With *Henry Ford Hospital* and *My Birth,* Frida had mastered surface and symbol. In *The Picture of Dorian Gray,* Wilde sets up a dialogue concerning the role of beauty in art. To enjoy the surface level was to embrace beauty for the sake of pure sensory pleasure in art. But to go beyond and into the symbolic realm was to search for something deeper and more meaningful, even moral.

Frida's paintings can be experienced on the surface level without digging for symbolic significance, or they can elicit a desire to search for the hidden meaning that she took great pleasure in devising. Ultimately, though, Frida subverted this comparison of surface beauty with symbolic depth, as *My Birth* and *Henry Ford Hospital* lack surface beauty. To experience Frida's Detroit paintings on a surface level is to take in their immediate power. In Wilde's novel, crime and art are compared; both evoke incredible sensations. Frida combines the two. The crime scene takes her disturbing painting of birth up a notch, increasing its visceral punch.

Like Joseph Campbell, Frida was a synthesizer of ideas and images from around the world. One work of art that might have sparked her imagination is a striking fourth-century Greek limestone sculptural group from New York's Metropolitan Museum. In this sculpture, a woman lies back exhausted after giving birth. Due to the age of the limestone, her face has been eroded, giving it a deathlike, skeletal appearance.

Frida had visited the Metropolitan Museum one year before starting *My Birth,* marveling at the Greek, Christian, Roman, and Etruscan art: "It's very interesting and one can learn a lot of new things."[25] This sculpture would have stood out in her mind, given its unusual subject of a woman giving birth. The sculptural group also includes two female attendants who are missing the upper portions of their bodies because of damage to the artwork. As a result, the original concept of two female assistants or midwives helping a woman give birth has ended up looking macabre, as a hand resting on the mother has no body attached to it. In the sculpture's damaged state, it appears as if a disembodied hand is growing out of the

dead-looking mother. The second dismembered attendant is placed at the mother's feet. Originally she was holding the baby, but due to the erosion of the upper body, it looks as if the newborn lies on its own unattended. This haunting sculpture of a dead-looking mother and an isolated baby are significant ingredients in *My Birth*.

But Frida mixes them up and creates a much more shocking view, placing a nude woman's torso and open legs front and center as the woman gives birth on a bed. As with the ancient Greek sculpture, mother and baby are isolated from each other, with Frida alluding to a double death. And yet the title is *My Birth*, something Frida elaborated upon when she described the painting as "how I imagined I was born."[26] Not surprisingly, the work is filled with dualities: birth/death, mother/daughter, violence/calm, purity/impurity.

Frida's letters to Dr. Eloesser while she was pregnant convey some of the fears about pregnancy and giving birth that many women feel. Certainly Frida, who was conversant with medical facts and terminology, would have been aware that in Mexico in the early 1930s, "145.6 babies died per 1,000 births."[27] Even though the death rate had been almost cut in half since the time Matilde had given birth to Frida (when it had been 290.6 per 1,000 births), it would take another twenty years before those numbers would decrease to under 100 neonatal deaths. Of course, Frida's painting is more than a statement about the statistical possibilities of infant mortality or the risk of death for the mother. She understood the fluid and close relationship between life and death, something she'd experienced at least twice in her young life and which had defined her existence. *My Birth* is a sober reminder of the solitary experience of being born and dying.

There is little comfort or aesthetic pleasure to glean from the painting, except for those luminescent white pillowcases trimmed with pink lace. Bookending the mother's covered head, they seem to function as the light of life propping up the mother's dead body. By contrast, in the framed picture of Our Lady of Sorrows presiding over the bleak bedroom, the Virgin's mottled skin looks as if it's decaying, reminiscent of the aging portrait of Dorian Gray in Wilde's novel.

Our Lady of Sorrows was important to Catholic women like Frida's mother, as she offered comfort in times of unbearable pain. Her Latin name, Mater Dolorosa, translates as "mother full of grief." Frida emphasizes the full weight of her grief by turning the usually young and beautiful

Virgin with a slightly pained expression into an older woman whose face looks ravaged by pain. A similar treatment appears in Carlo Crivelli's *The Lamentation* (1470), at the Detroit Institute of Arts. It's an unusual image of Mary. She looks to be in her late fifties or sixties, with leathery, wrinkled skin and half-open eyes raised to the heavens. Her mouth is open, with her tongue sticking out. It's a grotesque image, especially since her face is close to her dead son's, who is painted in the exact opposite manner—young and beautiful. Frida's Lady of Sorrows with upturned eyes and open mouth also bears some resemblance to her own mother, a devout Catholic, who had just endured a painful death at the age of fifty-six.

Instead of daggers in her heart, Frida's Virgin of Sorrows has two daggers piercing her throat. She is literally speechless, something Frida emphasizes with the empty scroll running across the bottom of the painting. The lack of words underlines the perilous situation. Normally a *retablo* miracle painting would be inscribed with heartfelt thanks to Mary for saving a loved one. In Frida's painting, as Herrera points out, the mother has not been saved.

But there's another, less obvious reason Frida included Our Lady of Sorrows. Matilde died on September 15, the feast day of Our Lady of Sorrows. On this day, processions carry large images of the Virgin through the streets of Mexico in her honor. It must have felt to Frida and her family as if Matilde had been carried across the boundary line of life into death by the Virgin herself.

When the viewer looks at the distraught Mary hanging above the dead woman in *My Birth,* sadness prevails. But as the eye travels down to the woman's splayed legs with a bloodied child emerging, the impulse to recoil is equally strong. Part of Frida's brilliance lies in her ability to create paintings that evoke different emotions, sometimes leaving us with mixed feelings of attraction and repulsion.

The Virgin Mary is central to Frida's ability to elicit such feelings. Mary is a virgin due to the Immaculate Conception, making her a pure mother (images of her giving birth to Christ are an anomaly). Frida pairs the weeping, pure virgin mother with the dead mother who is in an "impure" position with legs spread apart, giving birth. It's hard to even imagine that the Virgin of Sorrows ever gave birth to Christ, because the birth process itself is messy. How can a human woman give birth without becoming "impure"—opening her legs, becoming bloody, excreting fluids, screaming,

panting? The blunt Frida created an equally blunt image. There's nothing hidden or glossed over except the mother's identity. Frida rejects the socially accepted norms in Western painting and in society by merging and doubling these concepts of pure and impure, concepts that were invoked time and again when judging a woman's worth: sex before marriage, for example, made a woman impure and unmarriageable. By rejecting these norms, Frida brings out the inherent contradiction of the Virgin Mary, a "pure" mother, trying to save an "impure" woman who had to menstruate and have sex in order to procreate.

This is where Frida starts to synthesize her images. If the Virgin Mary's purity is unattainable for most women, then the sacred and profane Aztec goddess Tlazolteotl represents the complexity of women's experiences. As a manifestation of the earth goddess Coatlicue, Tlazolteotl in her duality symbolizes filth/cleanliness, life/death, and sexual desire/sexual excess—central elements in Frida's painting.

Tlazolteotl squats when giving birth, her legs splayed open to allow her son, Centeotl, the maize god, to emerge from the birth canal. The Aztecs could see this powerful goddess in several of the codices they created, such as the Codex Barbonicus, and Frida "adapted the image of the Aztec goddess of parturition" to her work, as art historian Barbara Braun points out.[28]

Clearly, the image of Tlazolteotl giving birth with her legs open in the Codex Barbonicus caught Frida's attention. There was also a birth/life/death trinity there that resonated with Frida. The Aztec artist covered Tlazolteotl with the flayed skin of a dead captive while she gives birth. Frida contrasts her scene of birth with a dead mother whose face and torso are covered in a sheet. In both, the child emerging from the mother's vagina has an adultlike head turned to the side. And these adultlike babies look androgynous.

Androgyny is not what typically comes to mind when discussing the Aztecs. The popular image is one of bloodthirsty male warriors. Yet historian Inga Clendinnen says there's "little indication of male priority in the Aztec creation of humankind story."[29] This is because even at the top of the complex hierarchy of deities, Ometeotl, the creator god, was considered androgynous. The birth of all living things, the Aztecs believed, required both male and female contributions. It's not surprising, then, that Tlazolteotl had male attributes and that her baby Centeotl, the maize god, had a

female personification, known as Chicomecoatl. Just as duality was central for the Aztecs, it was also central for Frida. Duality, for both Frida and the Aztecs, was understood as the balance of opposites.

And *My Birth* is a painting of dualities exquisitely balanced, both vertically and horizontally. Vertically, a line goes from the painting of Our Lady of Sorrows hanging above the dead woman's head down to the baby's head. Horizontally, the border along the back wall and the scroll along the foreground define the bedroom space where the bed stands front and center.

Tlazolteotl embodied everything Frida was grappling with at this juncture of her hero's journey. Frida would always retain her androgynous nature, but the European Leonardo would fade into the background, with indigenous figures such as Tlazolteotl taking on a stronger presence in Frida's art and life as her sense of self grew stronger roots in the soil of Mexico before the Conquest. Tlazolteotl is the pre-Hispanic answer to the Virgin Mary.

But Frida the synthesizer makes an important creative choice; she alters the squatting Tlazolteotl giving birth into a mother lying flat on her back. This supine position is not a natural one for women when giving birth—it goes against gravity, and the kneeling, squatting, or sitting position was the "most common throughout the world" prior to the seventeenth century, as scholar Lauren Dundes explains.[30]

For Frida, it would have been significant that the reclining position for birthing mothers originated in Europe, not in indigenous Mexico. Prior to the 1600s, birthing postures in Europe were much the same as elsewhere in the world, but around that time male doctors began to supplant women as birthing attendants, and they preferred their female patients lie down when giving birth because it gave them more control, Dundes notes.

Initially, it was deemed indecent for a male doctor to be present with a woman lying on her back, knees bent. This changed in the seventeenth century when Louis XIV of France started a trend by having his mistresses use a new birthing bed during delivery. The king apparently found viewing a woman with her legs splayed open while giving birth lying down sexually titillating. He requested his mistresses give birth this way while he looked from behind a screen. Louis the XIV became a peeping Tom, turning the natural process of birth into something salacious.

Frida pounced on the tension that arises from these two elements of the natural and the salacious bumping up against each other. She places

viewers in the position of Louis XIV. We possess the power of a king as Frida provides a bird's-eye perspective, allowing us to look down on this anonymous dead woman's legs spread apart.

The discomfort arises as Frida blurs the lines between the natural process of birth and the licentious desire to stare. The image is fraught with edginess, as Frida truncates the woman's body: her abdomen, vagina, and legs look cut off from the upper portion of her body, including her head, recalling pornographic art and photos. For art aficionados, French artist Gustave Courbet's *Origin of the World* comes to mind because this nineteenth-century Realist painting zeroes in on a reclining woman's parted thighs, pubic hair, belly, and partially uncovered breast. Like the woman in *My Birth,* she has no head, and no upper body is visible. The woman has been reduced to her sexual parts.

And in some ways, medical imagery of birth shares this reduction of women to body parts with pornographic images. As the specialist fields of medicine and science emerged, the female body was broken up into its parts to gain a better understanding of how it functioned. Medical textbooks and illustrations for teaching purposes in the eighteenth and nineteenth centuries emphasized the anatomical parts of the female body, and Frida owned Francis Henry Ramsbotham's *The Principles and Practice of Obstetric Medicine and Surgery, in Reference to the Process of Parturition* (1841), with its sixty-four plates and numerous woodcuts. Not one of the 142 illustrations shows a woman's body intact.

There is one Ramsbotham illustration in particular that strikes a chord similar in its uncomfortableness to *My Birth*. The illustration is supposed to show a child's head beginning to crown, "seen separating the labia."[31] This illustration shows a close-up of a woman's legs splayed open, with an abstract circular form emerging from a vagina with wavy pubic hair above. The legs are cut off at the upper thigh by a cloth draped over them, and another cloth covers the abdomen above the pubic hair. Frida's dead mother is shown from the same point of view, with her legs spread open facing us. In Frida's case, the "baby's" head has emerged, but as in the Ramsbotham illustration, she depicts the pubic hair just above the labia and drapes the mother's torso with a similar type of cloth. In both images the cloth has pronounced folds resembling those seen in classical sculptures and reliefs.

Anatomical illustrations stressed "the utmost realism," Kahlo scholar David Lomas contends, in order to convey scientific truths.[32] Frida said

she painted her own reality. But in both cases, the desire to create the real often morphed into something disturbing and surreal. Just perusing Ramsbotham's book makes this clear. In addition to illustrations of deconstructed female body parts, the illustrations showing the birth process often incorporate forceps and other birthing instruments, referred to as "blades." These blades are inserted into a disembodied uterus by disembodied hands; thus a woman's body parts are impaled, just as Frida was impaled by a metal rod entering her back and exiting "through the side of her vagina, tearing the labia," during her bus accident.[33] It was a trauma that mixed violence with sex in Frida's mind, as she tried to downplay the horrific nature of this violation by joking that this was how she had lost her virginity.

When it came time to paint *My Birth,* Frida incorporated a violent act, but not in an overt manner. She doesn't paint a "blade" inserted into the dead woman's vagina; instead, she thrusts daggers into Our Lady of Sorrows' neck. One instrument seen in Ramsbotham's book, an osteotomist, resembles these daggers. It is a long, scissorlike tool with sharp ends to "break up the bones of the child's head" in the event that it got stuck in the birth canal. The osteotomist's crossed handles and tapered blades ending in pointy tips resemble the shape of the daggers and the angles at which they project from the Virgin's neck.

Frida's use of the daggers isn't an explicit reference to birthing tools. But her placement of them in the neck instead of the heart conjures up a similar image of a birth canal (the throat) leading to a vaginal opening (the mouth). It's another doubled image in the painting and one that is specific to women's bodies.

Frida's subtle reference to birthing tools, birth, and the female body is in dialogue with two sections of Diego's mural at the Detroit Institute of Arts. As they struggled to communicate verbally, Frida began to spar with Diego as an equal in art.

A look at Diego's small *Pharmaceutics* mural on the south wall shows his use of "daggers." He painted five surgical scissors inserted into the top of a bloodied head, with disembodied doctor's hands (above) performing brain surgery to remove a tumor. The perspective is unusual because only the top of the head is seen; it's embedded into an abstract undulating white

clothlike form, making it difficult to discern that it is indeed a head. But it does resemble the baby's head crowning in Ramsbotham's book. To make this connection to birth stronger, Diego paints female reproductive organs to the side of the head. The way Diego positions the scissors radiating out at an angle from the head is reminiscent of how Frida has placed the daggers in the Virgin's neck.

Both artists were fascinated with medical imagery and used it as inspiration for their concurrent paintings. Yet the way they use this medical imagery has very different implications. In Diego's mural, the scissors are there to aid in a surgery that can save someone's life. But in *My Birth,* the osteotomist-like daggers inserted into the Virgin's neck (doubling as the birth canal) are there to harm.

Frida's vision of birth is not for the squeamish. By contrast, Diego's vision of birth on the east wall of the Detroit Institute of Art is comforting. Here he painted *Infant in the Bulb of a Plant.* The baby, with its arms wrapped around itself, is secure within a uterus-like pod under the earth, with fallopian-like tubes branching out toward fossilized paintings of sea life. It's an image of human life connected to all life forms throughout time. He called the infant a "germ cell," symbolizing the origins of life and "humanity's dependence on the raw materials of the earth," writes Rivera scholar Linda Downs.[34] Diego made the cartoon for the infant soon after Frida had returned from Mexico, which means she'd already created her lithograph of the miscarriage and she was in the process of creating *My Birth.*

Diego's baby in the bulb of the plant has more in common with Frida's lithograph than her painting, as both connect humans to nature. But the relationship of the baby to nature is quite different. In Frida's lithographic image, it's the death of her baby, seen in the blood dripping down her leg from the miscarriage, that nourishes the earth below like Tlazolteotl, rather than the baby being nourished by the earth, as in Diego's mural. The mural depicts a serene environment, with two nude females above and on either side of the baby. As Diego said, the women represent the "growth of the vegetable life from the soul."[35]

This seamless connection between woman and nature is nowhere to be found in *My Birth.* The beautiful white-skinned baby in Diego's cozy pod has been transformed into a brown-skinned, adultlike "baby Frida," whose head has emerged into a room fraught with danger, violence, and death.

From the title *My Birth*, we expect to see a loving image of mother and child after birth, but what we get is quite the opposite. As with *Henry Ford Hospital*, Frida depicts what Euro-American social convention dictated ought to remain private and concealed: "medicine straddles the border of public and private," observes Kahlo scholar Lomas.[36] Ultimately, Frida questions how the female body is treated in a Judeo-Christian world. Notice how the vertical line of females is crossed by the horizontal line running along the back wall. On this cross, three females are placed on the vertical axis. Have they, in the words of scholar Gannit Ankori, been crucified in this "Catholic maternal legacy of suffering, blood, and pain"?[37]

When Frida painted *My Birth*, she was struggling with pain and anger as a result of her mother's death. Diego's lack of sympathy intensified these feelings. Frida even made a drawing of herself wearing a boyish cap and earrings along with an indignant expression that she titled *Very Angry*. Like her sister Kitty, at this moment, she felt marriage as a restrictive cage. Like her mother, she had experienced loss of control over her female body. In her case, it was due to a miscarriage; in her mother's case, it was due to breast cancer. In both instances, the female body "failed" to live up to society's definition of womanhood. In the painting, however, the female body has been subjected to violence (in the case of Mary), death (in the case of the mother), and isolation (in the case of the baby). The unanswered question that lingers is: Who is responsible for the violent actions?

Like the work of most great artists, Frida's work asks more questions than it answers. But all men are implicated in the crime depicted in *My Birth*. Frida's female trinity of Virgin Mary, mother, and child is, on some level, a response to the male trinity of Father, Son, and Holy Spirit that dominated women's lives (the image doubles as the crucifixion as well). In countries like Mexico and the United States, where Christian ideals were an integral part of society's norms concerning women, who were supposed to be virginal and pure before marriage and fertile mothers after marriage, women who strayed outside these strict moral boundaries were condemned to violence and to outsider status. By the time Frida painted *My Birth*, she'd strayed from both norms. Yet her outsider status had not granted her freedom. She vacillated between accepting her fate with Diego as a caged woman who needed to control her own "Kahlo" temper and

seeking to be the rebel who wanted the same freedoms that society granted to her husband.

The painted surface became one arena where Frida could wage her fight for freedom. This is one reason her paintings in Detroit become more personal. It's not just the subjects themselves; it's her use of metal instead of canvas for *Henry Ford Hospital* and *My Birth*. The metal, as many scholars point out, mimics the *retablo* miracle paintings Frida loved.

Writer and critic John Berger believes metal offered something else for Frida—the smooth surface was like skin. It required her to treat the surface in similar ways to her own brown skin—wash it, perhaps sand it (exfoliate), and prime with a lead-based paint (moisturize). Berger notes: "When she painted her pictures, it was *as if* she were drawing, painting, or writing words on her own skin. If this were to happen there would be a double sensitivity, because the surface would also feel what the hand was tracing—the nerves of both leading to the same cerebral cortex."[38]

This "double sensitivity" would be felt by viewers as well, but it would take time for many to catch up with Frida's radical outsider vision. When, some fifty years later, people peered into her paintings, those who felt marginalized recognized her pain, suffering, and rebelliousness. The sheer intensity felt in *My Birth* allowed Frida to turn her feelings of victimization and sorrow into an active force to be reckoned with, at least as an artist. Whereas Diego "painted for the future," writes Berger, with his work symbolizing a future he imagined and hoped would come to pass, Frida, he says, painted in the present, claiming everything for all time.[39] Because of this, her Detroit paintings simultaneously speak of universal truths and truths specific to women.

In mythic terms, *My Birth* is a visual representation of Frida's rebirth. She would later acknowledge in her diary that she was "the one who gave birth to herself."[40] This second rebirth had begun in 1932 with her miscarriage and was completed after the loss of her mother. She had to die once again in order to be reborn with fresh eyes. But it was not an easy death. She famously said she felt murdered by life. On a symbolic level, she entered the "crime scene" and reemerged dazed and in a half-conscious state, like the "baby."

As an artist, she would no longer hide behind someone else, as she

did with her portrait of the horticulturalist Luther Burbank. And people started to take notice. One of Diego's mural assistants acknowledged her unique talent, saying her paintings "were like gems, really. She knew the essence of things, essence of people, essence of situations: she went right to the point."[41] Such serious considerations of her work aided in strengthening her identity as an artist. This can be heard in Lucienne's words: "She does the most wonderful bits of creation. . . . She does it as she eats and sleeps."[42] With *My Birth*, Frida, who now painted because she needed to, had reached her mature style at the age of twenty-five. This was a remarkable feat. Her husband, who considered his Detroit murals to be his best work, was forty-six. It's no wonder he often said Frida was the more talented of the two.

Frida had figured out a way to create commanding images drawn from complex ideas and emotions using an economy of means to pack a punch. Few, if any, can look at *My Birth* and feel nothing. This is one reason the performer Madonna purchased this painting and hung it in the entryway to her home. It was a test of sorts. "If someone doesn't like this painting, then I know they can't be my friend," she told Kevin Sessums of *Vanity Fair*.[43]

First impressions are central to our understanding of the world, and they're created within seconds of encountering someone or something, says writer Malcolm Gladwell.[44] Frida understood this. From this point on, she would, by and large, create paintings that elicited strong, pulsating emotions in the blink of an eye.

The Provocateur

She [Frida] was just like a naughty child saying bad words.

—LUCIENNE BLOCH

 By the end of 1932, Frida's artistic powers were stronger than they had ever been. She still suffered from physical ailments, grief, and general malaise, but her relationship with Diego was less tense.

At work on his murals at the Detroit Institute of Arts, Diego had gotten into a painting rhythm. One day Stephen Dimitroff entered the garden courtyard where Diego's murals were half completed. He found the sight "breathtaking."[1] Alone in the courtyard, he gazed at "four giant nudes—red and black mothers-of-the-earth, recumbent on the left, the white and yellow races on the right, the geologic strata of iron, coal, lime and sand below them."[2]

He was there to find a job as Diego's assistant. All of a sudden, he heard "muffled voices and decided to go upstairs to the mezzanine."[3] On the upper floor, he located the voices coming from an open door. Looking in, he saw a "heavy-set, giant of a man and a young, petite dark-haired woman" seated eating chicken. The heavy-set man motioned for Stephen to come in and pointed to a chair. Hesitantly Stephen sat down.

He introduced himself as an art student at the Chicago Art Institute, but said he'd had "enough of art schools."[4] He continued: "I want to see the real thing in process of creation. I arrived from Chicago this morning."[5]

But he had the feeling Diego couldn't understand what he was saying. The dark-haired woman had "an enigmatic smile," so he tried again, but this time in Russian.[6] Diego responded in Spanish. Then Stephen tried French, then more English and finally his native Bulgarian. He wanted to know if Diego needed a helper—anything, even sweeping. Finally Diego said, shaking his head, "'No. No need—No,' then 'No have.'"[7] Stephen persisted, saying he had quit his job at Buick just to watch Mr. Rivera paint. Diego raised his hand and corrected him: "Diego—NO mister!"[8] Then a disgruntled Diego wiped his hands and got up from the table.

Before he could leave, Frida said something to him in Spanish, but the only word Stephen could decipher was *pobrecito,* meaning "poor." She must have pleaded with Diego to take in the artist because he was poor. According to Stephen, "Diego listened to her gravely, then said with a beautiful smile, 'Okay, you come watch.'" Stephen was delighted. He stood up, "shook hands and thanked him and his wife Frida profusely."[9]

Thanks to the woman with the enigmatic smile, Stephen joined Diego's crew of assistants, an opportunity that changed his life in many significant ways. He learned from the chemist Antonio Sánchez Flores—nicknamed "Yay"—how to grind pigments on a glass plate and turn them into a smooth mixture. Soon, Stephen—nicknamed "Dimi"—met all the assistants: Clifford Wight, the head plasterer; Art Niendorf, called "Nien"; Ernest Halberstadt; John Hastings; and eventually Lucienne, after she returned from New York.

Ernie Halberstadt showed him the Greek diner nearby where a good drawing could buy a meal. In fact, Ernie told him he'd traded art for decent Balkan and Armenian food several times. Since Dimi was working for free, this was a great tip. Even the paid assistants weren't making much money. Nien even had to pawn his watch to make ends meet. Before Lucienne had left for Chicago and New York, she'd told Frida how alarmed she was by Nien's lack of money: "This fellow works so hard and is so proud, he doesn't dare mention it."[10] Frida ended up advocating for Nien, and Diego sent him a check.

This must have meant a lot to Nien. The crew worked more than eight hours a day, preparing the plaster and pigments and handling various other tasks, allowing Diego to paint for an average of ten hours a day, sometimes more. He couldn't start work until the plaster was applied to the walls, and he needed to begin right away because once the plaster dried, the

pigments would no longer be absorbed. Timing was everything, but Lucienne said sometimes Diego didn't arrive for three hours after receiving the call that the plaster was ready. This was because "he had to have a battle with himself."[11] The heightened tension could help elicit some of his best work, but this "battle" had a negative impact on his assistants, who needed to be in sync with him. One time they'd finished plastering at eight in the morning and called Diego to tell him to come and paint. Dimi remembered that Frida had answered the phone and said she'd give Diego the message. But by noon, with the plaster drying, there was still no sign of Diego. At twelve-thirty he sauntered in with a group of Mexicans. They were in a jovial mood, but Diego's paintbrush never touched the wet plaster. The assistants had to scrape it off and redo it for the next morning.

As much as Diego fashioned himself a worker, not wanting to be called "Mr. Rivera," he was really a high-paid manager. He didn't always recognize the disparity between his privileged lifestyle and his assistants' daily struggle for the basics. Angelica Reyes Esperilla, who visited Diego's murals with her father, a laid-off factory worker, noticed his higher status and was surprised "that white people were being ordered around by this Mexican."[12]

It was Frida who noticed the assistants' poverty and suffering. She must have whispered in Diego's ear that it was unethical to work Dimi so hard when he wasn't getting paid, because one day Yay turned to Dimi and said: "Diego thinks I am working you too much. He says you should paint and draw. He wants to see your work. Do you have any here?"[13] Dimi didn't have anything with him, but the next morning he brought his portfolio to show Diego. Dimi found him on the scaffold, painting the north panel of the bustling automobile factory. Diego motioned for him to come up. Dimi climbed the steep, rickety ladder, portfolio in hand. After steadying himself, he proceeded to hold up his watercolors of landscapes, still lifes, and portraits; one depicted his father coming back from his factory job holding his lunchbox. In English Diego said: "Very fine, good aquarelle, sketches good. But why you not paint workers factory? That interesting."[14] Dimi was stunned and didn't know how to answer, saying later, "The factory was just plain routine to me. I went down pondering this."

Later, as Dimi was going out the back entrance with his portfolio, he saw Frida and the maid Sarah carrying Diego's lunch. Frida said hello and asked what he was holding. Then she motioned with her head for him to put it on the watchman's table. She looked at all the work. As Dimi

recalled, "At the one of my dad carrying his lunch pail she turned to her companion and said, 'Good, very good.' The maid said, 'That's just like my dad coming home from work.' Frida closed and tied the portfolio, tapped me on the shoulder sweetly, and said, 'Keep working, keed [kid], keep working.'"[15]

Frida wasn't much older than Dimi, but she spoke to him as the more experienced artist. A new level of confidence showed; her morning routine of painting in her studio at the DIA provided the backbone of a serious artist. When it was time for a break, she'd go visit Diego and the gang up on the scaffolding.

Sometimes when Frida was up on the wooden platform she would watch Diego paint; other times she'd sketch. When it was time for lunch, they'd eat together, and afterward Frida often went back to her studio. Both were working on paintings that depicted Ford industries. There's a photograph that captures this, with Frida painting in front of Diego's south wall mural while Diego looks over her shoulder.

In December, Diego was working on the north wall, the mural filled with the intensity of the automotive factory. Dimi described it as "flames, steaming furnaces, monster machines like apparitions from another planet, dwarfing the men who mingled among the snake-like conveyor belts."[16] The workers in Diego's mural move in all different directions, pulling and pushing, yet it looks like a beautiful choreographed dance.

Henry Ford's idea back in 1917 had been to create a self-sufficient 2,000-acre factory complex that could turn raw materials into running vehicles in the shortest amount of time possible. The machines and workers were integrated via the assembly line, and the time needed to build a car shrank from twelve to two and a half hours. But it was hard on the men's bodies and numbing for their minds. This modern approach to factory work spawned images of workers as robots, as depicted in Fritz Lang's 1927 film *Metropolis*. This negative image didn't bother Ford, as the River Rouge plant, completed in 1928, was the largest and most powerful integrated industrial factory in the world.

This all changed in October 1929, but Diego's murals emphasize the wonder and enthusiasm of the pre-Crash days. It is Diego's nostalgic love poem to the Detroit workers, glorifying the bleak situation at the end of

1932, when the Ford plant was only one-fifth of what it had been, with "only half the number of workers at half the wages it had in 1929," as Rivera scholar Linda Downs explains. The times were so bleak that the Ford Motor Company, as historian Steve Babson reminds us, had lost its dominant economic position in the automotive industry and much of its "public support due to the refusal to update the Model T."[17] Diego's nostalgic perspective appealed to Henry and Edsel Ford, creating a comfortable bridge between the Communist and the capitalists.

Maybe Diego's enthusiasm for Ford Motor Company was bolstered by the landslide victory of Franklin Delano Roosevelt in early November. The president-elect, who had struggled to walk again after being stricken with polio, seemed to understand the plight of struggling Americans, with his campaign promises to create federal programs aimed at the "forgotten man." Whatever the case, Diego pumped his excitement into these murals.

He was a notorious workaholic. The long, irregular hours suited his temperament, but it could be challenging for Frida, who "was a real homebody," according to Lucienne.[18] She continued to try to bring some sense of order to Diego's life. If he wasn't back at the Wardell at a decent hour, Frida went to find him and bring him home. Sometimes she had to charm him off the scaffolding.

He'd climb down and wipe his forehead with a red bandana. Then, giving Frida a "Cheshire Cat" grin, he'd bend down and kiss her with a loud, juicy "mwah."[19] One time she held out a cigar for him. He took it from her small hands, then handed it back. "Niendorf, who understood Spanish, offered her a light. She bit the cigar, lit it, puffed a few times and then gave it to Diego, whispering some tender words. He spent another fifteen minutes looking at the piece he had just finished, then another twenty minutes up there painting again. Finally, Frida playfully eased him toward the door and out the back exit," as Dimi recalled.[20]

Frida's jocular, mischievous side was beginning to resurface. Her psychological rebirth elicited an even stronger desire to break with social conventions. She no longer felt the need to purchase European-style dresses and shoes so as not to "appear shabby" and "be eaten alive," as she had in New York. She wore her Mexican-style dresses and skirts, sometimes with a fur coat over them if the weather was harsh. She and Diego were

often invited out for dinner at the homes of the affluent, many of whom lived in the Grosse Pointe Shores area. They went to a folk dancing party where Frida did "a heel and toe" with Henry Ford.[21] He was so enchanted that he presented her with a new car, a Lincoln Continental, and threw in a chauffeur who could take Frida around Detroit. But Diego declined the gift, saying it was too lavish.

Despite Henry Ford's niceties, Frida, who knew the industrial mogul was an avowed anti-Semite, turned the screw on him at one of his dinner parties at the 1,300-acre Fair Lane estate overlooking the mighty River Rouge. Henry's son, Edsel, and Edsel's wife, Eleanor, were there, as well as a number of art world luminaries, such as William Valentiner, the director of the Detroit Institute of Arts. Everyone was seated at a long table chatting it up. At one point there was a lull in the conversation, and Frida turned to Henry and "innocently" asked him: "Mr. Ford, are you Jewish?"[22] There was a pause, and then "everybody roared," according to Lucienne.[23] Ford never answered the question.

He didn't have to. Frida had made her point. And she'd done it in a brilliant fashion, using feigned naïveté to her advantage, as Ford usually brought up the "Jewish problem" with his dinner guests. Frida beat him at his own game. For many, the "Jewish problem" would have seemed a normal dinner topic, as anti-Semitism was prevalent in the United States and becoming even more pervasive in Germany. Even though some people would have been uncomfortable with the subject, most would have found it difficult to challenge this powerful and admired man. Frida was aware that he and Edsel were responsible for Diego's mural commission, but her use of covert humor made it difficult for Henry to determine if Frida was aware of the implications of what she was saying. Of course, she was.

Frida would probably agree with historian Hasia Diner that "Ford's anti-Semitism is dangerous because he was an American hero."[24] Many people took his anti-Jewish rhetoric to heart, including Adolf Hitler. In his book *Mein Kampf* (1925–1926), Hitler praised Ford, citing the anti-Semitic articles that had appeared in Ford's newspaper, the *Dearborn Independent*, between 1920 and 1927.[25] Articles such as "Does Jewish Power Control the World Press?" and "Jewish Power and America's Money Famine" helped to fuel anger and prejudice against Jews.

Hitler had been particularly inspired by a book that the *Dearborn Independent* published in 1921: *The Protocols of the Elders of Zion*, believed to

have been fabricated by the Russian czar's secret police (Okhrana) in the late nineteenth century. By 1903, portions of the *Protocols* were serialized in a Russian newspaper (and in 1905 they were published as an appendix to a book) to foment virulent anti-Semitism. Originally the book was claimed to have been authored by a secret cabal of Jewish leaders who were plotting to control the world. By 1921 the book had been exposed as a fraud, yet Ford's newspaper reprinted it as if it were legitimate. A libel lawsuit that ended in a mistrial put the paper out of business and forced Ford to make a public apology. That apology might have saved Ford's automotive company, but it didn't quell the rising paranoia. The paper had lent credibility to a conspiracy theory that Jewish bankers and leaders were trying to take over the world. Hitler wrote, "I shall do my best to put his [Ford's] theories into practice in Germany."[26]

Frida, who considered herself half Jewish, took aim at Henry Ford in the only way she thought possible: to embarrass him through feigned ignorance. But for scholar Malka Drucker, it was more: "Frida tried to wake people up to the events in Europe and to their own prejudices, and acting outrageously in Detroit helped defuse her anger."[27] Frida might have also wanted to create some distance between herself and Diego and Henry Ford because, like Hitler, Diego had praised Ford. He lauded him to Detroit journalists as a "true poet and artist, one of the greatest in the world."[28] He also famously remarked that Marx made theory, Lenin applied it with his sense of large-scale social organization, and Henry Ford made the work of the socialist state possible.

Frida knew Diego was no Hitler supporter; he had seen one of Hitler's early speeches in Germany that filled him with "forebodings."[29] And he certainly wasn't anti-Semitic. Yet how could he praise someone who was an avowed anti-Semite and admirer of Hitler? Perhaps some of Frida's anger stemmed from Diego's rapturous embrace of Henry Ford. It bothered her that in the United States, "only the '*important people*' can make it, even if they are scoundrels."[30]

Henry Ford was not the only target of Frida's antics. She was invited for tea at the homes of the wealthy, many of whom found her Mexican outfits bizarre. Their wealth hadn't necessarily exposed them to different types of art and cultural traditions. Peggy deSalle, who in 1950 opened up the first art gallery in the Detroit area, discovered that the wealthy patrons "literally feared" coming into an unfamiliar space.[31] Frida had little patience for such provincialism. She would make sarcastic comments about the Catholic

Church, or pretend to misunderstand the meaning of what she was saying in English. She sometimes inserted profanity, such as when she incorporated "Shit on you!" into a sentence while having tea with Henry's wife, Clara Ford, and her fellow Colony Club members.[32] Frida had found that friends like Lucienne took delight in her mispronunciations, a favorite being "So help me Goth."[33] With a mind that delighted in spinning words to see how they could be shuffled and rearranged, Frida took this endearing quality of mispronunciation, which probably began as an innocent mistake, and used it to her advantage. For Frida, the "innocent" front could create just enough doubt in people's minds. This allowed her to broach controversial subjects, such as the advantages of Communism at a tea in Henry Ford's sister's house, and leave the guests wondering if she had really meant what she'd said.

When Frida returned home to the Wardell after her teas and dinners, she'd say, laughing, "What I did to those old biddies!"[34] Diego egged her on, finding his wife's antics amusing. He could vicariously enjoy Frida's expressions of disdain for snobby behavior, while in order to satisfy his patrons he had to toe the line. But Frida did make distinctions between people, even among the upper class. For example, it doesn't appear that she ever put Edsel and Eleanor Ford in an uncomfortable position, nor William Valentiner; she liked them. Her ire was directed toward those she found hypocritical, snobbish, prejudiced, and closed-minded.

If the society women found Frida's clothes bizarre, then they probably would have been aghast at her latest paintings. She was at an odd crossroads. Detroit was the place where she'd had her major artistic breakthrough, and yet it was not a city that supported her as a female artist with a radical style. There was a small art community geared toward men, and the Detroit Institute of Arts had an impressive collection, but during the Depression the arts suffered. Edgar P. Richardson, the DIA's education director, said that Detroit in 1932 was "a disaster such as none could be conceived . . . it was a terrible human situation we were living in while the [Rivera] fresco was going forward—the whole world was collapsing around us."[35] Within this environment, it was almost impossible for women to find financial and institutional support as professional artists.

Peggy deSalle said that in the thirties, both men and women attended Thursday night soirees at muralist Paul Honore's studio, where they

discussed art, literature, and world affairs, but that she couldn't think of one successful local female artist at that time. The Scarab Club, a nonprofit arts organization that was a local hub for artists, writers, and musicians, barred women. The Egyptian scarab was chosen to symbolize rebirth and to represent the boundless creative spirit of artists. Scarab gallery director Treena Flannery Ericson said: "Rivera came here a lot, but women weren't allowed upstairs [in the lounge] at the time. Frida wouldn't have come."[36]

Located on Farnsworth Street, the club was a short walk from the DIA. Diego frequented the place when he wanted to relax, gabbing with the locals while puffing on a cigar. He even signed his name on one of the wooden beams in the second-floor lounge alongside other famous artists, such as Marcel Duchamp and Norman Rockwell. The second-class treatment of women was evident in a February *Detroit News* article featuring Frida's paintings. The title says it all: "Wife of the Master Mural Painter Gleefully Dabbles in Works of Art." The article's author, Florence Davies, who had previously written about Frida, once again singled Frida out as an artist, yet simultaneously cut her down to size.

The accompanying photographs—one of Frida painting a strong self-portrait, and the other a reproduction of *Self-Portrait on the Borderline Between Mexico and the United States*—belie the title. Even Davies conceded that her "painting is by no means a joke" and that she "has acquired a very skillful and beautiful style."[37] But Davies didn't quite know how to interpret Frida's quips, such as when she told Davies that she had never studied with Diego or anyone else. With a twinkle in her eyes, Frida said: "Of course, he does pretty well for a little boy, but it is I who am the big artist." When Frida "explode[d] into a rippling laugh," Davies tried to get her to respond in a serious manner, but Frida just mocked her and "laugh[ed] again."[38]

Later in the article, Frida again one-upped "the master mural painter," warning, "'Diego better look out. Of course, he's probably badly frightened right now.'" Once more, Davies was unsure how to take Frida's bravado. In the end, she concluded that "the laughter in her eyes tells you that she's only spoofing you—and you begin to suspect that Freda believes Diego can really paint."

There's no doubt that Frida believed in Diego's talent, but by inverting the power dynamics, making him the "little boy" and her "the big artist," she again used humor to shake things up and question assumptions. Humor was Frida's power. She loved comedians like the Marx Brothers and Charlie

Chaplin. They were, as Fuentes puts it, "anarchists, perpetually at odds with the law, pursued by the fuzz, answering the demands of law and order with pratfalls, custard pies, and an undefeatable innocence."[39] This was Frida's shtick in Detroit: to stare down hypocrisy, bigotry, prejudice, and injustice with "innocent" antics.

After Frida's rebirth in Detroit, the "naughty child" in her, as Lucienne put it, was ready to take on the role of the provocateur, a role she would perfect as part of her new persona going forward.

Frida manifested that provocateur spirit in *Self-Portrait on the Borderline Between Mexico and the United States,* the painting she'd begun before leaving for Mexico and had finished in time for Davies's February article in the *Detroit News.* It's one of her most complex paintings to date, with a smoke-belching Ford factory, high-rises, and machines occupying the right side, and the ruins of an Aztec pyramid, a crumbling wall, a skull, two ceramic figurines, flowers, and cacti occupying the left. In the middle, on a border marker, stands Frida, with perfect posture. She wears a colonial-style floor-length pastel pink dress with fitted bodice and three rows of ruffles adorning the bottom of the skirt. Long white lace gloves add the finishing touch to this proper attire, something she might have worn when attending one of the teas in Grosse Pointe. But details are always significant in Frida's paintings.

The proper-looking young lady becomes provocative when one notices her tight-fitting bodice and hard nipples. The contours of her breasts and her obvious bralessness would have raised eyebrows among the Detroit area's upper crust. Like Eva Frederick, the African American woman Frida painted in San Francisco, she doesn't look self-conscious or demure. Instead, her straight posture and outward-directed gaze convey the impression of a confident woman. The lit cigarette in her hand aligns her with the "New Woman." Yet this new, independent woman is also associated with indigenous Mexico, as she holds a small paper Mexican flag and wears a necklace featuring the flag's colors: red, white, and green.

It's striking that Frida, a *mestiza,* wears a hybrid outfit, with European and Mexican elements, while standing on a border marker. "The Mexico/United States border is a site where many different cultures 'touch' each other and the permeable, flexible, and ambiguous shifting grounds lend themselves to hybrid images," observes scholar Gloria Anzaldúa.[40] Frida

plays up her hybridity through her outfit and her connection to both sides of the border. The most glaring example of the "shifting ground" she stands on is seen in the name written on the square concrete border marker: Carmen Rivera. It's the first and last time she'll sign a major painting with this "alias," but technically, Carmen was one of her names (Magdalena Carmen Frida Kahlo y Calderón is the full name written on her birth certificate) and Rivera was her married name.

The idea to start using the name Carmen was conceived in New York just before Frida and Diego left for Detroit. Their friend Malú Cabrera threw them a going-away party at which Frida underwent a "baptism" whereby she "was re-christened Carmen." This "sacred" ritual was fully enacted, as Frida "was dressed up as a baby, Diego as a priest, and Malú as her godmother."[41]

This baptism was probably half tongue-in-cheek and half serious due to the turbulent times and the prospect of moving to the Midwest, a more conservative region of the country where the Ford Hunger March had just left several peaceful protesters dead. The Spanish name Carmen, made famous by Bizet's opera of the fiery Gypsy who seduces a naive soldier, worked to hide Frida's German Jewish roots and to flaunt her sassy, independent side.

Frida took the name change seriously enough to inform her cousin Carmen that she had taken on her name. In February 1933, around the time Frida had finished the painting, her cousin wrote to her as "Mrs. Carmen Rivera." Her letter suggests that the name change is real: "I was very pleased to know you are now named Carmen since one day you told me Diego likes this name, but I'm wondering whether it could cause you any trouble as far as property paperwork is concerned."[42]

Frida never legally changed her name, but she did use Carmen in Detroit. Newspaper reporter Florence Davies refers to her as "Carmen Rivera," saying her close friends call her "Freda," and Frida signed a drawing of Ernest Halberstadt with the name "Carmen." Taking on an alias in *Self-Portrait on the Borderline* has other implications as well. It underscores the linguistic transformation that often occurs under circumstances of border crossings, when adopting a new name while in another country helps one to fit in or pass in the face of discrimination and persecution. Inscribing her name, even an alias, on the base of the concrete border marker also acknowledges her corporeal presence in this space, as if to say, *I was here.*

When Frida began this painting, she'd been contemplating the differences between Mexico and the United States after living in San Francisco, New York, and Detroit, listening to discussions about machines and technology, and seeing Ford's massive River Rouge plant. But these differences were magnified in her mind once she'd embarked on her train trip back to Mexico, a lone Mexican woman crossing the border twice and visiting her homeland under emotionally fraught circumstances.

The complex relationship between these two neighboring countries is apparent in the photographs Frida's father had made of the new Ford Motor Company plant in Mexico City. Guillermo's photos show a modern glass building surrounded by a large tract of land with rows of trees evenly planted and mountains in the background. Ford's imprint on the Mexican land is undeniable. Inside the factory, a spotless environment flooded with light makes the pipes, machines, and wheel-less cars on an assembly line look like pristine modern sculptures. The emphasis is on the forms, as there are no people in sight, unlike in Diego's bustling factory interiors. Instead, each black-and-white photo is a balanced study of light and shadow, shape and line.

Frida's factory is also devoid of humanity. But hers isn't in Mexico. Instead, it's close to the Mexican border, signaling industry's encroaching presence in Mexico. Part of the factory is obscured by Frida's dress, dissolving any clear demarcation of borderlands, and hinting at the fear of those who were "violently opposed to the extension of industrialism—1931 model—in Mexico," writes Stuart Chase in his book *Mexico: A Study of Two Americas* (1931), which was illustrated by Diego.[43] Chase sums up the trepidation some felt when he asked: "Will the machine roll Latin America flat, trampling down the last vestige of the authentic American culture?"[44]

Frida's painting raises these types of questions at a time when she was personally affected by the extension of American industrialism. She was in between her husband (in the United States) and her father (in Mexico), both employed for a time by Ford. Her husband would say that Pan-Americanism was the only way for Mexico to avoid being trampled by the United States. But Frida the skeptic wasn't so sure that these two neighboring countries could share power. As she saw it, "Mexico is, as always, disorganized and messed up. The only thing it has left is the great beauty

of the land and of the Indians. Everyday the ugly part of the United States steals a piece; it is a shame, but people have to eat and it is inevitable that the big fish eat the small one."[45]

Frida's painting is a symbolic landscape of the mind, placing the Aztec empire and Ford's industry side by side. The downfall of the powerful Aztec nation foreshadows the potential demise of Ford's River Rouge plant; the encroachment of Ford's factories threatens the beauty of the Mexican land and its indigenous cultures. As the provocateur in the center, Frida prods us to think about this complicated relationship. Just look at where she places the American flag. It's embedded in the large smoke plumes rising out of the Ford factory, as if it's going up in smoke. Even the stars and some of the stripes are obscured by bluish black smoke. This image can be interpreted in various ways, but it's clearly not an endorsement of the Ford Motor Company, especially given Henry Ford's treatment of the workers. On New Year's Day in 1933, Ford cut employees' wages for the second time in three years, prompting nine thousand workers to go on strike. Almost exactly one month later, Frida's *Self-Portrait on the Borderline* appeared in the *Detroit News,* in the article in which Davies had to acknowledge that Frida's paintings were "by no means a joke."

Frida's different take on Ford and American factories sets her painting apart from some American artists, such as Georgia O'Keeffe (*East River No. 1,* 1928) and Charles Sheeler (*American Landscape,* 1930), who depicted smoke-stacks, but not with any obvious negative connotations. Sheeler's painting shows the sprawling Ford plant as a new American landscape, giving the busy factory pumping out pollutants a veneer of tranquility and beauty, as machines, buildings, ladders, clouds, and a smokestack are reflected in the river's calm water. Above, white plumes billow out of a smokestack as if filling the sky with light, fluffy clouds. Frida may have been familiar with Sheeler's painting; Abby Rockefeller owned it until 1935, when she donated it to the Whitney Museum of American Art.

As an outsider and as a Mexican woman, Frida provided a more complicated perspective on this modern American landscape, understood in relation to the Mexican landscape. For Frida and her contemporaries, learning about pre-Hispanic Mexico was like opening a long-locked door and peering through the doorway into a dark space with pulses of light visible in the far distance. Those pulses, each one an uncovered archaeological site or burial, reveal a lost history and identity. In Frida's Mexico,

an Aztec twin pyramid is in ruins, but the base stands as erect as Frida. It's her foundation as well as Mexico's, and a reminder of the advanced Aztec empire. A blood- and fire-spewing sun (Huitzilopochtli, a war deity), a lightning bolt (Tlaloc, a rain deity), and a crescent moon (Coyolxauhqui, a moon deity) hover over the ruins, laying claim to the continued power of the natural and cosmic forces the Aztecs believed animated the universe.

Frida surrounds the crescent moon in a dark blue/black cloud with a fingerlike point touching a white cloud next to it, wrapped around the sun. The touching "fingers" of the clouds animate a red lightning bolt, as if creating energy. As a bisexual *mestiza,* Frida, like the bisexual creator god Ometeotl, represents "the *unity* of opposites."[46]

As a unifying figure, Frida stands between two disparate cultures, something she depicts with shrewd contrasts. The United States is dominated by a Ford factory, high-rises, exhaust vents, and electrical objects. Frida seems to say that they come with a price. The factory smoke pollutes, and the tall buildings block the sky, sun, and moon. They are replaced by electrical objects—the orange sun on the Mexican side corresponds to an orange-colored speaker on the U.S. side, the yellow moon corresponds to a light-bulb emitting yellow rays, and the lightning aligns with a black generator.

In a clever move, Frida fuses the black wires of the generator on the U.S. side with the white roots of the poisonous jack-in-the-pulpit plant on the Mexican side. The generator is also plugged into the border marker Frida stands on, connecting her to both sides. The white roots entwined with the black wires establish the nature/industry duality, acknowledging the coexistence of light and dark forces in the natural and industrial worlds. The natural world contains both poisonous and nonpoisonous plants, and the industrial world mines the earth to produce electricity. Are these light and dark forces equal?

Frida doesn't provide a clear answer, but Diego took up the same subject with those four large female nudes of differing races and their corresponding raw materials. Steel is made from coal (black race), sand (yellow race), iron (red race), and lime (white race). In between these goddesses are enormous hands, muscular and clenched, popping out of the base of a pyramid (south wall) and a volcano (north wall). The dynamic hands hold on to the metals (manganese, nickel, tungsten, and molybdenum) needed

for the production of steel. These examples, Diego told *Detroit News* reporter Florence Davies, highlight the Aztec idea that "the constant cycle of destruction and construction is essential to all growth."[47] In order to create (construct) steel and its by-products, humans mine (destroy) the earth.

As Diego and Frida knew all too well, death and life are first cousins to destruction and construction. It was on their minds, so it is no surprise that, once again, images of life and death ended up in their paintings. Diego's images of the large earth goddesses find their counterparts in Frida's landscape in the form of two small female ceramic figurines, one from Nayarit, in western Mexico (1500 BCE–150 CE), and the other from Casas Grandes, in northern Mexico (1250–1450 CE). They predate the Aztec empire, representing a mother culture in the Americas. The Aztecs said they came from a place called Aztlán in western Mexico, believed by some scholars to be Nayarit. Frida and Diego were trying to acquire these objects at that time, purchasing many such figurines from western Mexico and the Casas Grandes figurine in the painting.[48] Frida loved them as much as Diego did, and in years to come she would surround herself with the Nayarit standing and seated female figures in her Coyoacán studio.

In her painting, the ceramic figurines are not merely props to convey her love of a mother culture in the Americas. They and the objects near them enact the personal and cultural drama of life born out of death. Frida chose her "actors" carefully. The rounded, pregnant-looking Casas Grandes female squats, making her vulva visible and calling attention to women's sexuality and/or birthing. Yet a skeletal head lies on the ground just behind her, undercutting her allure. The purple *Pulsatilla* (pasqueflower) in front of the Casas Grandes female also symbolizes death, as it can be ingested to induce a miscarriage.

But the flower and skull are the supporting actors of death, designed to showcase the main actors "on stage." If the Casas Grandes female symbolizes sexuality and pregnancy, then the Nayarit female holding a headless child in her right arm as if breastfeeding symbolizes the potential for death as a result of pregnancy and birth. The child's body is nestled up against the mother's body, with one of the infant's arms cradling the mother's nipple. But without a head, it can't suckle. In a macabre twist, the mother holds the child's head in her left hand. It's a scene of unbearable maternal pain, and the mother's face screams shock and horror. Her uneven, pupil-less eyes indicate she's in a daze, and her open mouth with

teeth bared shows her extreme distress. The combination of this headless child with the *Pulsatilla* reminds us, as art historian Helga Prignitz-Poda has pointed out, of Frida, the childless mother who had once tried to induce a miscarriage.

It may be the closest thing to an admission of guilt on Frida's part. But the figurine is a stand-in for her in another way as well. With its left foot missing, the figurine is broken, an important symbol for Frida moving forward, emphasizing that she was not ill but broken. Like the wall and pyramid behind her, the Nayarit female is no longer whole.

At the time Diego was collecting the Nayarit figures, not much was known about them except that they had been buried in unusual deep shaft-and-chamber tombs. Those tombs seem to mimic the birth canal, alluding to the Mesoamerican preoccupation with death and birth. "We see death as origin. We descend from death. We are all children of death. Without the dead, we would not be here, we would not be alive," says Carlos Fuentes.[49] Death is not the end but the beginning. Frida visualized this in *My Birth* with a child being born to a dead mother. In *Self-Portrait on the Borderline,* she brings this Mexican philosophy out of the personal space of the bedroom and into the public domain of the Mexican soil—all the objects placed on the Mexican earth symbolize in some way death and life.

Diego too incorporates death giving birth to life in the mammoth stamping press on his south wall mural. He was fascinated with Ford's stamping press, which, "gave birth" to fenders. "Workmen feed flat sheets of metal into the die jaws of the press and jump back when it slams with tons of pressure to form large three-dimensional body parts," explains Rivera scholar Linda Downs.[50] Diego painted it to resemble Coatlicue, the earth goddess of life and death. Both Diego and Frida took pleasure in synthesizing images from disparate sources; it was part of their complex visual syntax.

Although they couldn't always find the words to express their raw feelings concerning the death of their son and Frida's mother, they knew how to communicate with each other through their art. In Detroit, their visual language acquired more depth and nuances, allowing for a richer dialogue. As poet and critic Dan Chiasson observes: "Love is a form of reciprocity, at times even a barter economy."[51] To reciprocate love requires the dissolution of self-interest. But for a self-absorbed man like Diego, this probably wasn't possible. When Diego failed to reciprocate Frida's gestures of love and need

after she returned from Mexico, they both used art to barter their way back into each other's hearts and souls. It was the one constant in their turbulent lives together.

While their paintings speak to the significance of an Aztec death/life, destruction/construction dialectic, when it came to the subject of Ford's industries, their perspectives began to diverge. Diego's perspective was more hopeful than Frida's. He came to the subject with an enthusiasm he'd felt since boyhood. He thought, "The steel industry itself has tremendous plastic beauty. It is as beautiful as the early Aztec or Mayan sculptures."[52] Frida didn't seem to agree. There is little plastic beauty in her small Ford factory devoid of human life, except for the modern lines of headless humanoid vents with armlike appendages standing in a row in front of the factory. They call to mind those images of factory workers as robots and Diego's vent designs for *Horsepower,* the ballet that presented a critical view of industrial dominance.[53]

Frida said the industrial part of Detroit was "the most interesting."[54] But she always retained a skeptical outlook that industry was truly the new religion, a perspective she alluded to in *Henry Ford Hospital.* You can hear her skepticism in this letter to Abby Rockefeller at the end of January 1933: "What are the news in New York? Is [sic] the people talking about technocracy all the time? Here everybody is discussing it and I think every where, I wonder, what is going to happen in this planet?"[55] Frida's concerns about others' preoccupation with technocracy—the idea that experts in science, technology, and engineering should govern—connects to the potential for powerful countries such as the United States, Germany, and England to use their cutting-edge technology to dominate other, less technologically advanced countries.

After all, Ford Motor Company was not just in Mexico but in England and Germany as well, with the first Cologne-produced Ford car rolling off the line in May 1931. Once Hitler became Germany's chancellor in 1933, his positive relationship with Henry Ford allowed Ford Motor Company to continue to flourish there. Frida asked what was going to happen on this planet at an important moment in history. In hindsight, a U.S. Army report from 1945 tells us that the German division of Ford served as an "arsenal of

Nazism" with the consent of headquarters in Dearborn, according to Ken Silverstein's reporting.[56]

In Frida's cautionary landscape, she "innocently" stands on a border marker, nipples visible under her proper evening attire, while holding a cigarette on the United States side, a dual symbol of emancipation for women and control over Ford autoworkers, who were forbidden from lighting up. Isn't there an odd contradiction between Henry Ford the opponent of smoking and Henry Ford the industrial polluter? Frida slips in this question by having the cylindrical shape of her burning cigarette mimic the thin cylindrical shapes of the factory smokestacks. But Frida's burning cigarette on the U.S. side is also a slap in the face to Henry Ford because she is breaking his rules.

She effectively "acts out" on the U.S./Mexico border, a space that was defined during the Prohibition era as transgressive. In Mexico, one name for the border is *la línea* (the line). In Spanish, this word is feminine, explaining why Mexicans often refer to the border as "her," according to art historian Amelia Malagamba-Ansotegui.[57] This transgressive female space is a perfect setup for the "proper" Frida decked out in her frilly pink dress with her subversive hard nipples and burning cigarette.

It's a far cry from fellow Mexican painter Ángel Zárraga's *The Borderline,* which was reproduced in the special May 1931 issue of *Survey Graphic.* Zárraga shows a Mexican woman from behind with two long braids hanging down her back and two arms outstretched as she looks over a waist-high fence toward the U.S. city with its tall buildings and smokestacks, hoping to get in.

Frida completely inverts Zárraga's depiction. Her contemplative eyes and alluring outfit catch our attention from the start. She has turned around to address us with the United States and Mexico behind her on either side. She's not holding out her arms hoping the United States will admit her into the country. Instead, she is in control.

When Frida said everyone was talking about technocracy, she wasn't exaggerating. Lucienne mentioned the same thing in her journal. They were living in the Machine Age, which is what makes Frida's painting all the more remarkable. Once again, she connects a woman wearing pink to

urban, "male" buildings. Frida's pink dress creates a visual symmetry with the pink high-rise—she even has it face front, mimicking her stance on the border marker. To make her mischievous point, she places the "feminine" pink high-rise next to and slightly above a "masculine" blue-gray one, allowing the "feminine" building to dominate in this so-called masculine land of industry and engineering.

Frida's rectangular blue and pink skyscrapers are echoed in Georgia O'Keeffe's painting *Manhattan* (1932), which was made in response to a MoMA exhibition featuring American artists and their mural designs. Georgia had found out she'd been chosen to participate in the exhibit the previous March, while Frida was still in New York. In May, when the exhibit was up, Lucienne went to see it and wrote Frida, providing a critique of Georgia's painting. "The one of O'Keeffe showed skyscrapers very stiff and in pattern, like some publicity posters, with here and there some little rose [*sic;* they are actually camellias] painted over the surface, the same roses borrowed from her skull paintings."[58] At the bottom of her letter she even drew a pen-and-ink drawing of O'Keeffe's work, showing skyscrapers at a right angle with flowers floating on the façades.

Georgia's flat, Cubist-like painting differs in style from Frida's, but they include similar features. Georgia's impressive skyscrapers—the main ones without windows, like Frida's—place pastel pinks alongside blues with round, soft-looking pink and blue camellias floating in the land of hard-edged rectangular buildings.

Around the time Frida was painting *Self-Portrait on the Borderline,* she'd been thinking about Georgia, trying to put in words what she was feeling: "I wanted to write you a letter. I wrote many, but every one seemed more stupid and empty and I tore them up. I can't write in English all I would like to tell, especially to you."[59] Georgia too was not inclined to verbal expression, stating, "Words and I are not friends."[60] So, Frida seems to have turned to the international language of painting, Georgia's preferred dialect.

Frida could speak to Georgia through the syntax of flowers, an inside joke. She could take the stereotype of Georgia as the "lusty" flower painter and express her feelings of lust for Georgia. In Frida's beloved Mexican soil she placed brown, pink, and green jack-in-the-pulpits, flowers Georgia had exhibited in New York two years before. Frida nestled Georgia's jack-in-the-pulpits, a flower that grows in the moist forest areas of eastern North

America, between two cacti in the Mexican desert. As in Georgia's *Jack-in-the-Pulpit* series, Frida shows the stages of growth with a triad—one is closed, one is partially open, and the third is completely open, with a pink flower and visible white stamen peeking out and leaning toward the artist.

Just in case Frida's flower arrangement is too subtle for Georgia, she inserts the Casas Grandes ceramic figurine, with her visible vulva, directly behind the jack-in-the-pulpit. This figurine acts as a bridge between Frida and Georgia, as it is from the Mogollon culture, found in northern Mexico and in the southwestern United States. Frida's merging of the United States and Mexico in the foreground, with those white roots of the jack-in-the-pulpits conjoined to the black cords of the generator plugged into Frida's border marker, can also be read as a flirtatious note to Georgia; opposites (white roots, black cords) can attract and create electricity.

Frida had never stopped thinking about Georgia. After her tumultuous summer and fall, she reached out to her with a phone call. It was good to hear Georgia's voice after so many failed attempts to put her feelings down on paper. As it turned out, Georgia had been having a rough time too. Her relationship with Alfred had deteriorated, sending Georgia into a major depression. She was exhausted, and to make matters worse, she suffered from insomnia, headaches, and "uncontrollable weeping," according to her biographer Anita Eisler.[61] Although Georgia's state of mind wasn't the best when Frida called, hearing from her was probably the kind of lift Georgia needed.

By the time Frida wrote to Georgia on March 1, Georgia had been admitted to Doctors Hospital, on Eighty-Fifth Street in New York City. She had suffered a nervous breakdown, or what Dr. Edward B. Janks diagnosed as "psychoneurosis."[62] As Eisler notes: "Janks's only treatment, apparently, was to continue to forbid Alfred's presence."[63] Sibyl Browne, a mutual friend, had informed Frida that Georgia was sick, but Frida didn't know the details.

It's unfortunate that Frida and Georgia never had the opportunity to speak frankly about what each had been going through since the time Frida had left New York, as they'd both endured some of the lowest points in their lives, including hospital stays. Frida wanted to tell Georgia her troubles but knew she shouldn't because "most of them are sad and you mustn't know sad things now."[64] Instead, Frida confessed how much Georgia had

been on her mind and how much she longed to see her. She'd be leaving Detroit for New York in two weeks and planned to visit Georgia in the hospital with flowers in hand, adding: "It is so difficult to find the ones I would like for you."[65] Frida's letter sounds self-conscious; trying to find the right words in English and the right flowers for this older, rather intimidating artist wasn't easy, because as Frida coyly admitted: "I like you very much Georgia."[66]

Diego's walls on the DIA's inner Garden Court (now called Rivera Court) were finished by March 13. At some point, word got out before the murals were opened to the public that the vaccination panel (which features three scientists; a blond little boy getting vaccinated by a male doctor; a female nurse; and a horse, sheep, and cow demonstrating what vaccines are made from) was a sly reference to the Holy Family.

Various religious leaders began stating publicly that the murals made a mockery of the Holy Family.[67] A *Detroit News* editorial said the murals were "foolishly vulgar . . . un-American" and must be "whitewash[ed]."[68] Accusations that Diego was a Communist abounded. As in San Francisco, some expressed resentment that the Fords had handsomely paid a Mexican artist instead of a white American artist, something that would have stung in that moment, as Detroit's banking system had just collapsed on February 14.

Dr. William O. Stevens, the head of the newly opened Cranbrook Academy of Art—a suburban Detroit school devoted to architecture and interior design—asked why there had been no competition to decide which artist should paint the DIA's courtyard. Cranbrook had a strong pro-German feeling at the time, according to art dealer Peggy deSalle, even after Hitler had become chancellor two months earlier. Hitler blamed Communists for burning the Reichstag on February 27, claiming that they were engaged in a conspiracy to overthrow the German government. Eleven days before Diego's mural controversy hit American papers, *Time* magazine ran a story that covered the expansion of Hitler's power due to the Reichstag Fire Decree, which suspended important provisions in the Constitution, such as the right of free speech. When detractors in Detroit charged that Diego was a Communist, the accusations tapped into the fear Hitler had unleashed of Communist plots worldwide.

With hot opinions flying back and forth over Diego's murals, the

DIA's courtyard opened to the public on March 21. The crowds were huge, Helen C. Bower reported; between one o'clock and five o'clock that afternoon, some three thousand visitors paid ten cents apiece to enter the courtyard and see the murals for themselves. On Sunday, March 26, one of the largest crowds ever—ten thousand people—jammed into the courtyard to see the so-called blasphemous murals. The response was overwhelmingly positive: when the Arts Commission convened a meeting, they voted unanimously to accept the murals. Edsel Ford, the president of the Arts Commission, said: "I admire Rivera's spirit. I really believe he was trying to express his idea of the spirit of Detroit."[69]

The controversy faded as quickly as it had begun. And this was because Edsel Ford and his assistants George Pierrot and Fred Black had manufactured it. Their intention was to bring in revenue, as a bankrupt city had slashed the DIA's budget, forcing Edsel to underwrite the museum, something he did not want to continue doing. He asked Black and Pierrot to publicize the museum. When Pierrot heard an Episcopal clergyman say he thought the vaccination panel made fun of the Christian Holy Family, he saw it as an opportunity to drum up controversy in the name of increasing attendance. Black said he kept Edsel informed: "I would show him [Edsel] all these things, and in most cases, he'd laugh. He thought it was a great scheme."[70] It worked. Attendance increased exponentially, membership went up, and the Common Council increased the museum's budget to $132,326 for the coming year. This meant Edsel no longer had to "underwrite the salaries of the curators."[71]

Diego and Frida missed most of the controversy, having left on March 20 so that Diego could get started on his new mural. He was on a high, as he'd just completed some of his best work to date and had commissions in New York, Chicago, and Minneapolis. He was ready to take on New York first, with his most prestigious mural commission yet, at the RCA Building in the new Rockefeller Center.

Frida too felt ebullient. She was leaving Detroit with five new paintings—technically four because she had given William Valentiner *Self-Portrait on the Borderline*—and a new level of confidence.

VII

NEW YORK

Emboldened Frida

Quetzalcoatl: In Mesoamerica, the bird and the serpent are symbolic representations of two regions significant to religious and cosmological thought: heaven and earth. This double entity is a synthesis of opposites: it conjugates the destructive and germinal powers of the earth (serpent) and the fertile and ordering forces of the heavens (the bird).

—ENRIQUE FLORESCANO

 Frida was happy to pull into New York's Grand Central Terminal. It was grand in every way, but the opulent main concourse, its high, rounded ceiling floating above the crowds, was particularly stunning, with six zodiac signs—February through July—sparkling in gold leaf on a blue-green background. Frida's sign, the Cancer crab, with eyes facing down and pincers held out, looks as if it's ready for an embrace. All six signs came alive from the 2,500 stars, each illuminated at that time with a ten-watt lightbulb. But some of the cosmic beauty was diminished by water damage from almost ten years earlier.

The disfigured ceiling was a fitting welcome for Frida and Diego, re-affirming the Aztec dialectic of construction/destruction embedded in the paintings the two had created in Detroit. But that day, destruction was on the rise, as the Associated Press reported that the first Nazi concentration camp was scheduled to open two days later in Dachau, a lovely Bavarian town near Munich.

Frida and Diego had already felt anti-Jewish and anti-Communist sentiments in the "shabby old village" of Detroit, and they were elated to return to a more cosmopolitan city. If the weather was a predictor of the future, however, it didn't look good in that third week of March, with spring

nowhere in sight. As the cold whipped through the air with an unsettling chill,[1] Frida braced herself for this last part of the journey.

Frida and Diego returned to the Barbizon-Plaza Hotel at 106 Central Park South, where they enjoyed a spacious two-bedroom suite on the thirty-fifth floor. Just living in this residence for artists could invoke the Muses. What they didn't know in March was that by July, the Barbizon-Plaza would be in foreclosure. For the time being, the location was ideal for Diego's work, as Rockefeller Center was between Fifth and Sixth Avenues and Forty-Eighth and Fifty-First Streets.

After Frida and Diego settled in, they went with Lucienne and Dimi to the RCA Building to inspect the wall. It was impressive, an immense white space facing the plaza entrance in the seventy-story Art Deco skyscraper, which was still under construction. May 1 was the scheduled date of its official opening. As the centerpiece of a twenty-one-building complex, the RCA Building was to house a mass media entertainment complex, with NBC and RKO Radio Pictures two of the first entities to rent spaces.

The huge success of the film *King Kong* pulled RKO out of bankruptcy. It also provided great publicity for the new RCA Building, as did news of Diego's mural. He had already been dubbed the "Fiery Crusader of the Paintbrush" by Anita Brenner in an article for the *New York Times Sunday Magazine*.

Lucienne marveled at how Anita was assigned this article before Diego even began the mural: "The way the U.S. explodes unripe news is terrific."[2] Still, Anita wrote that Lucienne was one of Diego's assistants, a comment that bolstered her confidence: "Then I'll play that part."[3] Even though Lucienne had assisted Diego with his movable murals for the MoMA exhibit and had worked on the Detroit murals, her position had been undefined and her hours sporadic, and she had never garnered the recognition she deserved. Working on the RCA project, however, she became one of the "boys," putting in long hours photographing sections of the mural, tracing drawings on the wall, and plastering, all for no pay. Lucienne bought herself a pair of blue-striped overalls, and Dimi purchased a machinist's cap for her. "Now I can scramble all over the scaffold and show the boys how well I can climb over the metal pipes from top to bottom," Lucienne

bragged.[4] At five feet one inch, she may have been the shortest assistant, but she was not inconsequential.

Diego started working on April 2, throwing his assistants—seven in all—into the crazy schedule of plastering through the evening and early morning hours, with short breaks at an all-night diner about a block away on Sixth Avenue, just beneath the rattling elevated trains. It was obvious that Lucienne and Dimi were enamored with each other; within a month, they were living together. Frida was thrilled for the two of them. "Lucienne is in love with a boy, and she has changed a lot. She is more human now, and not so 'important,'" she wrote Clifford Wight.[5]

After nursing a bad cold at the end of March, Frida began going to the RCA Building to see the progress of Diego's mural, *Man at the Crossroads*. Sometimes she even showed up in overalls, as if she were one of the crew. She enjoyed talking to Dimi, Nien, and Lucienne and teaching them Mexican ballads in the temporary shack Dimi and Nien had set up for operations. These three assistants, plus Yay, had been joined in New York by painters Ben Shahn, Lou Block (Malú's husband), and Hideo Noda (who had worked on Diego's California School of Fine Arts mural in San Francisco). Clifford was no longer the head plasterer; he'd gone to Chicago to make preparations for the World's Fair mural Diego was to paint for the General Motors pavilion.

Frida also needed to visit Georgia. She arrived just in time to see her before she left Doctors Hospital. Upon her release, Georgia planned to head straight for the North River Pier to catch the Matson liner to Bermuda. There she would continue her slow emotional and psychological recovery, far away from Alfred. As Frida had promised, she brought Georgia flowers. It was the perfect ambiguous gesture for both women at this crossroads in their lives. Frida wrote to Clifford after her visit: "O'Keeffe was in the hospital for three months . . . She didn't make love to me that time. I think on account of her weakness. Too bad."[6]

A few nights after Frida said goodbye to Georgia, she, Diego, Lucienne, Dimi, and Lucienne's sister, Suzanne, went to the Lyric Theater on Forty-Second Street to see Francis Hall Johnson's *Run, Little Chillun,* a play that was billed as a "Negro Folk Drama in Four Scenes."[7] It was heartening to see a successful all-black play even as the high-profile Scottsboro case

continued to make its way through the court system. In November 1932, the U.S. Supreme Court had ruled that the Scottsboro Boys had been denied the right to counsel, sending the case back to the circuit court in Decatur, Alabama. In January, the International Legal Defense, under the umbrella of the Communist Party of America, retained Samuel S. Leibowitz, a New York lawyer, to defend the boys. The drama in the courts emphasized the struggles of African Americans living in a segregated society as second-class citizens.

While Diego was working one day, an unlikely visitor came to the scaffolding—Lupe Marín, his ex-wife. The early April spring weather must have warmed Lupe's heart; Frida was surprised that she "was kind and sweet."[8] For two weeks, Lupe and Frida went out together to theaters, movies, restaurants, Chinatown, Harlem, and five-and-dime stores. They also went to Macy's department store in Herald Square, where Lupe proceeded to fall down the escalator, telling onlookers "she wasn't an acrobat!" When they walked down the street, Lupe spoke to everyone, even police officers, in Spanish, acting like "coocoo the parrot girl," Frida quipped.[9] While shopping, she would yell to the clerks in Spanish as if she were in La Merced, the huge public market in Mexico City. As Frida told Clifford, "Well I can't tell you in words all the things she did, but was absolutely miraculous that nobody took her to an asylum."[10]

Frida thoroughly enjoyed Lupe's crazy behavior. As humor was central to her way of being, she found it in every aspect of life, even the unintelligible and tragic. She often turned her observations into humorous witticisms, parodies, drawings, or songs. When Frida was in a New York taxi, she passed by a sign that read PHARMACEUTICALS.[11] She thought it such an odd word that she wrote a song on the spot and sang it with feeling and intensity, sparking a smile from the driver. Tarzan films struck her as uproarious. She went to Brooklyn to see *Tarzan the Fearless,* an absurd story about a white ape-man who lives in the so-called jungles of Africa.

After Lupe left, Frida found out that Lucienne was working through the night, sometimes eighteen hours at a stretch. Most of her time was spent at the RCA Building. She enjoyed it, but at nightfall it was a bit eerie, with only two lamps to illuminate the large white wall, and a quiet interrupted only by the sound of night watchmen's keys jingling or the occasional boom of

thunder. It was a fitting environment to feel the power of Diego's first images of fascist warfare on the upper left side of the wall—airplanes overhead, gas bombs, death rays, tanks, and a platoon of soldiers wearing gas masks with bayonets held high, one shooting gas into the air with a hose.

Perhaps the events in Germany the day before Diego began painting had unnerved him. The Nazis weren't using chemical weapons on that day, but they were flexing their muscles by calling upon Germany to boycott Jewish businesses. Hitler and Joseph Goebbels, his propaganda minister, said the boycott was in retaliation for German and non-German Jews providing negative stories to the American and British press about what was happening under Hitler's rule.

One night, Lucienne's sister, Suzanne, and brother, Ivan, known as "the kids," brought beer to the assistants. It was a celebration of sorts, as the Cullen-Harrison Act had just been passed several days prior, legalizing low-alcohol-content beer. It was a prelude to Prohibition's official ending, slated for December 5. Beer stalls had been set up all over the city, and even at four o'clock in the morning, customers were still crowding around. Lucienne had already seen one person drunk in the subway. Her unusual hours meant she saw this underground world between three and five in the morning, something she made note of in her journal: "All the left overs of humanity are crowded in the subway pale and thin. . . . They're the cleaners of office rooms or the unemployed spending countless nights where it isn't too cold. . . . It seems as though half of New York is awake at night—a half I never knew existed—one all rich people should be forced to see to make them think a little."[12]

Diego wanted to make the rich take notice with his mural. One way he did this was by contrasting the scene of fascist warfare on the upper left side of the wall to a May Day demonstration in Moscow on the upper right. It was a scene Diego had taken from his sketchbook of watercolors made while in Moscow several years before, a sketchbook Mrs. Rockefeller purchased and donated to MoMA. Instead of the camouflage green dominating the fascist scene on the left, the upper right is bathed in red—flags, women's headscarves, and a large banner that reads "Workers of the World Unite in the IVth International!!" The man in the center holding up this banner is Leon Trotsky, the exiled Russian revolutionary who had played a major role in the new government of the Soviet Union but who had been ousted by Joseph Stalin when he came to power

in the mid-twenties. Trotsky's Fourth International was an alternative to Stalin, and Diego aligned himself with Trotsky over Stalin.

Directly above Trotsky's head is a swastika in gray that's made to look as if it's carved onto a huge statue of a beheaded Julius Caesar, the ancient Roman ruler and military general. Diego said the workers had arrived at a "true understanding of their rights" and as a result, "tyranny" had been destroyed, "personified by the crumbling statue of Caesar."[13] The reference to Hitler and the Nazis is chilling.

The red was also significant, not just because it screamed "Communist" but because Raymond Hood, the architect of the RCA Building, had stipulated that the mural be painted in black and white. In the negotiations, with the help of Nelson Rockefeller, Diego had won the right to use some color, but he couldn't "resist the bright red splashing of propaganda," Lucienne wrote.[14] She thought Diego would catch some flak for that.

Frida told Lucienne that Mrs. Rockefeller had been by and had even climbed up on the scaffolding to get a closer look. "Mrs. R" said that the May Day demonstration at Lenin's tomb was the finest part of the unfinished mural. In response to Lucienne's quizzical look, Frida said, "Mrs. R has a radical taste."[15] Her son Nelson must have trusted his mother's opinion, as he sent Diego a friendly note telling him how everyone "is most enthusiastic about the work you are doing."[16]

Perhaps Mrs. R, who raised her son to abhor racial and ethnic discrimination, felt even more sympathetic to Diego's positive images of Communists because of what was happening in Germany. The day before she stopped by, Hitler had rounded up forty thousand political opponents—Communists, trade unionists, and anyone who was not a National Socialist, as the American journalist H. R. Knickerbocker reported in the *New York Evening Post* on April 7. They were incarcerated at the newly opened concentration camp in Dachau. On that same day, the German government enacted the Law for the Restoration of the Professional Civil Service, banning non-Aryans from civil service jobs.

Frida had relatives in Germany and was keeping a close eye on the events unfolding under the Nazis. Writing her father, she expressed fear that a war with Germany, instigated by tension with England, could be on the horizon. She was probably influenced by articles in the *Manchester Guardian,*

a British newspaper, detailing the important constitutional changes Hitler was making, such as appointing administrators with dictatorial powers for all German states, as well as the violence and intimidation directed toward Jews and Communists. In one particularly disturbing story, the paper recounted how a young girl leaving a picketed Jewish shop was surrounded by storm troopers who were about to take her picture for the purposes of shaming her in print. A passer-by held up his hand to block her face; he was severely beaten.[17]

It was a particularly disturbing time for Frida to be living in the United States, away from the security of her home. When she was older she reflected, "In 1933–34, I was very interested in political things."[18] She made her most blatantly political painting at this time, *My Dress Hangs Here, in New York* (later retitled *My Dress Hangs There*). Frida wrote on the back in chalk: "I painted this in New York when Diego was painting the mural in Rockefeller Center."[19] Most likely she worked on the painting throughout this nine-month stay in New York and even back in Mexico, finishing it five years after she'd left the United States.

Frida's painting captures the tumultuous times—a city besieged by demonstrators, who flow in and out of a fictive space that mimics the Wall Street area, with Federal Hall, Trinity Church, a billboard of Mae West, and the Statue of Liberty as the most eye-catching icons. Her visual dialogue with Diego picked up where it had left off in Detroit. The dualities the two loved to mold and transform were taking shape in both of their paintings: great wealth alongside desperate poverty, beauty turning into ugliness, black and white united, muted colors with red as an accent. Frida's accent color can be found in two red gas pumps with white stars, recalling Texaco's logo, and the Communist gold star on a red flag. But what Frida and Diego place at the center of their paintings is quite different. Frida originally placed a plain dress hanging as if on a clothesline in the center of the city, whereas Diego placed a blond-haired male worker controlling a machine at the center. Frida inserts the feminine, while Diego highlights the masculine.

Diego's man is at the crossroads "looking with hope and high vision to the choosing of a new and better future." This was the assigned theme from the Rockefellers. And this better future is tied to science and technology. The worker at the center has large hands that hold the controls of an immense, futuristic light-emitting machine. Its two intersecting

ellipses look like huge propellers on an airplane, except they're covered with disease-causing microbes as well as stars, planets, and the moon. In front of the worker is a gargantuan disembodied hand holding a ball of light that radiates out onto the ellipses. As the chosen theme states, this man at the crossroads isn't just looking to a better future but is choosing one. Likewise, Diego asks us to choose sides.

On the left side that shows menacing soldiers in gas masks spewing deadly gas into the air, there are workers underneath carrying signs that say "Want Work Not Charity" and "Divided We Starve United We Eat" even as police mounted on horses beat them and as the rich huddle in their own underground speakeasy playing bridge, socializing, and sipping champagne. The right side depicts the May Day demonstration of workers singing and cutting off tyranny's head, while underneath, athletic women are ready to run a race united, just like the group of men next to them: a black worker, a farmer, a soldier, and the Russian Communist revolutionary and theorist Lenin.

For Diego and his assistants, which side to choose was clear. The assistants lived a life of poverty, working for little money, and sometimes for nothing at all. They were pursuing their dream of making art, working with Diego to learn the fresco technique, and attaching themselves to the utopian ideal that a more just world was possible, one where workers, black and white, Jew and Gentile, enjoyed good pay and job protection. They believed in the more peaceful world filled with equality and justice for all, seen on the right side of the mural.

Diego emphasized "justice for all" with the inclusion of a black man in the group of the worker, soldier, farmer, and Lenin in the unity section on the right. He took the black man, reviled in American society, and made him a figure of unity in the Communist Soviet Union. This idea grew out of the Communist Party of America's sponsorship of the legal defense of the Scottsboro Boys in their retrials (Diego contributed money for the legal fees). The trials had seized America's attention, which was at a fever pitch around the time Diego was beginning his mural. Haywood Patterson, one of the older boys, had his retrial first. He was represented by his new lawyer, and with Ruby Bates recanting her story that Patterson had raped her, there was hope that he would be acquitted. But an all-white jury found Patterson guilty, sentencing him to the electric chair. On April 9, people in Harlem took to the streets in protest. Tensions were so high that the judge

presiding over the remaining cases for the eight other Scottsboro Boys postponed their trials.

These protests ended up in Frida's painting in the form of a collage compiled from newspaper photos. Crowds of people from the photos fill up the foreground. On the left side of her painting, people are protesting the Scottsboro verdict. A demonstrator's sign reads "Smash Scottsboro Frame Up" (the "Smash" is from a Communist Party slogan: "Smash Lynching and Segregation"). Nearby, a black man holds a sign that says "Negro White on the Picket Lines"; a white woman slightly behind him holds a sign with the words "Negro White Workers." Frida re-created what she'd witnessed: a scene of solidarity between white and black members of the working class, a unity that the Communist Party advocated.

Diego's assistant Hideo Noda was a member of the John Reed Club, a place for Marxist-leaning artists, writers, dancers, and intellectuals, and was caught up in the high emotion of the verdict. He began work on a gouache simply titled *Scottsboro Boys,* featuring a small-town scene with Haywood Patterson in prison garb, his last name and prison number emblazoned across his gray shirt. Noda's gouache was eventually shown in the John Reed Club–sponsored exhibition "Hunger, Fascism, and War."

The John Reed Club artists were not the only ones addressing racial prejudices, class inequities, and protests. The MoMA mural exhibition from the previous year had displayed many similar types of political images in their prototypes for possible murals with radical content. A year later, Diego's fresco was now being painted on an actual wall, one housed in a new skyscraper, making Rockefeller Center part of the "New Frontier," as the complex's architects put it. All eyes were on Diego—quite literally, as the Rockefellers charged a fee for the public to stand and watch Diego's mural come to life. The grand opening of the building was ironically scheduled for May Day.

Diego and his assistants sensed the momentum of history as they worked crazy hours, fueled by their passion for art and social justice. Tensions could be high, such as the time when Diego noticed the assistants having a tough time with the perforated tracing paper used to transfer images onto the wall. A draft kept blowing the paper around, causing rips. Diego blamed the assistants. Another time, the long work hours created both laughter and anger when they all went to the nearby diner at five in the morning. Diego "was so tired he laughed uncontrollably and spit

dripped from his mouth."[20] In his bleary-eyed state, he mistakenly poured six spoonfuls of salt onto his cereal. When it was time to head home, he, Frida, Lucienne, and Dimi began walking, but Diego had to stop in front of a store window to admire it. The others could hardly stand upright, let alone listen to Diego blather on about the display. "Frida was so furious she pulled the meanest tongue out at him."[21]

Back at the RCA Building, reporter Joe Lilly from the *New York World-Telegram* came to check on the progress of the mural and to interview Diego. Lilly was particularly interested in the right section, where Lenin was featured. According to Diego's autobiography, he told Lilly that

> as long as the Soviet Union was in existence, Nazi fascism could never be sure of its survival. Therefore, the Soviet Union must expect to be attacked by this reactionary enemy. If the United States wished to preserve its democratic forms, it would ally itself with Russia against fascism. Since Lenin was the pre-eminent founder of the Soviet Union and also the first and most altruistic theorist of modern communism, I used him as the center of the inevitable alliance between the Russian and the American.[22]

Lilly thought Diego had a good sense of humor, but the headline on his article the next day did not elicit laughter. Rather, it made Rockefeller look like a fool: "Rivera Paints Scenes of Communist Activity and John D. Jr. Foots Bill." To make matters worse, Diego was quoted in the article as saying: "Mrs. Rockefeller said she liked my painting very much. . . . Mr. [Nelson] Rockefeller likes it too."[23]

This was April 24. With approximately one week until opening day, the headline created controversy. It, along with the ringing endorsement by Mrs. R. and Nelson, made it nearly impossible for the Rockefellers to ignore. There was too much riding on this new building becoming a huge financial success. They needed wealthy patrons to rent office space and the public to clamor to attend Radio City Music Hall to see movies and musical theater. Accusations of Communist sympathies could cause the public to take notice and flock to see a mural under fire, as the DIA mural had

shown in Detroit. But in the case of the RCA Building, such public furor wasn't going to help fill office space.

The Rockefellers wanted to prevent the spark of controversy from exploding into a firestorm. They halted public viewing of the mural-in-progress. On May 1, the building was opened, but Diego's mural wasn't quite finished. Lucienne noticed that instead of downplaying the Communist references, Diego had added some, including making Lenin's visage more apparent, and painting a "hammer and sickle right in a red star" in the elliptical "propeller" filled with stars in the sky on the communism side.[24]

That day Lucienne and some of the others took a break to go to the May Day parade in Union Square, "where hatred for policemen grew quite sharp in me as I watched them glaring at everyone as though each one would explode," she wrote.[25]

Diego continued to refine the right-hand section of the mural showing the soldier, the black worker, the farmer, and Lenin joining hands. He even wanted to paint Lucienne and Dimi looking up at these figures as comrades in love. Hints poured in from Frances Flynn Paine, the architects, and the construction heads to consider tempering the vibrant red, the "realism," and the subject matter. But Diego did none of that.

On May 4, with only a small section still unpainted, Diego received a letter from Nelson Rockefeller. Although Nelson said he'd seen the "thrilling" mural and thought Diego had rendered the portrait of Lenin "beautifully," he went on to say that it seemed that the Lenin portrait "might very easily seriously offend a great many people."[26] Nelson said he disliked having to ask Diego to remove the face of Lenin, but "I am afraid we must ask you to substitute the face of some unknown man where Lenin's face now appears."[27]

The simple solution would have been to acquiesce and paint over the face of Lenin. But Ben Shahn wrote up a protest letter saying all the assistants would strike if Diego removed Lenin, and all but Nien signed it. Shahn argued that the removal of Lenin would "weaken him [Diego] as well as the painting."[28] Diego worried that Shahn was correct: if he gave in to this demand, others would come later. An artist should have the freedom of expression. Besides, the Rockefeller commissioners had known in

advance what he was going to paint from a preliminary drawing, which included a man in a cap who was supposed to be Lenin. Diego had modified the original figure by removing the cap and using his gift for naturalism to make Lenin stand out.

Bertram Wolfe, Diego's friend and biographer and a member of the Communist Party (Opposition), advised Diego to acquiesce to Nelson and alter the face in order to save the rest of his painting. But even though the Communist Party of Mexico had rejected Diego's membership and the Communist Party USA had taken pot shots at him for colluding with wealthy patrons, Diego still wanted to appease them. His mural was in sync with some of the pressing issues of the day: the rise of fascism and a rise in solidarity between black and white workers to counter the forces of oppression. Surely Abby and Nelson Rockefeller, who had been his champions all along, would stand up for his vision.

After Diego weighed all the possibilities, he wrote back to Nelson on May 6, saying that Lenin had been in the original approved drawing. Yes, he had made changes, but these involved the placement of the figure and enhanced realism of Lenin's face. He then addressed the business aspect, arguing that if someone were offended by the depiction of a "deceased great man," this same type of person would be offended by the entire concept of his mural.[29] For this reason, he would rather see the mural be mutilated in its entirety to preserve "its integrity" than make the requested changes.[30]

To save face and attempt a middle path, Diego went on to suggest that he could balance Lenin's face with the face of President Lincoln on the left, taking out the drinking scene and replacing it with the man who "symbolizes the unification of the country and the abolition of slavery, surrounded by John Brown, Nat Turner, William Lloyd Garrison or Wendell Phillips and Harriet Beecher Stowe."[31]

Diego felt relatively secure that the compromise he offered would be accepted. As Lucienne noted: "Diego doesn't seem much perturbed. They couldn't possibly do anything to such a tremendous piece of art work."[32] Yet Nelson never replied. Diego continued painting. In the next few days more protest marches took place in the United States. Everyone knew that on May 10, the Nazis were planning a mass burning of books by Jewish authors, the works of opposition political theorists, and any books deemed a corrupting influence. Hitler was tightening his grip, closely watching what

German reporters wrote and monitoring what foreign correspondents were sending home. If there was news critical of the Nazis, the German reporters would be imprisoned or beaten; foreign correspondents would be sent home, if they were lucky. Dorothy Thompson, an influential reporter and the *New York Post's* Berlin bureau chief, was the first foreign correspondent kicked out. From Paris she wrote, "Chancellor Hitler is no longer a man, he is a religion."[33]

Frida had felt Hitler's grip and began bracing herself for war. Lucienne felt it as well, noting in her journal that "Hitler is threatening the Jews in the vilest manner and all the foreign countries are not against him for that. I wonder why."[34] With freedom of speech being extinguished in Germany, the Rockefellers had an important decision to make about Diego's mural glorifying Lenin and the solidarity between blacks and whites.

As the collective angst intensified, Frida and Lucienne needed a break. They went to see a film about the Russian Revolution, which Lucienne noted was "authentic with Trotsky and all."[35] Then they went to the Polish neighborhood and shopped around, going into Frida's favorite five-and-dime stores. Lucienne was amazed by Frida's powers of observation: "Suddenly she would stop and buy something immediately. She had an extraordinary eye for the genuine and the beautiful."[36] Walking through a dime store with Frida was like following a "tornado": she moved swiftly through the aisles picking things up that pleased her. "She'd find cheap costume jewelry and she'd make it look fantastic," remembers Lucienne.[37] Often Frida shared her finds with friends.

Frida's powers of observation applied to people and situations as well. During lunch at an Italian restaurant, Frida told Lucienne she should start taking photographs of the mural right away since "rash" things could happen at any time. The atmosphere at the RCA Building had changed quite radically. Guards now told the assistants that photographs were forbidden. Luckily, Lucienne had taken a few photographs before the guards started showing up. But she needed more, and so she decided to risk it. She snuck in her camera, hiding it in her overalls. Dimi helped. He placed the light on the Lenin section for the so-called purpose of plastering, but it was really to give Lucienne enough light to take photographs. It felt like "a matter of life and death," she wrote.[38] In as inconspicuous a manner as possible,

Lucienne began lifting her camera and snapping, even as "twenty detectives" walked around with suspicious eyes.[39] She was able to use the large sheets of tracing paper to help camouflage her activities.

On May 9, the police presence doubled. They were everywhere, including in the shack that had been set up for Diego and his assistants on an upper floor. Entry to the shack was now barred to everyone but the painter and his workers. The noose was tightening. The police watched Diego and his assistants' every move. The artists tried to do their work as if nothing unusual were taking place. The assistants took their normal dinner break while Diego stayed to paint. When they returned at six o'clock that evening, Lucienne felt an "electricity in the atmosphere."[40] She looked up to see Frances Flynn Paine staring down from the balcony. Lucienne went up to her to ask "if anything could be done between John Rockefeller, Jr. and Diego."[41] Frances was skeptical, saying it was up to Diego to compromise. Later, while Lucienne was talking to the writer Anita Brenner in the shack, Anita was suddenly ordered out of the building. Soon Frances was asked to leave as well. "It's getting hot," Lucienne whispered to Dimi.[42] The two went to the area where they mixed plaster, stealing a kiss here and there while talking of the future.

Over by the mural, Mr. Robertson, the head contractor, surrounded by men in civilian clothes and uniforms, asked Diego to come down off the scaffolding. He took Diego to the shack and gave him an ultimatum: if he wanted to continue working on the mural, he would have to remove Lenin. When Diego refused, he was handed a check and asked to leave. Then the Rockefellers went into action. The entrance to the building was locked, a thick curtain went up to block any view of the mural, all windows were covered, a large canvas was hung over the mural, and the scaffolding was taken down. Outside, police on horseback stood guard.

Lucienne and Dimi were unaware of what was happening until they saw Diego walking toward them in street clothes instead of his usual overalls. Something was up. "Stop work," he said. "I've been told to stop because of Lenin."[43] Lucienne was furious and cried out in anger. Diego replied in French: "Maintenant c'est la bataille!" (Now it's the battle!).[44] Lucienne began to hear sounds of workmen "coming from all sides with boards and hammers and hectic hammering going on in the lobby." She decided to write on the painted-over windows by scraping off the white paint to spell out "Save Rivera Murals" and "Workers Unite."

The assistant Lou Block started calling the newspapers to alert them, but suddenly the phone went dead. The guards' footsteps grew louder, so the assistants hid. When the assistants finally made their way down to the lobby, Lucienne looked through a line of guards to see the wall covered with boards. She and the others cleared everything off the scaffolding that remained, but Lucienne "threw the paint water all over the floor in disgust."[45] Her heart was broken. The assistants were the last ones out the door. They headed over to the office of Diego's lawyer, Philip Wittenberg. Then they took Lucienne's film to be developed at Fine Grain Laboratory, with the hope that the work could be rushed in order to give pictures to the newspapers. The *New York Times* published a midnight edition with the front-page headline "Rivera Is Ousted as Rockefellers Ban His RCA Mural." Lucienne's photograph of the Lenin section made it into the newspapers the next day, but not on the front page.

Before the sun came up, Lucienne, Dimi, and Nien went to see Frida and Diego at the Barbizon-Plaza. There a group had gathered to discuss the next move. Everyone was fired up—how could the Rockefellers suppress freedom of expression? Frida must have marveled at her father's prediction. Back in March, he'd joked that Frida would stay in the United States until the *gringos* told Diego, "Now Ponciano, go back home, we can't stand you anymore!"[46] But Diego wasn't about to leave without a fight.

He had a plan: he was going to paint murals at "three communist schools for nothing as a reply to Rockefeller."[47] Diego asked his assistants to help him paint these murals on a tight budget. He couldn't do it without them. The assistants made plans to live communally on $30 a month and work collectively as if in a guild. Lucienne thought this was "a new and important step in revolutionary ideals." When they left Frida and Diego's in Nien's Ford, it felt as if they were "at a starting point of something very great."[48]

The next day, however, the high came crashing down with the news of the book burnings in Germany. In thirty-four towns, university students threw books by authors such as Bertolt Brecht, Theodore Dreiser, Ernest Hemingway, and Helen Keller into huge fire pits in order to "cleanse the German spirit." The American Jewish Congress had coordinated in advance huge nationwide demonstrations against the Nazi persecution of Jews. A crowd estimated at between 80,000 and 100,000 marched through New York's streets for six hours. It was the largest protest in New York's

history. Frida and Diego did their part. They attended an exhibition featuring Lionel Reiss's Jewish portraits, works intended to present positive, lifelike images of Jews in opposition to Hitler's anti-Semitic propaganda.

Five days later, Columbia University students protested the firing of economics instructor Donald Henderson because he was a Communist. A black-draped coffin was labeled "Here Lies Academic Freedom."[49] Diego and Frida attended, with Diego speaking to the crowd, encouraging them to "unite, because you are the workers of tomorrow."[50]

The Rockefellers were probably relieved that news of the book burnings in Germany and protests in the United States dominated the papers and radio, making their firing of Diego less noteworthy. But this didn't mean the mural controversy was over. On May 27, the *Literary Digest,* an influential weekly newsmagazine with a circulation of over a million, ran a story on the mural controversy alongside a story about Germany's book bonfire, simultaneously connecting the two controversies in the public's mind. The article "Rivera in Hot Water" proclaims the *mestizo* artist an outspoken critic of oppression and exploitation in an attempt to create a new, inclusive art, one that will "advance civilization."[51] The article on the book burning concludes that the "Nazis deliberately and systematically mean to turn the minds of the German people to preparation for war."[52]

Frida and Diego were determined to become outspoken critics of fascist oppression. Frida worked hard to help get Diego's words translated into English. An Associated Press photograph of them taken after the firing shows Frida, dressed in a simple Mexican-style dress and choker necklace, seated at a typewriter, fingers on the keys, expression focused; Diego sits next to her holding a letter as if dictating. They look calm, but the ashtray on the side table filled with cigarette butts hints at the tense situation. Frida, proud of her active role, sent a copy of this photograph to her family back home.

They were impressed by Diego's bravery but worried about his and Frida's safety. The Mexican press was filled with stories about Diego's battle with one of the most powerful men in the United States. "The newspapers say a lot of things but usually they are just gossip. . . . I've noticed with sadness that Diego looks very deteriorated, maybe it's because of the diet; also, all the dirty tricks they've played on him must be very disheartening. I feel for you with all my heart, for I understand how hard this time must have been with Diego," wrote Adri.[53]

The battle was still on, but the Rockefellers remained silent. Rumors circulated that it was all a publicity stunt on Diego's part to attract attention for his proposed mural at the Chicago World's Fair, work on which was scheduled to begin on May 27. Diego hadn't even sent the sketch to General Motors for approval, but he had decided to make "it more radical than first intended."[54]

The phone in Frida and Diego's room began ringing off the hook. Friends were inquiring: *What's going on? Have you spoken to Albert? Have you heard if your mural is going forward?* Albert Kahn, the architect in charge of the General Motors pavilion at the fair, sent Diego a telegram saying how angry he was at him. Diego replied that "it had been due to the mistake of one assistant and that he was sorry as the assistant was Ben [Shahn]," according to Lucienne, who sent the telegram.[55]

The white lie didn't work: Diego lost the Chicago mural as well as the one in Minneapolis. But he "was not fazed." With the $14,000 the Rockefellers had paid him, Diego set out to find a new location for his retaliation murals. Instead of the three Communist schools he had mentioned earlier, he chose the New Workers School, "a rickety loft building between Fifth and Sixth Avenues on Fourteenth Street," Lucienne recalled.[56] It was the headquarters of the Communist Party (Opposition), started by Jay Lovestone, a former Communist Party member who had been kicked out for deviating from Stalin's militant stances. With the new location secured, Diego began doing research with Bertram for his twenty-one-panel *Portrait of America,* beginning in colonial times and extending up through 1933.

Diego's focus on his new murals didn't mean the heat was off on the RCA controversy. A United Front meeting was held at Columbus Circle, and all the leftist groups were given ten minutes to make a speech. They decided to surround the RCA Building holding up picket signs. Diego's assistants worked hard on theirs: "We Assistants of Diego Rivera Demand the Right to Finish Our Work." When they all went to the RCA building with their signs, the crowd wound around the building. Police watched closely as the protesters picketed for an hour, yelling "Freedom in art." Lucienne wrote in her journal how moving it was to see that "one woman watching on 6th Avenue had tears in her eyes."[57]

The newspapers and magazines were still covering the story. Protests, op-eds, images, an E. B. White poem, and Diego's willingness to discuss the matter in public lectures or with newspaper journalists kept the controversy

alive. Frida did her best to add to the brouhaha. She brought out her mischievous side when reporters visited the couple's hotel suite for a story on Diego. According to Lucienne's sister Suzanne, Frida was "lying in bed sucking on a long stick of candy" as if she were a child.[58] Then she slyly hid the phallus-shaped stick under the covers. When reporters began to ask her questions, she slowly lifted the blanket with her candy stick, as if she had an aroused penis, maintaining a straight face the entire time. Frida delighted in making the reporters uncomfortable.

Geraldine Sartain for the *New York World-Telegram* described her as "the comely young wife of the artist," a "girlish Spanish type, olive skinned, doe-eyed, lithe, slender."[59] Frida was quoted as saying:

> The Rockefellers knew quite well the murals were to depict the revolutionary point of view—that they were going to be revolutionary paintings. They seemed very nice and understanding about it and always very interested, especially Mrs. Rockefeller. We were their guests at dinner two or three times, and we discussed the revolutionary movement at great length. Mrs. Rockefeller was very nice to us always. She was lovely. She seemed very interested in radical ideas—asked many questions. You know she helped Mr. Rivera at the Museum of Modern Art and really battled for him.[60]

With the mural space at the New Workers School arranged, Frida began packing up the Barbizon-Plaza Hotel room at the end of May. The plan was to move into a spacious two-bedroom apartment downtown, and Frida gave her family the new address: "8 West Fourteenth Street."[61] The apartment, Lucienne thought, was "the swellest place." It was near a dime store and a "wonderful place for her [Frida] to paint."[62] Frida felt more at home in this less affluent area and in a building without a doorman.

By the time Frida and Diego moved at the beginning of June, the weather was hot and steamy. With windows open and daylight beginning to get longer, Fourteenth Street was buzzing day and night with a cacophony of sounds: radios, firecrackers, banging car doors, footsteps, street musicians, the clinking of pennies thrown into cups, and many voices—some speaking in Italian, some in Yiddish, and some in English with strong Irish accents.

Once Frida was settled in the new apartment, she found a maid to help with the cooking and cleaning. This allowed her to focus on painting and political activities. In June, Frida finished her *Self-Portrait with Necklace,* which she'd begun in Detroit. In this work her new confidence and talent as a painter are evident. There's a marked change from the young bride seen in her two earlier self-portraits created in Mexico. Frida presents herself closer up, emphasizing the naturalism of her facial features—hair parted and pulled back, small forehead, rouged cheeks, red lips to match, mustache, deep brown eyes, and thick black eyebrows. She is alluring, strong, and beautiful, with androgynous touches. Her outfit, like her face, presents contrasts: heavy Aztec jadeite beads over a plain white top with delicate lace adorning the scoop neck. Unlike in her previous two self-portraits, in this one she doesn't idealize herself.

In this way, her self-portrait is reminiscent of Paula Modersohn-Becker's *Self-Portrait with Camilla Twig* (1907). Frida had seen this painting when it was shown at MoMA's "German Painting and Sculpture" exhibition two years prior. Modersohn-Becker's self-portrait possesses a bold confidence. With thickly applied paint and obvious brushstrokes, she shows herself standing in front of a light blue curtain looking out with large, penetrating eyes, hair parted and pulled back, red lips pursed, wearing a plain ivory-colored scoop-neck top and thick beads around her neck.

Although Frida's thinly applied paint and naturalistic style are different from Modersohn-Becker's, both women were "courageous and combative," as the poet Rainer Maria Rilke said of Modersohn-Becker after her untimely death.[63] Both women wanted to create images of themselves that didn't conform to tradition, so that "someday there will be girls and women whose name will no longer mean the mere opposite of the male," as Rilke wrote about his friend.[64]

In the catalog for MoMA's "German Painting and Sculpture" exhibition, which Frida owned, a brief bio of Modersohn-Becker states, "She was one of the most advanced and promising painters in Germany,"[65] and it noted that two houses had been converted into galleries devoted to her memory. It must have been inspiring to learn about this fellow female painter of portraits and self-portraits who had been daring and successful in her short life. Given Frida's personal understanding of the close, intimate relationship between life and death, the knowledge that Modersohn-Becker had died eighteen days after giving birth in 1907, the same year she made

the self-portrait on display, would have affected Frida on a deep level, especially because it is the same year Frida was born. In some cosmic way, it was as if Modersohn-Becker's death gave birth to Frida.

In Frida's *Self-Portrait with Necklace,* she presents herself as a strong, proud Mexican woman. Only the month and date written on the front convey that she made it while living in the United States. Ironically, some sixty years later, this painting became associated with the United States, as it was reproduced on American postage stamps.

My Dress Hangs There is just the opposite: it's clear she was inspired by New York and the explosive times. Frida's new apartment was spacious enough for her to have her own studio, especially while Diego was busy researching his new mural subject: U.S. history. In *My Dress Hangs There,* Frida also focuses on U.S. history, but one in the making, with her collaged images taken from newspaper photos of soldiers, people in breadlines, unemployed workers asking for help, and protesters. Frida's newspaper photos create a vast sea of crisscrossing lines of actual people. She provides a record of events, as if pasting the clippings into a scrapbook, only with the eye of an artist.

Her simple dress, hanging just above the protesters, conveys her allegiance with what President Roosevelt called the "forgotten man." The disembodied dress evokes both the freshly washed dresses drying on lines outside the Lower East Side tenements and the "forgotten woman." Frida knew quite well how hard women worked, both inside and outside the home, receiving in return little pay, little appreciation, and no platform from which to voice their grievances. When she completed the painting back in Mexico, she changed her dress to that of the Tehuana style her mother grew up with, making it a more obvious symbol of a strong indigenous Mexican woman.

Even in Frida's day, it was the Tehuana women, not the men, who controlled the markets in their region. And where does Frida place her Tehuana dress? In the financial district of New York, in front of Federal Hall, a statue of George Washington, and a graph showing "Weekly Sales in Millions." This important spot, where George Washington took the oath of office of the presidency and where the first Congress, Supreme Court, and executive branch offices were located, is the seat of greed in Frida's

New York. With the wealthy getting wealthier and the poor getting poorer, Frida seems to be saying, perhaps it's time for women to have more control over finances in the United States, like the Tehuana women back home. Yet the dress is empty.

The powerful Frida seen in *Self-Portrait with Necklace* has vanished. The empty dress becomes a dual symbol of the financial independence and strength of the Tehuana women, on the one hand, and the voiceless women with little or no political power, on the other. American women had only won the right to vote thirteen years earlier, and Mexican women would not be able to vote until 1953.

Even the church, that institution at the center of so many women's lives, couldn't empower them. Trinity Church, standing next to Federal Hall, is implicated in the imbalance of wealth. Frida ties a maroon-colored ribbon from the church tower down to one of the columns on Federal Hall, and she's placed a red snakelike line along the cross in the window, making it look like a dollar sign. Diego too included the spire of Trinity Church in his street scene of protesters, but Frida clearly ties it to corruption and finance.

A Mae West billboard blocks part of the church façade, a reminder of how she outraged moralists with her suggestive banter. The ribbon Frida's dress hangs on is connected to a toilet up high on a pedestal; the toilet seat touches the Mae West billboard. Perhaps it's an inside joke implying that Mae West and Frida both had "potty mouths." Another visual link between the women comes in the similar maroon color seen in both the Tehuana dress and West's dress.

Frida loved Mae West. She'd seen her film *I'm No Angel,* where West plays a circus lion tamer who makes it big on Broadway while hustling wealthy men, all with the classic Mae West racy double-entendres, bawdy wisecracks, and slinky body language. A poster for *I'm No Angel* says, "Goodness has nothing to do with it! She has lost her reputation . . . but never missed it!" Before the establishment of the strict Motion Picture Production Code, Mae West could get away with saying: "When I'm good I'm very good. But when I'm bad I'm better." She was a woman after Frida's heart. (And she appealed to Diego as well. He commented that West was "the most wonderful machine for living I have ever known—unfortunately on the screen only.")[66] Despite Frida's admiration for West, however, the billboard she dominates in the painting is deteriorating, with its edges

peeling back. And she's above a burning building with red flames and blue-black smoke rising up near her.

The classical-looking building going up in flames calls to mind the burning of the German Reichstag. A 1933 *Variety* blurb compared Mae West to Hitler, saying, as the "biggest conversation-provoker," Mae West was "as hot an issue as Hitler."[67] It would be just like Frida to take a quote like this and spin it into a provocative, layered image. Mae West was hot, meaning both alluring and threatening; she would be especially threatening to someone like Hitler, who would not have approved of her independent spirit. Likewise, the hot issue at that time was Hitler's attempt to take full control of the German government by blaming the Reichstag fire on so-called hostile Communists who he claimed were planning a takeover. In a sense, they were both provocateurs, but while West was bucking gender norms, Hitler was attacking the rule of law.

Lucienne had asked why all the foreign countries weren't against Hitler. Frida had asked Abby Rockefeller if everyone in New York was discussing technocracy like they were in Detroit and everywhere else, and what was going to happen to the planet? William Dodd, the U.S. ambassador to Germany, was alarmed that American companies were doing business with the Nazis, writing President Roosevelt: "Standard Oil Company (New York sub-company) sent 2,000,000 here in December 1933 and has made $500,000 a year helping Germans make Ersatz gas for war purposes . . . I mention these facts because they complicate things and add to war dangers."[68] As it turned out, the Rockefeller-owned Standard Oil of New Jersey also provided "vital ethyl lead gasoline to Nazi Germany—over the written protests of the U.S. War Department," writes historian Antony C. Sutton.[69] Without this fuel, the Nazis, who "began secretly and illegally building the Luftwaffe in preparation for the next war," would not have been able to fly their planes, says journalist Robert Sherrill.[70] Yet Standard Oil of New Jersey supplied the needed process for manufacturing the gasoline to I. G. Farben, a chemical manufacturer that supplied the Nazis with poisonous gas as well as aviation fuel.

Could this be one reason Diego emphasized poisonous gas with soldiers wearing gas masks while planes fly overhead in his RCA mural? His *Modern Industry* panel for the New Workers School mural touched even

closer to I. G. Farben by showing how poisonous gas gets made—in a lab by scientists. Taken together, these two scenes from different murals convey the relationship between the science lab and the battlefield, a necessary link for the Germans in the buildup to World War II and the extermination of Jews, homosexuals, Gypsies, and anyone deemed "degenerate."

In Diego's RCA mural, he took a rather direct dig at John D. Rockefeller Jr.'s devout Baptist teetotaler image. He made one of the men drinking and cavorting with women in the speakeasy scene resemble John D. Jr., a resemblance Diego turned into a portrait once he re-created the mural back in Mexico. David Rockefeller, Nelson's brother, said: "The final provocation may have been an ad hominem attack on my father."[71] Diego took it a step further when he placed spores, germs, and cells in the ellipsis above Rockefeller's head—specifically, the microorganisms responsible for syphilis, gonorrhea, gangrene, and tetanus. Joe Lilly in his inflammatory article made the connection for the Rockefellers, writing: "Germs of infectious and hereditary diseases [are] so placed as to indicate them as the results of a civilization revolving around nightclubs."[72] A eugenicist would view someone infected with a sexually transmitted disease or a hereditary one as "undesirable." Perhaps this is one reason John D. Jr. wrote to his father saying that the RCA mural was "obscene and in the judgment of Rockefeller Center, an offense to good taste."[73]

The younger John D. Rockefeller had been in favor of Prohibition until 1932, when he decided to withdraw his support for the Eighteenth Amendment due to the disrespect people showed for the law. One law he did support, which had been upheld by the U.S. Supreme Court in 1927 in *Buck v. Bell,* was forced sterilization of those deemed "undesirable." The Rockefeller Foundation was a major financial supporter of the eugenics movement, specifically funding research institutes such as the Eugenics Record Office in Cold Spring Harbor, New York, which gathered information, both biological and social, on Americans to investigate heredity and prove that some races were superior to others. The Kaiser Wilhelm Institute for Anthropology, Human Heredity, and Eugenics in Berlin was conducting similar experiments in the 1920s, and the Rockefeller Foundation also provided funding to this German institution until 1939.[74]

Frida's concern about the technocratic model and its possible abuses was prescient because such a model took hold in Germany within months of Hitler's rise to power. The Kaiser Wilhelm Institute, under the Nazis,

became an incubator for creating an Aryan master race. This scientific research center would now participate in "mass sterilizations in the interest of 'race hygiene' . . . the 'euthanasia' campaign, the persecution and annihilation of Jews, Sinti, and Roma, and the plans for a new ethnic order in occupied Eastern Europe," writes scholar Hans-Walter Schmuhl.[75] The institute was an example of "a technocratic model," with political aims driving the pseudo-science of eugenics.[76] And in this period, when there were no formal scientific ethical standards or institutional review boards to ensure that human research subjects weren't harmed, the abuses were grave. When Frida asked Mrs. Rockefeller if everyone was talking about technocracy in New York, did she know the Rockefeller Foundation was a major donor to one of the largest institutes promoting this technocratic model?

Diego's *Modern Industry* and *World War* panels, painted side by side at the New Workers School, suggest that she and Diego were aware of the close connections between wealthy businessmen like John D. Rockefeller Jr. and the complex business of a technocratically driven war. In *Modern Industry,* images of car magnate Henry Ford, inventor Thomas Edison, and financier J. P. Morgan are in the foreground, while in the background the "biological laboratory is developing war surgery," writes Bertram Wolfe.[77] John D. Rockefeller Jr.'s arm reaches into the *Modern Industry* panel to crank out money. His face and upper body, however, are in the *World War* panel. Behind his face are horrific images of war: emaciated figures, melted and deformed faces, Communists behind bars, and dead women and children with blood running down their faces. Just above Rockefeller's prominent visage is a placard that reads: "Smash Rockefeller Serfdom!" Just above this placard is another sentence: "Colorado Fuel and Iron, Ludlow," a reference to one of the deadliest clashes in the United States between corporate power and striking workers. John D. Rockefeller Jr., who owned the Colorado Fuel and Iron Company, had been criticized for ordering what came to be known as the Ludlow Massacre of 1914.

Diego's murals at the New Workers School were using the "history of the United States to build a case for Communism and to warn how disunity could facilitate the advent of Fascism," writes art historian James Wechsler.[78] In a panel featuring Hitler, Diego brings home the destructive power of this fascist leader, who is seen in profile with arms raised, mouth open, and yelling into a microphone, as Nazi flags and the military fill

up the upper left portion of the scene. People and SS men crowd around Hitler, with one woman wearing a sign roped around her neck that says: "I have given myself to a Jew." Albert Einstein, who fled Nazi Germany, is seen as well. Just below Hitler's open mouth, a "Nazi doctor [is] performing sterilization surgery," according to Wechsler.[79]

Diego admitted: "I want to be a propagandist."[80] The stakes were too high for him not to be one. It wasn't just payback time for John D. Rockefeller Jr. While Rockefeller's action regarding the RCA Building mural had been the impetus for the New Workers School murals, the rising Nazi stranglehold, coupled with Diego's own mindset, inspired murals that became more obvious in their critiques. At the time, Albert Einstein praised Diego's murals. As someone who had just fled Nazi Germany, he understood the need to use a megaphone, whatever the medium, to wake people up.

Frida's *My Dress Hangs There* is a political painting, but unlike Diego's New Workers School murals, there is no obvious message. With images of George Washington, the Federal Building, the Stock Exchange chart, and the Statue of Liberty, the painting takes up the question of whether the United States is living up to its founding values of democracy and liberty, questions Frida had asked in *Window Display on a Street in Detroit* two years earlier. Since then her sophistication as a painter had become striking. She'd come a long way with her ability to organize a vast array of objects, and she'd experimented with the medium of collage in her painted city scene. Frida, whose lion stand-in projected a silenced roar in *Window Display on a Street in Detroit,* had found her artistic voice. Her fiery spirit was channeled into a painting that, though not obvious, depicts a no-holds-barred critique of New York, the capitalist heart of the United States, the place where the Rockefellers held sway.

For the rest of June and into July, Diego and Frida's relationship showed outward signs of trouble, with Diego often in a cross mood. One day when Diego came to paint, the plastered wall was "soaking."[81] He flew off the handle. To blow off steam, he began chatting up Louise Nevelson, a young woman he had met through their mutual friend Marjorie Eaton. "He saw her [Louise's] greatness," Marjorie remembered.[82] This was huge. Louise was in a transitional period of her life. She'd made the bold decision to leave her husband and son for art. Marjorie, an artist herself, explained

how Louise needed a place to live and paint, so Diego invited both women to move into a first-floor studio that was available in the building where he and Frida were living. He also invited the two women to join him as mural assistants.

In mid-July Frida came to the New Workers School for the first time, managing to make it up the steep stairs. She wanted to see Diego's murals. Lucienne noted the difference in style; the new mural was very detailed, and she wrote, "I can't understand how he is going to continue in this style which is no style."[83] Perhaps Diego felt the same way. He began to show up late, sometimes as much as six hours late, or even failed to show up at all. What happened to the battle? Yay thought it had been diluted by Diego's interest in Louise, the new girl. Louise told Yay that Diego "likes [me] very much."[84] The next day Yay confirmed that "Diego was having a real affair with that fool Louise."[85] This irritated Lucienne: "She probably thinks Diego will fall for her seriously—become the wife of a famous man. But such a stupid woman can't ever have a real hold on him. Frieda is too perfect a person for anyone to have the strength to take her place."[86] Frida, who had just turned twenty-six, received what must have felt like a slap in the face from Diego for her birthday. "I feel so bad for Frieda," Lucienne wrote.[87]

Louise was no fool. She understood the importance of making contacts with influential artists, and she was thrilled to be in this famous, charismatic man's orbit. "He [Diego] was one of the most unique men in the world. . . . He was brilliant but not too analytical . . . and he wasn't bound by anything," Louise said.[88] This openness impressed Louise, who enjoyed socializing at Frida and Diego's place, where people from all walks of life were to be found. Their apartment, Louise remembered, "was always open in the evening, and anyone who wanted to would come."[89]

Perhaps Louise mistook Diego's disregard for boundaries as a signal that Frida wouldn't mind if her husband had an affair. According to Louise's sister Lillian, Louise adored both Diego and Frida. Yet Marjorie Eaton relays a story that conveys either Louise's naïveté or her callousness. "He [Diego] really loved Louise and took her to a trading post in the Village where he would buy her jewelry, which she would then pass along to Frida."[90] Louise also left her mark by giving Diego a German Expressionist–style portrait she'd painted of him. At this time she was just getting her feet

wet studying at the Art Students League and the Hans Hofmann School of Fine Arts. But some twenty years later she'd have her big break, making a name for herself as an innovative sculptor and installation artist.

Diego became wrapped up in Louise's intense energy. It was as if she invigorated him during these hot days in late summer. As one humid day turned into another, Frida often stayed in the bathtub until the sun went down, while Diego showed up sporadically to paint. Sometimes he trudged up the stairs holding his chest because his heart hurt. His foul moods continued. When a bit of lime dropped on J. P. Morgan's painted face, making a streak, Diego flew into a rage, calling Dimi "the most awful names."[91] Diego phoned Frida and said: "The best thing I ever did was destroyed by my assistants."[92] Lucienne was amazed, commenting, "He never used to be like that."[93] Dimi felt awful.

By August, with the heat reaching 100 degrees, Lucienne's father, Ernest, came to the New Workers School to meet Diego and Frida. He was "knocked completely down by the greatness of the work as well as Diego's simple ways and strong quiet while working."[94] Frida and Diego were invited to hear Ernest Bloch's *Avodath Hakodesh* (Sacred Service), a fifty-minute score for baritone, mixed chorus, and orchestra that he'd based on a Sabbath morning service using the Reform version common in the 1930s. Ernest, who grew up in a devout Jewish household in Switzerland, felt he could only write vital and significant music if it expressed his Jewish identity, something under attack at this time. The score was performed at Steinway Hall in Midtown Manhattan. Without air-conditioning in the hall, the dense humidity, like the baritone of the cantor, filled up the space. Frida and Diego could hardly stand it—they "seemed utterly bored."[95] Afterward, though, the mood grew lighter when they all had "sodas with Gershwin."

The composer of *Rhapsody in Blue* was "tickled" to meet the controversial Diego. George Gershwin was a painter himself. His bachelor pad on Riverside Drive and Fifty-Seventh Street was filled with paintings—on the walls, standing up against furniture, facing out, and turned over. He had something else in common with Diego: a desire, as he said, to turn "every attractive female visitor into a model."[96] And, like Diego, he was a man of the Machine Age, believing that almost everything had been influenced by

it. Gershwin spoke to Diego about his art collection, including his favorite Georges Rouault, and Diego, Lucienne noticed, perked up. "Diego was all sweet as he was not opposed to help Gershwin add to it [his collection] by selling him some of his stuff."[97]

A few days later, Lucienne went to see Frida at her apartment. Frida was not feeling well—"Her foot felt paralyzed"—so Lucienne stayed with her until one in the morning, reading aloud from William Henry Hudson's novel *Green Mansions: A Romance of the Tropical Forest*.[98] This love story was overly escapist for Lucienne, who felt there was "too much happening in the world right now . . . to seek shelter in fantasy."[99]

The New Workers School was bustling with meetings and talks, so Lucienne, Frida, and Diego could stay up-to-date on the latest news, including the dressmakers union strike. Also, the American Federation of Labor was organizing workers, and Jay Lovestone was speaking about what he'd seen on a trip to Europe and how bad it was for Communists under Hitler. At the end of September, Lucienne was invited by Lovestone to give a talk at a meeting about the strikes taking place.

In that same month, Frida and Diego moved once again, this time to the fourteenth floor of the Brevoort Hotel, on Fifth Avenue at Eighth Street. From here, they could see the top of the new Empire State Building. But even the Machine Age brilliance of this iconic building couldn't energize Diego. Instead, he wallowed in indecision. Diego wouldn't admit it, but he'd been deflated by Rockefeller's dismissal and the cancellation of the other murals. Back in Mexico, he had a wall at the medical school waiting for him.

Maybe he should just leave and go back home, he thought. On the other hand, maybe he should finish the New Workers School murals. His relatively ordered life when painting at the RCA Building had devolved into chaos. Money was running out, and the affair he was having with Louise caused Frida emotional pain, which intensified her physical difficulties, including foot paralysis and fainting spells. Frida tried to counterbalance her husband's chaotic lifestyle and unpredictable moods with domestic routine and her honest opinions. But the Diego who had reveled in his wife's antics now bristled when she used her brazen attitude with him, especially when he knew she was right.

Fights erupted, and during one particularly heated exchange an agitated Diego pulled out a kitchen knife and slashed to shreds one of his oil

paintings of cacti in a Mexican desert. Lucienne tried to intervene and save the canvas, but Diego looked "mad and menacing."[100] Frida warned her to stay back: "He'll kill you."[101] Lucienne and Frida were horrified, but Diego just put the ripped-up shreds of canvas into his pocket and walked away. Lucienne cried out to him in several languages: "*Salo imbécile*, idiot!"[102] They feared he would "do something rash to himself," and indeed, they had reason to fear the worst. This was not the first time Diego had looked "mad and menacing." Friends like Ilya Ehrenburg, who had known Diego back in Paris, said he suffered from "spectacular fits," resulting in his eyes rolling up, "foaming at the mouth," chasing people with sticks, and taking off into the night.[103]

Frida "trembled all day and couldn't get over the loss of the canvas. She said it was a gesture of hate toward Mexico. He feels he must go back there for Frida's sake because she is sick of New York. And she tells me that she doesn't care to go back but must support this as the alibi as Diego cannot make up his mind," Lucienne confided to her journal.[104]

That evening Diego returned "crestfallen." At least he had returned; many nights he stayed away, finding solace in Louise's bed. On the nights he didn't come home, Frida called Lucienne to ask her to drop by. If she was busy, Frida would call Lucienne's sister Suzanne and say, "Oh, I hate to be alone! Please come and see me."[105] One time when Suzanne visited, Frida busied herself making little puddings for Diego to have when he finally returned home. Maybe Frida imagined that occupying her time with cooking for Diego could hide the harsh reality of his infantile behavior. But she wasn't always good at hiding the truth in her art.

In a bust-length self-portrait using the fresco technique, Frida created an inverted image of *Self-Portrait with Necklace*. With her head slightly turned in the opposite direction of her previous painting, Frida depicts herself in a mirror image, even down to wearing a beaded necklace. It's stunning, however, to look at these two women side by side. The oil painting shows a strong, self-assured Mexican woman; the fresco portrays a decimated soul, her eyes devoid of life. Frida felt the need to write around the fresco image things like "Very ugly," "Absolutely rotten," and, in Spanish, "No sirve" (it doesn't work). Then, out of disgust, she dropped the work on the floor. A piece broke off, but Lucienne, always Frida's greatest champion, salvaged the remaining fresco; she and Dimi thought it beautiful.

Frida was hard on herself as an artist. This was modeled for her by her

father, who was the same way. When it came to nurturing his daughter's talent, Guillermo could praise Frida's paintings as beautiful, but he could also offer severe criticisms of her photographs and paintings. In one letter he wrote concerning some photographs she'd sent of New York, "I beg you, don't send me any more garbage like that because they are so ugly and harsh they are not fit even as toilet paper."[106] Interestingly, Frida used the word "ugly" to describe her fresco, and she included a garbage can and a toilet in *My Dress Hangs There*. In another jab, Guillermo wrote asking Frida to estimate how long it would take her to travel to Mexico by foot, stating, "It wouldn't be a bad idea if in your spare time you made an estimate (but well done of course, not like your paintings)."[107]

Guillermo once said he thought Frida was the most like him of all his children, and in his blunt brutality he treated her as he treated himself. He often bemoaned his inability to control his temper, negative moods, and melancholy, stating: "I slap myself for all the stupid things I did and still do, but all I get is the certainty that I've been a blockhead my whole life!"[108] In this unhealthy mirroring, Guillermo at times emotionally whipped himself and his daughter as if there were no separation between the two. A similar dynamic existed in Frida's relationship with Diego, who admitted that the more he loved a woman, the more he mistreated her.

It's fitting that during the chilly month of December, as Frida and Diego were winding down their stay in the United States, Lucienne was reading D. H. Lawrence's *The Plumed Serpent,* set in warm Mexico. Lawrence, one of Frida's favorite authors, had lived in Mexico back in the early 1920s, where he saw the impressive ruins of Teotihuacan. Quetzalcoatl, the plumed serpent, is carved on the side of one of the pyramids there. In Lawrence's novel, the rediscovery of the pre-Hispanic religion of Quetzalcoatl, with its emphasis on duality, transforms the beleaguered Mexican people. The feathered serpent in the earth is described by Lawrence as the "snake of the fire," "coil like gold," rising "like life."[109] Lawrence also uses alchemical oppositions, such as fire and water or quicksilver and gold, to convey the differences between men and women, as well as the potential for balance.

This spoke to Frida and Diego's relationship, which was filled with tension due to Diego's indecision about his future and his flagrant affair with Louise. Could they find their way back to a state of balance? In art,

they could find a meeting point: Frida uses a red snakelike form in the window of Trinity Church to double as a dollar sign (profit over everything else) that has become too important to the rich. Diego in his New Workers School *Modern Industry* panel shows a horrific scene of a black man with distorted serpentine legs hanging from a rope and going up in flames while a crowd watches, including three wearing Ku Klux Klan hoods, in front of Trinity Church, the Armory, the Federal Court Building, and the Federal Reserve Bank. In both paintings, snakelike forms seem to convey the painful reality that religious, judicial, and financial institutions are complicit in securing their profits over human life. But, from the perspective of the dual-natured Quetzalcoatl, there's hope that the opposite can prevail.

In Frida's *My Dress Hangs There,* water and fire are foregrounded. Water is seen above the city, with a building on fire and the entire Wall Street area caught up in a tense, fiery protest. The Statue of Liberty presides over the cool waters. She's needed to help bring balance back to the United States. The boat coming into New York Harbor symbolizes the *Oriente,* which Frida and Diego boarded on December 20, 1933, to head back to Mexico. Would the cool waters be enough to restore balance to Frida and Diego's fiery relationship?

Frida couldn't answer this question. All she knew was that she left Gringolandia a different person than when she'd arrived. And she'd created her best art. She may have had her gripes with the United States and she may have suffered the trauma of a double death in Detroit, but it was the place where her creative spirit broke through to new heights, allowing her genius to soar. As Lawrence aptly observed: "All art partakes of the Spirit of Place in which it is produced."[110]

Epilogue

 When Frida and Diego returned to Mexico, their relationship continued to unravel. Diego had a huge light-filled studio to return to, but his mood was anything but light. He was even more sullen and irritable than in New York. It didn't help that a little over a month after they'd returned, Diego's Rockefeller Center mural, which was supposed to be taken off the wall and given to MoMA, was destroyed. Seven months later, he still hadn't touched a brush, and he blamed Frida, as she related to her friend Ella Wolfe: "He thinks everything that is happening to him is my fault, because I made him come to Mexico."[1]

Diego vented his anger at Frida by having an affair with Cristina, Frida's younger sister, whose marriage had ended. It became more than a casual fling. Until the end of Frida's life, it was a three-way relationship, with amorphous boundaries and Cristina playing many roles to Diego and Frida. Diego made sure Frida felt the knife of betrayal enter her heart, uttering these brutal words: "Look, the one I loved was your sister; you were just the doormat of my love."[2] Isolda, Frida's niece, acknowledged: "Whenever he quarreled with Frida, he could be very abusive with words."[3]

Initially Frida sank into a depression, coupled with anxiety. "I can no longer continue in the very great state of sadness that I was in, because

I was heading with large strides toward a neurasthenia of that horrible type that makes women turn into idiots and *antipáticas* [nasty people] and I am even happy to see that I was able to control the state of semi-idiocy that I was in," she wrote Dr. Eloesser.[4] Frida's characterization of neurasthenia turning women into idiots and nasty people conveys the extent to which women's mental health issues were denigrated, with women often dismissed as "hysterical."

Frida wanted to distance herself from this stigma, though her intense emotional response to the ongoing betrayal by her husband and sister was understandable. But even her friend and confidant Dr. Eloesser had used the term "hysterical screams" to refer to Frida's response to Diego's affairs. And Diego himself had said that he was pleased Frida's early paintings did not merely copy other artists' styles such as Best-Maugard's use of decorative patterns, which were "preferred by hysterical old women who confuse painting with the impossible aspirations of a uterine complex." These words, uttered by two of the men Frida felt closest to, convey the extent to which even open-minded, bohemian men were susceptible to gender bias. Frida, like Georgia O'Keeffe two years earlier, felt demoralized. She too lost her creative spark and was unable to paint for a year.

In a world where men were perceived as more rational and sane than women, Frida struggled to find some sense of emotional balance. Ultimately the pain was so great that she fled to New York for several months. After some distance and time with Lucienne Bloch and Ella Wolfe, she came to a decision. She wrote Diego in the summer of 1935 and told him: "At bottom *you and I* love each other dearly."[5] Despite Diego's "liaisons," Frida said, she was content knowing that Diego loved her.

Her contentment isn't obvious in the art she produced once she returned to Mexico from New York in 1935. But she obviously found her creative footing again. Between 1935 and 1940, Frida made some of her best work, incorporating many of the elements she'd begun utilizing while in the United States. And she finally painted the bloodiest thing she could think of. *A Few Small Nips* (1935) is harder to look at than *My Birth*. The violence is explicit as a dead and bloodied nude woman lies on a bed. Frida has transformed a place of intimacy and quiet slumber into a house of horrors. It's obvious who has repeatedly plunged a knife into this woman. The murderer stands over her, smirk on his face, bloodied knife in hand, as if proud of his actions. His look of satisfaction makes the murder creepy,

sending chills to every nerve in the body. To emphasize the violence, Frida splattered red paint onto the unfinished wood frame of the painting. She doesn't allow anyone to walk away without feeling the terror of what it's like to live in a world where women are devalued so much that a drunken boyfriend can brutally murder his girlfriend and defend himself in court by saying, "But I only gave her a few small nips!"—something Frida had read about in a newspaper account.[6]

Frida responded to this statement by creating a tension between this absurd declaration and its brutal consequences. *A Few Small Nips* is about this man's murdered girlfriend, but it's also about Frida's own horrendous pain and the pain of all women. Frida told a friend she painted the murderer with a look of satisfaction "because in Mexico killing is quite satisfactory and natural."[7] The woman in *A Few Small Nips* is an example of the completely "defenseless" *chingada,* the one who is ripped open and lacerated by the *chingón,* as Octavio Paz explains. The personal connection Frida felt with the painting is evident in the way she hung it in her studio and reworked it over the years—adding the stocking and shoe on the woman's leg, changing the frame to a wooden one, painting blood on the frame, putting stab marks in the frame, and leaving the knife sticking out of it.

When interviewed a few years after making *A Few Small Nips,* Frida told a reporter: "I like to paint blood. I don't know why. Maybe I should be psychoanalyzed." Upon reflection, she added: "The desire to paint blood may come from the year of suffering I spent in bed after a street car crushed a bus I was on during 1926 [sic]."[8] The streetcar accident left Frida's body covered in blood and gold pigment. It was an absurd combination of horrific beauty, but Frida, from Detroit on, became a master at painting horror, beauty, and the tension between the two, often with an eye toward the female condition.

By the time Frida created *Self-Portrait with Cropped Hair* (1940), she'd inserted her own image. Unlike the murdered woman in *A Few Small Nips,* Frida's the murderer. She's not a victim. She sits in a chair dressed in a man's suit, with short tresses. The long strands of hair she's cut off are strewn about the floor like blood. She holds the weapon in her hand: an open pair of scissors, phallus-like. In this act, Frida has acquired male power by cutting off the locks that define femininity. She stares down the "filthy rat race," defying the social norms that define a woman's worth by her attractiveness to men. Paz, who delves into the myriad meanings of the

word *chingar,* elucidates another as connected to Mexican social life. It is an arena of combat, he says, where people are divided into the strong and the weak. Frida places herself within the "male" category of the strong ones. She underscores her acerbic critique of social norms by placing lyrics from a popular song at the top of her painting: "Look if I loved you, it was for your hair. Now that you are bald, I don't love you anymore." *Self-Portrait with Cropped Hair* gives the suit-wearing Leonardo of Frida's youth a voice.

One year earlier, she'd also defied social norms by creating a painting of lesbian love and affection. *Two Nudes in a Forest* (1939) depicts a nude dark-skinned seated woman caressing a lighter-skinned nude woman who is lying in the dark-skinned woman's lap, out in nature with a spider monkey lurking in the foliage. Here Frida creates another work of art that places lesbian desire in nature, conveying what Frida believed—that homosexuality is natural. The painting was a gift to the actress Dolores del Río.[9] The subject of the painting inserts female agency at a time when few women artists possessed the power to speak their truths. Frida had taken a subject "from the margins of the mainstream," as lesbian artist Harmony Hammond put it, and used it "as a site of resistance."[10]

Some of Frida's strength and boldness as a painter, seen in *Self-Portrait with Cropped Hair* and *Two Nudes in a Forest,* came from her rising public profile as an artist. The year 1938 was a magical one for Frida. Her powerful and unique paintings began to attract some attention. At the beginning of the year, Diego encouraged Frida to submit some of her work for a group show at the University Gallery in Mexico City. This exposure led to Julien Levy offering Frida a solo exhibition in November at his gallery at 15 East Fifty-Seventh Street in New York. In April, André Breton and his wife, the artist Jacqueline Lamba, visited Frida and Diego. Breton was taken with Frida's art, proclaiming her a natural Surrealist. This was a label Frida rejected, but being associated with the movement helped her career. In the summer of 1938 Frida had her first major sale. The actor Edward G. Robinson had come to Mexico and was interested in Diego's work. But while Frida was talking to Robinson's wife, Gladys, Diego showed Edward some of Frida's paintings. As Frida recalled, "Robinson bought four of them from me for two hundred dollars each."[11] She was thrilled to have some financial independence.

The money helped fund Frida's trip to New York for her exhibition. This was a major event for a little-known artist. Although American readers

of *Vogue* had been introduced to Frida a year earlier, as part of an article on the "señoras of Mexico," these same readers later learned that this exotic Mexican beauty was more than a fashion icon. A second *Vogue* article, "Rise of Another Rivera," by Diego's friend Bertram Wolfe, presented Frida as a talented painter. Wolfe's article, though important, emphasizes Frida's relationship to Diego with the title, and her portrait of Diego is reproduced to the left of the title. In contrast, the Julien Levy Gallery took the opposite approach. In the press release advertising Frida's show, Diego's name was still referenced, but for a very different reason: "The work of this newcomer is decidedly important and threatens even the laurels of her distinguished husband."[12]

Julien Levy's gallery was a significant place for Frida to have her work shown, as it specialized in modern artists, particularly those with a Surrealist bent. It was the place where Dalí's *Persistence of Memory* had made its first appearance in 1932, two years before MoMA acquired it. While Frida could appear bold in her paintings, she didn't necessarily feel this way about her talent. She confessed to Julien: "I was always shy and afraid to show my things."[13] Yet, through the negotiations involved in planning her exhibition, Frida began to gain some confidence, suggesting to Julien he might want to use a toy airplane she owned as a framing device for her painting *They Ask for Planes and Only Get Straw Wings*. Frida's twenty-five small yet extraordinary paintings must have looked even more exceptional on the undulating walls of the Levy Gallery. Like Frida's art, the curved walls broke with tradition.

On November 1, 1938, Frida, at thirty-one, attended the opening of her first solo show. She gushed to Alejandro that the "crowd here treats me with great affection and they are all very kind."[14] Many art world luminaries, potential buyers, and friends were there, such as Georgia O'Keeffe, Alfred Stieglitz, critic and friend Walter Pach, *Vanity Fair* managing editor Clare Boothe Luce, MoMA curator Alfred H. Barr, MoMA president Conger Goodyear, Columbia University art historian Meyer Shapiro and his sister Mary Sklar, artists Ben Shahn, John Sloan, George Biddle, Nick Muray, and Bertram and Ella Wolfe.

Seeing Georgia again in this context turned Frida into a colleague of the older artist rather than an underling. She'd seen one of Georgia's exhibitions; now it was Georgia's turn to be the spectator. Her presence was significant because Georgia could have easily missed Frida's opening. At

this point in her life she'd been living in New Mexico almost half the time—from mid-July through December—but this year she returned to New York in November, just in time to attend Frida's exhibition. If anything more happened between them during the two months Frida was in New York, there are no known letters to shed light on it.

As it turned out, Frida's show was a critical and monetary success, quite a feat during the Great Depression. After the gallery opening, she sold approximately half of her paintings. There was even a struggle over one painting. Conger Goodyear, who desired a painting of Frida with one of her spider monkeys, called *Fulang-Chang and I,* found to his dismay that Mary Sklar already owned it. He commissioned Frida to make another one for him, which she completed while in New York. Ultimately, Mary Sklar's version ended up in MoMA's permanent collection and Conger Goodyear's at the Albright-Knox Art Gallery in Buffalo, New York. Today MoMA owns three Kahlos—*Fulang-Chang and I* (gift of Mary Sklar), *Self-Portrait with Cropped Hair* (gift of Edgar Kaufmann Jr.), and *My Grandparents, My Parents, and I* (gift of Alan Roos).

Walter Pach wrote a positive review in *Art News* and purchased one of her paintings. Nick bought *What the Water Gave Me,* a brilliant psychological and erotic painting showing Frida in the bathtub from her perspective, leaving us with a view of her legs and feet submerged in water surrounded by symbolic objects; Breton loved it so much he reproduced an image of it in the 1938 Surrealist journal *Minotaure* and his book *Surrealism and Painting.* He also wrote the essay for the Levy exhibition catalog.

It was fitting that Nick owned the painting of Frida in the water surrounded by a plethora of "bath toys," each one a clue that, if deciphered, could elucidate the depths of his lover's soul. The two had resumed their affair while she was in New York. Nick had been a big help with all the preparations for the exhibition. Their letters are filled with a sweet, intense passion: "I miss every movement of your being, your voice, your eyes, your hands, your beautiful mouth, your laugh so clear and honest. YOU. I love you my Nick."[15]

Frida also conveyed her lust for Nick through a painting she made for him of a close-up Georgia O'Keeffe–type flower, called *Xóchitl* (1938), the Nahuátl word for flower and the Aztec goddess of love. She identified with Xóchitl, using it as her name on many of the letters to Nick. This was a carryover from her use of flowers embedded in the triangles of her

velvet dress in the portrait she painted for Alejandro and her use of the jack-in-the-pulpits to communicate feelings for Georgia in *Self-Portrait on the Borderline.*

But Nick was not the only man she had an affair with while in New York, away from Diego's jealous glare. Julien Levy also became her paramour. Julien's friends found Frida enticing, with her "theatrical quality" and "high eccentricity," as Surrealist critic Nicolas Calas recalled.[16] She even felt free enough to pose topless for Julien, as he snapped many black-and-white photos of her—sitting upright fixing her long braided hair; arms up with hands in hair and deep eyes burrowing into ours; looking away from the camera, cigarette in hand. From these images and letters Frida sent Julien over the years after she left New York, there's a sense of ease between them and affection: "I kiss your magnificent eyes and you know I adore you as always. Frida." Her signature is accompanied by a lipstick imprint.[17]

At the end of 1938 and the beginning of 1939, Frida was at a high point in her career. She was meeting more people in the art world and doing so without Diego and his largesse. This doesn't mean Diego hadn't done his best to help Frida; he had. He made phone calls and wrote letters of introduction to help her meet the well-connected and to receive good publicity. In January 1939, after Frida had been fêted in New York, she sailed to Paris for a group show called "Mexique." Breton had invited Frida to show her work in this exhibit alongside photographs by fellow Mexican photographer Manuel Álvarez Bravo, as well as the works of some eighteenth- and nineteenth-century Mexican painters, pre-Hispanic art, *retablos,* and some popular art objects. In the small exhibition catalog Breton put together, Frida stands out. He devoted three and a half pages to her essay, whereas Álvarez Bravo garnered only a paragraph. And her essay was accompanied by a large reproduction of a painting entitled *My Nurse and I.* Although the catalog lists eighteen of Frida's paintings, in a letter she penned Nick, she wrote: "Few days ago Breton told me that the associated [*sic*] of Pierre Colle, an old bastard and son of bitch, saw my paintings and found that only two were possible to be shown, because the rest are too *'shocking'* for the public!!"[18]

Somebody must have eventually convinced the gallery owner, Pierre Colle, that the public could indeed handle all but one of Frida's paintings (the exception was probably *My Birth,* listed as *Birth* in the catalog),

because the critic L. P. Foucaud commented that each of the seventeen paintings was a "door opened on the infinite and on the continuity of art."[19] He found them to be authentic and sincere, high praise for a non-French woman, as artist Jacqueline Lamba pointed out: "Women were still undervalued. It was very hard to be a woman painter" and an unknown foreigner.[20]

Frida's trip to Paris exposed her to some interesting artists, such as Pablo Picasso, who taught her a few Spanish songs, and Wassily Kandinsky, who was so moved by her art that he lifted her in the air and kissed her on both cheeks. The Louvre ended up purchasing one of her paintings, a self-portrait called *The Frame* (1938), making her the first Latin American artist to become part of the Louvre's collection (today the Centre Pompidou–Musée National d'Art Moderne owns it). Diego marveled that not even he, Orozco, or Siqueiros—the three great Mexican muralists—could boast of this accolade.

At the end of March 1939 Frida returned to New York. She looked forward to seeing Nick, as they had been corresponding while she was in Paris, pouring out their longing, sadness, and challenges. Nick even said in one letter that he'd move for his "darlingest Xóchitl": "You have wrapped (packed) my heart into yours and there it is. I am building a future on it, to live in Mexico."[21] But when Frida was reunited with Nick, she discovered he was involved with someone else. This unexpected news prompted Frida to leave New York early.

Nick seems to have had a revelation of his own: Frida would always be devoted to Diego. He discovered that the drawing Frida had sent him seven years earlier had been a warning: Diego's hold upon her would never dissipate entirely. Nevertheless, Frida was devastated by the breakup. Nick made clear he wanted to remain a good friend: "Frida you are a great person, a great painter. I know you'll live up to this. I also know I've hurt you. I will try to heal this hurt with a friendship that I hope will be as important to you as yours is to me."

When Frida returned to Mexico, she experienced tension in her marriage, with fights erupting constantly. By midsummer it was so bad that Frida and Diego separated. But if Frida's relationships with Diego and Nick were disintegrating, her career still seemed to have wings. She was in contact with Julien, who was acting as her dealer by connecting her to interested galleries in Los Angeles and Chicago. By September Frida was

working on a new painting, called *The Two Fridas,* for an upcoming group exhibition in Mexico; it would be her largest work to date, at 5'7" by 5'7". While she was working on it, Nick came to Mexico for a visit, only five months after breaking off their relationship. The simmering, explosive energy between them comes through in a series of photographs taken at Frida's house in Coyoacán. Nick captures some of the most sumptuous color photographs of Frida wearing her Tehuana *huipil* with red, yellow, and black designs set off by puffs of pink bougainvillea in her black hair, with a turquoise wall as backdrop. If you could drink photographs, these would stimulate the palate with a complexity of flavors in every sip.

In one photo, Frida, Nick, Rosa Covarrubias, and Cristina pose on a balcony. Rosa and Cristina are on the right and Frida and Nick occupy the left, but the intensity of emotion burning under the surface is so strong that Rosa and Cristina seem out of place. Frida stands a bit behind and to the side of Nick. She wraps her arm around his neck with her pointer finger brushing his cheek. The touch of Frida's finger is registered in Nick's eyes. This photograph conveys that the dance of seduction was still on. Whether Frida and Nick acted on this dance is a mystery, but after he left, Frida and Diego began divorce proceedings. The fall and winter of 1939 were tough months for her, and she often found herself "drinking a full bottle of brandy each day."[22]

Frida isolated herself from friends who were close to Diego. Her social life slowed, but her creative life picked up. She finished *The Two Fridas,* one of her finest paintings. It was now ready for the upcoming January 1940 "International Exhibition of Surrealism" that Breton had organized with Surrealist painter Wolfgang Paalen and Peruvian poet César Moro at Inés Amor's Galería de Arte Mexicano in Mexico City. It was a huge event, with a who's who of Mexico attending the opening and everyone dressed in their finest.

It must have been quite a sight to see Frida standing in front of *The Two Fridas.* The Fridas in the painting sit next to each other holding hands on a green Mexican bench with an El Greco–like sky behind them, similar to *View of Toledo,* the painting she'd gushed over at the Metropolitan Museum in New York. Although the two Fridas look alike, they are also different in important ways. The Frida on the right has darker skin and wears the Tehuana style of dress with a heart on the outside, and the Frida on the left has lighter skin and wears a Victorian wedding gown with a high-necked

lace collar. The "bride" has literally had her heart ripped open, as her torn bodice reveals a heart that's missing its front wall, allowing us to see inside it. The hearts in this painting—wounded and intact—conjure up the Aztec heart as the axis mundi between the material and spiritual realms. Frida uses both the heart—wounded and intact—and blood to convey the feeling of pain and strength on a human and divine level.

A red artery, similar to what she'd used in *Henry Ford Hospital,* runs from the Tehuana Frida to the bride, but the bride needs to stop the flow of blood by clamping the artery with a hemostat. From a medical perspective, it hasn't been completely successful, as blood continues to drip onto Frida's white lap. From an Aztec perspective, bloodletting was a sacred act, giving thanks to the divine for human and plant life, and in the painting, the shedding of blood can be seen as giving new life to her European side.

The bride survives the physical wound because she's connected to the Tehuana's intact heart, hanging on the outside of her *huipil.* The artery for this healthy heart begins in the Tehuana's left hand. This hand also holds a small oval picture of Diego as a little boy, with the red artery looped around it like a frame. In the painting, Dieguito is part of the flow of blood, but he's miniaturized, giving him less visibility than the enormous Fridas. The Tehuana Frida radiates power. Her heart is intact and she sits with her legs visibly wide open beneath her skirt. This body language, deemed appropriate for men, was seen as inappropriate for a "proper" woman. Frida implies that the indigenous woman has freed herself from such European mores, emphasized by the bride's proper pose and outfit, which serve to hide her body. Nevertheless, the two Fridas hold hands, indicating that Frida carries both aspects within her. The hand-holding is reminiscent of Frida telling Alejandro when she was younger: "I'll just have to be a friend to those who love me as I am."

The blood of life and death is a detail Frida had begun working with in Detroit, with her depictions of blood on white creased sheets in *Henry Ford Hospital* and *My Birth.* One important difference between the Detroit paintings and this one is that Frida is no longer lying in bed in a vulnerable position. Instead, she's seated, and her wounded side is fortified and held up by her intact side. There is visible pain in the bride's eyes, but she isn't crying like in *Henry Ford Hospital.* By this point, Frida was back in her homeland and her childhood house, buoyed by her family and the country she so loved. Blood and the concept of duality became important for Frida's

art while she was living in the United States. Once she returned to Mexico, she added the heart, making this trilogy—heart, blood, duality—central to her mature paintings.

Duality was ultimately at the root of Frida's sense of self—not a divided self, but one that was at peace with the search for a unification of opposites, as the Aztecs and alchemists espoused. It related to her bisexuality, her androgyny, her ethnicity, her marriage, and her art. Even the diary she began in 1944 included many of the images and symbols of duality she'd referenced in her paintings, such as yin/yang symbols, third eyes, and androgynous figures. But to understand her duality is to recognize it as a holistic approach to life, as she confirmed: "Everything is all and one."[23] Alejandro explained it by saying Frida's great passion was for life and that it was "manifested as love—for animals, plants, nature, her good friends, women or men."[24] Her childhood friend Juan O'Gorman agreed with Alejandro, saying he didn't consider Frida bisexual but rather "ambi-sexual." Her love, including sexual love, was for everything and everyone: "love for living, love for plants, love for the little animal, love for the little monkey, the tuna plant, love for her family, love for Rivera, love for her friends, love for her house, love for her ancestry. It is a very distinct characteristic that she was a person that loved everything around her. She put all that love into her painting and it shows."[25] Frida put it simply: "Love is the basis of all life."[26]

Frida's imposing painting *The Two Fridas,* which speaks with a specific set of symbols coming out of Mexican culture, was a perfect image to represent the complexity of modern Mexico in a groundbreaking Museum of Modern Art exhibition entitled "Twenty Centuries of Mexican Art." The show, curated by Miguel Covarrubias, ran from May 15 to September 30, 1940. The entire museum was devoted to some five thousand pieces of Mexican art from pre-Hispanic through modern times. The publicity release touted it as the largest and most comprehensive exhibition of Mexican art ever assembled.

Frida's representation at the exhibition with *The Two Fridas* is a testament to how much her career had taken off since she'd first arrived in New York in 1931. At that time she hadn't even come into her mature style. By 1940 she was one of the honored artists in a major show celebrating the culture she so loved, including a spectacular opening with Mexican cuisine served to a star-studded group—Mexican minister of culture Ramón

Beteta, gallery owner Inéz Amor, muralist José Clemente Orozco, archae-
ologist Alfonso Caso, composer Carlos Chávez, artists Georgia O'Keeffe
and Alfred Stieglitz, businessmen Nelson Rockefeller and Edsel Ford, and
movie stars Greta Garbo, Hedy Lamarr, Paul Robeson, and Edward G.
Robinson.

The fact that this exhibition took place at all is amazing, and that Diego
and Frida were included is ironic, because it was Nelson Rockefeller, now
president of MoMA and Diego's former nemesis, who took it on at the last
minute. In an unusual twist of fate, Nelson and Miguel became partners
because they decided to bring the exhibition, originally planned for a mu-
seum in France, to New York. The outbreak of war in 1939 made it risky
to ship art treasures over to Europe, as the vessel could be attacked at sea
or the art could be confiscated on land.

Nelson liked the idea because he had recently been made coordina-
tor of the new Office of Inter-American Affairs by President Roosevelt.
The president wanted Nelson, with his business ties in Latin America, to
counter fascist influences. Nelson understood the power of art to bring
people and countries together, so he negotiated with President Cárdenas
of Mexico, winning him over to the idea. Unfortunately, in the end, Frida
wasn't able to enjoy the grand affair of "Twenty Centuries of Mexican Art"
because she was in San Francisco.

In the fall of 1939, when Frida created *The Two Fridas*, she and Diego
were getting a divorce. In the fall of 1940, when the painting was hanging
at the Museum of Modern Art in New York, Frida was in San Francisco
remarrying Diego. Through the efforts of their mutual friend Dr. Eloesser,
Frida and Diego decided it was better for them to be together rather than
apart. At this time, Diego was in San Francisco painting a mural called *Pan
American Unity* for the "Art in Action" exhibit at Treasure Island's Golden
Gate International Exposition. With World War II raging in Europe and
Asia, he was promoting unity in the Americas on the West Coast, while on
the East Coast Nelson Rockefeller was promoting unity between Mexico
and the United States.

Frida appears in Diego's mural as a standing Tehuana painter, palette
in hand, and she appears in *The Two Fridas* as a powerful seated Tehuana
woman, Diego in hand. In Frida's version, she doesn't take for granted the
otherworldly connection she has with Diego, the miraculous flow of blood
between them, as she noted in her diary. In Diego's version, Frida stands

as a statuesque woman and painter, but behind her sits Diego, with his back to her, holding hands with the actress Paulette Goddard, whom he had hoped to marry prior to his decision to remarry Frida. Frida's painting focuses on their relationship in the realm of the mythic, and his focuses on their relationship in the realm of the real.

Amid the complicated dynamics between Frida and Diego, a circle was completed. Frida had entered San Francisco for the first time at the age of twenty-three, a newly married woman, and when she returned to San Francisco to remarry, she was thirty-three, the same age as Christ when he died—something she referenced in one of her paintings at the time, *Self-Portrait Dedicated to Dr. Eloesser* (1940), with a crown of thorns around her neck. That painting too creates a circle, because in 1931 when Frida was first in San Francisco getting to know Dr. Eloesser and Jean Wight, she'd tried out many of her new ideas with the portrait she'd made of Jean. At that point she was still unsure of herself as a painter, hiding behind Jean, afraid to make a bold statement. But the ingredients were there: Jean's spiky red coral necklace laid the groundwork for the thorn "necklace" ten years later.

The blood Frida now felt free to paint drips down her neck. She's turned the spikes from Jean's necklace into thorns and the coral into blood. She sets off the crown of thorns around her neck with a simple brown shawl covering her shoulders and coming down into a V-shape, like the V-neck top in Jean's portrait. There are a few other similarities as well, making it clear that Jean's portrait was a prototype. Frida, however, looks quite different from the lifeless Jean. She looks like Julien's description of her as a "mythical creature, not of this world—proud and absolutely sure of herself, yet terribly soft and manly as an orchid."[27] All these dualities are present. She looks manly and hard with her facial hair and riveting expression, underscored by the background of broken branches and crisp-looking leaves, yet she's also alluring, with red lips set off by a gorgeous bouquet of flowers decorating her hair. The androgynous beauty Frida had painted in her 1933 *Self-Portrait with Necklace,* shown from a close-up perspective, was also the precursor to masterpieces like this seven years later.

Considering the innovative, strong body of work Frida created from 1932 through the 1940s, along with her successful solo New York show, the Louvre's purchase of *The Frame,* and her inclusion in MoMA's "Twenty Centuries of Mexican Art" show, one might assume that Frida's career con-

tinued to soar. Yet this is not what happened. Her work was included in a few exhibitions of Mexican art in the 1940s, but Frida wouldn't have another solo exhibition until 1953, shortly before her death. Her friend Lola Álvarez Bravo, a photographer, owned the Galería Arte Contemporaneo in Mexico City, and she organized the show, realizing that Frida might die soon. It was Frida's first solo exhibition in her homeland. Despite her poor health, Frida didn't want to miss the opening, so she arranged to have her four-poster bed delivered to the gallery. Frida sat upright in her bed in the middle of the gallery while throngs of people greeted her, gazed upon her paintings, sang *corridos,* and drank.

It was an incredible, festive night that gave way to a successful exhibition run. It received positive reviews, and calls from Europe and the United States came into the gallery asking about Frida's work. The show was so popular that it was extended for a month. José Moreno Villa, a poet and critic, wrote: "It is impossible to separate the life and work of this singular person. Her paintings are her biography."[28] *Time* magazine struck the same note with an article titled "Mexican Autobiography," which connected Frida's life to her paintings. Once again, it seemed as if Frida's career was taking off, but it would take another twenty years for some important articles to be written, such as Gloria Orenstein's "Frida Kahlo: Painting for Miracles" in 1973 and Teresa del Conde's "La Pintora Frida Kahlo" ("The Painter Frida Kahlo") in 1974.

In 1976 Linda Nochlin and Ann Sutherland Harris organized the groundbreaking U.S. traveling exhibition "Women Artists 1550–1950." Frida's marriage portrait (*Frieda and Diego Rivera*) was included along with a short bio and discussion of her work in the catalog. This was one of the first exhibitions to focus on women artists from Europe and the Americas. It was an important inflection point for the feminist art movement, which sought to uncover unknown or little-known women artists and to begin a process of understanding and analyzing why so many women artists were never written into the Western art history canon. Frida's inclusion in the exhibit, though significant, repeated the refrain that "the painting is characteristically autobiographical," a characterization that could be perceived as indicating the work is narcissistic and second-rate, especially if women are seen as inherently more emotional than men, lacking the intellectual brilliance needed to create masterpieces.

Artist and curator René Yañez understood Frida's brilliance. He

suggested a Frida exhibition to the San Francisco Museum of Modern Art. The institution "turned down an opportunity to take the first major Kahlo exhibition" in the United States, says art historian Whitney Chadwick.[29] Women, she said, took to the streets to protest, picketing the museum. (Their voices wouldn't be heard until 2008, when that museum accepted the Walker Art Center's traveling exhibition "Frida Kahlo.") Yañez took action as well. As one of the co-founders of San Francisco's Galería de la Raza, he organized an exhibition to honor Frida's importance, especially to the Chicano/a community, with "Homage to Frida Kahlo" in 1978. The artist Amalia Mesa Bains said: "She inspired us. Her works didn't have self pity, they had strength."[30] Although SFMOMA wasn't interested in a Frida Kahlo exhibition in 1978, the Museum of Contemporary Art Chicago was. "Frida Kahlo, 1910 [sic]–1954: An Exhibition" was the first solo museum exhibit to feature her work. A desire to learn more about Frida Kahlo the artist was intensifying, creating an ideal environment for the publication of Hayden Herrera's consequential biography, *Frida*.

The 1983 biography dramatically increased Frida's visibility, especially outside of Mexico, as a woman and artist, but the merging of Frida the person with the Frida depicted in the self-portraits had been cemented. In some ways, Frida's creation of her vibrant personas and unique style of dress aided this easy merging of painter and paintings, but as art historian Margaret Lindauer points out, "Kahlo became synonymous with a 'look' rather than with her creative production."[31] By focusing on Frida's "look" and her art as autobiography in an art world that favors male genius, Frida's own genius tends to get buried. It's more acceptable to prize female artists' looks and their supposed emotional, sensual creative outpourings. The autobiographical perspective diminishes all the hard work, forethought, and trial and error of learning her craft. And it takes away Frida's authority as creator. She didn't just paint her pain or joy. She drew upon a vast knowledge of art, philosophy, world religion, botany, biology, politics, history, and Mexican cultural traditions.

Everything Frida created, whether it was her own personas or her paintings, was well thought out. She also, as Juan O'Gorman noted, approached everything with love. The sincerity with which she constructed her personas and paintings is felt, and this has endured, allowing her art and look to continue to grow in popularity.

Her stature has increased exponentially since the 1980s, with the suc-

cessful 2002 Hollywood film *Frida,* produced by and starring Salma Hayek and directed by Julie Taymor, propelling Frida's art and life to an even larger audience. When Hayek wrote an op-ed for the *New York Times* in 2017, called "Harvey Weinstein Is My Monster Too," she detailed for the first time her harrowing experience of Weinstein sexually harassing and emotionally abusing her during the creation of the film. In this powerful piece, Hayek asks questions that were just as pertinent in Frida's time: "But why do so many of us, as female artists, have to go to war to tell our stories when we have so much to offer? Why do we have to fight tooth and nail to maintain our dignity?" Salma, like Frida before her, had to figure out a way to succeed in a man's world. It speaks to the ongoing challenges women face, as well as to the resilience of women such as Frida Kahlo and Salma Hayek. In the end, both artists' works have prevailed.

Frida has become an icon, inspiring countless people around the world, an incredible phenomenon considering her near obscurity outside of Mexico at the time of her death. But without a fuller understanding of how she struggled to find her artistic voice in the pivotal period of the 1930s, we run the risk of seeing her as a woman and artist who, through sheer force of will, overcame gender bias. She certainly had a strong will and she overcame great odds, but her legal rights and her ability to recognize and combat internalized sexism and misogyny were hampered by the era in which she lived. When Frida died in 1954, Mexican women had just won the right to vote the previous year. This doesn't mean women in Mexico hadn't been politically engaged. They had been, particularly during and after the revolution. Frida wasn't alone as a trailblazer, but she often felt alone. She didn't live to experience the second wave of feminism in Mexico beginning in 1968 or in the United States in 1963. This would provide a new consciousness, one that linked women's individual experiences to larger societal norms and unjust laws.

Frida's attitudes about what it meant to be a woman in a male-dominated world were complex. In many ways she was ahead of her time, yet in other ways she was a product of her time. Art was the one arena where she had total control, in part because she wasn't dependent upon buyers. She created innovative paintings, many of which were masterpieces, but they were not recognized as such until more recently.

Frida's art continues to grow in popularity, with museums around the world sponsoring numerous exhibitions that consistently break attendance

records. The public can't seem to get enough of Frida Kahlo. Ultimately, she achieved what many artists find elusive: she was able to transform the personal into something universal, allowing people the world over and throughout different time periods to see and feel themselves in her paintings.

Acknowledgments

When I began working on this book in 2008, I had no idea it would take over ten years. In that time, I've encountered so many people who have made this book possible. First, a heartfelt thank-you goes to my agent, Laurie Fox. Without her enthusiasm for Frida's journey, there would be no published book. I am eternally grateful. I also want to give a special thank-you to Linda Chester for her warmth and support. A sincere thank-you goes to my editor, Elisabeth Dyssegaard, whose attention to both small details and larger themes was invaluable. Her instincts are impeccable. Likewise, managing editor Alan Bradshaw and production editor Jennifer Fernandez made me a better writer with their close reading of my manuscript and excellent suggestions. A warm thank-you goes to associate editor Laura Apperson for all her help and support. I am indebted to Karen Wolny, who originally acquired this book for St. Martin's Press and was its first passionate advocate.

Frida didn't keep a diary in the 1930s, but Lucienne Bloch did. When I met Lucienne Allen, Bloch's granddaughter, she was generous with her stories and access to her grandmother's journal. She allowed me to copy as much as I wanted. Allen's generosity granted me more than information to fill in Frida's life. I was able to peer into Bloch's private musings and feelings and benefit from this remarkable woman's observations about herself,

her family, her love interests, the art world, and her time with Frida and Diego.

It was paramount to see Frida and her journey through her own eyes. To achieve this, I spent time photographing the hundreds of letters in the Nelleke Nix and Marianne Huber Collection of Frida Kahlo Papers, housed at the National Museum of Women in the Arts. A trove of letters, postcards, telegrams, and some drawings, written in English and Spanish, between Frida and her family and friends, made it possible for me to write a much richer book. I'm grateful to Jennifer Page, the library assistant, for all her help answering questions through email and assisting me with the letters at the library. Likewise, I'm grateful to Heather Slania, director of the Betty Boyd Dettre Library and Research Center. Her help made the lengthy process of getting through all the letters much easier.

Once I sifted through all the letters, separating the ones written in English from the ones written in Spanish, Cristina Visus took over translating the letters from Spanish into English. This was a crucial step in the process of getting inside Frida's head. I wanted to find someone who was both an experienced translator and a lover of Frida and her paintings. Cristina, a friend for years, was the first person who came to mind. I'm grateful that she agreed to take on this laborious task.

Many of us feel as if we know Frida because of her bold self-portraits and the many accounts of her later life as a mature artist and woman, but piecing together her art and life in this three-year period in the United States required painstaking work, tying together bits of information I found in the many archives and libraries I camped out in, such as the San Francisco Museum of Art Library and Archives, the Hoover Institution at Stanford University, the F. W. Olin Library at Mills College, the Diego Rivera Archive at City College of San Francisco, the Detroit Institute of Arts Research Library and Archives, the Detroit Public Library, the Scarab Club, the Conrad R. Lam Archives for the Henry Ford Health System, the Benson Ford Research Center, the Harry Ransom Center at the University of Texas at Austin, the Laredo History Archive, the American Art and Portrait Gallery Library, the Philadelphia Museum of Art Library and Archives, the Museum of Modern Art Archives and Library, the New York Public Library, the Museo Frida Kahlo, and the Museo Casa Estudio Diego Rivera y Frida Kahlo.

While everyone at these various institutions was helpful, there are a

few people I need to thank by name: Janice Braun, Associate Library Direc-
tor at the F. W. Olin Library; Barbara Rominiski, Head Research Librarian
at SFMOMA; Maria Ketcham, Head Librarian at the DIA Research Library
and Archives; Xavier Soberanes and Ximena Jordán at the Museo Frida
Kahlo; Julia Bergman and Christopher Kox at the Diego Rivera Archive at
the City College of San Francisco. Thanks also to Melanie Bazil, who on my
first research trip to Detroit was the Senior Archivist at the Conrad R. Lam
Archives for Henry Ford Health System. She answered a long list of ques-
tions and took me on a tour of Henry Ford Hospital, providing historical
details from 1932, when Frida was a patient there. On my second trip to
Detroit, Melanie had moved to the Benson Ford Research Center, and once
again she was incredibly helpful. I also appreciate Dr. Adnan R. Munkarah,
Chief Medical Officer at Henry Ford Hospital and Chair of the Department
of Obstetrics and Gynecology, who took the time to speak to me about
various medical issues and procedures concerning miscarriages in 1932.
Treena Flannery Ericson was kind enough to speak to me about Diego
Rivera's time spent at the Scarab Club in Detroit. I'm grateful that I met
documentary filmmaker Grace Raso while conducting research in Detroit.
Our mutual interest in Frida sparked some interesting conversations over
dinner, and her help while I was in Detroit is much appreciated. I also want
to thank art historians Carolyn Kastner and Sharyn Udall for spending time
with me in Santa Fe discussing Georgia O'Keeffe and Frida Kahlo. Their
perpsectives helped me to understand both artists on a deeper level. To art
historian Whitney Chadwick, my mentor, colleague, and friend, thank you
for exposing me to Frida Kahlo's art when I was a student and for inspiring
me to think about art within its social and historical contexts.

I am extremely grateful to Dan Trujillo at Artists Rights Society for
all his help in obtaining permission to reproduce Frida Kahlo's images.
And I am grateful to the Banco de México Diego Rivera and Frida Kahlo
Museum Trust for granting me that permission.

If the letters and Bloch's journal provided insight into the daily activi-
ties and thoughts of Frida, Diego, and Lucienne, then all the research trips
I took to experience the places where Frida had lived helped to make some
of the details in the letters and journal come alive. The more I went to the
places where Frida had been, the more I could imagine her life. I even
re-created, as best I could, a train trip Frida took from Detroit to Laredo.
Staying in this border city, a place where Frida was stranded for twelve

hours, allowed me to see and feel this unique place. Likewise, talking to Rosie Ozuna about her life growing up in Laredo several years after Frida had passed through further helped me to imagine what it must have been like in the 1930s. I am thankful for the time Mrs. Ozuna spent with me reminiscing. I'm also grateful to Carla Aurich for always being a generous hostess and wonderful friend, welcoming me into her home in New York on two different occasions while I was conducting research. Likewise, I want to thank Susan Bailey for opening up her warm home to me on a research trip to Santa Fe and for always supporting me as a friend and colleague.

My writing group deserves a big thank-you for all the invaluable feedback I received over the years. The group dwindled, and in the end there were three who continued to read chapters and push me to be a better writer. Thank you so much, Patricia Albers, Linda Gray Sexton, and Carol Markson! Wendy Tokunaga also helped me to be a better writer. Her edits were on the mark. And her excitement for the book helped me get through a challenging period. My colleague Jackie Francis generously took time out of her busy schedule to discuss Frida's *Portrait of Eva Frederick*. Her insights helped me to think through the complicated discourse of "racial art." I'm grateful as well to Beth Flynn and Steve Stevens for reading some of my chapters and providing insightful feedback. I value our long friendship. A special thank-you goes to Mary Jo Stout, Pam Dong, Julie Raia, Cheryl Gomes, and Sue Feltovich for their tireless support. You always picked me up in just the right moments when my energy was lagging. Likewise, my students at the University of San Francisco have lifted my energy with their insightful comments and perspectives.

I also want to thank some of the Frida scholars who have done groundbreaking work, making it possible for me to have such a strong foundation: Hayden Herrera, Carlos Fuentes, Gannit Ankori, Sarah Lowe, Margaret Lindauer, Helga Prignitz-Poda, Teresa del Conde, Salomon Grimberg, Luis-Martín Lozano, Victor Zamudio-Taylor, Janice Helland, Sharyn Udall, and Whitney Chadwick.

There are many friends and some family I need to thank for all the support they have provided me on this long and challenging journey. Their checking in to see how the writing was going and sending inspirational texts or emails kept me going. Thank you to Paula Birnbaum, Kate Lusheck, Rebecca Stamm, Jan Feathers, Jan Pitcher, Susanne Shakeri,

June Kanda, Lita Kurth, Kathleen Huse, Suzanne Stewart, Marcia Smies, Thuy Nguyen, Mike Robins, Andrea Bloom, Carol Meyerhof, David Meyerhof, Sarah Simons, Kim Simons, Rich Mallonee, Melinda Stahr, Lisa Stahr, Grace Stahr, and Carl Stahr.

A heartfelt thank-you goes to my mother, Illene Stahr. Your ongoing support and love have helped me remain steadfast. You are the only person who has read everything I've written. Thank you for always believing in me.

Finally, a huge thank-you to my husband, Gary, and my daughter, Mei Lin. You have put up with my long hours writing and rewriting. You've listened to me talk about all things Frida. You've helped me figure out the right word or sentence construction. You've made dinner, vacuumed, gardened, and gone grocery shopping so I could stay focused on Frida. I could not have finshed this book without your immense love.

Gary, I'm so grateful for all the chapters you've read and reread. Your attention to detail is staggering. Your ability to make me laugh keeps me grounded; your love and commitment fill me with joy. Thank you for urging me to realize my dream.

Mei Lin, thank you for being patient throughout this whole process. I'm glad that we had the opportunity to take several research trips together. You are a fantastic traveling partner. Your abundant creativity inspires me. Your love keeps me going.

Notes

INTRODUCTION

1. Isabel Allende, *The House of the Spirits,* trans. Magda Bogin (New York: Atria, 1985).

PROLOGUE

1. Hayden Herrera, *Frida: A Biography of Frida Kahlo* (New York: Harper Perennial, 2002), 141.
2. Carlos Fuentes, "Introduction," *The Diary of Frida Kahlo: An Intimate Self-Portrait,* ed. Phyllis Freeman (New York: Harry N. Abrams, 1995), 23.
3. Fuentes, "Introduction," 19.
4. Gannit Ankori, *Frida Kahlo* (London: Reaktion Books, 2013), 221.
5. Isolda P. Kahlo, *Intimate Frida* (Buenos Aires: Gato Azul, 2005; Bogotá: Cangrejo, 2006), 118.
6. Ankori, *Frida Kahlo,* 123.
7. Fuentes, "Introduction," 21.
8. "Art: Square-Foot Show," *Time,* December 29, 1931.
9. Diego Rivera with Gladys March, *My Art, My Life* (New York: Citadel Press, 1960), 174.
10. Kahlo, *Intimate Frida,* 122.

ONE: FRIDA IN THE WILDERNESS

1. Letter from Frida to her mother, November 10, 1930, Nelleke Nix and Marianne Huber Collection: The Frida Kahlo Papers, Special Collections, Library and Research Center, National Museum of Women in the Arts, Washington, DC (henceforth "NMWA").
2. Letter from Frida to her mother, November 10, 1930, NMWA.
3. Letter from Frida to her mother, November 10, 1930, NMWA.
4. Isolda P. Kahlo, *Intimate Frida* (Buenos Aires: Gato Azul, 2005; Bogotá: Cangrejo, 2006), 111.
5. Kahlo, *Intimate Frida,* 111.
6. Carlos Fuentes, "Introduction," *The Diary of Frida Kahlo: An Intimate Self-Portrait,* ed. Phyllis Freeman (New York: Harry N. Abrams, 1995), 11.

7. Diego Rivera with Gladys March, *My Art, My Life* (New York: Citadel, 1960), 175.

8. Several of Frida's friends, such as Adelina Zendejas, have commented that when she walked, she looked as if she were floating due to the length of her skirts and dresses and the way she controlled her movements to cover up a limp. Most authors say Frida and Diego arrived on December 10, but two of Frida's letters to her mother state December 9, NMWA.

9. Ralph Stackpole first met Diego in Paris in the 1910s, and as their friendship grew in the 1920s, so did Stackpole's enthusiasm for mural painting. However, in order to garner an invitation for Diego, Stackpole needed to convince three important men: architect Timothy Pflueger; William Gerstle, president of the San Francisco Arts Commission; and art patron Albert Bender. With the help of University of California, Berkeley, art professor Ray Boynton, who had studied mural painting with Diego in Mexico in the 1920s, Stackpole worked his powers of persuasion. All three men eventually agreed that Rivera's murals should grace two walls in San Francisco, and they used their money and influence to make it a reality.

10. *Art Digest* article reprinted in Bertram D. Wolfe, *Diego Rivera: His Life and Times* (New York: Alfred A. Knopf, 1939), 320.

11. Rudolf Hess made his statements prior to Diego's arrival, but I think they reveal how this "foreigner" wasn't able to charm everyone. Rudolf Hess, "The Tragedy of Rivera," *Argus* 4, no. 1 (1928): 1–2.

12. "Rivera Arrives in San Francisco to Paint Stock Exchange Murals," *San Francisco Chronicle,* November 11, 1930, 13.

13. Salomon Grimberg, *Frida Kahlo: Song of Herself* (London: Merrell, 2008), 91.

14. Some of the descriptions of Frida and Diego's living quarters are taken from my own viewing of the space, including photographs I took. Other specifics come from Frida's letters and from John Weatherwax's unpublished story "The Queen of Montgomery Street," ca. 1930, in the John Weatherwax Papers, 1928–1933, Archives of American Art, Smithsonian Institution, Washington, DC.

15. Letter from Frida to her mother, November 10, 1930, NMWA.

16. Weatherwax, "The Queen of Montgomery Street," 10.

17. Letter from Frida to her mother, November 10, 1930, NMWA.

18. Letter from Frida to her mother, December 4, 1930, NMWA.

19. Esther Johnson, "Rivera Sketching Helen Wills, Calls Her Typical 'Modern American Girl,'" *San Francisco Chronicle,* December 10, 1930, 4.

20. Journal entry from Dr. William Valentiner file, Detroit Institute of Arts Library.

21. Johnson, "Rivera Sketching Helen Wills," 4.

22. Selina Hastings, *The Red Earl: The Extraordinary Life of the 16th Earl of Huntingdon* (New York: Bloomsbury, 2014), 138.

23. Letter from Frida to her mother, February 12, 1931, NMWA.

24. Herbert Asbury, *The Barbary Coast: An Informal History of the San Francisco Underworld* (New York: Alfred A. Knopf, 1933), 101.

25. All information about this incident comes from Frida's letter to her mother, January 1, 1931, NMWA.

26. Letter from Frida to her father, November 14, 1930, NMWA.

27. Postcard from Frida to her mother, 1930, NMWA.

28. Kenneth Rexroth, *An Autobiographical Novel* (New York: Doubleday, 1966), 365.

29. Linda Gordon, *Dorothea Lange: A Life Beyond Limits* (London: W. W. Norton, 2009), 65–75.

30. Maynard Dixon's comments were published by the United Press on September 23, 1930; reprinted in Wolfe, *Diego Rivera: His Life and Times,* 321.

31. Most of the information on Dorothea Lange comes from Gordon's book, including the fact that "polios" is a term polio survivors used for each other (5, 65–75).

32. Information from a November 10, 1930, letter from Frida to her mother, NMWA.

33. Grimberg, *Song of Herself,* 116.

34. Harris B. Shumacker Jr., *Leo Eloesser, M.D.: Eulogy for a Free Spirit* (New York: Philosophical Library, 1982), 236.

35. Shumacker, *Leo Eloesser,* 236.

36. Letter from Frida to her mother, December 4, 1930, NMWA.

37. Letter from Frida to her mother, November 21, 1930, NMWA.

38. William Blaisdell says in the 1930s Leo always had his dog with him, even while driving. See "Leo Eloesser: The Remarkable Story of the Medical Volunteer in Spain," *The Volunteer,* December 3, 2016, 3.

39. Letter from Frida to her mother, December 8, 1930, NMWA.

40. Letter from Frida to her mother, December 8, 1930, NMWA.

41. Letter from Frida to her mother, December 25, 1930, NMWA.

42. Letter from Frida to her mother, November 30, 1930, NMWA.

43. Letter from Frida to her mother, November 30, 1930, NMWA.

44. Letter from Frida to her mother, November 30, 1930, NMWA.

45. Letter from Frida to her mother, November 30, 1930, NMWA.

46. Information about Bender's art collection: letter from Suzanne Bloch to Albert Bender, October 9, 1933, Albert M. Bender Papers, Special Collections, F. W. Olin Library, Mills College, Oakland, CA.

47. Letter from Frida to her father, November 14, 1930, NMWA.

48. Letter from Frida to her father, November 14, 1930, NMWA.

49. Letter from Frida to her mother, November 30, 1930, NMWA.

50. Letter from Frida to her mother, November 10, 1930, NMWA.

51. Robert Chao Romero, *The Chinese in Mexico, 1882–1940* (Tucson: University of Arizona Press, 2010), 2.

52. Vasconcelos elaborated upon his ideas in *La raza cósmica: misión de la raza iberoamericana* [The cosmic race: the mission of the Iberoamerican people] (Mexico City: Espasa Calpe, 1948), 47–51.

53. Vasconcelos, *La raza cósmica,* 47–51.

54. Vasconcelos, *La raza cósmica,* 47–51.

55. Romero, *The Chinese in Mexico,* 2.

56. Frida Kahlo, *The Letters of Frida Kahlo,* ed. Martha Zamora (San Francisco: Chronicle Books, 1995), 38.

57. Hayden Herrera, *Frida: A Biography of Frida Kahlo* (New York: Harper Perennial, 2002), 118.

58. Information on the Chinese Exclusion Act found in Iris Chang, *The Chinese in America* (San Francisco: Chronicle Books, 2003), 130–145. Despite restrictive immigration laws, by 1905, San Francisco's Chinatown had grown to house forty thousand in a district that was demarcated from Sacramento to Pacific Avenue and from Kearny to Stockton Streets. It was and still is one of the largest Chinatowns in the United States. Frida's estimation of ten thousand Chinese was far too low in 1930.

59. Chang, *The Chinese in America,* 211.

60. Kahlo, *Letters,* 41.

61. Kahlo, *Letters,* 82.

62. Letter from Frida to her mother, February 16, 1931, NMWA.

63. Letter from Frida to her mother, February 16, 1931, NMWA.

64. Herrera, *Frida,* 94.

65. "China Poblana," *Wikipedia.*

66. Mark D. Lacy, "La China Poblana: Asian Influence in Mexico Stems from Seventeenth Century," n.d., Houston Institute for Culture, www.houstonculture.org/mexico/lachina.html.

67. Letter from Frida to her mother, January 8, 1932, NMWA.

68. Letter from Frida to her mother, February 16, 1930, NMWA.

69. Letter from Frida to her mother, March 12, 1931, NMWA.

70. Letter from Frida to her mother, November 21, 1930, NMWA.

71. Letter from Frida to her mother, November 14, 1930, NMWA.

72. Letter from Frida to her mother, November 21, 1930, NMWA.

73. Frida Kahlo, *Frida by Frida: Selection of Letters and Texts*, ed. Raquel Tibol (Mexico City: Editorial RM, 2003), 82.

74. Letter from Frida to her mother, January 13, 1931, NMWA.

75. Letter from Frida to her mother, February 12, 1931, NMWA.

76. Tensions between the two countries were high between 1925 and 1927. The U.S. government had been seething since 1925 due to President Calles's new laws regulating the oil industry and foreigners' rights to own land in border zones and coastal areas. President Calles responded to the anger by ordering troops to take up strategic positions and brace for a possible war.

77. Letter from Frida to her mother, January 15, 1931, NMWA.

78. Letter from Frida to her mother, January 15, 1931, NMWA.

79. Letter from Frida to her mother, January 15, 1931, NMWA.

80. Letter from Frida to her mother, January 15, 1931, NMWA.

81. Letter from Frida to her mother, January 15, 1931, NMWA.

82. Letter from Frida to her mother, January 15, 1931, NMWA.

83. According to Frida's letter to her mother, she saw the walkathon on January 14, 1931, and into the early morning hours of the fifteenth. She dated her drawing of Eva Frederick January 1931.

84. Grimberg, *Song of Herself*, 75. Some authors have said the drawing is really of Maudelle Bass, an African American dancer and artist's model, but Bass didn't move to California from her native state of Georgia until 1933, and at that time she moved to Los Angeles, not San Francisco. See Carla Williams, "The Women Who Posed: Maudelle Bass and Florence Allen," in *Black Womanhood: Images, Icons, and Ideologies of the African Body*, ed. Barbara Thompson (Hanover, NH: Hood Museum of Art, Dartmouth College, 2008), 249.

85. The name Jezebel comes from the ninth-century pagan queen of Israel who came to epitomize the "wicked woman." By the nineteenth century, black women in the United States were referred to as Jezebels due to their "insatiable appetites." The Jezebel image promoted within white society featured a young black woman with long, straightened hair who used her sexuality to seduce the white slave master as a way of attaining power. In reality, the Jezebel stereotype was a way to justify the rape of enslaved women by their white masters. See Dionne Stephens, "Freaks, Gold Diggers, Divas, and Dykes: The Sociohistorical Development of Adolescent African American Women's Sexual Scripts," *Sexuality and Culture* 7, no. 1 (2003): 3–49.

86. Galadriel Mehera Gerardo, "Writing Africans Out of the Racial Hierarchy: Anti-African Sentiment in Post-Revolutionary Mexico," *Cincinnati Romance Review* 30 (January 2011): 172.

87. Richard J. Powell, *Black Art and Culture in the 20th Century* (London: Thames and Hudson, 1997), 42.

88. Alain Locke, "Enter the New Negro," *Survey Graphic*, March 1925. For more information concerning the depictions of African Americans in this period, see also Jacqueline Francis, *Making Race: Modernism and "Racial Art" in America* (Seattle: University of Washington Press, 2012), 83.

89. Deborah Willis, "Picturing the New Negro Woman," in *Black Womanhood: Images, Icons, and Ideologies of the African Body*, ed. Barbara Thompson (Hanover, NH: Hood Museum of Art, Dartmouth College, 2008), 235.

90. Grimberg, *Song of Herself,* 89.

91. Grimberg, *Song of Herself,* 103.

92. Grimberg, *Song of Herself,* 89.

TWO: COLLISION, RECOVERY, AND REBIRTH, 1925–1927

1. Baltasar Dromundo, *Mi Calle de San Ildefonso* (Mexico City: Editorial Guarania, 1956), 46.

2. In 1914, archaeologist Manuel Gamio uncovered some ruins in the southwest corner of what had been the Great Temple within an Aztec ceremonial center, known as the Templo Mayor. He found a long stone wall with serpent heads, as well as some other items that were put on public display. A small museum was built at the archaeological zone. In 1978, the Mexican Light and Power Company was working in the area and workers happened upon an enormous stone disc depicting the decapitated body of Coyolxauhqui, the moon goddess and the sister of Huitzilopochtli, the sun god. The disc was found at the entrance to Huitzilopochtli's side of a great temple, which had two temples at the top. Since 1978, ongoing excavations have been taking place at this site, and today the Templo Mayor Museum stands on the edge of the ruins. The museum and ruins are directly across from the National Preparatory building.

3. Olga Campos, "My Memory of Frida," in Salomon Grimberg, *Frida Kahlo: Song of Herself* (London: Merrell, 2008), 52.

4. Correspondence on display at Museo Frida Kahlo, 2016. Also see: *You Are Always with Me: Letters to Mama, 1923–1932 Frida Kahlo,* translated by Héctor Jaimes (London: Virago Press, 2018), 23.

5. Grimberg, *Song of Herself,* 85.

6. Hayden Herrera, *Frida: A Biography of Frida Kahlo* (New York: Harper Perennial, 2002), 28.

7. Herrera, *Frida,* 28.

8. Herrera, *Frida,* 28.

9. Olga Campos interview with Frida Kahlo in Grimberg, *Song of Herself,* 69.

10. Statement by Alejandro Gómez Arias, translated by Ruben Bautista, published in *Frida Kahlo: Exposicion Nacional de Homenaje* (Mexico City: Instituto Nacional de Bellas Artes, 1977) and reproduced in *Frida Kahlo and Tina Modotti* (London: Whitechapel Art Gallery, 1982), 38.

11. Gaby Granger and Rainer Huhle, *Frida's Vater: der fotograf Guillermo Kahlo* (Munich: Schirmer Mosel, 2005). The authors traced Guillermo Kahlo's paternal ancestors to Frankfurt and Pforzheim, Germany, saying they were Lutheran Protestants. Some scholars have wondered if Guillermo's mother, Henriette Kaufmann, was Jewish. In an interview, Alejandro Gómez Arias told Gannit Ankori that Frida's father spoke fluent Yiddish. See Ankori, *Imaging Her Selves: Frida Kahlo's Poetics of Identity and Fragmentation* (Westport, CT: Greenwood Press, 2002), 46.

12. Gannit Ankori, "The Hidden Frida: Covert Jewish Elements in the Art of Frida Kahlo," *Jewish Art* 19/20 (1993/94), 224–247.

13. Gannit Ankori discusses Frida's library and her ability to read in different languages in *Imaging Her Selves,* 184.

14. Herrera, *Frida,* 29. Herrera says Frida memorized the whole of *Imaginary Lives,* but Alejandro Gómez Arias states that she memorized a "few pages" in a statement he made for a 1977 exhibition of Frida's work in Mexico (*Frida Kahlo and Tina Modotti,* 38).

15. Gómez Arias, in *Frida Kahlo and Tina Modotti,* 38.

16. Gómez Arias, in *Frida Kahlo and Tina Modotti,* 38.

17. Herrera, *Frida,* 33.

18. Raquel Tibol, *Frida Kahlo: cronica, testimonios y aproximaciones* (Mexico City: Ediciones de Cultura Popular, 1977), 24.
19. Herrera, *Frida,* 13.
20. Martha Zamora, *Frida Kahlo: The Brush of Anguish* (San Francisco: Chronicle Books, 1990), 18.
21. Tibol, *Cronica,* 31.
22. Herrera, *Frida,* 49.
23. Alejandro's recollection of the accident from Herrera, *Frida,* 48.
24. Isolda P. Kahlo, *Intimate Frida* (Buenos Aires: Gato Azul, 2005; Bogotá: Cangrejo, 2006), 59.
25. Frida Kahlo, *Frida by Frida: Selection of Letters and Texts,* ed. Raquel Tibol (Mexico: Editorial RM, 2003), 31.
26. Tibol, *Cronica,* 32.
27. Frida told Raquel Tibol that Mati didn't abandon her; a short transcription appears in *Frida by Frida,* 35.
28. Herrera, *Frida,* 49.
29. Kahlo, *Frida by Frida,* 31.
30. Frida Kahlo, *The Letters of Frida Kahlo,* ed. Martha Zamora (San Francisco: Chronicle Books, 1995), 20.
31. Herrera, *Frida,* 53.
32. Kahlo, *Frida by Frida,* 36.
33. Herrera, *Frida,* 58.
34. Herrera, *Frida,* 58.
35. Kahlo, *Frida by Frida,* 40.
36. Kahlo, *Frida by Frida,* 40.
37. Olga Campos interview with Frida Kahlo in Grimberg, *Song of Herself,* 71.
38. Kahlo, *Letters,* 23.
39. Kahlo, *Letters,* 25.
40. Taken from Frida's words in Herrera, *Frida,* 64.
41. Luis-Martín Lozano, "The Esthetic Universe of Frida Kahlo," in Carlos Monsiváis et al., *Frida Kahlo,* trans. Mark Eaton and Luisa Panichi (Boston: Bulfinch, 2000), 23–24.
42. Of course, Frida's style was also influenced by the intense imagery she viewed every week at church. Sculptures of a bloody Christ and a risen Christ and a painting of the Virgin of Guadalupe adorn the large San Juan Bautista Church, which I visited in September 2016. It's clear that the dramatic presentation of these religious figures influenced Frida's mature style.
43. Herrera, *Frida,* 64.
44. Herrera, *Frida,* 147.
45. In the catalog raisonné *Frida Kahlo: Das Gesamtwerk,* ed. Helga Prignitz-Poda, Salomon Grimberg, and Andrea Kettenmann (Frankfurt am Main: Verlag Neue Kritik, 1988), 278, the editors put forth a symbolic reading, one that views the birth announcement as a celebration of female sexuality within the context of Hinduism and the pistil (the female part of a flower). This interesting interpretation comes closer to my symbolic reading of it, but it doesn't take into account the ciphers from alchemy, nor does it see Leonardo as the rebirth of Frida as androgynous artist.
46. Kahlo, *Letters,* 24. In both Zamora's and Tibol's publications of Frida's letters, they place the birth announcement at the beginning of the 1926 letters, indicating that it was created in or near January 1926.
47. Frida Kahlo, *The Diary of Frida Kahlo: An Intimate Self-Portrait,* ed. Phyllis Freeman (New York: Harry N. Abrams, 2005), 228.
48. Helga Prignitz-Poda, *Frida Kahlo: Life and Work* (Berlin: Schirmer/Mosel, 2003), 42.
49. Both quotes from Herrera, *Frida,* 13.

50. Gannit Ankori also sees the *O* as a perfect circle of wholeness. She says the "imperfect" Frida "aspired to be whole as she entered the perfect circle." Ankori, *Imaging Her Selves*, 98.

51. For a more in-depth discussion of Rrose Sélavy, see Dicktran Tashjian, "Vous Pour Moi: Marcel Duchamp and Transgender Coupling," in *Mirror Images: Women, Surrealism and Self-Representation,* ed. Whitney Chadwick (Cambridge, MA: MIT Press, 1998), 37–65.

52. Sasha Chaitow, "Who was Joséphin Péladan?" July 2011, peladan.net. See also Robert Pincus-Witten, *Occult Symbolism in France: Joséphin Péladan and the Salons de la Rose-Croix* (New York: Garland, 1976).

53. Teresa del Conde, "Frida Kahlo: A Profile," trans. Martha Zamora, in *The Art of Frida Kahlo 1990 Adelaide Festival* (Adelaide: Art Gallery of Western Australia and Art Gallery of South Australia, 1990), 7.

54. Herrera, *Frida,* 43.

55. Del Conde, "Frida Kahlo: A Profile," 7.

56. Herrera, *Frida,* 18.

57. Kahlo, *Frida by Frida,* 44.

58. Herrera, *Frida,* 60.

59. Aldolfo Best-Maugard, *A Method for Creative Design,* rev. ed. (New York: Alfred A. Knopf, 1946), 49.

60. Kahlo, *Frida by Frida,* 75.

61. To be more specific, Frida was influenced by the fifteenth- and sixteenth-century Renaissance styles of Sandro Botticelli, Leonardo da Vinci, Albrecht Dürer, and Lucas Cranach; the seventeenth-century Mannerist style of Agnolo Bronzino and Parmigianino; the nineteenth-century Post-Impressionist style of van Gogh; and styles coming out of the twentieth-century modernist movements, such as German Expressionism, Stridentism, and Cubism.

62. Kahlo, *Frida by Frida,* 47.

63. Kahlo, *Frida by Frida,* 53.

64. Salomon Grimberg in *Frida Kahlo: Das Gesamtwerk*, p. 278, postulates that Frida's use of the small *o* in her birth announcement for LEoNARDo sets off the words *Le Narde*, meaning pistil, the female part of a flower. This, he argues, points toward female sexuality.

65. Helga Prignitz-Poda sees the triangles as "male" "within blood-red bordered flowers."

66. There are two versions of Frida's self-portrait. In one, the triangles are gold, but in the other, they are outlined in black with a maroon center.

67. Gómez Arias, in *Frida Kahlo and Tina Modotti,* 38.

68. Prignitz-Poda says the boats are sinking, which refers to emblems cautioning against perils lurking in a harbor's vicinity, where shallows are difficult to discern. Sailboats, she points out, are rarely found in Mexican highlands. Thus, sailboats "suggest that something is not acknowledged for what it is." *The Painter and Her Work,* 33.

69. Grimberg, *Song of Herself,* 101.

70. Kahlo, *Frida by Frida,* 58.

71. Kahlo, *Frida by Frida,* 59.

THREE: COMMUNISM, MARRIAGE, AND MEXICANIDAD, 1928–1930

1. Frida Kahlo, *Frida by Frida: Selection of Letters and Texts,* ed. Raquel Tibol (Mexico City: Editorial RM, 2003), 54.

2. Hayden Herrera, *Frida: A Biography of Frida Kahlo* (New York: Harper Perennial, 2002), 86.

3. Herrera, *Frida,* 87.

4. Diego Rivera with Gladys March, *My Art, My Life* (New York: Citadel Press, 1960), 170.

5. Diego Rivera, "Dos años" [Two years], *Azulejos* 2, no. 2 (December 1923): 26.

6. Pete Hamill, *Diego Rivera* (New York: Harry N. Abrams, 1999), 127.

7. Herrera, *Frida,* 94.

8. Herrera, *Frida,* 94.

9. Herrera, *Frida,* 199.

10. Undated newspaper clipping (c. December 27, 1931), private archive, New York City, cited in Herrera, *Frida,* 457.

11. Herrera, *Frida,* 198.

12. Bertram D. Wolfe, *The Fabulous Life of Diego Rivera* (New York: Stein and Day, 1963), 247.

13. Olga Campos interview with Frida, 1950, in Salomon Grimberg, *Frida Kahlo: Song of Herself* (London: Merrell, 2008), 74.

14. Patricia Albers, *Shadows, Fire, Snow: The Life of Tina Modotti* (Berkeley: University of California Press, 1999), 178. Tina was known in Mexico as a free spirit, some referring to her more negatively as a femme fatale, especially after her sensationalized trial. Her sexualized image had emerged in large part after the American photographer Edward Weston exhibited nude photos he had taken of her in 1924.

15. Yet Tina had to brace herself for more drama because the authorities were determined to find a reason to quell her Communist activities. Nine months after the May Day debacle, Tina was accused of the assassination attempt made on Ortiz Rubio, the newly elected president. The allegation was preposterous, but authorities locked Tina up in the Lecumberri Penitentiary with just an iron cot and the stench of a dirty toilet, and they gave the "dangerous agitator" a choice—either abandon her Communist activities or leave Mexico. Tina chose deportation, embarking on the SS *Edam* headed for Europe on February 24, 1930.

16. See Stephen F. Eisenman, *Gauguin's Skirt* (New York: Thames and Hudson, 1997), and Peter Brooks, "Gauguin's Tahitian Body," in *The Expanding Discourse: Feminism and Art History,* ed. Norma Broude and Mary D. Garrard (New York: HarperCollins, 1992), 335.

17. Isolda P. Kahlo, *Intimate Frida* (Buenos Aires: Gato Azul, 2005; Bogotá: Cangrejo, 2006), 61.

18. Helga Prignitz-Poda, *Frida Kahlo: Retrospective* (Munich: Prestel, 2010), 90.

19. Rick A. López, "La India Bonita Contest of 1921 and the Ethnicization of Mexican National Culture," *Hispanic American Historical Review* 82, no. 2 (2002): 295.

20. It can be confusing to discuss this topic because the Aztecs referred to the fifth sun or era as the fourth sun or four movement (*nahui olin*). The historian James Maffie discusses the complexity of the glyph *olin* and *nahui olin* as it relates to moving through the four phases of the life/death cycle. See his *Aztec Philosophy: Understanding a World in Motion* (Boulder: University Press of Colorado, 2014).

21. The Calendar Stone is housed at the National Anthropology Museum. It was reproduced on the twenty-peso gold coin, produced from 1917 to 1921, and today is seen on the one-peso note.

22. Herrera, *Frida,* 32.

23. Kahlo, *Frida by Frida,* 41.

24. Anne Rubenstein, "Nahui Olin: The General's Daughter Disrobes," in *The Human Tradition in Mexico,* ed. Jeffrey M. Pilcher (Wilmington, DE: Scholarly Resources, 2003), 160. Art historian Gannit Ankori speculates that Frida may have been wearing the *nahui olin* necklace to reference the person Nahui Olin and signal her "transformation into a sexually liberated woman and specifically Rivera's lover." Ankori, *Frida Kahlo* (London: Reaktion Books, 2013), 72.

25. Although I could not confirm that Vasconcelos or Rivera were familiar with Khunrath's book *Amphitheatrum Sapientiae Aeternae,* there are some striking similarities between the engravings in Khunrath's book, particularly "The Hermaphrodite" and "The Four, the Three, the Two, the One," and Rivera's mural.

26. Luis-Martín Lozano and Juan Rafael Coronel Rivera, *Diego Rivera: The Complete Murals* (New York: Taschen, 2008), 16.

27. Lozano and Coronel Rivera, *Diego Rivera: The Complete Murals,* 17.

28. Luis-Martín Lozano, "The Esthetic Universe of Frida Kahlo," in Carlos Monsiváis et al., *Frida Kahlo,* trans. Mark Eaton and Luisa Panichi (Boston: Bulfinch, 2000), 66.

29. There are two ceramic clocks from Jalisco sitting in Frida's Coyoacán home (now a museum) that attest to Frida's creation of her own mythic time. She inscribed, with paint, the dates and time of her divorce in 1939 on one clock and her remarriage to Diego in 1940 on another. However, the month and time of their divorce is incorrect. The time and date on the latter clock is given as September 1939 at 2:53. In actuality, Frida and Diego began divorce proceedings in mid-October and their divorce papers came through on November 6. She uses September symbolically, as it's the month of her bus accident. The time 2:53 in this new divorce scenario now represents when her life as she knew it fell apart: first from the bus accident and then from the divorce. Helga Prignitz-Poda provides another interpretation. She says the numbers on the clock, if viewed as 7 minutes to 3, correspond to letters in the Spanish alphabet and point to her baptismal name, Frida Carmen. See *Frida Kahlo Retrospective,* 24.

30. Herrera, *Frida,* 102. The government's tolerance for Communist activities post-revolution had vanished, and it had begun to crack down on leftists, ultimately outlawing the Communist Party.

31. Herrera, *Frida,* 105.

32. Wolfe, *The Fabulous Life of Diego Rivera,* 6.

33. Diego speculated that his maternal grandfather, who was from the port of Alvarado in Veracruz, known for its "Negroid people," may have passed on three races to him: "white, red, and black." Diego's sister, María, rejected any possible African ancestry, saying their maternal grandfather had "fair skin and fine features." Most likely Diego concocted his African lineage, perhaps to distance himself from the possibility that his family had anything to do with using slave labor. Although there may not be any documents connecting Diego's maternal grandfather to slave labor, there was a connection to slavery through Diego's father's friendship with Governor Teodoro Dehesa of Veracruz, a city that was one of the major coastal centers of slavery. See Rivera, *My Art, My Life,* 18, and Patrick Marnham, *Dreaming with His Eyes Open* (New York: Alfred A. Knopf, 1998), 25, 38–39.

34. According to Esther Pasztory, the Aztecs took the twin pyramid construction from the Toltecs. When the Aztecs encountered the Toltecs at Tenayuca building a pyramid with two temples, they conquered them, finished the final stages of the construction, and made the dual style their own. They then took this design and used it at Teopanzolco in Cuernavaca, marking this place as the center of their growing empire until they moved the empire to Tenochtitlán in the fourteenth century. Esther Pasztory, *Pre-Columbian Art* (Cambridge: Cambridge University Press, 1998), 84.

35. Herrera, *Frida,* 105.

36. Rivera, *My Art, My Life,* 169.

37. Kahlo, *Frida by Frida,* 193.

38. Jonathan Kandell, "Dolores Olmedo, a Patron to Diego Rivera, Dies at 88," *New York Times,* August 2, 2002.

39. This self-portrait is discussed in *Diego Rivera: A Retrospective* (New York: W. W. Norton, 1986), 194.

40. Marnham, *Dreaming,* 230.

41. Kahlo, *Intimate Frida,* 124–125.

42. Kahlo, *Intimate Frida,* 164.

43. Marnham, *Dreaming,* 28.

44. Marnham, *Dreaming,* 28.

45. Marnham, *Dreaming,* 28.

46. Rivera, *My Art, My Life,* 20.

47. Rivera, *My Art, My Life,* 21.

48. Marnham, *Dreaming,* 29.

49. Rivera, *My Art, My Life,* 21–22.

50. For more information on Diego's behavior toward his ill son, see Marnham, *Dreaming,* 133–134.

51. Sarah Faithful, "Mexico's Choice: Abortion Laws and Their Effects Throughout Latin America," Council on Hemispheric Relations, September 238, 2016, 1.

52. Dr. Henriette Begun, obstetrician-gynecologist, wrote down Frida's medical history in 1946, published in Salomon Grimberg, *Frida Kahlo: Song of Herself* (London: Merrell, 2008), 116. The second account of the fetus being in the wrong position comes from Herrera, *Frida,* 106.

53. Herrera, *Frida,* 106.

54. Olga Campos interview with Frida, 1950, in Grimberg, *Song of Herself,* 74.

55. Breton became interested in Freud during World War I, but the interest in alchemy developed around 1928. See M. E. Warlick, *Max Ernst and Alchemy: A Magician in Search of Myth* (Austin: University of Texas Press, 2001), 100.

56. Charles Q. Choi, "Peace of Mind: Near-Death Experiences Now Found to Have Scientific Explanations," *Scientific American,* September 12, 2011, 2.

57. Irwin Lee, "Mystical Knowledge and the Near-Death Experience," in *Death, Dying, and Mysticism: The Ecstasy of the End,* ed. Thomas Cattoi and Christopher M. Moreman (New York: Palgrave Macmillan, 2015), 154.

58. Dennis William Hauck, *The Complete Idiot's Guide to Alchemy* (New York: Alpha, 2008), 29. Frida's color combinations of white, black, and red are also significant in alchemy. One of Frida's alembic vessels contains a white substance and the other a black substance on the bottom with white at the top. Within the alchemical process, the first step involves the breaking down of matter into its component parts, which is the black phase, referred to as *nigredo.* In the second step, the whitening or *albedo* phase, the component parts are washed. And in the third phase, the reddening or *rubedo* stage, the washed ingredients merge into a transformed new metal, such as gold.

FOUR: RULES OF MATRIMONIAL ENGAGEMENT

1. Letter from Frida to her mother, December 11, 1930, NMWA.

2. Letter from Frida to her mother, December 11, 1930, NMWA.

3. Letter from Frida to her mother, November 14, 1930, NMWA.

4. Letter from Frida to her mother, December 25, 1930, NMWA.

5. To read about research on creativity and the ability to enter into a state of "flow," see Scott Barry Kaufman and Carolyn Gregoire, *Wired to Create: Unraveling the Mysteries of the Creative Mind* (New York: Perigee, 2015), 30.

6. Letter from Frida to her mother, December 4, 1930, NMWA.

7. Letter from Frida to her mother, December 25, 1930, NMWA.

8. Luis-Martín Lozano, "The Esthetic Universe of Frida Kahlo," in Carlos Monsiváis et al., *Frida Kahlo,* trans. Mark Eaton and Luisa Panichi (Boston: Bulfinch, 2000), 68.

9. Letter from Guillermo Kahlo to Frida, August 8, 1932, and letter from Matilde to Frida, April 8, 1932, NMWA.

10. Notes in John Weatherwax,"The Queen of Montgomery Street," John Weatherwax Papers, 1928–1933, Archives of American Art, Smithsonian Institution, Washington, DC.

11. Notes in Weatherwax, "The Queen of Montgomery Street."

12. Notes in Weatherwax, "The Queen of Montgomery Street."

13. Notes in Weatherwax, "The Queen of Montgomery Street."

14. Letter from Frida to her father, November 14, 1930, NMWA.

15. Dr. William Valentiner File, Detroit Institute of Arts Library.

16. Hayden Herrera, *Frida: A Biography of Frida Kahlo* (New York: Harper Perennial, 2002), 117–118.

17. It's difficult to see details in a reproduction. My observations are based upon seeing the original at the Harry Ransom Research Center, University of Texas at Austin.

18. Letter from Frida to her mother, December 11, 1930, NMWA.

19. Letter from Frida to her mother, December 25, 1930, NMWA.

20. All the information about the New Year's celebration comes from a January 1, 1931, letter Frida wrote to her mother, NMWA.

21. Letter from Frida to her mother, January 1, 1931, NMWA.

22. Letter from Frida to her mother, January 1, 1931, NMWA.

23. Notes in Weatherwax, "The Queen of Montgomery Street."

24. Letter from Frida to her mother, January 15, 1931, NMWA.

25. Letter from Frida to her mother, January 24, 1931, NMWA.

26. Mark Micale's book *Male Hysteria* is discussed by Abigail Tucker in "History of the Hysterical Man," Smithsonian.com, January 5, 2009. As of 1980, hysteria is no longer classified as a mental disorder.

27. Letter from Guillermo Kahlo to Frida, September 4, 1932, NMWA.

28. Isolda P. Kahlo, *Intimate Frida* (Buenos Aires: Gato Azul, 2005; Bogotá: Cangrejo, 2006), 57.

29. Kahlo, *Intimate Frida,* 57.

30. Letter from Frida to her mother, December 11, 1930, NMWA.

31. Letter from Frida to her mother, December 11, 1930, NMWA.

32. Letter from Frida to her mother, January 13, 1931, NMWA.

33. Letter from Frida to her mother, January 24, 1931, NMWA.

34. Letter from Frida to her mother, February 12, 1931, NMWA.

35. Letter from Frida to her mother, November 21, 1930, NMWA.

36. Letter from Frida to her mother, November 21, 1930, NMWA.

37. Letter from Matilde to Frida, April 8, 1932, NMWA.

38. Letter from Matilde to Frida, April 8, 1932, NMWA.

39. Letter from Matilde to Frida, April 8, 1932, NMWA.

40. Letter from Matilde to Frida, April 8, 1932, NMWA.

41. Herrera, *Frida,* 14.

42. Letter from Frida to Diego, in Kahlo, *Frida by Frida,* 104.

43. Letter from Frida to her mother, January 24, 1931, NMWA.

44. Letter from Frida to Diego, September 10, 1932, NMWA.

45. Weatherwax, "The Queen of Montgomery Street."

46. Weatherwax, "The Queen of Montgomery Street."

47. Herrera, *Frida,* 117.

48. Carlos Fuentes, "Introduction," in Frida Kahlo, *The Diary of Frida Kahlo: An Intimate Self-Portrait,* ed. Phyllis Freeman (New York: Harry N. Abrams, 1995), 15.

49. From a critic's review quoted in Anthony W. Lee, *Painting on the Left: Diego Rivera, Radical Politics, and San Francisco's Public Murals* (Berkeley: University of California Press, 1999), 73.

50. Diego Rivera with Gladys March, *My Art, My Life* (New York: Citadel Press, 1960), 172.

51. Rivera, *My Art, My Life,* 287–288.

52. Quote from Plinio Apuleyo Mendoza's 1983 interview "Women; Superstitions, Manias, and Taste; Work" in David Streitfeld, ed. *The Last Interview: Gabriel García Márquez and Other Conversations* (London: Melville House, 2015), 34.

53. The literature on Diego Rivera states that he began working on his mural on January 17;

however, a letter from Frida dated January 24 states that Diego had begun work three days prior, which would mean he began painting on January 21.

54. Esther Johnson, "Rivera, Sketching Helen Wills, Calls Her Typical 'Modern American Girl,'" *San Francisco Chronicle,* December 10, 1930, 4.

55. Charles Chapman, *A History of California: The Spanish Period* (New York: Macmillan, 1921), 65. Montalvo's story was inspired by Columbus's adventures in the fifteenth century when he was searching for the land of riches where beautiful women wore gold and pearls. In Montalvo's version, California is an island of earthly paradise inhabited only by beautiful black women who wear armor made out of gold. *The Adventures of Esplandian* had struck a chord with Hernán Cortés, and when he landed on what is today Baja California, he proclaimed to his crew that they had arrived in Calafia's land.

56. Sally B. Woodbridge, *San Francisco Architecture* (San Francisco: Chronicle Books, 1992), 61.

57. Diego deviated not only from the black queen Califia but from the image of Athena (the Greek goddess of wisdom, warfare, and good governance) depicted on the California seal, adopted in 1849.

58. Diego quoted in Luis-Martín Lozano and Juan Rafael Coronel Rivera, *Diego Rivera: The Complete Murals* (New York: Taschen, 2008), 283.

59. Quoted in Lee, *Painting on the Left,* 72.

60. Tuce Hedrick, *Mestizo Modernism: Race, Nation, and Identity in Latin American Culture* (New Brunswick, NJ: Rutgers University Press, 2003), 151.

61. I use the word "fertile" based on this quote by Diego: "I painted a female nude in billowing clouds, symbolizing the fertility of the earth," quoted in Lozano and Coronel Rivera, *Diego Rivera: Complete Murals,* 284.

62. Letter from Frida to her mother, January 24, 1931, NMWA.

63. Rivera, *My Art, My Life,* 176.

64. Lee, *Painting on the Left,* 72.

65. Lee, *Painting on the Left,* 72.

66. Frida's friend Aurora Reyes made this comment about how Frida seemed to float above the ground when she walked. Elena Poniatowska and Carla Stellweg, eds., *Frida Kahlo: The Camera Seduced* (San Francisco: Chronicle Books, 1992), 107.

67. Erin O'Toole, "A Very Human Thing: The Arts Patronage of Albert Bender," in *Seventy-Five Years of Looking Forward* (San Francisco: San Francisco Museum of Modern Art, 2010), 1–2.

68. H. L. Dungan, "Three Exhibitions Open at Legion of Honor in S.F.," *Oakland Tribune,* November 8, 1931, 6.

69. Exhibition catalog, Institute of Modern Art, Boston, 1941.

70. "Modern Mexican Paintings," *Oakland Tribune,* May 10, 1942.

71. Albert Bender File, Special Collections, F. W. Olin Library, Mills College, Oakland, CA.

72. Fuentes, "Introduction," 22.

73. Fuentes, "Introduction," 22.

FIVE: PHOTOGENIC FRIDA

1. Photographs, letters, and documents from the Isolda P. Kahlo archive have shed new light on the family relationships. See Luis-Martín Lozano, *Frida Kahlo: The Circle of Affections* (Toluca de Lerdo: Fondo Editorial, Estado de México, 2015), 65.

2. Hayden Herrera, *Frida: A Biography of Frida Kahlo* (New York: Harper Perennial, 2002), 6.

3. Herrera, *Frida,* 19.

4. María Luisa Kahlo, Guillermo's eldest daughter from his first marriage, told this to Hayden Herrera in 1977; *Frida,* 7.

5. The use of inscriptions at the bottom of photographs can also be seen on a photo of Frida's

mother dated February 7, 1926: "When you see this portrait remember how much your mother loved each one of you." See Lozano, *The Circle of Affections*, 64.

6. Olga Campos interview with Frida, 1950, in Salomon Grimberg, *Frida Kahlo: Song of Herself* (London: Merrell, 2008), 85.

7. Edward Weston, *The Daybooks of Edward Weston*, ed. Nancy Newhall (New York: Aperture, 1973), 198.

8. This shawl can be seen in color in Denise Rosenzweig's *Self Portrait in a Velvet Dress* (San Francisco: Chronicle Books, 2007), 168.

9. Letter from Frida to her mother, December 18, 1930, NMWA.

10. Timothy Egan, *Short Nights of the Shadow Catcher: The Epic Life and Immortal Photographs of Edward Curtis* (New York: Houghton Mifflin Harcourt, 2012), 215.

11. Weston, *Daybooks*, 152–153. Edward wrote about photographing Tony Luhan on both April 9 and April 12, 1930.

12. Not everyone idealized the indigenous; archaeologist Manuel Gamio, who had studied under Franz Boas at Columbia University in New York, promoted culture rather than race as the shaper of people's development and characteristics. He viewed indigenous religion, culture, and language as inferior. For more see, Galadriel Mehera Gerardo, "Writing Africans Out of the Racial Hierarchy: Anti-African Sentiment in Post-Revolutionary Mexico," *Cincinnati Romance Review* 30 (2011): 179.

13. "Imogen Cunningham: Portraits, Ideas, and Design," interview by Edna Tartaul Daniel, University of California General Library/Berkeley Regional Cultural History Project, March 7, 1961; taped interviews from June 1959, conducted at Imogen's home at 1331 Greene Street, San Francisco, transcript 109.

14. "Imogen Cunningham: Portraits, Ideas, and Design," 109.

15. Margery Mann interview with Imogen Cunningham, 1973, microfilm reel #5051, Archives of American Art, Washington, DC.

16. Mann Interview with Imogen Cunningham.

17. Mann Interview with Imogen Cunningham.

18. Hulleah J. Tsinhnahjinnie, "When Is a Photograph Worth a Thousand Words?," in *Photography's Other Histories*, ed. Christopher Pinney and Nicolas Peterson (Durham, NC: Duke University Press, 2003), 44.

19. Margery Mann interview with Imogen Cunningham, 1973, microfilm reel #5051, Archives of American Art, Washington, DC.

20. It's possible that the Mixtec may have made this style of earring for the Aztecs to pay tribute. The Mixtec were based in Oaxaca, Frida's mother's birthplace.

21. Elin Sand, *Woman Ruler: Woman Rule* (San Jose, CA: iUniverse, 2001), 229.

22. A similar color version can be found in Rosenzweig's *Self Portrait in a Velvet Dress*, 164.

23. Rebecca Block and Lynda Hoffman-Jeep, "Fashioning National Identity: Frida Kahlo in 'Gringolandia,'" *Woman's Art Journal* 19, no. 2 (1998): 10.

24. Elena Poniatowska, *Las Soldaderas: Women of the Mexican Revolution*, trans. David Dorado Romo (El Paso, TX: Cinco Punto Press, 2006).

25. Letter from Frida to her mother, January 13, 1931, NMWA.

26. In 1923, black women were only allowed to make an appearance at the Miss America contest as dancers acting out the part of slaves. For more on race and beauty pageants, see Elizabeth King, "A Look Back at the Sexist, Racist History of Beauty Pageants," March 7, 2016, http://www.racked.com/2016/3/7/11157032/beauty-pageant-history.

27. López, "La India Bonita Contest of 1921," 299.

28. Translated in López, "La India Bonita Contest of 1921," 308.

29. López, "La India Bonita Contest of 1921," 310.

30. In "La India Bonita Contest of 1921," 324, López details the story of Maria's life in order to show how the image was quite different from reality.

31. Olga Campos interview with Frida Kahlo, October 27, 1950, in Grimberg, *Song of Herself*, 68.

32. Campos interview with Frida, in Grimberg, *Song of Herself*, 68.

33. Campos interview with Frida, in Grimberg, *Song of Herself*, 68.

34. Campos interview with Frida, in Grimberg, *Song of Herself*, 68.

35. Herrera, *Frida*, 43, 453.

36. Campos interview with Frida, in Grimberg, *Song of Herself*, 68.

37. Although this print was made in 1925, it wasn't published until October 1933, in a volume of poetry by Ernesto Hernández Bordes, *Caracol de distancias*, printed by Miguel N. Lira and Fidel Guerrero. See Frida Kahlo, *Frida by Frida: Selection of Letters and Texts*, ed. Raquel Tibol (Mexico City: Editorial RM, 2003), frontispiece.

38. Both quotes from Frida come from Campos interview with Frida, in Grimberg, *Song of Herself*, 103.

39. Block and Hoffman-Jeep, "Fashioning National Identity," 11.

SIX: PORTRAITURE AND NEW FRIENDSHIPS

1. Pele deLappe, *Pele: A Passionate Journey Through Art and the Red Press* (Petaluma, CA: Central A&M, 1997), 9.

2. DeLappe, *A Passionate Journey*, 7.

3. Chris Carlsson video interview with Pele deLappe, www.foundsf.org.

4. Emmy Lou Packard interview with Pele deLappe, April 5, 1983, page 1 of transcript, Rivera Archive, City College of San Francisco.

5. DeLappe, *A Passionate Journey*, 9.

6. DeLappe, *A Passionate Journey*, 10.

7. DeLappe, *A Passionate Journey*, 9.

8. Emmy Lou Packard interview with Pele deLappe, April 5, 1983, page 2 of transcript, Rivera Archive, City College of San Francisco.

9. DeLappe, *A Passionate Journey*, 9.

10. Tad Wise, "Pele the Conqueror!," *Woodstock Times*, October 5, 2013, 2.

11. DeLappe, *A Passionate Journey*, 8–9.

12. DeLappe, *A Passionate Journey*, 9.

13. Hayden Herrera, *Frida: A Biography of Frida Kahlo* (New York: Harper Perennial, 2002), 117.

14. *The Free Societal Encyclopedia*, alchertron.com.

15. This statement was made to Lee Krasner by Hans Hofmann in the 1940s, but there are many examples of this same type of statement being made to women artists throughout the ages. See Ann Eden Gibson's *Abstract Expressionism: Other Politics* (New Haven, CT: Yale University Press, 1997), 7–10.

16. Joanna Woodall, ed., *Portraiture: Facing the Subject* (Manchester: Manchester University Press, 1997), 7.

17. John Weatherwax, "The Queen of Montgomery Street," John Weatherwax Papers, 1928–1933, Archives of American Art, Smithsonian Institution, Washington, DC.

18. Letter from Frida to her mother, January 13, 1931, NMWA.

19. Frida's letter to Dr. Eloesser, March 15, 1941, in *Querido Doctorcito: Frida Kahlo–Leo Eloesser: Correspondencia = Correspondence* (Mexico City: DGE Equilibrista, 2007), 186–187.

20. Coral from the Mediterranean was imported to Mexico by the Spanish.

21. "Divorced Artist Still Loves Diego Rivera," *Evening Herald and Express*, December 30, 1939.

22. Harris B. Shumacker Jr., *Leo Eloesser, M.D.: Eulogy for a Free Spirit* (New York: Philosophical Library, 1982), 245.

23. Interview with Olga Campos, in Salomon Grimberg, *Frida Kahlo: Song of Herself* (London: Merrell, 2008), 91.

24. Campos interview with Frida in Grimberg, *Song of Herself*, 36.

25. Letter from Frida to Dr. Eloesser, March 15, 1941, in *Querido Doctorcito*, 185.

26. Frida quoted in Herrera, *Frida*, 250.

27. Letter from Frida to Dr. Eloesser, March 15, 1941, in *Querido Doctorcito*, 187.

28. Carlos Fuentes, "Introduction," in Frida Kahlo, *The Diary of Frida Kahlo: An Intimate Self-Portrait*, ed. Phyllis Freeman (New York: Harry N. Abrams, 1995), 22.

29. Celia S. Stahr, "Frida Kahlo: American Nationalism, and The New *Mestiza* Woman," in *Essays on Women's Artistic and Cultural Contributions 1919–1939*, ed. Paula Birnbaum and Anna Novakov (Toronto: Edwin Mellen Press, 2009), 142–143.

30. Campos interview with Frida, in Grimberg, *Song of Herself*, 67.

31. Besides using lines to diagram the focal points, Frida drew three eyes around the outside of the Golden Rectangle. *The Diary of Frida Kahlo*, 266.

32. Emmy Lou Packard notes based upon letter from Prentise Barrows, Albert's widow, October 1989, and Packard interview with John Weatherwax, February 13, 1987, both in Diego Rivera Archive, City College of San Francisco.

33. Packard interview with John Weatherwax, February 13, 1987, Diego Rivera Archive, City College of San Francisco.

34. This is taken from Jay Hambridge's 1926 book *The Elements of Dynamic Symmetry*, which Barrows and Diego loved. The square and diagonal bisecting it, according to Hambridge, provide remarkable shapes and constitutes the best architectural plan for the human figure.

35. Luis-Martin Lozano and Juan Rafael Coronel Rivera, *Diego Rivera: The Complete Murals* (Hong Kong: Taschen, 2008), 284.

36. Emmy Lou Packard, notes on Rivera's *Allegory of California* mural, Diego Rivera Archive, City College of San Francisco.

37. While Frida's March 12, 1931, letter to her mother conveys that Diego finished his mural prior to March 25, when the "Scottsboro Boys" were arrested, it's possible Diego could have made changes to his mural after hearing the news and possibly seeing a picture of the nine youths in the newspapers on March 26. It's more likely that he was thinking about the lynching of black men in general.

38. Emmy Lou Packard, notes on Rivera's *Allegory of California* mural, Diego Rivera Archive, City College of San Francisco.

39. Victor Fosado, "The Intuition of Retablo Painters and the Passion of Frida," in *The World of Frida Kahlo*, ed. Erika Billeter (Frankfurt: Kulturegesellschaft Frankfurt, 1993), 2.

40. William Blaisdell, "Leo Eloesser: The Remarkable Story of a Medical Volunteer in Spain," *The Volunteer*, December 3, 2016, 1.

41. Shumacker, *Leo Eloesser*, 231.

42. Blaisdell, "Leo Eloesser," 2.

43. Shumacker, *Leo Eloesser*, 241.

44. Shumacker, *Leo Eloesser*, 241.

45. Leo Eloesser letter to Frida, March 19, 1941, in *Querido Doctorcito*, 194.

46. Shumacker, *Leo Eloesser*, 235.

47. Shumacker, *Leo Eloesser*, 235.

48. Shumacker, *Leo Eloesser*, 236.

49. Website for the Zuckerberg San Francisco General Hospital and Trauma Center, http://sfgh .ucsf.edu/frida-kahlo.

50. Shumacker, *Leo Eloesser*, 248.

SEVEN: LUTHER BURBANK'S HYBRIDITY

1. The film was made between November 1941 and January 1942, and while it was a box office hit with memorable Irving Berlin songs, such as "White Christmas," it also contains a music and dance scene of Bing Crosby in blackface as Abraham Lincoln and Marjorie Reynolds's character Linda Mason in blackface as well. This scene conveys how racist imagery was acceptable in mainstream America ten years after Frida had visited the United States.

2. For information on the Bohemian Club, see sociologist G. William Domhoff's book *The Bohemian Grove and Other Retreats: A Study in Ruling-Class Cohesiveness* (London: Harper Torchbooks, 1975).

3. Letter from Frida to her mother, November 21, 1930, NMWA.

4. *Yesterday and Today: Luther Burbank Home and Gardens* (Santa Rosa, CA: Luther Burbank Home and Gardens, 1998), 14.

5. *Yesterday and Today,* 14.

6. Luther Burbank and Wilbur Hall, *The Harvest of the Years* (New York: Houghton Mifflin, 1927), 48.

7. *Yesterday and Today,* 4.

8. *Yesterday and Today,* 3.

9. Burbank and Hall, *The Harvest of the Years,* 44.

10. Burbank and Hall, *The Harvest of the Years,* 1. Luther's scientific articles concerning the effects of environment upon plants didn't seem to raise concerns for those in the eugenics movement because the American Breeders' Association, established in 1903, with its section on eugenics forming in 1906, made him an honorary member. This association was devoted to investigating and reporting on heredity in the human race and emphasizing the value of superior blood and the social threat of inferior blood. Despite Luther's honorary membership, he didn't seem to promulgate the ideas of the eugenics movement. See William D. Stansfield, "Luther Burbank: Honorary Member of the American Breeders' Association," *Journal of Heredity* 97 (March/April 2006): 95–99.

11. "Kahlo, Rivera and Burbank," Luther Burbank Home and Gardens Archive.

12. The photograph is housed at the Hoover Institution Archives, Stanford University, Ella Wolfe Collection.

13. Sarah Lowe, *Frida Kahlo* (New York: Universe, 1991), 80.

14. Emmy Lou Packard interview with Michael Goodman, March 14, 1987, Diego Rivera Archive, City College of San Francisco.

15. Rosamond Bernier, *Some of My Lives: A Scrapbook Memoir* (New York: Farrar, Straus and Giroux, 2011), 63.

16. Diego often referred to this book by Lord Kingsborough. He was introduced to Father de Sahagún's codices while working on his murals at the National Palace in Mexico City from 1929 through 1935. On his use of Aztec sources, see Barbara Braun, *Pre-Columbian Art and the Post-Columbian World* (New York: Harry Abrams, 1993), 215, 246 n. 58. Frida was also influenced by these same sources. She was well read, exclaiming in a journal entry dated November 1952: "I have read the history of my country and almost all the peoples." Many sources would have been available to Frida on Aztec culture prior to 1931. There were excavations taking place, and Braun notes that some of these codices were visible in the Mexican National Museum.

17. The most well-known "tree" image graces the cover of the Codex Fejervary-Mayer. It is a complex diagram of both space and time according to the 260 days of the ritual calendar. The central deity Xiuhtecuhti, god of fire and of time, is surrounded by four directional trees, with east at the top, which for the Aztecs meant the first day. Counting in a counterclockwise direction, the tree of the north is on the left, the tree of the west resides at the bottom, and the tree of the south is placed on the right. Each tree's direction has its own symbolism. For

more information on Frida and the Aztec cosmic trees, see Sharyn Rohlfsen Udall, *Carr, O'Keeffe, Kahlo: Places of Their Own* (New Haven: Yale University Press, 2000), 162.

18. Lucretia Giese, "A Rare Crossing: Frida Kahlo and Luther Burbank," *American Art* 15, no. 1 (January 2001): 58. According to Gannit Ankori, Frida obtained the photograph of Luther holding a philodendron on her visit to Luther's gardens. See *Frida Kahlo* (London: Reaktion Books), 77.

19. Burbank and Hall, *The Harvest of the Years*, 46.

20. Wanda Corn, "The Birth of a National Icon: Grant Wood's *American Gothic*," *Art Institute of Chicago Museum Studies* 10 (1983): 252–275.

21. Gannit Ankori, *Frida Kahlo* (London: Reaktion Books, 2013), 79.

22. Frida's letter to Isabel Campos, May 3, 1931, reproduced in Frida Kahlo, *Frida by Frida: Selection of Letters and Texts,* ed. Raquel Tibol (Mexico City: Editorial RM, 2003), 82–83.

EIGHT: INTERLUDE

1. Letter from Frida to her mother, May 21, 1931, NMWA.

2. Letter from Frida to her mother, May 21, 1931, NMWA.

3. See Frida Kahlo, *Frida by Frida: Selection of Letters and Texts,* ed. Raquel Tibol (Mexico: Editorial RM, 2003), 84, and Salomon Grimberg, *I Will Never Forget You: Frida Kahlo and Nickolas Muray* (San Francisco: Chronicle Books, 2004), 14. Grimberg thinks Frida met Nick in Mexico in May.

4. For Frida's niece Isolda, this indicates that her aunt wrote from San Francisco but included the incorrect heading "Coyoacán." See Isolda P. Kahlo, *Intimate Frida* (Buenos Aires: Gato Azul, 2005; Bogotá: Cangrejo, 2006), 248.

5. Nickolas Muray Papers, 1910–1978, Archives of American Art, Smithsonian Institution, Washington, DC (henceforth "Muray Papers"), Box 1, Folder 10, "Kahlo, Frida, 1931–1940."

6. Muray Papers, Box 1, Folder 10, "Kahlo, Frida, 1931–1940."

7. The Harry Ransom Center, where the drawing is housed, has speculated that the drawing could have been given to Nick later in 1939.

8. Leah Dickerman, *Diego Rivera: Murals for the Museum of Modern Art* (New York: Museum of Modern Art, 2011), 22.

9. Dickerman, *Diego Rivera,* 22.

10. Dickerman, *Diego Rivera,* 22.

11. Leah Dickerman video interview with David Rockefeller, 2012, in conjunction with the exhibition "Diego Rivera: Murals for the Museum of Modern Art."

12. Letter from Frida to her mother, November 16, 1931, NMWA.

13. Hayden Herrera, *Frida: A Biography of Frida Kahlo* (New York: Harper Perennial, 2002), 128.

14. Herrera, *Frida,* 129.

NINE: DUPLICITOUS NEW YORK

1. Letter from Frida to her mother, November 16, 1931, NMWA.

2. Letter from Frida to her mother, November 23, 1931, NMWA.

3. "Barbizon-Plaza Hotel," New York City Chapter of the American Guild of Organists, n.d., http://www.nycago.org/Organs/NYC/html/BarbizonPlazaHotel.html.

4. Suzanne Barbezat, *Frida Kahlo at Home* (London: Francis Lincoln, 2016), 71.

5. Letter from Frida to her mother, November 23, 1931, NMWA.

6. Letter from Frida to her mother, November 20, 1931, NMWA.

7. Letter from Frida to her mother, November 23, 1931, NMWA.

8. Letter from Frida to her mother, November 16, 1931, NMWA.

9. Letter from Frida to her mother, November 23, 1931, NMWA.

10. Darlene Rivas, *Missionary Capitalism: Nelson Rockefeller in Venezuela* (Chapel Hill: University of North Carolina Press, 2002), ch. 1.

11. Josefina Zoraida Vázquez and Lorenzo Meyer, *The United States and Mexico* (Chicago: University of Chicago Press, 1987), 20.

12. Leah Dickerman and Anna Indych-López, *Diego Rivera: Murals for the Museum of Modern Art* (New York: Museum of Modern Art, 2011), 41.

13. Letter from Frida to her mother, November 27, 1931, NMWA.

14. Letter from Frida to her mother, November 27, 1931, NMWA.

15. Rebecca Paul, "The History of Central Park's Hooverville, the Great Depression Pop-Up Shanty Towns," *6sqft,* November 17, 2015, https://www.6sqft.com/the-history-of-central-parks-hooverville-the-great-depression-pop-up-shanty-town.

16. Paul, "The History of Central Park's Hooverville."

17. Letter from Frida to her mother, November 27, 1931, NMWA.

18. Letter from Frida to her mother, November 27, 1931, NMWA.

19. Letter from Frida to her mother, November 20, 1931, NMWA.

20. Letter from Frida to her mother, November 20, 1931, NMWA.

21. Letter from Frida to her mother, November 20, 1931, NMWA.

22. Letters from Frida to her mother, November 20 and November 16, 1931, NMWA.

23. Letter from Frida to her mother, November 16, 1931, NMWA.

24. Letter from Frida to her mother, November 20, 1931, NMWA.

25. Letter from Frida to her mother, November 20, 1931, NMWA.

26. Letter from Frida to her mother, November 20, 1931, NMWA.

27. Letter from Frida to her mother, November 20, 1931, NMWA.

28. Letter from Frida to her mother, November 23, 1931, NMWA.

29. "Rivera," *New Yorker,* December 19, 1931, 15.

30. Frances Toor, *Modern Mexican Artists* (Mexico City: Frances Toor Studios, 1937), 36.

31. Toor, *Modern Mexican Artists,* 36.

32. Adriana Williams, *Covarrubias* (Austin: University of Texas Press, 2011), 145.

33. Williams, *Covarrubias,* 144.

34. Letter from Frida to her mother, December 26, 1931, NMWA.

35. Letter from Frida to her mother, December 26, 1931, NMWA.

36. Letter from Frida to Dr. Eloesser, May 26, 1932; the translation is taken from Hayden Herrera, *Frida: A Biography of Frida Kahlo* (New York: Harper Perennial, 2002), 132.

37. Letter from Carl Van Vechten to MoMA, January 8, 1932, MoMA Archives, Collection: MoMA Exhibitions, Series Folder 14.2.

38. Letter from Carl Van Vechten to MoMA, November 24, 1931, MoMA Archives, Collection: MoMA Exhibitions, Series Folder 14.2.

39. Margaret Hooks, *Frida Kahlo: Portraits of an Icon* (New York: Throckmorton Fine Art, 2002), 19.

40. Williams, *Covarrubias,* 138.

41. Letter from Frida to her mother, November 23, 1931, NMWA.

42. Letter from Frida to her mother, November 23, 1931, NMWA.

43. A didactic panel at the exhibition "Frida Kahlo and Diego Rivera" (Natasha and Jacques Gelman Collection), Heard Museum, Phoenix, June–September 2017, stated that *Landscape with Cacti* was created for Diego's MoMA show as a response to Frida's relationship with Nick Muray.

44. Letter from Frida to her mother, November 23, 1931, NMWA.

45. Letter from Frida to her mother, November 27, 1931, NMWA.

46. Letter from Frida to her mother, November 27, 1931, NMWA.

47. Letter from Frida to her mother, November 28, 1931, NMWA.

48. Bloch interview with Mary Fuller McChesney, August 11, 1964, 43, Box 1, Folder 2, Detroit Institute of Arts Research Library and Archives.

49. Letter from Frida to her mother, November 28, 1931, NMWA.

50. Letter from Frida to her mother, November 28, 1931, NMWA.
51. Letter from Frida to her mother, November 30, 1931, NMWA.
52. Letter from Frida to her mother, November 30, 1931, NMWA.
53. "Great Depression Timeline," http://great-depression-facts.com/great-depression-timeline/112.
54. Letter from Frida to her mother, November 30, 1931, NMWA.
55. Letter from Frida to her mother, November 30, 1931, NMWA.
56. Letter from Frida to her mother, December 4, 1931, NMWA.
57. Letter from Frida to her mother, December 4, 1931, NMWA.
58. Letter from Frida to her mother, December 4, 1931, NMWA.
59. Letter from Frida to her mother, December 4, 1931, NMWA.
60. Letter from Frida to her mother, December 4, 1931, NMWA.
61. Letter from Frida to her mother, December 4, 1931, NMWA.

TEN: THE SILENCED SCREAM

1. Letter from Frida to her mother, November 30, 1931, NMWA.
2. Hayden Herrera, *Frida: A Biography of Frida Kahlo* (New York: Harper Perennial, 2002), 233.
3. Salomon Grimberg, "The Lost Desire: Frida Kahlo in Detroit," in Mark Rosenthal et al., *Diego Rivera and Frida Kahlo in Detroit* (New Haven, CT: Yale University Press, 2015), 148. Grimberg offers a very different interpretation of *Window Display on a Street in Detroit,* connecting it to Frida's miscarriage.
4. Florence Davies, "Wife of the Master Mural Painter Gleefully Dabbles in Works of Art," *Detroit News,* February 2, 1933. Grimberg thinks Frida may have been inspired by the Currier and Ives print entitled *Washington's Reception by the Ladies, on Passing the Bridge at Trenton, N.J.* (1789), *Diego Rivera and Frida Kahlo in Detroit,* 147.
5. Letter from Frida to her mother, January 20, 1932, in Frida Kahlo, *Frida by Frida: Selection of Letters and Texts,* ed. Raquel Tibol (Mexico City: Editorial RM, 2003), 88.
6. Herrera, *Frida,* 105.
7. Herrera, *Frida,* 105.
8. I verified this with Lori Salmon, Art and Architecture Librarian at the New York Public Library, email, December 22, 2017.
9. Herrera, *Frida,* 130.
10. Letter from Frida to her mother, December 18, 1931, NMWA.
11. Letter from Frida to her mother, January 8, 1932, NMWA.
12. Herrera, *Frida,* 130.
13. Herrera, *Frida,* 130.
14. Herrera, *Frida,* 130.
15. Herrera, *Frida,* 130.
16. Herrera, *Frida,* 130.
17. Herrera, *Frida,* 130.
18. Pete Hamill, *Diego Rivera* (New York: Abrams, 1999), 154.
19. Letter from MoMA Registrar to Georgia O'Keeffe, January 23, 1932, MoMA Archives, Collection: MoMA Exhibitions, Series Folder 14.2.
20. Letter from Frida to Georgia, March 1933, Beinecke Rare Book and Manuscript Library, Yale University. The letter is also published in Sharyn Rohlfsen Udall, *Carr, O'Keeffe, and Kahlo: Places of Their Own* (New Haven, CT: Yale University Press, 2000), 286–287.
21. Alicia Inez Guzman, *Georgia O'Keeffe at Home* (London: Francis Lincoln, 2017), 69.
22. Anita Pollitzer, *A Woman on Paper: Georgia O'Keeffe* (New York: Touchstone, 1988), 207.
23. Guzman, *Georgia O'Keeffe at Home,* 69.
24. Pollitzer, *A Woman on Paper,* 204.

25. Whitney Chadwick, *Women, Art, and Society* (London: Thames and Hudson, 2002), 306.

26. Chadwick, *Women, Art, and Society,* 306.

27. Pollitzer, *A Woman on Paper,* 195; Barbara Buhler Lynes, *O'Keeffe, Stieglitz and the Critics, 1916–1929* (Chicago: University of Chicago Press, 1989), 69, 120, 92; Benita Eisler, *O'Keeffe and Stieglitz: An American Romance* (New York: Penguin Books, 1991), 277.

28. Eisler, *O'Keeffe and Stieglitz,* 277.

29. Eisler, *O'Keeffe and Stieglitz,* 235.

30. Herrera, *Frida,* 198.

31. Lucienne Bloch, January 10, 1932, unpublished journal entry, access and copies granted by Lucienne Allen in 2015, Old Stage Studios (henceforth "Bloch, unpublished journal"). Some portions of the journal have been published.

32. The letter Frida sent to Clifford was written while Frida was in New York a second time, in April 1933. Frida tells Clifford that she isn't able to see Georgia in 1933 and therefore "she didn't make love to me that time" (*Frida by Frida,* 109). This implies that Georgia had made love to Frida the first time she was in New York, November 1931–April 1932.

33. Eisler, *O'Keeffe and Stieglitz,* 425.

34. Eisler, *O'Keeffe and Stieglitz,* 424.

35. Hunter Drohojowska-Philp, *Full Bloom: The Art and Life of Georgia O'Keeffe* (New York: W. W. Norton, 2004), 335, Drohojowska-Philp says Georgia entered their home to find Stieglitz photographing Norman nude. Eisler says Georgia entered either their home or the gallery, An American Place; *O'Keeffe and Stieglitz,* 427.

36. Art historian Sharyn Udall, who wrote *Carr, O'Keeffe, Kahlo: Places of Their Own* (New Haven, CT: Yale University Press, 2000), said she thought Georgia probably had romantic relationships with women; conversation with the author, January 8, 2018. Eisler discusses three important relationships Georgia had with women, which were complicated and emotionally intense: those with Leah Harris, Rebecca Strand, and Maria Chabot. According to art writer Calvin Tompkins, Paul Strand knew his wife had had an affair with Georgia, see Eisler, *O'Keeffe,* 516–517. See also Chabot's unpublished "Personal Reflections," which conveys her intense feelings for O'Keeffe, housed at the Georgia O'Keeffe Museum Research Center Archives. For published letters, see *Maria Chabot–Georgia O'Keeffe: Correspondence 1941–1949* (Albuquerque: University of New Mexico Press, 2003).

37. Letter from Georgia to Alfred, October 8, 1942, Letters to Alfred Stieglitz, 1933–1944, Beinecke Rare Book and Manuscript Library, Yale University.

38. For a fuller discussion, see Havelock Ellis, *Studies in the Psychology of Sex: Sexual Inversion,* 3rd ed. (Philadelphia: F. A. Davis, 1922).

39. Linda M. Grasso, *Equal Under the Sky: Georgia O'Keeffe and Twentieth Century Feminism* (Albuquerque: University of New Mexico Press, 2017), 65.

40. Celeste Connor, *Democratic Visions: Art and Theory of the Stieglitz Circle, 1924–1934* (Berkeley: University of California Press, 2001), 191. Georgia used the phrase "the Great American Thing" in a letter. See also Wanda M. Corn, *The Great American Thing: Modern Art and National Identity 1915-1935* (Berkeley: University of California Press, 1999).

41. Pollitzer, *A Woman on Paper,* 212.

42. Drohojowska-Philp, *Full Bloom,* 446.

43. Drohojowska-Philp, *Full Bloom,* 446.

44. Didactic panel at the Georgia O'Keeffe Museum, Santa Fe, New Mexico, January 9, 2018.

45. Letter from Frida to her mother, December 18, 1931, NMWA.

46. Letter from Marina Channing to Frida, September 4 (probably 1932), NMWA.

47. Letter from Frida to her mother, December 26, 1931, NMWA.

48. Letter from Frida to her mother, January 8, 1932, NMWA.

49. Letter from Frida to her mother, January 14, 1932, NMWA.

50. Letter from Frida to her mother, January 14, 1932, NMWA.

51. Letter from Frida to her mother, January 20, 1932, in Kahlo, *Frida by Frida,* 89.

52. Letter from Frida to her mother, January 20, 1932, in Kahlo, *Frida by Frida,* 89.

53. Letter from Frida to Abby Rockefeller, January 22, 1932, in Kahlo, *Frida by Frida,* 92.

54. Bloch, unpublished journal, March 3, 1932.

55. Bloch, unpublished journal, March 27 and April 12, 1932.

56. Teresa del Conde, "Frida Kahlo: A Profile," trans. Martha Zamora, in *The Art of Frida Kahlo: 1990 Adelaide Festival* (Adelaide: Art Gallery of Western Australia and Art Gallery of South Australia, 1990), 5.

ELEVEN: INDEPENDENCE DAY

1. Letter to the Wights from New York, April 12, 1932, in Frida Kahlo, *Frida by Frida: Selection of Letters and Texts,* ed. Raquel Tibol (Mexico City: Editorial RM, 2003), 95.

2. "Noted Mexican Painter Arrives: Artist to Create Two Frescoes for Art Institute," April 22, 1932, Burton Special Collections, Detroit Public Library.

3. Florence Davies, "Rivera Arrives to Paint Murals at Art Institute," *Detroit News,* April 22, 1932.

4. Davies, "Rivera Arrives."

5. Letter to Dr. Leo Eloesser from Coyoacán, March 15, 1941, in Kahlo, *Letters,* 109.

6. *Detroit News,* March 2, 1999.

7. Didactic panel, Burton Special Collections, Detroit Public Library.

8. Joyce Shaw Peterson, *American Automobile Workers, 1900–1930* (Albany: State University of New York Press, 1987), 16.

9. *Michigan History,* vols. 77–78, History Society of Michigan, 1993.

10. Maurice Sugar, *The Ford Hunger March* (Berkeley, CA: Meiklejohn Civil Liberties Institute, 1980), 20.

11. Sugar, *The Ford Hunger March,* 25.

12. Sugar, *The Ford Hunger March,* 21.

13. Hayden Herrera, *Frida: A Biography of Frida Kahlo* (New York: Harper Perennial, 2002), 135.

14. Bloch interview with Mary Fuller McChesney, August 11, 1964, 44, Box 1, Folder 2, DIA Museum Library and Archives.

15. Lucienne Bloch, 1978 interview by Hayden Herrera, *Frida,* 134.

16. Letter to Dr. Leo Eloesser from Detroit, May 26, 1932, in Kahlo, *Frida by Frida,* 100.

17. Luis-Martín Lozano, *Frida Kahlo: The Circle of Affections* (Mexico City: FOEM, 2007), 61.

18. Frida's statement made to Olga Campos, in Salomon Grimberg, *Frida Kahlo: Song of Herself* (London: Merrell, 2008), 95.

19. Letter to Dr. Leo Eloesser from Detroit, May 26, 1932, in Kahlo, *Frida by Frida,* 98–101.

20. Letter to Dr. Leo Eloesser from Detroit, May 26, 1932, in Kahlo, *Frida by Frida,* 98–101.

21. Letter from Adriana to Frida, July 2, 1932, NMWA.

22. Leslie Reagan, *When Abortion Was a Crime: Women, Medicine, and Law in the United States* (Berkeley: University of California Press, 1997), 147. A 1934 obstetrics/gynecology report from the Henry Ford Hospital lists castor oil and quinine for "induction"; Melanie Bazil, senior archivist, Conrad R. Lam Archives, Henry Ford Health System, July 17, 2014.

23. Letter to Dr. Leo Eloesser from Detroit, May 26, 1932, in Kahlo, *Frida by Frida,* 98–101.

24. Letter to Dr. Leo Eloesser from Detroit, May 26, 1932, in Kahlo, *Frida by Frida,* 98–101.

25. Letter to Dr. Leo Eloesser, July 29, 1932, in Kahlo, *Frida by Frida,* 121–123.

26. Bloch, unpublished journal, May 30, 1932, 61.

27. Bloch, unpublished journal, May 30, 1932, 61.

28. Letter to Dr. Leo Eloesser from Detroit, May 26, 1932, in Kahlo, *Frida by Frida,* 99.

29. Lucienne quoted in Herrera, *Frida,* 141.
30. Letter from Carito Romero to Frida, July 4, 1932, NMWA.
31. Letter from Carito Romero to Frida, July 4, 1932, NMWA.
32. Letter from Carito Romero to Frida, July 4, 1932, NMWA.
33. Letter from Carito Romero to Frida, July 4, 1932, NMWA.
34. Frieda Rivera, Western Union telegram, July 1, 1932, 11:00 AM, Detroit Institute of Arts Library and Archives.
35. Letter to Dr. Leo Eloesser, July 29, 1932, in Kahlo, *Frida by Frida,* 103.
36. Bloch, unpublished journal, July 5, 1932, 78.
37. Lucienne Bloch, 1978 interview by Hayden Herrera, quoted in Gannit Ankori, *Imaging Her Selves: Frida Kahlo's Poetics of Identity and Fragmentation* (Westport, CT: Greenwood Press, 2002), 158.
38. Bloch, unpublished journal, July 5, 1932, 78.
39. Herrera, *Frida,* 141.
40. Lizette Boreli, "Nitrous Oxide Side Effects: EEG Test Shows Laughing Gas Alters Brainwaves for Three Minutes After Administration," *Clinical Neurophysiology,* July 7, 2015.
41. Author interview with Dr. Munkarah in Detroit, June 3, 2015. In March 2018, Dr. Munkarah was promoted to Executive Vice President and Chief Clinical Officer of Henry Ford Hospital.
42. Author interview with Dr. Munkarah in Detroit, June 3, 2015. The Obstetrics/Gynecology report for 1929 "listed spinal anesthesia and/or reinforced with ethylene," for pain management in the abdomen, pelvis, and lower extremities. Email from Melanie Bazil, senior archivist, Conrad R. Lam Archives, Henry Ford Health System, July 17, 2014. Ms. Bazil wrote that Dr. Pratt had not listed any specific information about anesthesia in his 1932 report.
43. Bazil told me the hospital archives should have a copy of Frida's hospital medical record, but it was missing. She didn't know what had happened to it. Interview, July 6, 2014.
44. Bloch, unpublished journal, July 6, 1932, 79.
45. Undated note from Frida to Mati, probably written July 5, 1932, NMWA.
46. Postal telegram from Mati to Frida, July 6, 1932, NMWA.
47. Herrera, *Frida,* 141.
48. In a letter from Ella Wolfe to Frida, July 16, 1932, NMWA, she states that Frida had a fever for five days.
49. Bloch, unpublished journal, July 13, 1932, 81.
50. Bloch, unpublished journal, July 13, 1932, 81.
51. Bloch, unpublished journal, July 13, 1932, 81.
52. Martha Kneib, *Meningitis* (New York: Rosen, 2005), 30.
53. Bloch, unpublished journal, July 13, 1932, 81.
54. Babette Rothschild, *The Body Remembers: The Pschophysiology of Trauma and Trauma Treatment* (New York: W. W. Norton, 2000), 5–7.
55. Bazil took me on a tour of the hospital on July 6, 2014. I saw the basement and a few of the old pipes running along the ceiling and I asked her if those pipes would be the same ones Frida had seen; she told me that while the hospital had undergone some architectural changes since Frida's time at the hospital, the few remaining pipes were original, making them "gray and white."
56. William James, "The Subjective Effects of Nitrous Oxide," *Mind* 7 (1882).
57. Audio tour at "Diego Rivera and Frida Kahlo in Detroit" exhibition, Detroit Institute of Arts, June 3, 2015.
58. Bloch, unpublished journal, July 16, 1932, 82.
59. Author telephone interview with Frank Venegas Jr., September 2014.

60. Author telephone interview with Frank Venegas Jr., September 2014.

61. Bloch, unpublished journal, July 17, 1932, 82.

62. Bloch, unpublished journal, July 17, 1932, 83.

63. Burton Special Collections, Detroit Public Library.

64. Bloch, unpublished journal, June 12, 1932, 68.

65. Bloch, unpublished journal, June 12, 1932, 68.

66. Bloch, unpublished journal, July 20, 1932, 83.

67. Bloch, unpublished journal, August 11, 1932, 92.

68. Lucienne Bloch's recollections taken from an interview with Karen and David Crommie for their film *The Life and Death of Frida Kahlo*, 1966.

69. Helga Prignitz-Poda, *Frida Kahlo: The Painter and Her Work* (New York: Schirmer/Mosel, 2004), 41.

70. Howard Devree, *New York Times* review, November 16, 1938.

71. Mary Ellen Miller, *The Art of Mesoamerica* (London: Thames and Hudson, 1996), 207.

72. Sven Nielsen and Seth Granberg, "The Expectant Management of Miscarriage," in Thomas H. Bourne, ed., *Handbook of Early Pregnancy Care* (Andover: Thomas Publishing Services, 2006), p. 39.

73. Annsofie Adolfsson, *Miscarriage: Women's Experience and its Cumulative Incidence* (Sweden: Liu-Tryck, 2006), p. 3.

74. Author interview with Dr. Munkarah in Detroit, June 3, 2015.

75. Bloch, unpublished journal, July 24, 1932, 85.

76. Bloch, unpublished journal, July 23, 1932, 85.

77. Bloch, unpublished journal, July 25, 1932, 85.

78. Bloch, unpublished journal, July 24, 1932, 85.

79. Bloch, unpublished journal, July 25, 1932, 85.

80. Bloch, unpublished journal, July 25, 1932, 85.

81. Bloch, unpublished journal, July 26, 1932, 85.

82. Bloch, unpublished journal, July 26, 1932, 85.

83. Bloch, unpublished journal, July 25, 1932, 85.

84. Bloch, unpublished journal, July 25, 1932, 85.

85. Bloch, unpublished journal, July 27, 1932, 86.

86. Bloch, unpublished journal, August 7, 1932, 91.

87. Bloch, unpublished journal, August 8, 1932, 91.

88. Bloch, unpublished journal, August 9, 1932, 91.

89. Bloch, unpublished journal, August 9, 1932, 92.

90. Bloch, unpublished journal, July 27, 1932, 86.

91. Bloch, unpublished journal, August 10, 1932, 92.

92. Some authors use the title *Frida and the Miscarriage,* while others use *Frida and the Abortion*. The discrepancy might have to do with language and translation. As Salomon Grimberg points out, *hacerse un aborto* translates as "to get an abortion," whereas *tener un aborto* means "to have an abortion," or in English, a miscarriage. The use of the term *aborto* to indicate a surgical abortion or a miscarriage in Spanish conforms to the historical use of the term in English, as the word "abortion" was used by "obstetricians and midwives to denote not only the elected termination of a pregnancy but a miscarriage as well." In fact, *A Theoretical and Practical Treatise on Midwifery* (1863) divided abortions into three categories: "spontaneous, accidental, and provoked," the last meaning a surgical procedure. In Frida's case, it's not clear what title she gave the prints in Spanish. Nevertheless, the way she presents it in visual form indicates a miscarriage. See Salomon Grimberg, "The Lost Desire: Frida Kahlo in Detroit," in *Diego Rivera and Frida Kahlo in Detroit* (New Haven, CT: Yale University Press, 2015), 148.

93. See de Sahagún's *A History of Ancient Mexico: 1547–1577* (Austin: University of Texas, 1977, digitized in 2008), 240.

94. In Frida's "marriage portrait," created in San Francisco, Diego holds the heart-shaped palette, but by the time Frida undergoes the second major trauma of her life in Detroit, she is becoming a mature artist.

TWELVE: BORDER CROSSINGS

1. Bloch, unpublished journal, September 2, 1932, 101.
2. Bloch, unpublished journal, September 3, 1932, 101.
3. Bloch, unpublished journal, September 3, 1932, 101.
4. Hayden Herrera, *Frida: A Biography of Frida Kahlo* (New York: Harper Perennial, 2002), 154.
5. Bloch, unpublished journal, September 4, 1932, 102.
6. Bloch, unpublished journal, September 4, 1932, 102.
7. Bloch, unpublished journal, September 4, 1932, 102.
8. Bloch, unpublished journal, September 6, 1932, 102.
9. Bloch, unpublished journal, September 6, 1932, 102–103.
10. Bloch, unpublished journal, September 6, 1932, 103.
11. Bloch, unpublished journal, September 4, 1932, 103.
12. Bloch, unpublished journal, September 7, 1932, 103.
13. Bloch, unpublished journal, September 7, 1932, 103.
14. "Indiana History (1920–1940)," Center for History website, centerforhistory.org.
15. Bloch, unpublished journal, September 8, 1932, 103.
16. Bloch, unpublished journal, September 8, 1932, 103.
17. Bloch, unpublished journal, September 8, 1932, 103.
18. Bloch, unpublished journal, September 8, 1932, 103.
19. Author telephone interview with Lucienne Allen, September 2008.
20. Manuel Gamio, *The Life Story of the Mexican Immigrant* (New York: Dover, 1971), 167.
21. Bloch, unpublished journal, September 8, 1932, 103.
22. Bloch, unpublished journal, September 8, 1932, 103.
23. Bloch, unpublished journal, September 8, 1932, 104.
24. Juan Rafael Coronel Rivera, "April 21, 1932," in *Diego Rivera and Frida Kahlo in Detroit* (New Haven, CT: Yale University Press, 2015), 139.
25. Coronel Rivera, "April 21, 1932," 139.
26. Bloch, unpublished journal, September 10, 1932, 104.
27. Bloch, unpublished journal, September 10, 1932, 104.
28. Bloch, unpublished journal, September 9, 1932, 104.
29. Bloch, unpublished journal, September 10, 1932, 104.
30. Jesús Velasco-Márquez, "A Mexican Viewpoint on the War with the United States," https://www.pbs.org/kera/usmexicanwar/prelude/md_a_mexican_viewpoint.html.
31. Bloch, unpublished journal, September 11, 1932, 104.
32. The *Laredo Times* quoted in Jonathan Burnett, *Flash Floods in Texas* (Miami: University Libraries, 2008), 61–62.
33. Bloch, unpublished journal, September 11, 1932, 104.
34. Bloch, unpublished journal, September 11, 1932, 104.
35. Bloch, unpublished journal, September 11, 1932, 104.
36. Bloch, unpublished journal, September 11, 1932, 104.
37. Camille Guérin-Gonzales, *Mexican Workers and American Dreams: Immigration, Repatriation, and California Farm Labor 1930–1939* (New Brunswick, NJ: Rutgers University Press, 1996), 93.

38. Guérin-Gonzales, *Mexican Workers,* 93.
39. Margaret Sterne, "The Museum Director and the Artist: Dr. William R. Valentiner and Diego Rivera in Detroit," *Detroit Perspective,* Winter 1973, 88–110. For more information on this topic, see Elena Herrada's oral history project, *Los Repatriados: Exiles from the Promised Land,* VHS tape, Fronteras Norteñas, 2001, and Francisco E. Balderrama and Raymond Rodríguez, *Decade of Betrayal: Mexican Repatriation in the 1930s* (Albuquerque: University of New Mexico Press, 2006, revised edition).
40. "A Decade of Mexican Repatriation," University of Michigan History website, http://umich .edu/~ac213/student_projects07/repatriados/history/mihistory.html.
41. Rufuyo Larriva in Louis Aguilar's "Artists Who Shook Detroit," *Detroit News,* November 16, 2000, 3F.
42. Manuel Gamio, "Migration and Planning," *Survey Graphic* 66, no. 3 (May 1, 1931): 174.
43. Diego's letter to Frida, September 7, 1932, quoted in Coronel Rivera, "April 21, 1932," 139.
44. Frida Kahlo, Western Union telegram, September 8, 1932, NMWA.
45. Diego Rivera, telegram, September 8, 1932, quoted in Coronel Rivera, "April 21, 1932," 140.
46. Bloch, unpublished journal, September 13, 1932, 105.
47. Bloch, unpublished journal, September 13, 1932, 105.
48. Bloch, unpublished journal, September 14, 1932, 106.
49. Herrera, *Frida,* 156.
50. Herrera, *Frida,* 156.
51. Frida's letter to Diego, September 10, 1932, NMWA.
52. Frida's letter to Diego, September 10, 1932, NMWA.
53. Frida's letter to Diego, September 10, 1932, NMWA.
54. Frida's letter to Diego, September 10, 1932, NMWA.
55. Frida's letter to Diego, September 10, 1932, NMWA.
56. Frida's letter to Diego, September 10, 1932, NMWA.
57. Frida's letter to Diego, September 10, 1932, NMWA.
58. Bloch quoted in Herrera, *Frida,* 155.
59. Letter from Guillermo Kahlo to Frida, September 4, 1932, NMWA.
60. Letter from Diego to Frida, September 11, 1932, quoted in Coronel Rivera, "April 21, 1932," 140.
61. Letter from Diego to Frida, September 12, 1932, quoted in Coronel Rivera, "April 21, 1932," 140.
62. Letter from Diego to Frida, September 13, 1932, quoted in Coronel Rivera, "April 21, 1932," 141.
63. Bloch, unpublished journal, September 21, 1932, 108.
64. Bloch, unpublished journal, September 21, 1932, 108.
65. Letter from Ella Wolfe to Frida, July 16, 1932, NMWA.
66. Letter from Guillermo Kahlo to Frida, September 4, 1932, NMWA.
67. Frida Kahlo Western Union telegram, September 12, 1932, 5:00 PM, NMWA.
68. Bloch, unpublished journal, September 22, 1932, 109.
69. Bloch, unpublished journal, September 22, 1932, 109.
70. Bloch, unpublished journal, September 24, 1932, 109.
71. Bloch, unpublished journal, September 24, 1932, 109.
72. Interview with Olga Campos, in Salomon Grimberg, *Frida Kahlo: Song of Herself* (London: Merrell, 2008), 85.
73. Bloch, unpublished journal, September 25, 1932, 110.
74. Bloch, unpublished journal, September 25, 1932, 110.
75. Letter from Guillermo Kahlo to Frida, September 4, 1932, NMWA.

76. Letter from Guillermo Kahlo to Frida, September 4, 1932, NMWA.
77. Letter from Guillermo Kahlo to Frida, September 4, 1932, NMWA.
78. Letter from Guillermo Kahlo to Frida, September 4, 1932, NMWA.
79. Bloch, unpublished journal, September 26, 1932, 110.
80. Letter from Diego to Frida, September 18, 1932, quoted in Coronel Rivera, "April 21, 1932," 141.
81. Bloch, unpublished journal, October 4, 1932, 115.
82. Bloch, unpublished journal, October 4, 1932, 115.
83. Bloch, unpublished journal, October 7, 1932, 116.
84. Bloch, unpublished journal, October 8, 1932, 116.
85. Bloch, unpublished journal, October 22, 1932, 122.
86. Bloch, unpublished journal, October 22, 1932, 122.
87. Bloch, unpublished journal, October 23, 1932, 122.
88. Bloch, unpublished journal, October 30, 1932, 125.
89. Bloch, unpublished journal, October 30, 1932, 125.
90. Bloch, unpublished journal, October 30, 1932, 125.
91. Bloch, unpublished journal, October 31, 1932, 125.
92. Bloch, unpublished journal, November 1, 1932, 128.
93. Bloch, unpublished journal, November 2, 1932, 128.
94. Diego Rivera with Gladys March, *My Art, My Life* (New York: Citadel Press, 1960), 193–194.
95. Bloch, unpublished journal, November 2, 1932, 128.
96. Bloch, unpublished journal, November 2, 1932, 128.
97. Bloch, unpublished journal, June 14, 1932, 68.
98. Letter from Diego to Frida, October 1, 1932, quoted in Coronel Rivera, "April 21, 1932," 141.
99. Frida's letter to Diego, September 10, 1932, NMWA.

THIRTEEN: RESURRECTING DEATH

1. Sarah Lowe, *Frida Kahlo* (New York: Universe, 1991), 65. Margaret A. Lindauer discusses Lowe's ideas and *My Birth* at length in *Devouring Frida* (Middletown, CT: Wesleyan University Press, 1999), 22, 88–112.
2. Mary Rodrique, *DAC News,* June 2007, 48.
3. Typewritten manuscript from Helen Vinton to Frida, quoted in Coronel Rivera essay, "April 21, 1932," in *Diego Rivera and Frida Kahlo in Detroit* (New Haven, CT: Yale University Press, 2015), 138.
4. Letter from Adriana Kahlo to Frida, December 14, 1932, NMWA.
5. Bloch, unpublished journal, November 4, 1932, 129.
6. Bloch, unpublished journal, November 4, 1932, 129.
7. Isolda P. Kahlo, *Intimate Frida* (Buenos Aires: Gato Azul, 2005; Bogotá: Cangrejo, 2006), 31.
8. Letter from Cristina Kahlo to Frida, November 4, 1932, NMWA.
9. Isolda Kahlo, *Intimate Frida,* 31.
10. Letter from Adriana Kahlo to Frida, November 4, 1932, NMWA.
11. Letter from Cristina Kahlo to Frida, November 4, 1932, NMWA.
12. Letter from Cristina Kahlo to Frida, November 4, 1932, NMWA.
13. Letter from Carmen to Frida, November 7, 1932, NMWA.
14. Letter from Carmen to Frida, November 7, 1932, NMWA.
15. Letter from Adriana Kahlo to Frida, November 12, 1932, NMWA.
16. Letter from Adriana Kahlo to Frida, November 12, 1932, NMWA.
17. Letter from Adriana Kahlo to Frida, November 12, 1932, NMWA.
18. Letter from Cristina Kahlo to Frida, December 12, 1932, NMWA.

19. Letter from Adriana Kahlo to Frida, November 4, 1932, NMWA.

20. Letter from Guillermo Kahlo to Frida, February 5, 1933, NMWA.

21. Letter from Adrianna Kahlo to Frida, February 20, 1933, NMWA.

22. Letter from Lucienne Bloch to Frida, November 20, 1932, NMWA.

23. Octavio Paz, "The Sons of La Malinche," in *Labyrinth of Solitude: Life and Thought in Mexico* (New York: Grove Press, 1961), 21. As the title of Paz's essay suggests, the concept of *la chingada* is connected to La Malinche and her relationship with Cortés, which for some conveys her betrayal of the Mexican people and for others her rape and victimization at the hands of the Spanish conquistador. Paz argues that Mexican men suffer anxiety as the bastard sons of the Spaniard. Chicana scholars have reinterpreted La Malinche as the ancestral mother who is powerful. See Cristina Herrera's *Contemporary Chicana Literature: (Re)Writing the Maternal Script* (New York: Cambria Press, 2014).

24. Alejandro Gómez Arias conveyed this to Gannit Ankori in an interview in March 1989. *Imaging Her Selves: Frida Kahlo's Poetics of Identity and Fragmentation* (Westport, CT: Greenwood Press, 2002), 15 n. 42.

25. Letter from Frida to her mother, November 16, 1931, NMWA.

26. Hayden Herrera, *Frida: A Biography of Frida Kahlo* (New York: Harper Perennial, 2002), 157.

27. Francisco Alba, *The Population of Mexico: Trends, Issues, and Policies* (New Brunswick, NJ: Transaction Books, 1982), 38–39.

28. Barbara Braun, *Pre-Columbian Art and the Post-Columbian World: Ancient American Sources of Modern Art* (New York: Harry N. Abrams, 1993), 226.

29. Inga Clendinnen, *Aztecs: An Interpretation* (New York: Cambridge University Press, 1991), 173. Androgyny was emphasized and Tlazolteotl was considered a female deity with a male side. In another Aztec book called the Codex Laud she's featured as the topless goddess with breasts; she is standing in profile and wearing both a man's loincloth and a woman's skirt. This androgynous goddess has arms outstretched, passing a child to a female figure of death. The image reaffirms the dangers involved in the birth process, something Frida underscores in *My Birth*.

30. Lauren Dundes, "The Evolution of Maternal Birthing Position," *American Journal of Public Health* 77, no. 5 (1987): 363.

31. Francis Henry Ramsbotham, *The Principles and Practice of Obstetric Medicine and Surgery, In Reference to the Process of Parturition* (Philadelphia: Lea and Blanchard, 1842), 111.

32. David Lomas, "Body Languages: Kahlo and Medical Imagery," in *The Body Imaged: The Human Form and Visual Culture Since the Renaissance,* ed. Kathleen Adler and Marcia Pointon (New York: Cambridge University Press, 1993), 6.

33. Salomon Grimberg, *Frida Kahlo: Song of Herself* (London: Merrell, 2008), 128.

34. Linda Banks Downs, *Diego Rivera: The Detroit Industry Murals* (New York: W. W. Norton), 69. There's one possible threat to Diego's baby in the mural. Black shapes under the fossilized sea life have been interpreted as plowshare blades. Downs remarks that these images could be seen as presenting a possible danger to the baby. But they do not look menacing.

35. Downs, *Diego Rivera*, 69.

36. Lomas, "Body Languages," 12.

37. Gannit Ankori, *Frida Kahlo* (London: Reaktion Books, 2013), 28.

38. John Berger, "Frida Kahlo," in *Portraits: John Berger on Artists* (New York: Verso, 2015), 336.

39. Berger, "Frida Kahlo," 339.

40. Frida Kahlo, *The Diary of Frida Kahlo: An Intimate Self-Portrait,* ed. Phyllis Freeman (New York: Harry N. Abrams, 1995), 228.

41. Stephen Dimitroff, interviewed by Karen and David Crommie for their film *The Life and Death of Frida Kahlo,* 1966.

42. Bloch, unpublished journal, January 1, 1933.

43. Kevin Sessums, "White Heat," *Vanity Fair,* April 1990, 147.

44. I'm referring here to Gladwell's book *Blink: The Power of Thinking Without Thinking* (Boston: Little, Brown, 2005).

FOURTEEN: THE PROVOCATEUR

1. Stephen Pope Dimitroff, *Apprentice to Diego Rivera in Detroit and Fresco Workshops Manual,* 1986, Detroit Institute of Arts Museum Library and Archives, Box 1, Folder 4.

2. Dimitroff, *Apprentice to Diego Rivera.*

3. Dimitroff, *Apprentice to Diego Rivera.*

4. Dimitroff, *Apprentice to Diego Rivera.*

5. Dimitroff, *Apprentice to Diego Rivera.*

6. Dimitroff, *Apprentice to Diego Rivera.*

7. Dimitroff, *Apprentice to Diego Rivera.*

8. Dimitroff, *Apprentice to Diego Rivera.*

9. Dimitroff, *Apprentice to Diego Rivera.*

10. Bloch, unpublished journal, June 20, 1932.

11. Bloch interview with Mary Fuller McChesney, August 11, 1964, Box 1, Folder 2, DIA Museum Library and Archives, 21.

12. Angelica Reyes Esperilla quoted, in Louis Aguilar, "The Artists Who Shook Detroit," *Detroit News,* November 6, 2000, 3F.

13. Dimitroff, *Apprentice to Diego Rivera.*

14. Dimitroff, *Apprentice to Diego Rivera.*

15. Dimitroff, *Apprentice to Diego Rivera.*

16. Dimitroff, *Apprentice to Diego Rivera.*

17. Downs, *Diego Rivera,* 30; Steve Babson et al., *Working Detroit: The Making of a Union Town* (Detroit: Wayne State University Press, 1986), 58–59.

18. Bloch interview with Mary Fuller McChesney, 44.

19. Reyes Esperilla remembers Frida playfully poking fun at Diego by saying he looked like "the Cheshire Cat in *Alice in Wonderland*" when he smiled. Aguilar, "The Artists Who Shook Detroit."

20. Dimitroff, *Apprentice to Diego Rivera.*

21. Hayden Herrera, *Frida: A Biography of Frida Kahlo* (New York: Harper Perennial, 2002), 137.

22. Herrera, *Frida,* 135.

23. Bloch interview with Mary Fuller McChesney, 45.

24. Hasia Diner interview in the DVD *The Jewish Americans,* Thirteen WNET New York (New York: David Grubin Productions, 2008).

25. See Vincent Curcio, *Henry Ford* (New York: Oxford University Press, 2013), ch. 8.

26. A. James Rudin, "The Dark Legacy of Henry Ford's Anti-Semitism," *Washington Post,* October 10, 2014. On the United States' influence on Hitler, see James Q. Whitman, *Hitler's American Model: The United States and the Making of Nazi Race Law* (Princeton, NJ: Princeton University Press, 2018).

27. Malka Drucker, *Frida Kahlo* (Albuquerque: University of New Mexico Press, 1991), 62.

28. Louis Aguilar, "Detroit Was Muse to Legendary Artists Diego Rivera and Frida Kahlo," *Detroit News,* April 6, 2011, 15.

29. Diego Rivera with Gladys March, *My Art, My Life* (New York: Citadel Press, 1960), 142–146.

30. Letter from Frida to Dr. Leo Eloesser, March 15, 1941, in Frida Kahlo, *The Letters of Frida Kahlo,* ed. Martha Zamora (San Francisco: Chronicle Books, 1995), 109.

31. Peggy deSalle interview with Dennis Barrie, January 27–July 16, 1975, for the Archives of American Art.

32. Downs, *Diego Rivera,* 60.

33. Letter from Lucienne Bloch to Frida, May 5, 1932, NMWA.

34. Herrera, *Frida,* 135.

35. Desmond Rochfort, *Mexican Muralists: Orozco, Rivera, Siquerios* (San Francisco: Chronicle Books, 1998), 130.

36. Author interview with Treena Flannery Ericson, June 2015.

37. Florence Davies, "Wife of the Master Mural Painter Gleefully Dabbles in Works of Art," *Detroit News,* February 2, 1933, 16.

38. Davies, "Wife of the Master," 16.

39. Carlos Fuentes, "Introduction," in Frida Kahlo, *The Diary of Frida Kahlo: An Intimate Self-Portrait,* ed. Phyllis Freeman (New York: Harry N. Abrams, 1995), 15.

40. Gloria Anzaldúa, *Borderlands = La Frontera* (San Francisco: Aunt Lute Books, 1999), 107.

41. Ricardo Perez Montfort, "Self-Portrait on the Borderline Between Mexico and the United States," in *Frida Kahlo 1907–2007* (Mexico City: Palacio de Bellas Artes, 2008), 130.

42. Letter from Carmen to Frida, February 13, 1933, NMWA.

43. Stuart Chase and Marian Tyler, *Mexico: A Study of Two Americas* (New York: Macmillan, 1931), 313.

44. Chase and Tyler, *Mexico,* 306.

45. Letter from Frida to Dr. Leo Eloesser, June 14, 1931, in *The Letters of Frida Kahlo,* 43.

46. Michael D. Coe, *Mexico* (London: Thames and Hudson, 1984), 158.

47. Florence Davies, "Rivera Tells Meaning of Art Institute Murals," *Detroit News,* January 19, 1933, 4.

48. Some of their collection, including the Casas Grandes figure, can be seen in Gilbert Médioni and Marie-Thérèse Pinto, *Art in Ancient Mexico: Selected and Photographed from the Collection of Diego Rivera* (New York: Oxford University Press, 1941), 208.

49. Fuentes, "Introduction," 23.

50. Downs, *Diego Rivera,* 140. Downs also points out that Diego created a half-human/half-skull head painted in grisaille on the west wall to resemble a terra-cotta mask from Tlatilco, Mexico (1000–500 BCE).

51. Dan Chiasson, "Touching Souls," *New Yorker,* October 9, 2017, 66.

52. Davies, "Rivera Tells Meaning of Art Institute Murals," 4.

53. See Richard Boleslavsky's illustrated article from *Theatre Arts,* 1932.

54. Letter to Dr. Leo Eloesser from Detroit, May 26, 1932, in Kahlo, *Frida by Frida,* 98.

55. Letter from Frida to Abby Rockefeller, January 24, 1933, in Kahlo, *Frida by Frida,* 106.

56. Ken Silverstein, "Ford and the Führer," *The Nation,* January 8, 2000.

57. Amelia Malagamba-Ansotegui, "The Real and the Symbolic: Visualizing Border Spaces," in *Transformations of La Familia on the U.S.-Mexico Border,* ed. Raquel R. Marquez and Harriett D. Romo (South Bend, IN: University of Notre Dame Press, 2008), 234.

58. Letter from Lucienne Bloch to Frida, May 5, 1932, NMWA.

59. Letter from Frida to Georgia O'Keeffe, March 1, 1933, Alfred Stieglitz/Georgia O'Keeffe Archive, Yale Collection of American Literature, Beinecke Rare Book and Manuscript Library, Yale University, YCAL MSS 85. Also published in Sharyn Rohlfsen Udall, *Carr, O'Keeffe, and Kahlo: Places of Their Own* (New Haven, CT: Yale University Press, 2000), 286–287.

60. Benita Eisler, *O'Keeffe and Stieglitz: An American Romance* (New York: Penguin Books, 1991), 3.

61. Eisler, *O'Keeffe and Stieglitz,* 436.

62. Eisler, *O'Keeffe and Stieglitz,* 437.

63. Eisler, *O'Keeffe and Stieglitz,* 437.

64. Letter from Frida to Georgia O'Keeffe, March 1, 1933, Alfred Stieglitz/Georgia O'Keeffe Archive, Beinecke Rare Book and Manuscript Library.

65. Letter from Frida to Georgia O'Keeffe, March 1, 1933, Alfred Stieglitz/Georgia O'Keeffe Archive, Beinecke Rare Book and Manuscript Library.

66. Letter from Frida to Georgia O'Keeffe, March 1, 1933, Alfred Stieglitz/Georgia O'Keeffe Archive, Beinecke Rare Book and Manuscript Library.

67. "Debate over Worth of Rivera's Murals: This Vaccination Panel Set Off the Explosion," *Detroit Free Press,* March 26, 1933.

68. Editorial, *Detroit News,* March 22, 1933.

69. Downs, *Diego Rivera,* 177.

70. Downs, *Diego Rivera,* 178.

71. Downs, *Diego Rivera,* 179.

FIFTEEN: EMBOLDENED FRIDA

1. Hayden Herrera, *Frida: A Biography of Frida Kahlo* (New York: Harper Perennial, 2002), 162.

2. Bloch, unpublished journal, March 21, 1933, 51.

3. Bloch, unpublished journal, April 1, 1933, 53.

4. Bloch, unpublished journal, April 8, 1933, 53.

5. Letter from Frida to Clifford Wight, April 11, 1933, in Frida Kahlo, *Frida by Frida: Selection of Letters and Texts,* ed. Raquel Tibol (Mexico City: Editorial RM, 2003), 109.

6. Letter from Frida to Clifford Wight, April 11, 1933, in Kahlo, *Frida by Frida,* 109.

7. Bloch, unpublished journal, March 30, 1933, 52.

8. Letter from Frida to Clifford Wight, April 11, 1933, in Kahlo, *Frida by Frida,* 108.

9. Letter from Frida to Clifford Wight, April 11, 1933, in Kahlo, *Frida by Frida,* 108.

10. Letter from Frida to Clifford Wight, April 11, 1933, in Kahlo, *Frida by Frida,* 109.

11. Hayden Herrera, *Frida: A Biography of Frida Kahlo* (New York: Harper Perennial, 2002), 163.

12. Bloch, unpublished journal, April 11, 1933, 55.

13. Desmond Rochfort, *Mexican Muralists: Orozco, Rivera, Siquerios* (San Francisco: Chronicle Books, 1998), 131.

14. Bloch, unpublished journal, April 14, 1933, 56.

15. Lucienne Bloch, "On Location with Diego Rivera," *Art in America* (February 1986), 102–120.

16. The April 3 note is reproduced in Bertram D. Wolfe, *The Fabulous Life of Diego Rivera* (New York: Stein and Day, 1963), 324.

17. "The Manchester Guardian Forbidden in Germany," *Manchester Guardian,* April 8, 1933, https://www.theguardian.com/theguardian/2015/apr/08/manchester-guardian-germany -war-hitler-archive-1933.

18. Salomon Grimberg, *Frida Kahlo: Song of Herself* (London: Merrell, 2008), 82.

19. Herrera, *Frida,* 173.

20. Bloch, unpublished journal, April 27, 1933, 59.

21. Bloch, unpublished journal, April 27, 1933, 59.

22. Diego Rivera with Gladys March, *My Art, My Life* (New York: Citadel Press, 1960), 205–206.

23. Bertram D. Wolfe, *The Fabulous Life of Diego Rivera* (New York: Stein and Day, 1963), 325.

24. Bloch, unpublished journal, May 1, 1933, 60.

25. Bloch, unpublished journal, May 1, 1933, 60.

26. Wolfe, *The Fabulous Life of Diego Rivera,* 325.

27. Wolfe, *The Fabulous Life of Diego Rivera,* 325.

28. Bloch, unpublished journal, May 6, 1933, 61.

29. Wolfe, *The Fabulous Life of Diego Rivera*, 326.
30. Wolfe, *The Fabulous Life of Diego Rivera*, 326.
31. Wolfe, *The Fabulous Life of Diego Rivera*, 327.
32. Bloch, unpublished journal, May 8, 1933, 61.
33. Dorothy Thompson, "Hitler a Religion, Ousted Woman Says," *Daily Argus-Leader* (Sioux Falls, SD), August 27, 1934, 11.
34. Bloch, unpublished journal, May 31, 1933, 71.
35. Bloch, unpublished journal, May 7, 1933, 61.
36. Herrera, *Frida*, 163.
37. Herrera, *Frida*, 163.
38. Bloch, unpublished journal, May 8, 1933, 61.
39. Bloch, unpublished journal, May 8, 1933, 61.
40. Bloch, unpublished journal, May 10, 1933, 63.
41. Bloch, unpublished journal, May 10, 1933, 63.
42. Bloch, unpublished journal, May 10, 1933, 63.
43. Bloch, unpublished journal, May 10, 1933, 63.
44. Bloch, unpublished journal, May 10, 1933, 63.
45. Bloch, unpublished journal, May 14, 1933, 63.
46. Letter from Guillermo Kahlo to Frida, March 29, 1933, NMWA.
47. Bloch, unpublished journal, May 15, 1933, 64.
48. Bloch, unpublished journal, May 15, 1933, 64.
49. Herrera, *Frida*, 168.
50. "Columbia Students Fight on Campus over Soviet Parade," *Chicago Daily Tribune*, May 16, 1933, 16.
51. "Rivera in Hot Water," *Literary Digest*, May 27, 1933, 13.
52. "Germany's Book Bonfire," *Literary Digest*, May 27, 1933, 14.
53. Letter from Adriana Kahlo to Frida, May 22, 1933, NMWA.
54. Bloch, unpublished journal, May 17, 1933, 65.
55. Bloch, unpublished journal, May 17, 1933, 65.
56. Bloch, "On Location with Diego Rivera."
57. Bloch, unpublished journal, May 19, 1933, 66.
58. Herrera, *Frida*, 163.
59. Geraldine Sartain, "Rivera's Wife Rues Art Ban," *New York World-Telegram*, June 10, 1933.
60. Sartain, "Rivera's Wife Rues Art Ban."
61. Letter from Adriana Kahlo to Frida, May 29, 1933, NMWA. Lucienne's journal says that Frida and Diego lived across the street from the NWS on Fourteenth Street, but she also says Frida and Diego lived on Thirteenth Street, which Herrera also states in her biography.
62. Bloch, unpublished journal, June 4, 1933, 71.
63. Ruby Brunton, "A New Biography of Paula Modersohn-Becker Reveals an Artist Committed to Painting Women," *Hyperallergic*, November 16, 2017, https://hyperallergic.com/411938 /a-new-biography-of-paula-modersohn-becker-reveals-an-artist-committed-to-painting -women.
64. Brunton, "A New Biography."
65. Museum of Modern Art, *German Painting and Sculpture* (New York: MoMA, 1931), 30.
66. Herrera, *Frida*, 175.
67. "Land," *Variety*, October 17, 1933.
68. Antony C. Sutton, *Wall Street and the Rise of Hitler: The Astonishing True Story of the American Financiers Who Bankrolled the Nazis* (Forest Row: Clareview Books, 2010), 15.
69. Sutton, *Wall Street and the Rise of Hitler*, 164.

70. Robert Sherrill, "With a Branch at Auschwitz," *New York Times,* August 6, 1978.

71. Leah Dickerman, *Diego Rivera: Murals for the Museum of Modern Art* (New York: Museum of Modern Art, 2011), 40.

72. Dickerman, *Diego Rivera Murals,* 41.

73. Dickerman, "Leftist Circuits," *Diego Rivera Murals,* 41.

74. Sutton, *Wall Street and the Rise of Hitler,* 164.

75. Hans-Walter Schmuhl, *The Kaiser Wilhelm Institute for Anthropology, Human Heredity, and Eugenics, 1927–1945* (Dordrecht: Springer, 2008), 3.

76. Schmuhl, *The Kaiser Wilhelm Institute,* 2.

77. Bertram Wolfe quoted in Luis-Martín Lozano and Juan Rafael Coronel Rivera, *Diego Rivera: The Complete Murals* (New York: Taschen, 2008), 380.

78. James Wechsler, "History as a Weapon: Portrait of America," in Luis-Martín Lozano and Juan Rafael Coronel Rivera, *Diego Rivera: The Complete Murals* (New York: Taschen, 2008), 372.

79. Wechsler, "History as a Weapon," 376.

80. Lozano and Coronel Rivera, *Diego Rivera: The Complete Murals,* 372.

81. Bloch, unpublished journal, July 16, 1933, 84.

82. Laurie Wilson, *Louise Nevelson: Light and Shadow* (London: Thames and Hudson, 2016), ch. 4.

83. Bloch, unpublished journal, July 18, 1933, 84.

84. Bloch, unpublished journal, July 21, 1933, 93.

85. Bloch, unpublished journal, July 21, 1933, 93.

86. Bloch, unpublished journal, July 21, 1933, 93.

87. Bloch, unpublished journal, July 22, 1933, 93.

88. Wilson, *Louise Nevelson,* ch. 4.

89. Diana MacKown, *Dawns and Dusks* (New York: Scribner's, 1976), 57.

90. Wilson, *Louise Nevelson,* ch. 4.

91. Bloch, unpublished journal, September 3, 1933, 107.

92. Bloch, unpublished journal, August 30, 1933, 107.

93. Bloch, unpublished journal, September 3, 1933, 107.

94. Bloch, unpublished journal, July 30, 1933, 95.

95. Bloch, unpublished journal, August 1, 1933, 95.

96. *New York World,* May 4, 1930.

97. Bloch, unpublished journal, August 1, 1933, 95.

98. Bloch, unpublished journal, August 5, 1933, 101.

99. Bloch, unpublished journal, August 5, 1933, 101.

100. Bloch, unpublished journal, September 30, 1933, 117.

101. Bloch, unpublished journal, September 30, 1933, 117.

102. Bloch, unpublished journal, September 30, 1933, 117.

103. Patrick Marnham, *Dreaming with His Eyes Open* (New York: Alfred A. Knopf, 1998), 122, 123.

104. Bloch, unpublished journal, September 30, 1933, 117.

105. Herrera, *Frida,* 170.

106. Letter from Guillermo Kahlo to Frida, August 17, 1933, NMWA. In a letter from August 8, 1932, Guillermo praised Frida as someone who painted "beautifully." See *Diego Rivera and Frida Kahlo in Detroit* (New Haven, CT: Yale University Press, 2015), 241, n. 23.

107. Letter from Guillermo Kahlo to Frida, August 29, 1933, NMWA.

108. Letter from Guillermo Kahlo to Frida, June 14, 1933, NMWA.

109. D. H. Lawrence, *The Plumed Serpent* (New York: Vintage International, Penguin Random House, 1992), 196.

110. Lawrence quoted in Leonard Lutwack, *The Role of Place in Literature* (Syracuse, NY: Syracuse University Press, 1984), 140.

EPILOGUE

1. Hayden Herrera, *Frida: A Biography of Frida Kahlo* (New York: Harper Perennial, 2002), 182.
2. Emmy Lou Packard interviewed by Katie Davis for "Frida Kahlo: Artist and Rivera's Wife," *All Things Considered,* National Public Radio, March 10, 1990.
3. Isolda P. Kahlo, *Intimate Frida* (Buenos Aires: Gato Azul, 2005; Bogotá: Cangrejo, 2006), 159.
4. Herrera, *Frida,* 183.
5. Herrera, *Frida,* 186. By 1935, Lucienne and Dimi were married. They had two sons and a daughter (George, Pencho, and Sita) and built their lives around art. They continued to paint murals throughout the United States, with Dimi acting as plasterer and Lucienne as painter. One of Lucienne's most famous murals is *Evolution of Music* (1938), painted in the music room of the former George Washington High School in New York City. The couple eventually settled in Gualala, California. Stephen Pope Dimitroff died in 1996 and Lucienne Bloch died in 1999.
6. Herrera, *Frida,* 180.
7. Herrera, *Frida,* 181.
8. "Divorced Artist Still Loves Diego Rivera," *Evening Herald and Express,* December 30, 1939.
9. Herrera, *Frida,* 198.
10. Harmony Hammond, "A Space of Infinite and Pleasurable Possibilities: Lesbian Self-Representation in Visual Art," in *New Feminist Criticism* (New York: IconEditions, Harper-Collins, 1994), 97.
11. Herrera, *Frida,* 226.
12. Series III. Exhibition Announcements and Other Ephemera, 1931–1948, Julien Levy Gallery Records, Philadelphia Museum of Art Library and Archives.
13. Letter from Frida to Julien Levy, September 3, 1938, Series I. Correspondence, Bulk 1930–1948, Julien Levy Gallery Records, Box 16, Folder 1, Philadelphia Museum of Art Library and Archives.
14. Herrera, *Frida,* 232.
15. Letter from Frida to Nick while she was in Paris, February 16, 1939, in Herrera, *Frida,* 236.
16. Herrera, *Frida,* 234.
17. Letter from Frida to Julien Levy, April 10, 1943, Philadelphia Museum of Art Library and Archives.
18. Frida to Nick Muray, February 16, 1939, in Herrera, *Frida,* 242.
19. Herrera, *Frida,* 251.
20. Herrera, *Frida,* 250.
21. Letters from Nick Muray to Frida, February 6 and March 13, 1939, displayed in the exhibition "Frida Kahlo: Through the Lens of Nickolas Muray," Fresno Art Museum.
22. Herrera, *Frida,* 276.
23. Gannit Ankori, *Frida Kahlo* (London: Reaktion Books, 2013), 221.
24. Ankori, *Frida Kahlo,* 122.
25. Ankori, *Frida Kahlo,* 122.
26. Frida to Olga Campos, in Salomon Grimberg, *Frida Kahlo: Song of Herself* (London: Merrell, 2008), 101.
27. Herrera, *Frida,* 235.
28. Herrera, *Frida,* 410.
29. Conversation with the author, May 2008. Yañez, who first created "Pasión por Frida!" in 1987, brought this all-day event of tableaux vivants performed live by women impersonating

Frida to the 2008 SFMOMA Frida Kahlo exhibition. Yañez discusses his groundbreaking 1978 "Homage to Frida Kahlo" exhibit, as well as other significant Frida-inspired events and art, in the following 2016 video interview by Adriana Camarena (with Chris Carlsson): www.foundsf.org/index.php?title=Frida_Kahlo_Rediscovered_in_San_Francisco.

30. Amalia Mesa Bains, quoted in Ira Kamin's "Memories of Frida Kahlo," *San Francisco Sunday Examiner and Chronicle,* May 6, 1979, 50.

31. Margaret A. Lindauer, *Devouring Frida* (Middletown, CT: Wesleyan University Press, 1999), 154.

Image Credits

1. Frida Kahlo, *Portrait of Eva Frederick*, 1931. Oil on canvas, 24¾ × 18½ in. Museo Dolores Olmedo Patiño. Licensed by Schalkwijk/Art Resource, New York. © 2019 Banco de México Diego Rivera Frida Kahlo Museums Trust, Mexico, D.F./Artists Rights Society (ARS), New York.
2. Carl Van Vechten, *Frida with a Tehuantepec Gourd on Head*, 1932. Gelatin silver print, 9½ × 12½ in. Courtesy of Carl Van Vechten Papers Relating to African American Arts and Letters. James Weldon Johnson Collection in the Yale Collection of American Literature, Beinecke Rare Book and Manuscript Library. © Van Vechten Trust.
3. Carl Van Vechten, *Portrait of Zora Neale Hurston*, 1938. Gelatin silver photographic print. Library of Congress, Prints and Photographs Division, Carl Van Vechten Collection [reproduction number LC-USZ62-79898] © Public Domain.
4. Guillermo Kahlo, *Frida Kahlo*, 1926. Photograph © Guillermo Kahlo, courtesy of Throckmorton Fine Art, New York.
5. *Frieda Kahlo*, 1930. Photograph by Edward Weston. © Center for Creative Photography, Arizona Board of Regents.
6. Imogen Cunningham, *Frida Kahlo Rivera*, 1930. Photograph. © 2020 Imogen Cunningham Trust.
7. Frida Kahlo, *Frieda and Diego Rivera*, 1931. Oil on canvas, $39^3/_8 \times 31$ in. San Francisco Museum of Modern Art, Albert M. Bender Collection, gift of Albert M. Bender, © 2019 Banco de México Diego Rivera Frida Kahlo Museums Trust, Mexico, D.F./Artists Rights Society (ARS), New York. Photo: Ben Blackwell.

8. Frida Kahlo, *Portrait of Mrs. Jean Wight*, 1931. Oil on canvas, 24.9 × 18.1 in. Gretchen and John Berggruen, San Francisco, Private Collection. Licensed by Erich Lessing/Art Resource, New York. © 2019 Banco de México Diego Rivera Frida Kahlo Museums Trust, Mexico, D.F./Artists Rights Society (ARS), New York.

9. Frida Kahlo, *Portrait of Luther Burbank*, 1931. Oil on masonite, $34\frac{1}{4} \times 24^{7}/_{16}$ in. Museo Dolores Olmedo Patiño. Licensed by Schalkwijk/Art Resource, New York. © 2019 Banco de México Diego Rivera Frida Kahlo Museums Trust, Mexico, D.F./Artists Rights Society (ARS), New York.

10. Frida Kahlo, *Window Display on a Street in Detroit*, 1931. Oil on metal, $12\frac{1}{4} \times 15$ in. Mr. and Mrs. Abel Holtz Collection, courtesy of Gary Nader Fine Art, Miami, Private Collection. Licensed by Erich Lessing/Art Resource, New York. © 2019 Banco de México Diego Rivera Frida Kahlo Museums Trust, Mexico, D.F./Artists Rights Society (ARS), New York.

11. Frida Kahlo, *Henry Ford Hospital*, 1932. Oil on metal, $12\frac{1}{4} \times 15\frac{1}{2}$ in. Museo Dolores Olmedo Patiño. Licensed by Schalkwijk/Art Resource, New York. © 2019 Banco de México Diego Rivera Frida Kahlo Museums Trust, Mexico, D.F./Artists Rights Society (ARS), New York.

12. Anonymous, Mexican *retablo*, 1927. Digital Image: Celia Stahr. © Public domain.

13. Frida Kahlo, *My Birth*, 1932. Oil on copper, $12\frac{1}{2} \times 14$ in. Private Collection. © 2019 Banco de México Diego Rivera Frida Kahlo Museums Trust, Mexico, D.F./Artists Rights Society (ARS), New York.

14. Aztec Goddess *Tlazolteotl* wearing flayed human skin and giving birth to *Centeotl* from the *Codex Borbonicus*, c. 1519, photographic reproduction registered in U.S. Copyright office before January 1, 1924. © Public domain.

15. Frida Kahlo, *Self-Portrait with Necklace*, 1933. Oil on metal, $13\frac{3}{4} \times 11^{7}/_{16}$ in. The Jacques and Natasha Gelman Collection of Modern and Contemporary Mexican Art; the Vergel Foundation. © 2019 Banco de México Diego Rivera Frida Kahlo Museums Trust, Mexico, D.F./Artists Rights Society (ARS), New York.

16. Lucienne Bloch, *Frida Under the Sign "For Negroes,"* 1932. Courtesy of Old Stage Studios. © Lucienne Bloch.

17. Frida Kahlo, *Self-Portrait on the Borderline Between Mexico and the United States*, 1932. Oil on metal, $12\frac{1}{2} \times 13\frac{3}{4}$ in. Maria Rodriguez de Reyero Collection, New York, Private Collection. Licensed by Erich Lessing/Art Resource, New York. © 2019 Banco de México Diego Rivera Frida Kahlo Museums Trust, Mexico, D.F./Artists Rights Society (ARS), New York.

18. Frida Kahlo, *My Dress Hangs There*, 1933. Oil and collage on masonite, $18 \times 19\frac{1}{2}$ in. Private Collection. Photograph © 1993 Christie's Images. © 2019 Banco de México Diego Rivera Frida Kahlo Museums Trust, Mexico, D.F./Artists Rights Society (ARS), New York.

Index